SELLING
Contemporary Art

HOW TO NAVIGATE
THE EVOLVING MARKET

Edward Winkleman

ALLWORTH PRESS
NEW YORK

Allworth Press books may be purchased in bulk at special discounts for sales promotion, corporate gifts, fund-raising, or educational purposes. Special editions can also be created to specifications. For details, contact the Special Sales Department, Allworth Press, 307 West 36th Street, 11th Floor, New York, NY 10018 or info@skyhorsepublishing.com.

24 23 22 21 5 4 3 2

Published by Allworth Press, an imprint of Skyhorse Publishing, Inc. 307 West 36th Street, 11th Floor, New York, NY 10018.

Allworth Press® is a registered trademark of Skyhorse Publishing, Inc.®, a Delaware corporation.

www.allworth.com

Cover design by Mary Belibasakis

Library of Congress Cataloging-in-Publication Data is available on file.

Print ISBN: 978-1-62153-557-7
Ebook ISBN: 978-1-62153-473-0

Printed in the United States of America

TABLE OF CONTENTS

TABLE OF CONTENTS

INTRODUCTION

The Leo Castelli Model

In late 2008, just as I was finishing my book *How to Start and Run a Commercial Art Gallery,* it felt like someone he had turned off the spigots of the contemporary art market all at once. One day we were wheeling and dealing as normal, despite distant rumblings of a worldwide economic meltdown, and seemingly the next day everyone stopped returning phone calls or emails. People stopped going to the galleries as well. It all seemed so sudden, at least for the generation of younger art dealers who, having opened their galleries in the twenty-first century, had never known anything but boom times.

News of giant corporations and financial institutions going belly-up came on a regular basis. Many of them had been good, steady collectors. If these masters of the universe couldn't navigate the economic turmoil, what chance did mom-and-pop-style galleries stand? Smaller galleries in particular were nervous. Tales of 40 percent discounts being offered by top-level galleries to close deals sent chills through the community. How could we survive on that? Then the galleries started closing too. Not as many as people had predicted, perhaps, but enough to make those dealers still open begin to search for new ways to conduct business.

Many new models were floated and discussed, including that dealers should follow the example set by fashion designers and merge under an umbrella corporation, such as the luxury brands conglomerate LVMH. And while the advocates of such a model were definitely onto something, they mistook the parallel as being

between fashion designers and art dealers, when it actually turned out to be between fashion designers and visual artists themselves. Indeed, if the "Great Recession" (as the economic downturn has come to be called) issued any bold new practices into the contemporary art market, the open marketing of a visual artist by a conglomerate, or mega-gallery, as a "brand" would be high on the list. What I mean by that specifically is the shift from marketing individual art objects based on their quality to the marketing of any object made by a high-profile artist based on their name and demand for their work.

Granted, a more subtle branding of artists themselves had been a conscious part of marketing contemporary art for many decades, at least since 1960, when legendary art dealer Leo Castelli (1907–1999) managed to sell a sculpture of two beer cans by his then rising star artist Jasper Johns. But late 2008 saw a giant leap forward in a more direct approach to that practice. In the years that followed, this more blatant branding of artists over artworks, combined with an emphasis on expanding the power and even real estate of the conglomerate, would impact nearly every aspect of the contemporary art market, including how feasible it remained to run a gallery in what has become known as "The Leo Castelli Model."

In a nutshell, Mr. Castelli's model was to discover the best artists he could, nurture their careers, carefully guide their markets (especially by not pushing their prices too high too quickly), all with the intention of growing old and successful together in a mutually agreeable partnership. The specifics of this model include taking work on consignment (rather than buying it and reselling it, as retailers do in most other industries) and paying artists a percentage of any sales, typically in a 50/50 split; "representing" the artist such that they were expected to only sell through the gallery in return for sustained promotion and regularly scheduled exhibitions; and managing many of the more mundane aspects of their career, including handling logistics for museum or other gallery exhibitions, archiving their press and images of their work, and many other tasks artists would rather someone else free them from doing so they could focus on creating their work.

Leo Castelli did not invent many of the strategies behind his unparalleled success at selling contemporary art (and in reality, even he was not as consistent in such matters as legend has it), but he optimized a series of "best practices" for art dealing in a way that was so admired by artists and younger dealers alike that it unofficially became "the way it's done." The cornerstone of the model was for mutual trust and loyalty between dealer and artist to guide what was presumed to be a long-term relationship over the inevitable ups and downs of both an art career and the economy's cycles. Indeed, it was this presumption that artist and dealer were not only a team,

but that they would remain so for many years, that made an early heavy investment by the art dealer in the relatively unknown artist more sensible from a business point of view.

Again, even Leo Castelli didn't follow those best practices to the letter, but by 2008, when artist Damien Hirst, one of the biggest "brands" in the contemporary art world, cut out his powerful New York and London galleries by bringing a huge body of his work direct to auction, few could any longer claim the Castelli model was the only path to success. This book is an attempt to summarize the changes in the contemporary art market since 2008, with a particular focus on the challenges and innovations just now entering the market. It explores a number of shifting factors, and is based on a wide range of interviews with collectors, dealers, artists, fair organizers, and other art world entrepreneurs, with the ultimate goal of helping anyone attempting to sell contemporary art strategize on how to navigate the quickly evolving market.

Part I of this book is devoted to the major areas of change in the market over the past decade or so that are outside any individual dealer's control. Each chapter in Part I begins with a summary of that change. Each chapter in Part I then explores the strategies that galleries use, or might use, to more effectively navigate these areas of change.

Part II looks at specific areas of change that dealers themselves are initiating. In other words, things that dealers are doing differently to respond to outside forces or simply evolve with the times. Again, much of what is discussed in this part is likely to continue to evolve, and so each chapter also attempts to synthesize the collective wisdom of the art sellers interviewed in them to predict how these areas of change might play themselves out.

Part III of the book, co-authored by the art attorney (and my friend) M. Franklin Boyd, Esq., reflects an opinion held by more and more dealers, as well as many collectors of contemporary art: that as the market grows in size, the handshake way of doing business will increasingly need to give way to contracts. Some of the basics behind these contracts are discussed in my first book. New considerations in response to things that have changed since that time are outlined in the chapters dealing with Representation and Consignment contracts. Considerations not covered in the first book, such as contracts for new forms of art that have or may come along, are then discussed in later chapters.

Throughout this book, my goal is to present as accurate a picture of the landscape as can be described at this point, to share insights from art dealers from a wide range of backgrounds and experience, and to then examine strategies for using that information to the best advantage of dealers' artists and their business. There is not

very much discussion about the needs of artists in this book. Rest assured, though, that every strategy discussed is contextualized from the understanding of the fiduciary and ethical obligations to representing artists' best interests in everything a dealer does.

How quickly the market is evolving suggests that only the most fundamental of best practices and insights revealed throughout this book will remain helpful. As I note in my first book, though, there is no one-size-fits-all formula for selling contemporary art. Each successful dealer reinvents the model to some degree. My hope here is simply to consolidate the information and advice I can gather into one concise discussion of how the industry I love seems to be moving forward into the twenty-first century.

WHY 2008?

Each chapter in Part I of this book examines "What has changed?" within the years from 2008 to 2014–early 2015. Many of the changes in the contemporary art market discussed in this book were already well underway when I was writing *How to Start and Run a Commercial Art Gallery* in 2008, but they had not yet fully revealed themselves to be as significant as we recognize them to be today. As its title suggests, that book was conceived of as a summary of the best practices the industry had developed up to that time in setting up and running a "brick and mortar" gallery space. Even though it did touch upon many of the issues we'll look at more closely in this text, like art fairs, losing artists to other galleries, and contracts, that book did so from within an assumption that the Leo Castelli model was still the best way to run a contemporary art gallery. It remains a good way to run one, and many great and successful galleries today still essentially follow it, but that model's underlying strategy (that is, a contemporary art dealer finds and invest in great emerging artists and then together they work to grow old and successful together) is more challenging now due to the way things have evolved since 2008. Forces beyond any single dealer's control continue to put pressure on that model, and so by looking closely at this particular window, between 2008 and 2014–2015, I hope to build upon the first book's advice and share the strategies for effectively navigating these changes.

NEW YORK-CENTRIC

Many of the people I interviewed for this book who live and predominantly work outside of New York have told me how "New York-centric" some of my assumptions and questions were. After several false starts at conceiving of the book from a more international perspective, though, I eventually surrendered to this shortcoming. This book *is* written from a New York-centric point of view. Given that I am attempting to

discuss several issues within what is considered an increasingly "global" art market, this failing on my part needs to be acknowledged. But after giving it a great deal of thought, I have concluded that the market is evolving so quickly at the moment that no book I can write could hope to be timely, detailed, and globally comprehensive. By the time any such effort was researched and published, the strategies discussed would most likely be pointlessly out of date. That may still end up being the case by limiting my point of view to the city I know best, but I am at least more confident of the conclusions drawn here than I could hope to be if attempting to cover the entire planet. How helpful this ends up being to dealers outside New York may eventually depend on how truly global the market and its practices have become. Because New York remains, at least for the time being, the city with the strongest contemporary art market and is among those with the most contemporary art galleries, though, I do hope what is recorded here will be of interest to dealers in any location.

THE CALM AFTER THE STORM

It felt like it took me an extraordinary amount of time to make some final decisions on issues in this book. Partly that's because it contains much more subjective ideas than my first book did, and partly that's because, in an attempt to be timely, I repeatedly went back and revised entire sections in response to some new study that just came out that contradicted all the previously held conventional wisdom. The problem with that, as I eventually learned, was there is some new study coming out in the art world every week almost, each seemingly contradicting the previous conventional wisdom, only to see yet another emerge two weeks after that, reinforcing the previously held conventional wisdom.

The week I turned in the manuscript for this book, the *New York Times* published a review in which the critic described an event as creating a new turn "unlike anything I'd experienced in over four decades in the New York art world." My first thought was, "Oh great…I'll probably need to revise another eight chapters in response to that now." It also made me keenly aware, however, that many of the events that produced hyperbolic headlines in the art press or led longtime observers to conclude everything was different now, often seemed far less dramatic after a few weeks or months. If nothing else, the contemporary art market is remarkably adaptable. Even with a once-in-a century recession, followed a few years later by a once-in-a-century hurricane that did more damage to New York galleries in one night than was previously imaginable, such near-existential threats seem simply part of the landscape with a bit of distance. People go back to work. People adapt.

That theme, that what seemed so dark and threatening at one point looked much more manageable in the light of day, comes up a few times in the chapters that

follow. It is difficult when you are juggling so much change to always keep that perspective, and many things that come up in the art market do require a swift and decisive response, but rarely is there so little time that a bit of research and advice from other art market professionals is not possible first. That is what I have tried to assemble in this book—not to alarm anyone, but simply to arm dealers with the information that can help them make calm, considered decisions about the next once-in-a-century event sure to shake things up again any moment now.

ACKNOWLEDGMENTS

At several points while writing this book I thought it might be easier to run away to a South Pacific island and try my hand at fishing. The contemporary art market just kept evolving, and conclusions I had based entire sections or even chapters on were suddenly suspect, irrelevant, or simply wrong. I'll grumble about that some more in the Conclusions, but here I need to thank a few of the people who kept encouraging me to keep at it because despite its (many) shortcomings, I wish something like this book had existed when I launched my gallery. The openness of the other dealers, collectors, journalists, curators, fair organizers, attorneys, and artists who are quoted within or who helped inform the ideas and concerns discussed still impresses and humbles me.

Jimbo Blachly, Jennifer Dalton, Rory Donaldson, Yevgeniy Fiks, Ulrich Gebert, Gulnara Kasmalieva and Muratbek Djumaliev, Leslie Thornton, Andy Yoder, Julie Evans, Janet Biggs, Christopher K. Ho, Kate Gilmore, Chris Dorland, Ivin Ballen, Sarah Peters, Cathy Beigen, Joy Garnett, Shane Hope, Christopher Johnson, Eve Sussman and Simon Lee, William Powhida, Joe Fig, Thomas Lendvai, Alois Kronschläger, Nancy Baker, Rosemarie Fiore, Jani Leinonen, Leslie Brack, Joanne Carson, Analia Segal, Doreen McCarthy, Gary Petersen, Micah Harbon, Michael Waugh, and the irrepressible Amanda Church: you are but a handful of the contemporary artists I have been honored to work with one way or another over the years. I hope a heartfelt "thank you" here is not presumptuous. You all continue to amaze me.

Alain Servais, Glenn Fuhrman, Mark Coetzee, Sylvain Levy, Michael Hoeh, Noel Kirnan, Larry Rinkel, Laura Lee Brown and Steve Wilson, Alice Gray Stites, Marie Elena Angulo, Henry Zarb, John and Amy Phelan, Raymond Learsy and Melva Bucksbaum, Ann and Lee Fensterstock, Robert D. Bielecki, and the absolutely perfect Zoë and Joel Dictrow: each of you and many more shared insights from the collector's point of view that run through this book. I am grateful for your time, your patronage of contemporary art, and for your kind words and friendship. Christian Viveros-Faune, Dan Duray, Charlotte Burns, Jerry Saltz, Roberta Smith, Holland Cotter, Peter Schjeldahl, Martha Schwendener, Ken Johnson, "The" Georgina Adam, Anny Shaw, Julia Halperin, Gareth Harris, Paddy Johnson, Hrag Vartanian, Christopher Knight, and countless other writers I read religiously (I know, it looks like I'm sucking up for press here, but I'm sincere when admitting who I learn from): conversations I've had with each of you or things you have written are reflected in nearly every chapter here as well.

The list of dealers I have learned from is very long indeed, but I must acknowledge several who continue to fuel my admiration for the profession including Wendy Olsoff and Penny Pilkington, Ronald and Frayda Feldman, Jay Grimm, Pavel Zoubok, Valerie MacKenzie, Margaret Thatcher, John Post Lee and Karin Bravin, Magda Sawon and Tamas Banovich, the wonderful team at Mixed Greens (including Paige West), Heather Marx and Steve Zavaterro, Catharine Clark, Christian Siekmeier, Joe Amrhein and Susan Swenson, Paul Hedge, and Lisa Schroeder and Sara Jo Romero. I mention a few times in the book how I tend to really like art dealers; these people are the primary reason why.

Thanks must also go to a series of people who were very generous with their feedback, advice, or information, whether they meant to be or not, including Annette Schönholzer, Heather Hubbs, Helen Toomer, Helen Allen Smith, Andrew Edlin, Elise Graham, Amy Smith-Stewart, Judith Prowda, Richard Lehun, Mary Rozell, Eric Romano, Sarah Haselwood, Janet Phelps, Andras Szanto, Michael Hall, Ian Stewart, Kibum Kim, Josh Baer, Mindy Solomon, Carter Cleveland, Sebastian Cwilich, Garren Gotthardt, Annie Stancliffe, Chris Vroom, Carlos Rivera, Kenneth Schlenker, Cornell Dewitt, Mari Spirito, Jay Gorney, Annamária Molnár, Łukasz Gorczyca, Hans Knoll, Jochen Meyer, and Robin Cembalest.

The people at Allworth Press are a complete joy to work with. The extremely talented Tad Crawford (whose important contributions to the literature on the art business are unparalleled) is the best publisher anyone could ever hope for. His guidance and reassurance throughout this process has meant a great deal to me, as has the guidance of Zoe Wright and Ashley Vanicek. They have been extremely patient with this process and I greatly appreciate their support and encouragement.

I also must say a special thanks to two people. First is Elizabeth Dee, who has been an inspiration to me as a dealer, an art fair organizer, and a cultural producer, as well as a very dear friend. Many of the ideas in this book emerged from very open and honest conversations we have had about what art dealing means today, and what its potential is moving forward. You are one of a kind, Elizabeth, and if you did not exist, the art world would need to invent you.

A hug and huge thanks also go to William Flaherty, who in addition to making his lake house available for quiet writing time, also knew just when I needed an extra nudge of encouragement to get over that next hill. Thank you Wilski! It means a lot to me. My co-author for Part III of this book, M. Franklin Boyd, Esq., also deserves special thanks. Not only were Franklin's ideas and expertise the driving force of each chapter in that section, but her insights and experiences as a collector, consultant, and attorney have informed nearly every other chapter of this book as well.

And finally, in addition to providing excellent feedback on several chapters in this book, including world-class advice on running an art fair in Chapter 9, my partner in the gallery, the art fair, and the rest of the world, Murat Orozobekov, quite literally deserves a medal for his saintly patience and support, including positively heroic efforts to take care of me *and* run an art fair when I broke my leg in Istanbul last September. I do not need to tell him I could not have done this without him. He knows. This book is dedicated to him.

PART I

Recent Changes in the Contemporary Art Marketplace:
Things Beyond Each Dealer's Control

PART I

Recent Changes in the Contemporary Art Marketplace:
Things Beyond Each Dealer's Control

1

The Growing Globalization of the Contemporary Art Market

WHAT HAS CHANGED?

The increasing globalization of the contemporary art market has often been cited as one of the main reasons it did not completely collapse during the Great Recession.[1] Even as most American or European collectors were pulling back on acquisitions in late 2008 and 2009, others from around the world reportedly moved in to take advantage of the deals to be had among the severely shaken galleries and, in the process, kept more of them afloat than had been originally predicted. One conclusion from this perception is that even if your entire collector base is local, it behooves art dealers everywhere to understand the global trends at play in making the overall contemporary art market stronger or weaker and to learn how to strategize in concert with them.

Not everyone is convinced the contemporary art market is actually global in a significant way, though. In April 2014, Olav Velthuis (Associate Professor at the University of Amsterdam, who has been studying the emergence and development of art markets in so-called BRIC countries—Brazil, Russia, India, and China) gave a lecture at London's Courtauld Institute on what he called the "myth of a global art market." According to a report on the lecture in *The Art Newspaper*[2], Velthuis told the audience that his research revealed "that the majority of businesses are organized 'extremely locally,' despite aspiring to the borderless ideals of international artists who command global demand—which [Velthuis] said has been 'vastly

exaggerated'." Velthuis did reportedly later acknowledge that there is a "small top segment" of globe-trotting collectors who buy art around the world, but he argued that a disproportionate degree of press coverage about this minority served to perpetuate the myth of a truly global market. As a Courtauld professor in attendance pointed out during the Q&A, however, this small set of top collectors does account for a large percentage of the total art business.

Even if you accept that the contemporary art market has indeed gone global in a meaningful new way, it is not always easy to know how to respond to that information. Depending on which year's data or which news source you are reading, you may learn that "it's all about China" or "it's all about Brazil," no wait, "it's now all about Qatar." In other words, the big picture is a bit murky and also rapidly changing. There is also a perception that things are evolving so rapidly that if you rely on such reports to decide which new market to explore, it will already be too late by the time you get there.

Publicly available sources of information on where collectors are buying contemporary art are either limited to auction results, confusing, controversial, or all of the above. Among the most cited sources for such information are:

- *TEFAF Art Market Report.* Dr. Clare McAndrew, a cultural economist and founder of the Dublin-based research and consulting firm Arts Economics (www.artseconomics.com), is commissioned annually by The European Fine Art Foundation (TEFAF) to compile data on global art sales, which is then released each March in conjunction with TEFAF's art fair in Maastricht as the *TEFAF Art Market Report.* Not limited to contemporary art; combines "Postwar and contemporary art" in one category; based on auction sales and art dealer surveys. (www.tefaf.com)

- *Artprice's Contemporary Art Market Annual Report.* Founded by French artist/entrepreneur Thierry Ehrmann, the Lyon-based company Artprice, which aggregates worldwide auction results and publishes overall "Art Market Trends," also publishes a specific overview of the global contemporary art market each October in English, French, German, Italian, Spanish, and Chinese. This multi-language publishing may be partially responsible for why this report's name is not entirely consistent within the art press. The most recently available report is called, in English, *Contemporary Art Market 2014: The Artprice Annual Report.* Limited to contemporary art (defined as work by artists born after 1945); based only on auction sales. (www.artprice.com)

- *Skate's Annual Art Investment Report.* Founded by Russian art market analyst Sergey Skaterschikov, *Skate's Annual Art Investment Report* focuses on the very top of the contemporary art market, particularly within the

auctions, but also looks at special issue trends, such as performance among top galleries and ranking of the top art fairs. More of an analytic approach than in-depth data-mining, but designed to be a summary of their monthly newsletter with additional special issues. (www.skatepress.com)

When you bring up these sources of information among collectors, dealers, or some arts journalists, though, you are often likely to hear complaints about the sample sizes they use, the lack of supplied detail about their methodology, or simply the findings' true relevance to how they get discussed.[3] Especially among professionals who work in industries where such weaknesses are not tolerated in reports (such as finance), these reports have been considered of limited use outside of their auction data, which is seen as very reliable, but obviously of less value when considering the primary market. Despite these concerns, these reports are still frequently cited in the arts press, and therefore do indeed form perceptions and sway decisions in the art market.

Still, I kept running into inconsistencies while trying to reconcile their findings into a meaningful analysis and so ultimately decided to explore how "global" the contemporary art market has become through entirely different methods. It's not that these reports don't have value (I will indeed refer to parts of them later in this book), but rather that the way their data about the "global" question is interpreted, because of the way it is framed by their authors, leads readers to overestimate how actionable their findings are. With that in mind, we will look below at three other ways of trying to deduce how more "global" the contemporary art market has become since 2008. The first of these is admittedly highly subjective, but all three have the advantage of being more readily acted upon by individual art dealers focused on the primary market than I was finding for the data from the three reports mentioned above. My chosen metrics here include:

1. Changes in where the top 200 contemporary art collectors primarily reside

2. Changes in the primary location of the contemporary art galleries participating in the world's top art fairs

3. Locations where new art fairs are being launched

Changes in Where the Top 200 Contemporary Art Collectors Primarily Reside

Although it is assembled via a highly subjective process, the list of the world's "Top 200 Collectors" published by *ARTNews* magazine every summer is reported on far and wide and in that way influences the perceptions of where the biggest art collectors live, where they get their money (what industries they work in or where they inherited their fortunes from), and what they collect. (I should note here how thankful

I am to *ARTNews*'s former editor-in-chief Robin Cembalest and her staff for helping me with access to these lists.) The Top 200 Collectors list is not limited to those who collect contemporary art, but in the 2008 edition, 154 of the collectors listed (or a little more than 75 percent) either focused on or collected some contemporary art. Here is where the contemporary art collectors on the 2008 list predominantly resided (please note that percentages in the tables below do not total 100 percent due to rounding for space considerations):

The Primary Residence of the 154 Collectors of Contemporary Art in *ARTNews*'s List of the 200 Top Collectors in 2008

PRIMARY RESIDENCE	Number	% of total
US and Canada	93	60%
UK and Europe	47	30%
Mexico and South America	6	4%
Asia	4	3%
Turkey and the Middle East	2	1%
Other	2	1%

By the 2014 edition of *ARTNews*'s Top 200 Collectors, the categories for what type of art was being collected had changed somewhat, but of the 200 listed that year, 167 collectors either focused on or collected some contemporary art, which was a drop from the 171 listed in 2013 but still a fair increase over the 2008 list. Here's the breakdown for 2014 by primary residence:

The Primary Residence of the 167 Collectors of Contemporary Art in *ARTNews*'s List of the 200 Top Collectors in 2014

PRIMARY RESIDENCE	Number	% of total	COMPARED WITH 2008 LIST
US and Canada	86	51%	Large decrease
UK and Europe	57	34%	Moderate increase
Mexico and South America	8	5%	Small increase
Asia	14	9%	Large increase
Turkey and the Middle East	1	1%	No change
Other	1	1%	No change

While collectors in both Asia and Europe seem to have made noticeable gains in assuming positions among the Top 200 Collectors, and the biggest decrease in percentage is clearly among American collectors, there are a few caveats to using this list as a measure of how much more "global" the contemporary art market has become over the past several years. First, many people on the list often move from home to home within each year, and a number of these collectors primarily live in countries outside their country of origin. Second, the collectors appearing on the list shift from year to year for a wide range of reasons: individuals on the list pass away, get divorced and continue to collect separately, or stop collecting as much or altogether. Third, as noted above, these lists are compiled via a subjective process in which who is "important" may often be determined by who's getting the most attention for their collection that year. Human interest in what's "new" being what it is, there may be more attention paid to collectors who have made a splash than to others more quietly still adding to their established collections.

Still, looking at the numbers across all the years from 2008 through 2014 (see below), we see a fairly continuous decrease in the percentage of US-based collectors among the top 200, except for a slight bump back up in 2011 (Canadians on the list remain consistent). This does not necessarily mean fewer Americans are actively collecting contemporary art as much as it suggests collectors from other countries seemed more active. We also see both a big jump in 2009 and then a plateau in the percentage of collectors from Europe and the UK, until it begins to decrease again in 2013–2014. Most consistent is the slow-but-steady increase in the number of top collectors from Asia, with most of the new entries by 2014 residing in China, which corresponds with a number of larger Western galleries opening new spaces there (see Chapter 2), as well as an increase in the efforts to produce high-profile art fairs there (see Chapter 3).

The ARTNews 200 Top Collectors 2008–2014
(Number collecting Contemporary art)

PRIMARY RESIDENCE	2008 (154)		2009 (170)		2010 (161)		2011 (168)		2012 (168)		2013 (171)		2014 (167)	
	#	%	#	%	#	%	#	%	#	%	#	%	#	%
US and Canada	93	60%	93	55%	89	55%	95	57%	89	53%	87	51%	86	51%
UK and Europe	47	30%	62	37%	60	37%	59	35%	63	38%	62	36%	57	34%
Mexico and South America	6	4%	7	4%	5	3%	5	3%	5	3%	7	4%	8	5%
Asia	4	3%	5	3%	6	4%	7	4%	8	5%	13	8%	14	9%
Turkey and the Middle East	2	1%	1	.5%	1	.5%	2	1%	2	1%	2	1%	1	1%
Other	2	1%	1	.5%	0	0%	0	0%	0	0%	0	0%	1	1%

But let's look a bit more closely at the two regions where the numbers of collectors in the top 200 have increased over the past several years. First, breaking down the numbers in Europe and the UK by country, we see a few interesting trends:

The ARTNews 200 Top Collectors 2008–2014 in Europe and the UK (Number Who Collect Contemporary Art)

PRIMARY RESIDENCE	2008 (47)	2009 (62)	2010 (60)	2011 (59)	2012 (63)	2013 (62)	2014 (57)
Austria	2	3	2	2	2	2	3
Belgium	2	2	3	3	3	5	3
England	10	9	8	8	8	8	10
Finland	-	-	-	-	-	1	1
France	6	5	5	4	5	5	6
Germany	12	14	15	15	21	18	11
Greece	2	3	3	3	3	2	2
Italy	2	4	3	1	1	1	2
Monaco	-	-	-	-	-	-	1
Netherlands	2	4	5	4	3	4	3
Norway	1	1	1	1	1	1	1
Russia	-	1	2	2	2	2	1
Spain	1	3	3	3	1	1	-
Switzerland	6	12	9	12	12	11	12
Ukraine	1	1	1	1	1	1	1

Right after the recession, Switzerland and Germany saw the biggest increases in the number of their residents in the top 200, but whereas Switzerland has remained steady, Germany has recently decreased to almost half of its post-recession high. Most other countries' numbers essentially held steady, including England and France. And a few countries had residents join the elite collectors' circle for the first time, like Russia, Finland, and Monaco.

It is tempting to try to interpret these numbers as a reflection of real-world events, such as the fact that the economy in Germany (where the number of top collectors grew from twelve to over twenty at one point) is known to have remained fairly strong throughout these years, but then what explains the dip back down to eleven in 2014? The German economy was still among Europe's strongest then. The aforementioned factors (such as how top collectors may have moved primary residences, divorced, died, or stopped collecting) make any such economic narratives a bit too speculative for much use on their own, so later in this chapter we will compare these numbers with the findings from the other two metrics to see what actionable conclusions can be drawn within the larger picture.

Breaking down the Asian collectors on the list by country, the trend here is a slow, steady increase, but the overall numbers remain low:

The ARTNews 200 Top Collectors 2008-2014 in Asia
(Number who Collect Contemporary Art)

PRIMARY RESIDENCE	2008 (4)	2009 (5)	2010 (6)	2011 (7)	2012 (8)	2013 (13)	2014 (14)
China	1	2	2	2	2	6	8
Indonesia	-	-	-	-	1	1	1
Japan	2	2	3	3	3	4	3
South Korea	1	1	1	1	1	1	1
Taiwan	-	-	-	1	1	1	1

Even though the numbers for Asia are small in comparison with the United States and Europe, one conclusion here seems obvious: while Asia as a whole has steadily climbed or remained steady, it is China's top contemporary art collectors who have gained the most in international stature. Here again, it is tempting to conclude that this reflects how strong the economy in China has been during these years, but even if that partially explains the rise, that information alone is not actionable for most art dealers. Critical questions remain, such as "What exactly are these collectors acquiring?" For several years the perception has persisted that the top Asian collectors focus on Asian artists and big brand-name Western artists like Koons, Hirst, and Warhol, but have not shown much interest in collecting Western artists outside those few art stars. In early 2015, anecdotal reports from the fairs in Hong Kong suggested that may be changing, a little.

Changes in the Primary Location of the Contemporary Art Galleries Participating in the World's Top Art Fairs

According to *Skate's Annual Art Investment Report*[4], the top ten international art fairs in 2013 were:

1. Art Basel in Basel

2. The European Fine Art Fair (TEFAF; Maastricht)

3. Foire Internationale d'Art Contemporain (FIAC; Paris)

4. Art Basel in Miami Beach (ABMB; Miami)

5. The Armory Show (New York)

6. Paris Photo (Paris)

7. Feria Internacional de Arte Contemporáneo (ARCOmadrid; Madrid)

8. Frieze (London)

9. Art Cologne (Cologne)

10. Artissima (Turin)

Skate's notes that this ranking was based on four criteria: period on the market, number of participants, participation figures, and reputation among peers. That last category is, of course, somewhat subjective and depends on whom you ask.

Because the amount of contemporary art shown at TEFAF is considerably lower than at the other fairs listed, however, I have taken it out of my top-ten list here and added the thirteenth fair on Skate's list, Art Brussels (Brussels), instead, to create a somewhat customized list of the Top Ten International Contemporary Art Fairs for 2014, which we'll examine below for clues their participating galleries can reveal about shifts in the global contemporary art market. (I should perhaps also explain I did not add the eleventh and twelfth fairs on Skate's list: Art Basel in Hong Kong and Arte Fiera Bologna, respectively. In 2013 Art Basel in Hong Kong had only just undergone a change in ownership and branding, and so in 2014 it was basically a very different entity from what it had been in 2008, making the comparison in their participating galleries less meaningful. Also, despite Skate's ranking, Arte Fiera Bologna is overwhelmingly a national fair and not as internationally influential as the Skate's ranking would suggest in my opinion. Moreover, Artissima already provides insights into the Italian market's global influence, and Brussels is viewed as an up-and-coming contemporary art capital, so it helps round out the geographical diversity of my top-ten list.)

Here is a breakdown of changes between 2008 and 2014 in the numbers of galleries participating in these fairs from various regions across the world:

		NUMBER OF PARTICIPATING GALLERIES IN MAJOR FAIRS BY PRIMARY LOCATION						
Top Contemporary Art Fairs	*Year*	*US & Canada*	*UK & Europe*	*Mexico & South America*	*Asia*	*Turkey & Middle East*	*Other*	*Totals*
Art Basel in Basel	2008	74	208	7	14	2	3	308
	2014	76	178	10	17	3	1	285
		Up	Down	Up	Up	Up	Down	Down
FIAC	2008	19	152	1	4	3	0	179
	2014	45	126	8	6	6	0	191
		Up	Down	Up	Up	Up	Same	Up
Art Basel in Miami Beach (ABMB)	2008	104	132	17	9	4	0	266
	2014	109	114	32	10	0	2	267
		Up	Down	Up	Up	Down	Up	Up
Armory Show	2008	69	83	0	5	2	1	160
	2014	49	68	4	21[A]	3	0	145
		Down	Down	Up	Up	Up	Down	Down
Paris Photo	2008	21	63	0	21[B]	0	2	107
	2014	28	94	5	6	4	4	141
		Up	Up	Up	Down	Up	Up	Up

		NUMBER OF PARTICIPATING GALLERIES IN MAJOR FAIRS BY PRIMARY LOCATION						
Top Contemporary Art Fairs	*Year*	*US & Canada*	*UK & Europe*	*Mexico & South America*	*Asia*	*Turkey & Middle East*	*Other*	*Totals*
ARCO	2008	30	199	43ᶜ	21	2	1	296
	2014	12	175	31	0	0	0	218
		Down	Down	Down	Down	Down	Down	Down
Frieze (London)	2008	30	106	6	6	3	0	151
	2014	29	107	8	10	6	2	162
		Down	Up	Up	Up	Up	Up	Up
Art Cologne								
	2008	11	189	1	4	0	0	205ᴰ
	2014	21	196	0	6	4	1	228
		Up	Up	Down	Up	Up	Up	Up
Artissima	2008	13	107	1	4	1	1	127
	2014	12	146	5	5	5	1	174
		Down	Up	Up	Up	Up	Same	Up
Art Brussels	2008	11	163	0	3	1	0	178
	2014	17	163	2	3	6	0	191
		Up	Same	Up	Up	Up	Same	Up

ᴬIncludes 17 Chinese galleries in the Armory Show's China Focus section.
ᴮIncludes 18 Japanese galleries in Paris Photo's Guest of Honor section
ᶜIncludes 34 Brazilian galleries in ARCO's guest country section.
ᴰArt Cologne was undergoing major redevelopment this year. Although the press release for the fair states there were 140 participating galleries, their 2008 online catalog lists 205.

Using only the numbers of galleries here is not very helpful in trying to determine meaningful trends, though, because a few of these fairs have acknowledged either intentionally increasing or decreasing the total number of participants in trying to achieve other goals (such as creating a more spacious-feeling fair or producing a larger fair). Looking at the percentages, therefore, is more useful for identifying trends:

Top Contemporary Art Fairs	Year	PERCENTAGE OF PARTICIPATING GALLERIES IN MAJOR FAIRS BY PRIMARY LOCATION						
		US & Canada	UK & Europe	Mexico &South America	Asia	Turkey & Middle East	Other	Totals
Art Basel in Basel	2008	24%	67.5%	2.3%	4.5%	0.70%	1%	308
	2014	26.7%	62.4%	3.5%	6%	1%	0.4%	285
		Up	Down	Up	Up	Up	Down	Down
FIAC	2008	10.6%	85%	0.5%	2.2%	1.7%	0	179
	2014	24%	66%	4%	3%	3%	0	191
		Up	Down	Up	Up	Up	Same	Up
ABMB	2008	39%	49.9%	6.3%	3.3%	1.5%	0	266
	2014	40.8%	42.7%	12.0%	3.7%	0	0.7%	267
		Up	Down	Up	Up	Down	Up	Up
Armory Show	2008	43%	52%	0	3.1%	1.3%	0.6%	160
	2014	34%	47%	3%	14%[A]	2%	0	145
		Down	Down	Up	Up*	Up	Down	Down
Paris Photo	2008	19.6%	58.9%	0	19.6%[B]	0	1.9%	107
	2014	19.9%	66.6%	3.6%	4.3%	2.8%	2.8%	141
		Up	Up	Up	Down	Up	Up	Up

		PERCENTAGE OF PARTICIPATING GALLERIES IN MAJOR FAIRS BY PRIMARY LOCATION						
Top Contemporary Art Fairs	*Year*	*US & Canada*	*UK & Europe*	*Mexico &South America*	*Asia*	*Turkey & Middle East*	*Other*	*Totals*
ARCO	2008	10%	67%	15%ᶜ	7%	0.7%	0.3%	296
	2014	5.5%	80.3%	14.2%	0	0	0	218
		Down	Up	Down	Down	Down	Down	Down
Frieze (London)	2008	20%	70%	4%	4%	2%	0	151
	2014	18%	66%	5%	6%	4%	1%	162
		Down	Down	Up	Up	Up	Up	Up
Art Cologne	2008	5.3%	92.2%	0.5%	2%	0	0	205ᴰ
	2014	9.2%	86%	0	2.6%	1.8%	0.4%	228
		Up	Up	Down	Up	Up	Up	Up
Artissima	2008	10.2%	84.2%	0.8%	3.2%	0.8%	0.8%	127
	2014	7%	83.4%	3%	3%	3%	0.6%	174
		Down	Down	Up	Down	Up	Down	Up
Art Brussels	2008	6.2%	91.5%	0	1.7%	0.6%	0	178
	2014	9%	85.3%	1%	1.6%	3.1%	0	191
		Up	Down	Up	Down	Up	Same	Up

ᴬIncludes 17 Chinese galleries in the Armory Show's China Focus section.
ᴮIncludes 18 Japanese galleries in Paris Photo's Guest of Honor section
ᶜIncludes 34 Brazilian galleries in ARCO's guest country section.
ᴰArt Cologne was undergoing major redevelopment this year. Although the press release for the fair states there were 140 participating galleries, their 2008 online catalog lists 205.

Granted, neither of these tables is very "user friendly," but I provide them here as the reference for the summary below (and to explain a few caveats

about it below). This next table shows the totals across the top ten international contemporary art fairs for 2008 and 2014, revealing a slight increase in the number of participating US & Canada galleries, a slight decrease for Asia galleries, a plateau for UK & Europe galleries, and various increases for galleries from the other three regions.

	AVERAGE PERCENTAGE OF PARTICIPATING GALLERIES ACROSS THE TOP 10 INTERNATIONAL CONTEMPORARY ART FAIRS, BY PRIMARY LOCATION					
Year	US & Canada	UK & Europe	Mexico & South America	Asia	Turkey & Middle East	Other
2008	18.79%	71.82%	2.94%	5.06%	0.93%	0.46%
2014	19.41%	68.57%	4.93%	4.42%	2.07%	0.59%

I believe the change for Asia in the table above is misleading, because of the focus on Japanese galleries (at Paris Photo in 2008) and Chinese galleries (at the Armory Show in 2014). If those fairs are taken out for both years, the average percentage for Asia is 3 percent in 2008 and 3.7 percent in 2014. The change for Mexico and South America is also likely more accurately represented by taking out both years for ARCO, which had a focus on Brazil in 2008, resulting in an average percentage for Mexico and South America of 2 percent in 2008 and then doubling to 4 percent in 2014. I believe the table below, for which those fairs were omitted, more accurately reflects the true trends:

	AVERAGE (ADJUSTED) PERCENTAGE OF PARTICIPATING GALLERIES ACROSS THE TOP 10 INTERNATIONAL CONTEMPORARY ART FAIRS, BY PRIMARY LOCATION					
Year	US & Canada	UK & Europe	Mexico & South America	Asia	Turkey & Middle East	Other
2008	16.47%	77.19%	2.06%	2.99%	1.04%	0.26%
2014	19.24%	70.26%	4.07%	3.70%	2.27%	0.44%

Another consideration in the accuracy of these numbers that should be taken into account is how the success of Art Basel in Hong Kong (which launched as Art HK in 2007) most likely convinced a number of Asia-based galleries they could afford to stay closer to home. Along those same lines (that is, the assumption that galleries will, given the opportunity, do fairs closer to home), one more consideration here is that eight of the top ten fairs are located in Europe, which skews the results upward for percentages of galleries from the UK and Europe. Looking

at the trends for fairs outside Europe (including only Art Basel in Miami Beach and The Armory Show), we see a significant drop in the percentages of European galleries. This becomes all the more significant given the fact that the majority of sales at art fairs happen at US fairs (see Chapter 3), and again calls into question just how global the market has become. This next table shows the average percentages for Art Basel in Miami Beach and the Armory Show only, which is a good indication of the mix of galleries participating in the fairs in this list with reportedly the overall best sales:

	AVERAGE PERCENTAGE OF PARTICIPATING GALLERIES IN THE US-BASED FAIRS FROM THE TOP 10 INTERNATIONAL CONTEMPORARY ART FAIRS, BY PRIMARY LOCATION					
Year	*US & Canada*	*UK & Europe*	*Mexico & South America*	*Asia*	*Turkey & Middle East*	*Other*
2008	41%	51%	3.1%	3.2%	1.4%	0.3%
2014	37%	45%	7.5%	9%	1%	0.4%

Here it should be noted that this drop in the percentages of European galleries (between the fairs based in Europe and those based in the US), as well as the huge jump in the percentage of US galleries when looking at the US-based fairs, likely reflects a variety of realities beyond just how interested these dealers are in reaching a more international audience, including the national makeup of the fair's selection committees and any preferences reflected by that; the costs of shipping and travelling to fairs outside one's region; and more practical issues, such as language, visas, customs, etc. Still, none of this suggests that art dealers, as a professional class, have become globetrotters catering to clients irrespective of their location, which has been one interpretation of the claims that it's a "more global market." While perhaps incrementally heading in that direction, based on art fair participation trends, the "increasingly global market" seems more myth than reality, suggesting Professor Velthuis was more right than wrong.

Locations Where New Art Fairs Are Being Launched

Appendix A (at the back of the book) lists the more than 220 art fairs that focus primarily on contemporary art each year. There are many other fairs each year, but these exist predominantly to serve primary-market contemporary art dealers or are important fairs that include some contemporary art galleries. Details on the month and cities they take place in, as well as their websites, are included in Appendix A. The excerpt below focuses on the number of fairs per country.

Number of Discoverable Contemporary Art Fairs per Country

COUNTRY	Number		COUNTRY	Number
Colombia	1		Korea	3
Czech Republic	1		Mexico	3
Denmark	1		South Africa	3
Greece	1		Turkey	3
Guadeloupe	1		UAE	3
India	1		Austria	4
Indonesia	1		Brazil	5
Lebanon	1		Singapore	5
Lithuania	1		Taiwan	5
Monaco	1		Germany	7
New Zealand	1		Hong Kong	7
Philippines	1		Italy	8
Russia	1		Spain	8
Sweden	1		Belgium	9
Argentina	2		Netherlands	9
Australia	2		Switzerland	11
China	2		France	13
Canada	3		UK	24
Japan	3		US	66

There are two ways to think about the locations of art fairs, especially new ones, in the context of discerning how global the contemporary art market has become. The first involves why active collectors travel to or attend the fairs they do in the first place, and there are three main reasons for that: (1) they don't want to miss out on the art being presented there (i.e., it's a prestigious fair with presumably high-quality art); (2) the location is somewhere they're happy to go for a holiday anyway (and the fair is simply an additional excuse for socializing there); and (3) the fair is local for them and therefore convenient. These reasons can overlap, of course, but this last reason seems most relevant to the question of a globalized contemporary art market.

Another way to think about these numbers involves why art fair organizers would consider it a smart move to open fairs in any location. Among the rationales I have heard from fair directors are (1) a major fair already happens there, and the new fairs can take advantage of their promotional budgets or reputation to attract a part of that audience; (2) there's an underserved or potential new collector base in that location, and a fair is a good way to introduce dealers to them and vice versa; (3) a fair can be an effective way to promote local galleries; and (4) it's a competitive move by a fair attempting to get an advantage on other art fairs. We'll look at these reasons in more depth in Chapters 3 and 9, but in the context of how global the market has become, the second reason stands out.

Indeed, between 2008 and 2014 many dealers felt rising pressure to take the mountain to Mohammed, so to speak. In other words, to increase sales (or even to make any sales), dealers felt they needed to bring their available works to fairs located where their key collectors lived, rather than relying on those collectors visiting them in their galleries or at fairs in the larger art markets (in Chapter 4, we'll look at other ways the dealer-collector relationship is changing). The logistical advantages for collectors living in those locations are obvious—they save on travel, accommodations, shipping, etc. This pressure explains to some degree the seeming rise in the number of relatively minor regional fairs that New York, Paris, or London-based dealers began participating in, when previously they seemed happy to do fairs only in the major fair centers.

Comparing the Changes for More Clues

To explore the hypothesis that you can tell something about where the new active collectors live—and hence how global the market has become—by noting where the fairs have set up shop, though, let's combine all three sets of metrics for 2014: art fair countries by region, top collectors by location, and the numbers of galleries participating in the top fairs that year:

COMPARISON OF PERCENTAGES OF CONTEMPORARY ART FAIRS, TOP COLLECTORS, AND POWERFUL GALLERIES BY REGION (FOR 2014)				
Region	*Number of fairs*	*Percentage of total fairs*	*Percentage of top 200 collectors*	*Percentage galleries at top fairs*
US and Canada	69	31%	51%	19.2%
UK and Europe	100	45%	34%	70.3%
Mexico and South America	12	5%	5%	4.1%
Asia	27	12%	9%	3.7%
Turkey and the Middle East	8	4%	1%	2.3%
Other	6	3%	1%	0.4%

Considerations to keep in mind while analyzing these comparisons include that some of the new art fairs being created are really only hoping they will encourage local wealthy individuals to begin collecting art—that's the idea behind two fairs that recently launched in Silicon Valley, for example—but a concentration of wealthy individuals alone is no guarantee that a conveniently located new fair is all it takes to convert them into future contemporary art patrons. Likewise, even a notable concentration of established art collectors is no guarantee that a fair in that location will result in strong sales. Los Angeles fairs have struggled for years to build sales to match those in other locations, for example, despite nearly ten percent of the top 200 collectors who live in the US having homes there. The conventional wisdom remains that even though the Los Angeles contemporary art scene is red-hot, many of its established collectors continue to buy most of their art elsewhere (although, it should be noted, many smart people are working hard to change that). More importantly, even a super-energized art scene does not always correlate with collectors actually spending money there. Despite Germany ranking higher than nearly every European country in powerful galleries and top collectors, and despite Berlin having one of the most vibrant art scenes of any city in the world, the German capital has had a good deal of trouble building a viable major art fair where galleries were pleased with the sales.

Some things reflected in the table above do seem clear though. By any of these (admittedly Western-centric) measures, Europe and the US totally dominate, especially combined. The incremental increases from Asia and South America are noteworthy, but still small by comparison. The answer, then, to the question—*Is the art market becoming increasingly more global?*—seems to be yes, but not as fast as the hype would suggest.

As with many of the market developments explored in this book, there will be a significant difference of opinion among dealers on whether this is a good thing, a bad thing, or simply how things are heading. These opinions likely depend on where their gallery stands in the overall hierarchy or how they are positioned to benefit from it. For the world's top galleries, there seems to be open embrace of this increasing globalization:

> "We have opened galleries around the world because it better serves our artists," says Larry Gagosian, the founder of the gallery.
>
> "Clearly the art market has become much more global in the past few years," Gagosian says. "We see evidence of this in the expansion of museums and art fairs internationally. There is no reason why galleries such as ours can't benefit from this trend." [5]

For art dealers whose galleries fall more within the "mom & pop shop" category or simply those whose success relies more on the personal relationship between the

business's primary owner (as opposed to a team of sales directors) and their most loyal collectors, though, there are some specific challenges brought about by globalization that transcend the obvious limitations of resources. Indeed, Olav Vethius concluded there are some potential risks for the entire gallery system here:

> [T]he traditional gallery model has, since its emergence in late 19th-century France, been able to establish and stabilise the economic value of art in an era in which artistic values and artistic canons have become increasingly instable. To make that model work, close social relationships between dealer, artist and collector were essential. [...] [T]he global market and its key institutions (the art fair, the Internet and the auctions) may not lead to deterritorialisation, but to a less personalised market in which the aura of art will increasingly be under pressure. While the outcome of globalisation of art markets is hard to predict, we can already see that there will be winners and losers. Traditional galleries, with their dense social interactions, intricate "rituals" and their symbolically charged business practices, may belong to the latter category.[6]

But art dealers in traditional galleries are far from ready to give up the fight here, so how does a contemporary art dealer strategize around this increasingly global market? Below we'll discuss both the challenges and opportunities here.

STRATEGIES FOR NAVIGATING THIS CHANGE

In most chapters within Part I of this book, I will continually frame the strategies section from two different vantage points: (1) fighting against this change and hopefully winning, and (2) working within this market structure as it has emerged and, again, hopefully winning. In each chapter, I will particularly focus on how the challenges and strategies relate to small businesses, identifying these changes in basic business terms where possible and customizing the best advice from business experts to the particular circumstances of the contemporary art dealer. The discussion below combines concepts from basic business best practices for global competition, along with strategies already being adopted by various galleries. They fall under four broad categories:

- Take advantage of the Internet
- Open additional locations
- Collaborate with other dealers
- Other logistical considerations

Take Advantage of the Internet

Online art selling channels are discussed in detail in Chapter 6, but there are a few steps any art dealer can take to optimize their own website and social media presence within a globalized contemporary art market. Even if your decision is to fight against this trend, or simply to ignore it, some of the following strategies may still serve you well domestically. Updating your business website to help you compete globally includes two main considerations: (1) languages and website localization and (2) SEO (search engine optimization).

Languages and Website Localization

English is definitely the dominant language in the international art world, as is evidenced by the number of galleries participating in international art fairs whose websites are in both their local language and English. Most galleries located in English-speaking countries are so confident of English's dominance that it is the only language they use on their sites. As art dealers reach out beyond their domestic client base, however, one strategy to help an English-speaking dealer stand out might be to go the other direction. For instance, if you want to develop relationships with collectors in the UAE, consider making key information on your site available in Arabic. It may not be entirely necessary, but it can help you earn those collectors' attention and eventually their trust. An example of a gallery implementing a forward-thinking approach like this on their website is the New York-headquartered James Cohan Gallery. The navigation information for their entire site is available in Chinese and English. This is due obviously to the fact that the gallery opened another space in Shanghai in 2008, but even Gagosian Gallery, who have a location in Hong Kong and do translate the press releases for their exhibitions there into Chinese, currently still require Chinese-speaking visitors to navigate their site in English. The subtle message sent by how James Cohan's entire website is navigable via both languages is that Chinese-speaking clients are as welcome to information about their New York location as English-speaking clients are to information about their program in Shanghai.

One piece of information that the short-lived VIP online art fair asked participating art dealers to list for themselves and their staff members who were working that fair was what languages they speak. This was designed to increase international visitors' confidence that if they reached out to this gallery via the virtual art fair's instant messaging system, they could reach someone who could answer complex questions in their first language. It also seemed to serve as a sort of bragging advertisement for each participating dealer, as if to confirm they were ready to play on the global field. Art dealers interested in reaching and impressing global clients might consider

sending the same message on their own website's contact page by listing which languages they and their staff speak fluently.

In the near future, most websites will likely use some form of localization technology, especially as it becomes less expensive. As Wikipedia puts it, *"Website localization is the process of adapting an existing website to local language and culture in the target market."* Advanced localization technology does this on the fly. In short, when a visitor who is located in Brazil visits your website, advanced localization technologies will detect where they are and automatically switch navigation and/or text on your website to Portuguese for them. Eventually, such technology could also automatically not display images of any artwork that may be taboo in certain locations. The art dealers who implement this technology on their websites early may just get a leg up on building a more loyal global client base. A good place to learn more about website localization and its potential is the website for the company Cloud Engage (www.cloudengage.com). There are many others as well.

Search Engine Optimization (SEO)

Every business owner who has a website has probably received more spam email offering SEO services than they can count. Optimizing your website for search engines is a fairly well-known requirement for any business wishing to attract new clients via the Internet. Basically, if your website does not turn up at the top of a search for one of your artists, you have a big problem.

There are several basic concepts that can help get your website higher in the rankings of international search engines. At the very least, make sure your website's keywords appear in the languages of the audiences you want to find you. That alone may not be sufficient, though. Don't assume a target audience uses the same search engines you do. While Google dominates in Brazil and India, search engines such as Yandex (popular in Russian speaking countries), Naver (popular with Korean speakers), and Baidu (which over 60 percent of people in China prefer) all use methods different from Google's for determining which results to list first. Research the differences in how the specific search engines your target audience is likely to use make ranking decisions. Yandex and Baidu, for example, favor social media pages over standard websites, which may mean you want your gallery's Facebook page to be always up to date, and possibly even multi-lingual, as part of your strategy for such search engines.

Moreover, you may wish to create a presence on social networks popular in your target country. Even though Facebook rules most of the world, Kontakte is the dominant social network in Russia, and QZone is the dominant one in China. Research the most popular social network in your target country and establish a presence on it, but also research whether the sub-segment of the population there who buy art spend

more time on a different network, such as LinkedIn. Establishing and maintaining a productive presence on multiple social networks is obviously very time consuming, so doing your homework on which ones best match your goals is time well spent.

Making this even more complicated, unfortunately, many search engines now have built-in localization functionalities that prioritize search results for businesses local to where the searcher submitted an inquiry or prioritizes results that appear in the dominant language used in that location. This gives local art dealers who show the same artists you do a clear advantage over you. Developing an SEO strategy that overcomes such predilection may require purchasing additional domain names (such as www.yourgallery.ch, www.yourgallery.br, or www.yourgallery.ru) that redirect visitors back to your main website. This can get even more complicated by regional laws that may require you to have an actual office in that country to obtain those domains, but it's worth exploring.

Also consider the cultural differences or even vocabulary differences among your target audience. How the art world operates in your target location might require different approaches to your keywords and social network messages beyond merely translating them. For example, even among English speakers, the terms used for the public event that inaugurates a new exhibition vary from *opening reception* to *private view* to *vernissage*. Again, it may not be enough to simply translate your website's keywords; researching the actual terms used by your target audience is important.

One final SEO strategy is related to the way many search engines will favor your website the more it is linked to from popular local websites and especially high-quality websites. Submitting your exhibition information to international listing websites, participating in bulletin board conversations, or blogging on art-related websites originating in your target location can greatly increase your site's rankings. Obviously, always make sure your user name links back to information about your business or simply your website. Or directly link back to it in your comments. The more interconnected your website becomes, the higher it will climb in search results rankings.

Additional Locations

Although several major galleries maintained locations in different countries before the turn of the century, the contemporary history of opening a gallery in a foreign location to protect one's business or actively take market share there probably begins with Gagosian Gallery's decision to open their first London space in May 2000. The decision served as official notice that the juggernaut gallery, which was then already a force to be reckoned with, intended to expand its empire globally. In an interview

for this book, Glenn Fuhrman—a major New York-based collector and founder of the FLAG Art Foundation—outlined the logic behind such expansions:

When Anthony d'Offay [gallery] closed in London, a big void was left, and certainly Larry [Gagosian] and others said, "Why should I just let my good artists find another dealer in London? I'll be their dealer in London." And once that started working for him, other dealers started to do the same thing. And then when certain cities got crowded, you saw galleries say "Well, let me find another city," and Barbara Gladstone opened in Brussels. And then you started to hear about other locations around the world. I think it worked well for all those dealers, because having the space to offer your artists exhibitions became very important and if you didn't have enough space for twenty-five or thirty artists to show in your one gallery, you needed more galleries, just to give them shows, even though the reality is that everybody knows that most works end up getting sold back to America or wherever the big collectors are for that artist, regardless of where the location is.

For dealers who don't have any trouble giving all their artists regularly scheduled exhibitions in their one location, the idea of programming steady exhibitions for two locations may sound daunting. One consideration here, though, is that a second location need not begin with the "six to eight exhibitions a year" model most contemporary art galleries follow in their primary location. Even Gagosian eased his way into launching his London space. One-day events and sporadic one-month exhibitions, with nothing happening there being publicized in between, were the norm for Gagosian's UK location in its first several years. Fifteen years later, it still seems perfectly acceptable to collectors and fair selection committees that a gallery might run one location full time and run a second location, at least temporarily, as a randomly programmed project space.

One of the epiphanies that led to the creation of mega-galleries (which we'll discuss in depth in Chapter 2) was that at a certain price point it is more profitable to open a space in another location than to see the artists you worked hard to develop a market for be snapped up by any given gallery already operating there. Most artists want to show as much as they can around the world, and if you don't have a space in the locations they want their work to be seen in, it is understandable that they would agree to work with a gallery who is in that location. The flip side to this, though, is that opening up an additional space where some of your artists have preexisting relationships with other art dealers can get complicated. It may be tempting simply to make your artist choose, but, besides risking that your artist may choose the other

dealer (especially if their relationship is older), it's important to remember that the other dealer likely has as much motivation to protect his investment in this artist's career as you do. A careful negotiation, with both your artist and the other dealer, should be part of any such move to represent the artist in that new location. That often includes negotiating a better deal (for the artist) in terms of production costs or commission split than he or she has with you in your primary location, so consider ahead of time what you can offer to persuade him or her.

Beyond protecting your investment in your artists and helping your artists gain the wider audience they want, there are other potential advantages to having locations in different countries, not least of which is how art fairs increasingly seek out geographical diversity in whom they select to participate. Listing your locations in both Chicago and São Paulo on your fair proposal very likely enhances your chances of being accepted more than listing only one or the other. And while fair selection committees may likely be impressed by your international presence, collectors most certainly will be as well.

Collaborate with Other Dealers

Obviously a second location in a foreign country is not feasible, financially or practically, for many dealers on their own, but strategic partnerships with galleries in target locations has worked as well, if not better, for some galleries. Discussing how he came to co-found a gallery in Berlin, Parisian dealer Jocelyn Wolff explained at the Talking Galleries symposium in Barcelona in 2013:

> I co-founded [KOW gallery] in Berlin, somewhat as a protective shield to avoid seeing my most successful artists being stolen by other galleries. It was my response to the success of some of my artists, to build the project in a partnership with friends.[7]

The basic premise here is that it is better to share an artist than lose them entirely to another dealer in that other location. Whether losing them is avoided via a partnership or an expansion of your own business, it usually comes down to one's resources, obviously. Having said that, though, most of the emerging to mid-level galleries I know who tried to maintain two or more international spaces on their own gave the second one up within five years. Some of that was driven by the recession, but additional spaces in other countries may simply be a strategy only well-funded galleries (who can afford two sets of staff, the travel, and many other expenses) can manage for very long. Partnerships between galleries with fewer resources, though, can still achieve the main goals of protecting your investment, reaching a wider audience and collector base, and helping you get into better art fairs.

Other Logistical Considerations

Operating globally, even if only through art fairs in different countries, brings a whole new set of logistical considerations that dealers operating only domestically rarely need to think about. Dealers operating spaces in multiple countries must deal with these considerations almost constantly; they include:

- Customs and customs brokers

- Language issues

- Work visas

- Local tax, resale rights, or commerce laws

- Local religious holidays or variations in which season collectors or other art world workers take vacations

Because these issues will vary considerably per country, the following discussion touches only on some basic strategies for managing these challenges. There is no substitute for hiring both an attorney and an accountant in any foreign country when opening a space to help you navigate the legal specifics in that location.

One strategy, being used by galleries who find customs and customs brokers charges are cutting too deeply into potential profits when shipping larger artworks or artworks above certain price points internationally, is to ship the artist instead. This obviously only makes sense when the artist's travel and accommodation expenses are lower than the customs expenses, but this strategy can also be one of the fringe benefits a dealer offers their artists in negotiating representation in a market where they already have another gallery. Not only can artists bring certain amounts of their personal property (that is, their unsold artwork) into most countries without paying customs, but many of them would welcome an opportunity to spend time in another country while creating work for an exhibition or commission there. Here again, though, check with a local attorney to ensure this strategy in no way runs afoul of local laws.

Galleries operating globally can save a good deal of money by integrating their international storage and presentation strategies. Beyond shipping very expensive work to the free port closest to a potential client and meeting them there, to save on customs charges, dealers are taking advantage of even non-free-port storage locations that offer customizable viewing galleries. As we'll discuss in Chapter 3, an overwhelming amount of contemporary art that sells via art fairs does so in the United States. This has led many international dealers to leave artwork they had imported for a US fair but not immediately sold in storage here, either to present it at another US fair at some later point or, increasingly, to create an exhibition with

the work in the same storage facility. Of course an exhibition for a few clients is a risky investment, so storage facilities offering this service are building their reputations as exhibition spaces open to the public and encouraging visitors beyond simply private viewings. One New York-area storage facility offering such a hybrid service is Mana Fine Arts (www.manafinearts.com). Located just across the Hudson River in Jersey City, New Jersey, this huge storage facility has spent a small fortune renovating their vast warehouse spaces into a series of galleries where they present their own programming (as Mana Contemporary), but also exhibitions by galleries from other locations. At this time only one additional gallery is listed on their site, but the concept looks primed to grow.

Because collectors are less likely to be available or receptive to sales pitches during the religious holidays they observe or when they generally take vacations, another strategy to maximize your selling is to map out a timetable of your international client base that focuses on when they are best approached. While collectors in Europe or North America are generally tougher to reach during the northern hemisphere's summer months of July and August, those months are wintertime south of the equator. Organizing your exhibitions, art fairs, and sales pitches such that each is focused on Australia or Brazilian collectors in July and August can help you keep sales strong all year long.

Indeed, for mid-level and emerging galleries, there is a strong sense that October through December and then March through May are the best months to pitch what is up in your gallery to European or American collectors. During the other six months of the year it is typically much harder to get their attention, regardless of what you are exhibiting. Timing your exhibitions such that you present exhibitions by artists that your key southern hemisphere collectors are following during the northern hemisphere's off months can help keep your cash flow where you want it to be more than six months a year.

Two long-term considerations should also weigh on how you develop your global selling strategies. First is the cost of maintaining strong relationships with collectors living far away from you. Many collectors will favor the dealer who makes the effort to come see them on a regular basis. Dealers they do not see for years will fade from memory. It may not be enough only to touch base with them during art fairs if your competition is able to socialize with them on their home turf more frequently. How many such visits you can afford should inform where you seek new clients. The other long-term risk in maintaining spaces in different countries is, of course, exhaustion. Most of the mid-level dealers I've spoken with who closed their foreign spaces cited the drain on their energy and resources that frequent flying back and forth caused as the primary reason they closed the second location. As noted above, collaborations that do not require as much travel are a good alternative.

SUMMARY

While most observers will note that any individual dealer fighting against or ignoring the globalization of the contemporary art market is hardly going to stop it, there are significant financial and personal risks to leaping into another location or even just draining your resources via international art fairs. Focusing solely on domestic opportunities is bound to be a competitive advantage for certain galleries, even as it may limit how far they can take their artists' markets, which then creates the risk that they may leave for a gallery with an international reach. Ranking the strategies above in terms of cost and risk, I would argue that globalizing your gallery website is the least risky way to increase your presence on the international playing field, but without some additional strategies, possibly the least effective. Next would be to collaborate with like-minded dealers in other countries, both to keep the galleries you do not work well with there from enticing the artists you work with, as well as to increase your acceptance at major international art fairs by joint proposals such fairs may be more likely to respond to than any single-gallery booth idea you submit to them. Finally, when it is clear you have clients or at least leads in a location, and you have accounted for the various long-term financial and personal risks, opening a space in another country may be the right choice for you and your artists.

2

The Rise of the Mega-Gallery

WHAT HAS CHANGED?

While this book examines a series of new challenges for contemporary art dealers, perhaps none has changed the entire gallery system as thoroughly as the rise of the mega-gallery. Over the past few years, a great deal has been written about these powerful, expanding galleries and how their practices are seen as negatively impacting the gallery system or even contemporary art itself. Before we turn to those critiques, though, let me clarify my working definition of a "mega-gallery." In Chapter 5 (on the mid-level gallery squeeze), I outline a four-tiered hierarchy of commercial contemporary art galleries, including emerging galleries, mid-level galleries, top-level galleries, and mega-galleries. I delineate all four levels at length in Chapter 5, but throughout this book the term "mega-gallery" refers to an influential gallery with multiple international locations, deep pockets, a roster of at least forty artists, and a public perception that they're continuing to expand their enterprise.

The following information comes from the public websites (in Spring 2015) of six international contemporary art galleries that I consider "mega-galleries." Some of them disagree with that classification. (I know, because they have told me.) Still, here are the factors that make them so, at least by the criteria noted in the working definition above:

GALLERY	Number of locations	Total number of countries	Number of artists listed on website*
Gagosian	15	7	128
Pace	8	3	84
Hauser & Wirth	5	3	62
White Cube	6	3	55
David Zwirner	3	2	49
Marian Goodman	3	3	43

*Including artists' estates. It's not clear whether these artists are all officially "represented" by each gallery or not. For Gagosian, the number of "represented" artists can be assumed to be about ¾ of those listed on their site.

Comparing their 2015 numbers with how many artists each of these galleries worked with in 2008 shows growth in all of them over the past six years, and very striking growth in several of them:

GALLERY	Number of artists listed on website in April 2008	Number of artists listed on website in April 2014	Percent increase
Gagosian	94	128	36%
Pace*	51	84	65%
Hauser & Wirth	39**	62	59%
White Cube	48	55	15%
David Zwirner	31	49	58%
Marian Goodman	34	43	26%

*In 2008, the gallery was a joint venture named Pace Wildenstein.
**From January 2009.

But is this really such a different situation? Wasn't Gagosian growing all along, just like Leo Castelli had? Does the power and scope of these galleries today represent anything more than strong overall growth in the contemporary art market itself, and not, as is often implied, a sea change at the top with repercussions throughout the system in how one must now operate to be a successful gallerist?

Looking even further back to 2003 suggests some answers to those questions. The table below shows the number of artists listed on each gallery's website in the spring of years 2003, 2008, and 2015:

GALLERY	2003	2008	Change from 2003 to 2008	2015	Change from 2008 to 2015
Gagosian	107*	94	-13%	128	+36%
Pace (/Wildenstein)	37	51	+40%	84	+65%
Hauser & Wirth	24	39	+60%	62	+59%
White Cube	19	48	+150%	55	+15%
David Zwirner	20	31	+55%	49	+58%
Marian Goodman	37	34	-8%	43	+26%

*Gagosian gallery seemed to switch their website approach from 2002, where they seemed to list only the artists they represented to one in which they seemed to list every artist who had ever shown at their gallery. What the decrease in 2008 represents is unclear.

Earlier in the decade, there was no consistent trend among these galleries. Some were growing much more quickly than they seem to be today, while others were seemingly getting smaller (if only temporarily). It's the relative consistency of what's taken place since 2008 that suggests continually increasing one's roster is now a conscious strategy among mega-galleries. As we will see in Chapter 5, growing one's roster is not a universal approach to the current market, and so it does indeed distinguish other well-established and powerful galleries from the "mega-gallery" category. How long the other galleries can continue to avoid such growth is a central question of the mega-gallery era, which we will look at a bit later.

The acceleration in how many artists the mega-galleries take on only tells part of what has changed, though. Consider the phrases used in the description on the David Zwirner gallery website's "About" page. It reveals that the gallery wants the public to know that theirs is a story of continuous physical expansion:

The gallery's . . . expansion from 10,000 to 30,000 square feet in 2006. . . . In October 2012, David Zwirner expanded into Europe. . . . After a renovation . . . the building has almost 10,000 square feet throughout five floors, with main exhibition spaces on three levels. . . . Further expansion continued in New York with a new five-story building at 537 West 20th Street. . . . The 30,000 square foot gallery opened in February 2013. . . .

The message is clear: ever more exhibition space, ever more locations, and ever more artists on their roster. Being a "mega-gallery" is about growth, first and foremost. The fact that such growth is possible suggests the contemporary art market is very healthy, and every dealer should be happy about that, but this "corporatization" of the contemporary art market brings some unwanted changes as well, including pressure on many galleries to grow in kind, even if they're not ready for it; an arguably negative impact on the quality of the contemporary art itself; and an impact on the relationships between artists and dealers throughout the industry.

Impact on Gallery System

The general perception of how the rise of the mega-gallery has impacted the entire industry was summarized nicely by *The Art Newspaper* back in 2010: "Gagosian Gallery's . . . rapid expansion seems to play to today's cash-rich but time-poor collectors. . . . Other galleries have to play the same game—assuming they can afford to—or are forced to rethink their business models."[1] Catering to time-poor collectors is done most efficiently via branding artists, some of the ramifications of which we will look at more below, but being forced by other dealers to rethink your fundamental business model is the most invasive impact mega-galleries are having on the industry. Resentment about that unwanted pressure is understandable, but as mega-galleries are seemingly here to stay, it is not particularly productive, so in the strategies section below we will focus primarily on how to deal with their existence and/or what practices are required to become a mega-gallery yourself.

Again, it is tempting to point to a few other galleries, even Leo Castelli's, as evidence that the concept of a mega-gallery is nothing new. In 1985, Castelli's two SoHo spaces (at 420 West Broadway and 142 Greene Street) totaled more than 14,000 square feet, and the list of artists he had promoted (one might even say "branded") by then was a virtual Who's Who of the contemporary canon. But Castelli's empire seemed to expand in a more measured way than we're seeing today, if only because he was not in an obvious "arms race" against a strong field of other hyper-competitive dealers the way today's mega-galleries seem to be. Indeed, the drive to keep up, particularly with the Gagosian Gallery empire, is having ripple effects throughout the entire system in magnitudes that seemed less obvious, if they existed at all, in 1985.

Much has been written about what is frequently perceived as the mega-galleries' most immediate impact on the rest of the gallery system. To feed their growing empires, they are reportedly poaching artists from smaller galleries more aggressively than ever, which in turn is systematically changing the role smaller galleries have played in nurturing artists' careers. As art critic Jerry Saltz put it in a 2013 article titled "Saltz on the Trouble with Mega-Galleries" in *New York* magazine,

"The galleries where artists' careers are really built from scratch are being forced to expand lest they be overwhelmed or picked clean by the megas."[2] While the mega-galleries have indeed engaged in high-profile poaching, research presented in Chapter 5 indicates it is not yet as rampant a practice as many believe. Even if it becomes that rampant, though, as Saltz acknowledged, the obvious rejoinder here is that galleries are a business, and growing and trying to beat out their competition are things a business is supposed to do.

Beyond the poaching issue, though, a recent survey published by *The Art Newspaper* indicated just how powerful the mega-galleries have become and why other galleries (at least American ones) are right to be concerned about that:

> Nearly one-third of the major solo exhibitions held in US museums between 2007 and 2013 featured artists represented by just five galleries, according to research conducted by *The Art Newspaper*. We analysed nearly 600 exhibitions submitted by 68 museums for our annual attendance-figures survey and found that 30 percent of prominent solo shows featured artists represented by Gagosian Gallery, Pace, Marian Goodman Gallery, David Zwirner and Hauser & Wirth.[3]

To some degree, this over-representation in US museum exhibitions is not surprising, given these galleries have the resources and reputations to attract important artists and represent over 300 established artists between them. On the other hand, this survey raises several questions about the perceived responsibility of museum curators of contemporary art to discover and present under-recognized artists completely independently of the art market, as well as the impact that mega-galleries' ability and willingness to fund exhibitions has on curators' choices. Robert Storr, the dean of the Yale University School of Art, was quoted in *The Art Newspaper* report as saying, "[Museums] should be looking at a much wider swathe of artists. Curators are abdicating and delegating their responsibilities . . . to more adventurous gallerists who, aside from the profit motive and in some respects because of it, seem in many cases to be bolder and more curious than their institutional counterparts."[3]

According to the report, this over-representation seemed to peak within the first few years of the 2008 recession. "Notably, exhibitions dedicated to big-gallery artists were over 40 percent more common between 2007 and June 2009, when the recession caused corporate sponsorship to plummet, than in the ensuing years."[3] While that suggests the over-representation is perhaps subsiding, smaller galleries are still understandably concerned by this consolidation of influence with museums among the mega-galleries. Working to help their represented artists get museum exhibitions is one of the services galleries pitch to new artists they want to sign up. Should artists conclude that is increasingly unlikely for smaller galleries, this becomes yet another

challenge making it more difficult for them to grow their roster and thereby grow their business in order to compete with the mega-galleries.

But many smaller galleries have concluded that grow they must if they do not want to lose their current artists or possibly lose their ability to stay open at all. This pressure to expand or close has been dubbed "Grow or Go" by the Brussels-based art collector Alain Servais, who has written and lectured widely on this phenomenon in the gallery system. Through his popular, invitation-only newsletter "Art News Digest," Servais synthesizes news stories, including many on gallery empire expansion, and then frequently discusses the impact on galleries large and small. In his August 30, 2012 "Art News Digest" (which he granted me permission to reprint), Servais summarized the forces at play in very stark terms:

> With such high fixed costs, standing still or having a low-selling show or art fair is not an option. The mega-galleries have to focus on what an insider named for me "high-velocity" artists, which means artists selling at good prices but mostly selling a lot. I call those artists, Very Bankable Artists or VBA's.
>
> But there are few VBA's, and they are changing with the time, like fashion.
>
> So some VBA's suddenly have their "velocity" dropping like a stone,: For example, most of the Young British Artists like Damien Hirst or others.
>
> And this drop of velocity happened at a time where heavy infrastructure investments had been realized, like the new mega White Cube gallery in the neighborhood of Tate Modern.
>
> The immediate consequence was [White Cube owner] Jay Jopling calling every single VBA of its mega-competitors. And those mega-competitors have no other choice than to match offers, particularly in terms of exhibition spaces' sizes and multiple locations which allow them to increase the number of shows for one artist to more than the usual "once-every-two-years" that one space can usually accommodate.
>
> This is what Marc Glimcher [of Pace Gallery] has called "extremely brutal competition for artists."

In Chapter 5, we'll look at some statistics that reflect what is assumed to be the trickle-down effect among other dealers of this clash among the Titans, but for now it seems clear enough that this is a significant change from the Leo Castelli days when dealers would not discuss such matters so starkly or, at least, so publicly. In that way alone, if nothing else, the rise of the mega-gallery has changed the tone of the dialogue in the contemporary art market.

Again, though, growth is something businesses are supposed to embrace. For the highly personal business that is an art gallery, however, not having much choice in the matter is also changing the tone of the industry. Sometimes a dealer's growth in response to the mega-galleries is an offensive move into a location where new collectors are beginning to spend a lot more money on art, or one designed to attract (or retain) artists with new, bigger, more beautiful spaces. Sometimes, however, adding a new location is just a defensive move. In an article in *The Art Newspaper*, the Paris-based dealer Emmanuel Perrotin explained that his opening a space in New York (his fourth in addition to two in Paris and one in Hong Kong) was basically a defensive strategy:

> There are other, practical reasons for the Manhattan opening. New York dealers poach other galleries' artists so aggressively it may as well be a blood sport, and Perrotin feels the pressure. "My dream is to be able to keep my artists and to not feel so much the shadows of someone who wants to take what you have. It's not an egomaniac situation. I don't want to be the biggest; I just don't want to lose. So I need to make a move."
>
> Perrotin has worked with many of his artists—such as Cattelan and Murakami, whose careers have gone from negligible to supersonic—from a young age. "When you really invest your energy to develop the career of an artist and you finally create a nice situation for them, you push them to do a great show for another gallery in a different city like New York because you know it's important for them. But then you have to wait three years for new work—and every artist keeps their best for New York," Perrotin says.[4]

Whether an offensive or defensive strategy, this push for more locations and bigger spaces is sending ripples through the entire gallery system, contributing to skyrocketing rents in some gallery districts, and leading some very talented art dealers to close rather than compromise their vision (we'll look at several such dealers in Chapter 5).

Impact on Contemporary Art
More important than the impact on other galleries, some observers are concerned that as the mega-galleries increase their rosters, especially with younger or mid-career artists, their business model poses a threat to the quality of contemporary art itself. This was not always a concern about the growth of these galleries, mind you. Back when the term "mega-gallery" first gained mainstream usage, there was near-universal admiration for the quality of their exhibitions. In a 2009 article, *New York Times* art critic Ken Johnson wrote:

The rise of such mega-galleries has been a source of some consternation for contemporary art followers, many of whom like to imagine art as a spiritual escape from corporate culture. But it is a rare moment these days when there is not a must-see exhibition at Pace or Gagosian.[5]

By 2013, though, the limits of programming exhibitions of such high quality that consistently had begun to garner the mega-galleries increasing scorn. In his article on the "trouble" with mega-galleries, Saltz wrote:

> [M]ega-galleries do so many more contemporary shows of so many more artists of a certain ilk in so many places at once that the experience starts to feel preplanned and cynical. Often, in this context, even good work takes on deleterious meanings: hype, hubris, commodity fetishism, hyperefficiency, expeditiousness. [...]The megas (like all galleries) say their job is to nurture talent and help artists succeed, but if you look at what they do, it is more like branding: Find a buzzy artist, no matter how iffy, and get his or her name out there.[2]

Indeed, these newer, larger spaces were also increasingly designed by "starchitects" whose own reputations and super-slick visions seemed to demand that any art that went into them prove itself worthy, making many an exhibition that was not quite "museum quality" look all the worse for it, even as it may have looked perfectly fine or interesting in a different context. Mega-galleries' more established artists, with plenty of museum exhibitions under their belts, generally pull this off, but their younger artists (that is, the next generation of artists) seem to be struggling a bit with this. As Saltz put it:

> [S]omething happens to people when they sign with the megas. Too often, the artists are brought in at mid-career, and—like thirty-four-year-olds signed by the Yankees—they are poised for a decline. Every show of living artists in these galleries is ushered in like a career retrospective, a quasi coronation, with everything often already sold or spoken for. There's no space for debate about the merits. Many of these shows are too big by half, filled with dross. [...] The artist is a brand, and the brand supersedes the art. The scale and pace of these places often turn artists into happy little factories with herds of busy assistants turning out reams of weak work.[2]

In a later article, Saltz hits even harder, noting how the mega-galleries' ever-expanding size presents a particular challenge to the quality of the art so much money is spent promoting. Critiquing the fairly universally panned exhibition of work by actor-turned-artist James Franco that Pace presented in New York in 2014, Saltz wrote:

[T]his is what happens when one of these massive megagalleries loses its bearings and vision. Pace has all of this space all over the world. It has several galleries in New York and ones in London, Beijing, and of course, Menlo Park, in Silicon Valley. All these vast spaces must be filled with stuff at all times in order to maintain the operation. Spectacle, success, and supply-side abundance begin to take over. As overhead and corporate merchandizing increase, quality and aesthetic complexity begins to decrease. The gallery begins to seem lost, irrelevant, clueless.[6]

Impact on Artists and the Dealer-Artist Relationship

The rise of the mega-gallery has changed what it means to be a gallery-represented artist as well, and not just for artists represented by the mega-galleries. Artists in smaller spaces can see the disadvantages of working with dealers who don't get the best locations at the top art fairs, who don't obviously have the same pull with major museums, or who cannot offer them exhibitions in multiple locations around the world. Even though many dealers work extremely hard to maintain a close, productive relationship with their artists, what the mega-galleries can do for artists' careers is obvious and alluring.

Loyalty between a dealer and an artist was a cornerstone of the Leo Castelli model. This was as much a business strategy as it was a personally rewarding way to work. Promoting an unknown or simply under-recognized artist often only pays off for a smaller dealer if they keep working together through the development of a viable market and into the period where the dealer sees a return on their investment. As we will see in Chapter 5, the loyalty question often reflects more poorly on younger dealers than it does on younger artists, but dealers are still right to be concerned about how to frame their relationship with artists such that mega-galleries are not continuously reaping the rewards of the artists they supported and the markets they developed. In Part III of this book, we'll look at changes in the thinking behind consignment or representation contracts that the rise of the mega-gallery has played a big role in bringing about.

STRATEGIES FOR NAVIGATING THIS CHANGE

In this section, we will explore strategies for dealing with the rise of the mega-gallery from two vantage points: (1) fighting against Goliath or (2) working to become a giant yourself. There is a third point of view, of course, which is to ignore the giants and simply continue doing what you are doing, but there is no point in my discussing how any other dealer might do that. Here I will disclose that I personally have no interest in becoming a mega-gallery dealer. Not that I could, mind you, but I do prefer to maintain the degree of interaction with each artist in our program that only

being a smaller gallery permits. This is not a condemnation of the mega-galleries. Even as I may find a few of their practices unattractive, I do admire how they continue to enlarge and empower the contemporary art market and the impressive quality of the programming they frequently offer the public. In the end, my position is that currently they are part of the gallery system, plenty of great people work in them, and plenty of great artists work with them. Like any empire in history, I suspect there will come a point for some of them at which growing too large directly leads to their disintegration, but for the time being they are part of the market and the strategies below are designed to explore how best to compete against them or try to join them.

Fighting Goliath

Even though in his book *Killing Giants: 10 Strategies to Topple the Goliath in Your Industry*[7] Stephen Denny offers dozens of anecdotes that have you cheering for the little guy, his strategies tend to fit within a few basic themes: (1) use the giant's size against them; (2) if you cannot win the game playing by its current rules, change the rules; (3) being great at one thing is often not enough; and (4) success often comes more easily to the ones willing to do the thing no one else wants to do. Like many such books, it's longer on dramatic examples than it is on workable advice, but I recommend the book for two of the main ideas that guide Denny's thinking.

First is the fact that constraints can be good for business. The dual constraints of not having enough time or money are the number-one reason many dealers cannot take their business to next level. Denny points out how to think about that in a more productive light:

> The change we are faced with is a constraint—in this case, one of fewer resources. . . . We need to do more with less.
> So why is this good news?
> Constraints force us to make choices. Constraints make us think harder. But they also give force, focus, and structure to our creativity. It's too easy to throw money at problems. That's what giants do every day. . . . You don't have the luxury of considering this option, and frankly, as you'll see, this is actually a good thing. You're going to have to work harder to get where you're going, but the thinking and execution behind your efforts will have longer, more powerful effects. . . . It will stick, in other words. It will make more sense to everyone, including you.[7]

Denny's other idea is that there is value in taking down the giants. Even though I am approaching this strategy section from both points of view (both fighting against and fighting to become a mega-gallery), I personally admire some mega-galleries and

their business practices more than I do others. I would not mind seeing some of them forced to change how they operate. I believe it would be better for the entire industry and for contemporary art in general. Denny echoes my personal belief that the entire art industry need not surrender to the notion that growth at any cost is ethically neutral or that profit trumps every other concern in our business. As he puts it:

> While *Killing Giants*, without reservation, is a business book, it holds a deeper promise: that fighting and defeating giants, however large and imposing, is not only possible but noble. It isn't a question of money. It's a matter of progress and change for the better.[7]

Since the 2008 recession, many of my colleagues—overwhelmed by the financial challenges, the pace of change, and the power of the mega-galleries—have simply accepted that this is the new normal and decided they have no option but to play the game by the mega-galleries' rules as best they can. That is a valid choice if sincerely held, but it is not the only option. They can also fight the Goliaths and work to implement change for the better.

I am not saying this will be easy. The owners of the mega-galleries, aside from being great gallerists, are also clearly great businesspeople. Again, every contemporary art dealer has arguably benefited from how much they have collectively expanded the market. If their practices were not simultaneously making parts of the business I personally cherish less possible for smaller galleries, such as spending more time with artists in their studios, I would merely celebrate their accomplishments. As things have developed, though, I believe it is noble to keep the giants on their toes and for the smaller dealers to continually challenge their dominance.

It was a terrible tease, I realize, to note there are "ten strategies for killing giants" and not list them all. What follows is a summary of how each of Denny's strategies applies, or does not easily apply, to the contemporary art market. Even where they do not have a direct correlation, a few of his illustrating anecdotes may spur an idea among dealers struggling to find an edge against a bigger competitor. Please note that I do not imagine any dealer could make use of all these strategies, but rather would experiment with those that match their personal goals. Some of these ideas as shared are immediately workable, while others may be absurd in the context of the art market because of how pricing works or the uniqueness of art objects. As Denny himself notes, though, it is usually not any single idea that changes things, but rather the process of challenging the givens, taking them apart again and again, and recombining them until something clicks. If one struggling dealer reading this has one epiphany that leads to progress, to an innovation that brings us a better contemporary art market, this exercise will be worthwhile.

Strategy 1: "Create arguments the giant cannot win"

One observation Denny makes here that recurs throughout his book, and that will serve well any art dealer taking on mega-galleries via several of these strategies, is how often experts are better than evangelists. It is not merely that even the most enthusiastic salesperson, under enough pressure or exhausted after days of an art fair, will eventually begin to sound insincere (we have all caught ourselves sounding this way, admit it), but that in several situations Denny discusses, someone who is unmistakably an expert in what they are selling can persuade buyers much more consistently than someone who is simply excited about the artwork. Mega-galleries clearly have experts as well, though, so that is not in and of itself the point to this strategy. It is simply a reality that smaller galleries cannot afford to ignore in either how the principle approaches what they consign to sell or in who they hire as staff. Also, sometimes it is passion, rather than expertise, that closes an art deal, but do not underestimate the role expertise plays in fighting giants.

The main point of this first strategy—create arguments the giant cannot win—is to use the mega-galleries' size and stature against them. One problem every giant begins to face, as evidenced by some of the criticism mega-galleries have begun to receive for certain exhibitions, is, as Denny puts it, that quality "begins to take a back seat to supply chains and logistics." They simply must sell ever bigger and more expensive art to pay the bills in their expanding empires. Currently they are still winning market share because they have convinced many new collectors, and a few more-established ones, that bigger and more expensive art is better. If that perception shifted, though, and smaller art were perceived as more desirable or important, for example, the mega-galleries' size could go from being a strength to a liability. How else their rapid expansions could become a liability is an area ripe for strategic study.

Moreover, as Saltz had put it, "All these vast spaces must be filled with stuff at all times in order to maintain the operation. Spectacle, success, and supply-side abundance begin to take over. As overhead and corporate merchandizing increase, quality and aesthetic complexity begins to decrease."[6] One of the anecdotes Denny tells in this section is about the Boston Beer Company, which realized that to build a market for their quality brands, they had to change what Americans (who had seemed content to drink what people in other countries considered watered-down, tasteless brews) thought about beer in general. Jim Koch, the founder of the company, explained,

> When I started the company, it became very clear to me that my real competition wasn't other brewers, [it] was ignorance and apathy. It was people who didn't know about beer or care about beer.[7]

So they set about educating consumers on the difference between high and low quality in beers, and systematically changed the industry (craft brewing has exploded in recent years). This education was very cleverly communicated as something America needed in one of their first television commercials, by having Koch say, "Sam Adams is not a beginner's beer." Suggesting that there are better options out there than what you are currently buying, and that you owe it to yourself to learn about them, is a powerful motivator, particularly in the realm of culture. The smaller art galleries that convince collectors (and some museums) that quality does not automatically correlate to scale, and that the mega-galleries' offerings are systematically decreasing in "quality and aesthetic complexity," can succeed in creating an argument that the mega-galleries will have a hard time adapting to.

Strategy 2: "Speed" (or, "giants can't crush what they can't catch")
Two factors pull against "speed" being as effective a strategy in the contemporary art world as it can be in other industries: (1) artists cannot be rushed, and (2) perceiving quality cannot be rushed. Still, some of the lessons Denny offers here are applicable to fighting the art world giants, especially speed in collecting and acting upon information. Communicating faster/better with your artists and collectors about their needs, for example, might be easier if you set up a secure, private instant messaging service that integrates with your email or other communication systems on your desktop and mobile devices. Examples of such services include Microsoft Lync or HipChat (there are many others). Such private channels can facilitate more immediate communication than email or more professional communication than texting. They can also let you immediately exchange images and video, or even let you share your desktop for demonstrations.

The biggest obstacle to speed in any context is, of course, friction. One of the people Denny interviewed for this section was Mike Cassidy, former CEO of the successful start-ups Direct Hit and Xfire, who noted sagely, "Small companies are more often defeated by internal friction than by external competition." One way Denny recommends small companies avoid internal friction and speed up how quickly they can respond to new opportunities or challenges is to establish a culture where issues are quickly discussed, openly and frankly, with even the boss listening carefully, but then when a decision is made the entire team moves on it without any further questioning and no "I told you so's" permitted afterward. If mistakes are made, and they will be, the goal is to respond in the same streamlined, decision-making fashion. Spending too much time weighing conflicting opinions, or reviewing who said what at the previous strategy meeting, breeds friction.

Another way to avoid friction is to remove silos. In other words, do not compartmentalize gallery responsibilities to the point that any one person can become

a bottleneck. Everyone in smaller galleries should be able to do everything, from installing artwork to updating the online art selling channel listings. This has the added benefit of ensuring the owner stays fully in touch with the gallery's day-to-day operations, another strategy Denny recommends for remaining lean and mean.

Strategy 3: "Winning in the last three feet"
Beyond the cliché that it isn't over until it's over, this strategy focuses on the opportunities that exist within that gap between a "done deal" and money actually exchanging hands. The example Denny uses here involves a software manufacturer who had an agreement with a chain of stores to purchase high-profile advertising in their circulars for their Thanksgiving sales, only to be told right before the holiday that the store changed their mind and sold that ad space to one of their competitors instead. The software company was livid, of course, but rather than accept defeat, they sent well-trained personnel into each store to do live demos of their product, which cost a fraction of what the advertising would have, and led them to sell out their product in each location. Here again, it was expertise that made the decisive difference. The staff doing the demos knew their product, and as Denny notes, "When confronted with an 'authority' . . . we all tend to take their advice, all things considered." The other company only had the ads.

The genius of the winning software company's strategy is how they exploited their competitor's advertising money, which brought consumers into the stores ready to buy a solution to their software needs, only to be convinced to purchase the solution being demoed instead. This is essentially the strategy behind satellite art fairs, which take advantage of the big-budget promotions that the major fairs spend fortunes on to bring collectors to various locations. Even if you are participating in the major fair, it is very likely the top galleries, paying top price for the larger well-positioned booths, draw most of the top collectors. Making sure your booth stands out in this context, where collectors are primed to acquire, is simply common sense.

Other ways to "win at the point of influence," as Denny puts it, include co-opting the giants' offline messaging in your online efforts (without violating anyone's copyright, of course). Specifically, this could involve buying the keywords in top search engines that a mega-gallery's print campaign might lead someone to search on for more information about something they advertised. Say they are promoting an exhibition of an artist by whom you have a secondary-market work available, or perhaps they poached an artist from your roster and are promoting their first exhibition of her work, or they are simply promoting an exhibition whose title relates to previous exhibitions you produced or to work by your artists. There is nothing illegal about purchasing strategic keywords that exploit their splashy print ads or banners around

the city, again, so long as you do not violate their copyright. Of course, this begins to get into murky territory, but remember that it is giants you are fighting here. Besides, this is nothing compared with Denny's next strategy.

Strategy 4: "Fighting dirty"

We will spend a bit more time on this strategy than the other ones, not because I advocate making the contemporary art market even more cutthroat, but because of the quality of the innovative thinking that Denny identifies here. How dirty the mega-galleries fight among themselves is legendary, so even though Denny cautions his readers to tread carefully with these strategies, it is unlikely you will shock the art world by applying any of these ideas yourself. The underlying concept here is valid in any way you choose to implement it: make a strategic shift in how you promote something that no one else can see their way to first. The most effective shifts are ones that seem extremely obvious after the fact. Denny suggests you go through a series of "mental diagnostics" to develop such shifts:

> What assumptions am I making? What are the "facts"? What happens when I change them? What patterns of behavior, structure or timing do I see? Forget my vantage point for a moment: What does this situation look like from my opponent's perspective? What about the people we're both trying to serve—what do they see, or believe, or care about? How do each of these variables impact my options?[7]

The primary examples Denny focuses on here were actually fights between giants, so please excuse the fact that the best example I can find of one form of this strategy being used in the art world was a fight between two mega-galleries. How it might be used against a mega-gallery by a smaller one would depend on particular circumstances. Still, the idea is eye-opening.

The example Denny uses to illustrate this form of "fighting dirty," which he describes as "sabotaging your competitor's flagship launch with smart positioning of a drab market entry," took full advantage of a mixed message being communicated by the competition. Long story short, in 1992 Pepsi was launching a new, clear (colorless) cola called Crystal Pepsi with quite a bit of fanfare and high expectations, and their competitor Coca-Cola was worried. Rather than develop a clear version of their top brand, Coke, to compete, though, Coca-Cola put out a drink called "Clear Tab," knowing full well that Tab had been a failed product for them because the market had rejected any "diet" cola at that time. Their goal was to make people think Crystal Pepsi was also a diet drink. Pepsi never managed to clarify that it was not a diet drink, partially because they had sent mixed signals in trying to capitalize on the perception that all clear beverages were somehow pure and good for you, and

so Coca-Cola's strategy worked. Both clear colas failed miserably and were off the market within six months, which had been Coca-Cola's intention all along.

Although I am going a bit out on a limb here, this story reminded me of how Gagosian Gallery responded to the solo exhibition of new work by their represented artist Jeff Koons that rival gallery David Zwirner managed to present in New York in May 2013. To combat Zwirner's aggressive move on one of his star artists, Gagosian assembled a somewhat disjointed solo exhibition of Koons' work that opened the very next night at one of his New York spaces. Not only did this make it complicated to sort out which Jeff Koons exhibition anyone was referring to when they came up, but the particular works that Gagosian presented were of questionable quality and connectedness, which is not in keeping with the gallery's reputation. Indeed, of the Gagosian show, the *New York Times* wrote, "The show's motley assortment of works demonstrates how prolific and how up and down Mr. Koons is."[8] I have no inside information to verify this suspicion, but this would seem to be possibly a case of "sabotaging your competitor's flagship launch with smart positioning of a drab market entry." Even if it was not exactly that, Gagosian was clearly attempting to confuse the public and steal Zwirner's thunder in the process.

Another example of fighting dirty that Denny shares had two clever phases to it, which is a key to defeating giants we will return to in Strategy 9. A pharmaceutical company developed a drug to prevent the stomach ulcers that certain popular arthritis medicines caused. The company had a marketing problem, though, in how doctors prescribing the arthritis medicine were reluctant to admit to their patients they had been giving them something that caused them harm. The pharmaceutical company's solution was to combine their ulcer-preventing drug with the arthritis medicine, and promote it not as an ulcer drug but rather as a better arthritis drug that did not cause ulcers. This new vantage point of promoting their drug was not their only stroke of genius, though. At the same time, they played one of the most brutal and effective dirty cards you will find in any deck: they preemptively declared "the debate over" on whether the arthritis drugs did indeed cause ulcers. They did this by offering a $1 million grant to the first laboratory that could develop a means of early detection for ulcers caused by versions of the arthritis drug without their ulcer-preventing ingredient. This very public act of "philanthropy," which brought them much more than $1 million in press attention, had the added benefit of publicizing that the arthritis drugs caused ulcers without waiting for doctors to admit it and greatly increased the public's demand for the company's combo-drug in the process.

Denny's takeaway message with this story is that convincing people like doctors they are wrong is difficult. It is often easier to give them the ability to do what they are already doing better (like prescribing a "better" arthritis medicine). The same

logic arguably applies to contemporary art collectors. While it may not go over well for smaller galleries to suggest some of the expensive art a collector bought from a mega-gallery is not all that interesting, they can still build a context for more interesting art that the mega-galleries would look silly trying to duplicate. Done convincingly, the debate could be declared over in the art press fairly easily as well. The money spent on art at the mega-galleries would certainly counter any such declaration, for a while, but the art world thrives on evolution and innovation. The stranglehold the mega-galleries have on the market can be broken.

The final example from this section of Denny's book examined how a chocolate bar distributor upset their entire industry, up to and including how their biggest competitor sold their products in major stores, by brilliantly exploiting the humble distribution channel of vending machines. Like several of Denny's anecdotes, this one pivots off of pricing methods that do not easily make sense in a market of unique objects, but the lesson was to question the current market structures and look for ways to recombine them into new solutions that, again, the giants' loftier identities and higher price points might make difficult for them to exploit as well as smaller galleries, with price points that facilitate "impulse buys," can. One effort in this vein sure to gain traction is harnessing Instagram to sell artwork at fairs, prompted in part by the much-covered acquisition by a famous actor from a satellite fair he never attended:

> Hollywood star Leonardo DiCaprio is known to be an avid art collector, and is regularly seen attending major art fairs throughout the US. . . . However . . . rather than gracing the booths at New York's fairs last week, DiCaprio has spotted his latest acquisition on Instagram and called the gallery to secure the piece.
>
> The Copenhagen-based Gallery Poulsen posted an installation shot of their booth at New York's PULSE art fair. A sci-fi inspired work, *Nachlass* (2015), by the Brooklyn artist Jean-Pierre Roy evidently caught the actor's eye. A gallery employee reportedly confirmed the sale: "Leonardo spotted it on Instagram and bought it over the phone."[9]

Strategy 5: "Eat the bug"
Big companies, Denny points out, reward their employees not for taking risks, but for avoiding them. The concept behind "eat the bug" is to do the things the giants cannot afford to do, because the risk would be culturally or financially unacceptable. For one over-simplified example, mega-galleries rarely, if ever, take on new artists who do not already have highly viable markets. Even if they wanted to, their operation costs prevent them from doing so frequently.

Learning what the mega-galleries cannot afford to do, that you could do, is an exercise worth smaller dealers' time and money to get expert research on. As Denny notes, this is not a casual consideration. You want to discern what mega-galleries cannot afford to do for structural reasons, for marketing reasons, or for identity reasons, and then exploit those constraints. In conjunction, you need to ask yourself some questions. What are the strengths you have (e.g., connections, skills, insights) that the mega-galleries do not have? Which rules that apply to them do not apply to you? How does their stature or program fence them? Several of the more experimental exhibitions some of the mega-galleries have tried to present have notoriously fallen flat, for example. What the public will warmly embrace in smaller spaces, they might find ludicrous in a context that had just presented a museum-quality retrospective of a canonical legend.

Part of this analysis also includes considering what the mega-galleries gain or lose by countering any strategic move you make. Can they afford it? Just be aware that sometimes the answer will be yes, they can. Consider again Gagosian's response to Zwirner's Jeff Koons exhibition. If indeed the strategy was to sabotage Zwirner's show by smartly positioning "a drab market entry," Gagosian had to weigh what damage that might do to their star's presumed claim to being "the best artist of his generation." Knowing at that point that this claim would be validated in the following year by the Whitney Museum's last exhibition at their Madison Avenue location, where only Gagosian Gallery's logo appeared on wall text for Koons' retrospective, likely convinced Gagosian he could afford to risk that perception in order to undermine his competition's show. (Or not; again, this is merely speculation, offered for illustration.)

Strategy 6: "Inconvenient truths"
This strategy also focuses on competitive pricing models that generally make no sense for unique objects, but the one memorable takeaway (that mega-galleries can use as easily as smaller ones, but that is still good to have in your toolkit) is the power of changing your prospective client's emotional state. Specifically, Denny recommends "shift[ing] the rational player to an emotional footing and push[ing] an emotional player to think more rationally." In the context of selling art, it is often easier to close a deal by appealing to a collector's emotions, unless, of course, they are buying strictly for investment purposes. In either situation, Denny notes that "changing the emotional polarity . . . puts the fight on ground of your choosing."

Another bit of advice that he shares in this section is the importance of strategizing in constant harmony with your business's values. Can your staff recite your business's values? If not, how can you productively deliver on them? One of the most successful exhibitions at our gallery emerged directly from two of

my business's core values: artist-centric practices and open discourse. The exhibition was a collaboration between our gallery artist, Jennifer Dalton, and her friend, the artist William Powhida. And while it was described by some as a "loss leader," it was the most successful brand-building effort we have yet produced. Titled "#class," it was basically a month-long series of events that turned the gallery into a "think tank," where Dalton and Powhida, as stated in its press release, worked with "guest artists, critics, academics, dealers, collectors and anyone else who would like to participate to examine the way art is made and seen in our culture and to identify and propose alternatives and/or reforms to the current market system. By 'current market system' we mean the commercial model and attendant commodification of art, but also the unquantifiable, intangible, unpaid aspects of participating in the art world." The art critic Jerry Saltz listed it in his annual round-up as one of the ten best exhibitions in New York that year, but it was the overwhelmingly positive response from attending artists, other dealers, and collectors alike that made that month of madness worth it. Well, that plus the mountain of positive press it received.

The final bit of advice Denny offers under this heading unfortunately serves mostly to illustrate what smaller galleries are up against in choosing to fight the mega-galleries. Noting that "what's vivid is remembered long after what's valid is forgotten," he underscores how a quality emotional experience is often the most successful selling strategy. In the context of the gallery world, this reminds me of what New York-based collector Glenn Fuhrman said about Gagosian's space in Paris in an interview for this book:

> I think that gallery has become a really successful outpost for Larry [Gagosian], not just because there's a growing base in France, but it's obviously very close to London and easy to get to, and again it's a nice destination where American collectors are very happy to go. I've been to a couple of openings in Paris, and you see all the big collectors from New York who came over and made a weekend out of it. And Larry throws a big dinner party, which is super fun. You know, the collecting base and the artist base are mobile and enjoy the opportunity to travel a little bit. I'll also add that going to an opening in New York and the dinner afterward has gotten to be a little bit of a formula, and not that exciting. You know, [billionaire X] doesn't need Larry to buy him dinner at some restaurant, but going to Paris for a couple of days and having dinner in Larry's apartment above the gallery…that's a pretty nice thing, and I think people are very happy to do that, and that is a differentiated experience, as opposed to just going to an opening and having dinner at [standard after-party restaurant in Chelsea].

Given our entertainment budgets, such enthusiasm was disconcerting enough, but Glenn, who is a valued friend of our gallery, raised that experience again later in the interview:

Larry opened this gallery at the private airport in Paris, at Le Bourget. I mean it is incredible. It's absolutely massive. It's at the equivalent of Teterboro. It's literally in the middle of nowhere. Nobody lives near the airport, but all these people fly through that private airport, and they stop and they go see the show that's there. It's absolutely enormous, so it can have a giant outdoor Calder sculpture in the middle of it, big Jeff Koons sculpture, or whatever. And again, it's just something that's unique. I imagine it's something that wasn't super expensive because it's essentially an airplane hangar in the middle of nowhere, but again, it's just something that's a little bit different and people want to go see it. And part of the pitch is, you could fly in at 11:00 at night on a Sunday and Larry will make sure somebody will be there at the gallery to show you around before you head into Paris.

Perhaps you cannot compete with the glamour of a hangar-sized exhibition space, but that is not the only differentiated experience a gallery can offer collectors. I sincerely believe that in the long run the true quality of the art you are selling, promoted in harmony with your values, is what wins the day. As Denny writes, "If dogs don't like your dog food, the packaging doesn't matter." Still, do not underestimate the emotional experiences you are competing against. Find ways to make them irrelevant.

Strategy 7: "Polarize on purpose"

What Denny is focused on in this strategy is how certain smaller companies can benefit by communicating the polarizing differences between their brand and the brands of the giants, how those that stand apart in a meaningful way (and not just stand out) also impart that to their clients, who, by choosing what they are selling, also separate themselves from the conventional. In short, he highlights brands that are "distilled and refined, that have polarized their markets intentionally and strategically." In an era where too many new collectors succumb to pressure to buy "the right art," meaning essentially at least one signature piece by a list of the "right artists," leading to collections that are all but clones of each other, a truly individual collection is a joy to encounter. Moreover, it reflects a confidence and self-awareness one would expect of a captain of industry or true connoisseur. Being the dealer who helps build such collections is one way to fight against the mega-galleries and happily win by operating on your own terms.

The examples Denny offers here—a minuscule car, a budget boutique hotel, and a controversial vodka company—all share the confidence in the quality of their

product to admit readily they are not for everybody. In fact, they go to great lengths to communicate that position. All three of them are remarkably successful as well. As the vodka company put it, "A lot of people said you can't have a brand that is both luxury and irreverent. We disagreed." One bit of caution Denny offers here, though, is that "when you decide to be 'edgy,' understand that you're edgy to the end." In other words, make sure you are being true to who you are if you go this route. When you are sure, though, putting your true self out front as the defining difference of your approach leads similarly minded folks to trust and eventually to support you. Denny also notes that being edgy is not enough. It is still quality and discipline that make die-hard renegades successful.

Strategy 8: "Seize the microphone"

Denny starts this section by noting, "You don't have to accept that you're not big enough to be the industry spokesman, so naively grab the microphone and speak up for the whole industry." As I can personally attest, this is actually much easier than it sounds. When I launched my eponymous blog in 2005, with the goal of demystifying the art world and promoting our gallery in the process, it never dawned on me that I was acting as an industry spokesperson, but the number of calls or emails I receive for quotes each month from arts journalists confirms Denny's point that size is irrelevant in this strategy.

Of course, a few obligations come with this approach. You need to commit to listening to and responding responsibly to your audience. Denny notes that it is also important to make sure you seize the right ideas before you seize the microphone (or pay the price for broadcasting the wrong ones). It should also be noted that there is no direct correlation between creating a discussion where none existed before and sales. There are several strategies in Denny's book that take a long-term view of winning, and this is one of them.

Still, Denny writes, if there is no confirmed front-runner, there is no reason you cannot grab the microphone yourself. In the New York art world in 2009, when the entire gallery system, mega-galleries included, was reeling from the recession, art fairs sales were all but non-existent, and rumors of extremely drastic measures to save businesses up and down the ladder were flying, one smaller Chelsea dealer grabbed the microphone in an impressive display of resilience and leadership to produce a yearlong series of events with a team of two curators and fifty advisors that included twelve exhibitions and over fifty talks and community activities, with an eventual attendance of over 75,000 visitors. Dubbed "X" (or the "X Initiative"), it was the one bright spot in an otherwise very glum gallery year. As that Chelsea dealer, X Initiative founder Elizabeth Dee, explained, the idea was born out of "conversations that were happening in response to the political climate and economic turmoil."[10]

While each of the exhibitions was world-class (as the *New York Times* wrote of one of them, "To glimpse the future of contemporary art, or at least a slice of that future, spend some time at the X Initiative in Chelsea."[11]), it was one event billed as a "town hall meeting and panel discussion" that the X Initiative presented that made a huge difference in my resolve at that time. Titled "After the Deluge? Perspectives on Challenging Times in the Art World," the panel was moderated by Lindsay Pollock, who would go on to be editor-in-chief at *Art in America*, and included Jeffrey Deitch (then of Deitch Projects, but later to become Director of the Museum of Contemporary Art, Los Angeles); Brett Littman (Executive Director of The Drawing Center); the late Michael Rush (former Director of the Rose Art Museum); and Anya Kielar (an artist and co-founder of the highly acclaimed, but by then closed, gallery Guild & Greyshkul). The panelists examined, very pragmatically, what the art world was up against at that time and provided solid information on how best to move forward to a packed audience. I remember very clearly that there was a strong sense of fear in the room that dissipated as the evening progressed. It remains a defining moment in my personal career.

Mega-galleries in New York have demonstrated leadership in other contexts (David Zwirner, for example, was extremely generous in helping smaller galleries devastated by Hurricane Sandy, which slammed New York in 2012), but in what was arguably Chelsea's darkest hour, when galleries were closing every week, it was a smaller dealer who had the courage to seize the microphone and help make a big difference in all our lives. As Denny points out, and as certainly seemed the case in 2009, the giants are often focused on each other. This leaves a gap, and that creates an opportunity. (Elizabeth Dee Gallery's prestige rises every year. In 2010 she co-founded the wildly successful Independent art fair that we will examine in Chapter 9. She is also a co-author of Chapter 8 of this book.)

Strategy 9: "All the wood behind the arrow(s)"

I apologize if you have read this far hoping to find a single weapon you could turn around and use to fell a mega-gallery, but defeating giants, if you are even able to do so, can take years (it took most giants years to become such) and generally takes firing more than one shot. Still, this section is where Denny begins to assemble his various strategies into a feasible roadmap that we will customize for the contemporary art market after Strategy 10, so hang tough. What Denny focuses on in this section is how giants generally cannot know whether new challengers pointing arrows at them have another arrow (or more) and so prefer to avoid such confrontations. But killing giants often requires developing strengths in a pair of important areas. Giants can sidestep a single shot fired. It's the one-two approach that more successfully kills them.

This becomes easier, of course, when you develop your brand in a way that comprises two seemingly disparate but strategically complementary parts. An example Denny offers here is a company who created "green" household cleaners packaged in high-end designer containers and having spa-like scents. This "brand tension" makes it more difficult for competitors to find one simple way of combating your efforts. Of course, some mega-galleries became who they are by exploiting the same logic. Gagosian Gallery, for example, is believed to rake in money when the economy is strong from their primary market sales and yet still do quite well when the economy is struggling via their command of the secondary market, "as legions of vaguely embarrassed collectors look to raise needed money, as privately as possible."[12]

Strategy 10: "Show your teeth"

Two quick ideas here and we will get to the roadmap. First, using the example of a relatively small football player, Denny argues that sometimes the secret to beating a giant is being willing to grit your teeth and get run over. Sure, you might get a little bruised, but the giants, who are used to smaller businesses clamoring to get out from under their massive heels, will be ruffled a bit as well. They won't assume you will duck aside the next time, and so you have made yourself an additional problem for the giant, who prefers to focus its energies on other giants. Making yourself a distraction becomes your advantage, as giants have much more to lose battling small competitors than the small competitors have in reverse.

Second, Denny notes that giants often know that logistics and other big company concerns affect the quality of what they offer. This knowledge often leads them to harbor a silent fear that someone else, and not them, is actually the best in their industry. In the contemporary art business, only one dealer can be "the Leo Castelli of their generation." For a host of reasons, it is likely that most, if not all, of the mega-galleries fear that it is not them. Denny here offers a wonderful bit of final advice, both definitive and customizable at once: "Give that a fear a name!"

Roadmap for Plotting Your Fight with the Giant

To piece the ideas together into a workable roadmap for killing your particular giant, Denny recommends an exercise (customized for the contemporary art industry here). It begins with making a few lists. He focuses on his third strategy, "Winning in the last three feet," for the exercise, but incorporates ideas from several others.

Again, you may wish to seek expert advice on assembling this first list: what are the *key strengths of the mega-gallery* in your sights? In general, I would say a mega-gallery's strengths include:

- Access to the work of top artists

- An enviable Rolodex

- The resources to offer collectors a high-quality social experience

- Influence with top museums

- Ability to attract highly skilled employees

- Most powerful of all, the kind of influence that makes collectors want to please them or be in their inner circle

But your workable roadmap will require more specifics if you hope to identify the weak links in your specific target's armor. In 2012, for example, *The Art Newspaper* published some estimated totals on Gagosian Gallery's operation:

> Gagosian's permanent gallery spaces total more than 153,047 sq. ft (14,200 sq. m) spread across eight cities. . . . This is more than the entire 145,313 sq. ft (13,500 sq. m) exhibition space of Tate Modern, including its new extension and the Tanks. [...] How much is the real estate costing the business? The gallery owns its 25,000 sq. ft property on New York's West 24th Street, for which it paid a reported $5.75m in 1999. Property experts estimate that it could now be worth around $65m. On the other hand, the total rental cost of the other 11 spaces Gagosian occupies could be at least $11.4m a year, although calculations are based on media research and the opinions of a range of international property agents, and do not take into account Larry Gagosian's negotiating skills (our estimates are "between 30 percent and 50 percent too high," he says).
>
> The economist Don Thompson, author of *The $12m Stuffed Shark*, estimates that Gagosian employs more than 150 staff worldwide and that the gallery makes annual sales of around $1.1bn, or $20m a week. So in one rough estimate, other overheads and commissions notwithstanding, Gagosian Gallery earns in a week almost double its annual property costs.[13]

Gathering as much information as you can about your target's sales practices, discounts, expenses, margins, etc., is what this step entails. The details are where you will most likely find inspiration and/or ammunition for your assault. Next, list your own key strengths. List your *core strengths*, the things that got you to where you are (these are personal and might include heritage, passion, or values) and your *functional strengths*, which deliver your core strengths in a meaningful way (these come from what you do for your clients [artists and collectors] and might include personal

relationships with powerful people in the art world, recognized authority, or a savvy innovation in the business model).

After that, list *each and every step a collector takes in her interaction with your gallery*. Include those events that may not end in a purchase, but still connect the collector to the experience you are offering, such as a panel discussion, museum tour together, and so on. Obviously, these steps should parallel the same steps in the interactions between a mega-gallery dealer and his collectors. Review this list of steps in the context of your target's key strengths, looking to identify the steps where they probably spend the most time and money (hint, most giants spend it up front).

This is all preparation for the next phase: interview some of your best collectors, one-on-one. Ask them to compare their experience with your gallery and their experience with a mega-gallery. Ask them to comment on each step of the interaction that you listed. Depending on their stature as a collector, their experience with the mega-galleries may be quite limited or unhelpfully negative. You will gain more by convincing a top-level collector, whom mega-galleries try to please, to participate in this with you. Ask them specifically who they interacted with at the mega-gallery for each step, and whether they feel you have left any steps out of the process, which will reveal things you are not doing that the mega-gallery is.

Now study the gaps between the experience you offer and that the mega-gallery offers. Where is the mega-gallery weak? Where are they making assumptions about how "final" any given sale or even simply how close their relationship is with top collectors? Can you insert your message at any of those steps? Rate each step based on an honest assessment of how likely it is you could win the customer away at that point.

I realize this may not seem as simple in the close-relationship world of art sales as it might be in the world of cola sales, but if it were easy, there would arguably be a lot more mega-galleries. In this phase, also identify where you can create more gaps. What additional service or experience can you provide that the mega-gallery does not? Listening to your collector here about any frustration or disappointment they had with the mega-gallery can help identify these. As Denny notes, what we assume is standard practice often is only standard in how we do business. I was surprised to learn, for one simple example, that a major gallery selling a six-figure video artwork to a top collector simply mailed them a DVD in a plain envelope. The artists we work with create conceptually resolved, attractive presentations for their video artworks, which several of our collectors have subsequently used as an example of what all artists should be doing. This is a gap we didn't realize existed until that top collector told me how disappointed they were with that top gallery (especially at that price point).

Once you have an idea of where you might best insert the message aimed at changing collectors' perception of the experience and art you offer, spend some time perfecting that message. Begin with the probably safe assumption that the mega-gallery is considered superior in the mind of the collectors you are seeking to sway. Now challenge that assumption. You have studied that mega-gallery's strengths, each step of their transactions with collectors, and the points at which they are making potentially fatal assumptions. How do you compare favorably with that mega-gallery in those or other areas? Focus on the contrasts.

Frame the experience and the art that you offer collectors in that light, within that defining contrast, and then write down the message you would deliver, given the chance, "within the last three feet" of a collector writing a check to either you or a mega-gallery at an art fair, for example. Denny instructs his clients to rewrite this message, and rewrite it again, each time exaggerating the contrasts until they clarify a highly focused, unmistakably differentiating message. Once you have your final, concise message, make your staff learn it. Make them recite it. Ensure your entire operation is focused like a laser beam on inserting that message into each gap that presents itself or that they can generate.

Done thoughtfully, this exercise will hopefully give you the confidence to take on a giant, but as Denny notes, it is often a combination of effective strategies that generally have the biggest impact. A complex approach is more difficult for an opponent to figure out quickly and deflect. Also, do consider which of the mega-gallery's key strengths you cannot compete with, and push them aside. Keep in mind that if you take the "eat the bug" approach and strategize by doing something no one else wants to do, by the time the mega-galleries realize what you're doing, it may be too late for them to stop you. Indeed, building expertise where few others are keen to focus gives you plenty of elbow room to grow, make mistakes, and learn from them, until you're ready to take on the big guys. Niche expertise also makes you more difficult to displace. Finally, Denny emphasizes the importance of remaining flexible. That magic combination of arrows that takes down one giant may not work on another. More importantly, you need to give some thought to the next evolution of your own plan and what functional strengths you will need then. Once your plan succeeds, and you slay a giant, what then?

Becoming Goliath

As far as I have found, no one has written a step-by-step book on how to turn your mom-and-pop shop into a mega-gallery. As they say, if that kind of power came in a bottle, everyone would have it. Still, there are some key practices that either help a business become an international industry leader or systematically make that less likely. John Hall, CEO of Influence & Co., a company that helps individuals

and brands grow their influence, offered a list of questions to ask yourself if you're struggling to become a leader in your industry.[14] The answer to each of Hall's questions, of course, should be yes. A few of his questions are redundant in the context of the commercial gallery system, and a few don't pertain because of the much more personal relationship between clients and dealers, but the consolidated list below is a good start for analyzing where you might focus your energies to help your business enter the realm of the giants—if you are not already doing these things, that is. Certainly most of them apply to smaller galleries as well. We will also look at some of the specific strategies that made mega-gallery Gagosian the undisputed king of them all.

Are You an Honest Company?

A dealer's reputation is her most valuable asset. Even in the burgeoning realm of online art selling channels (as we'll discuss in Chapter 6), surveys confirm that buyers care deeply about who is standing behind the art being sold. Being viewed as honest unquestionably helps a dealer gain influence. "Honesty," as Hall contextualizes it, connotes being "honest, transparent, and consistent, which is what customers like." The one of those three that sticks out like a sore thumb in the art industry is "transparent." Indeed, a truly infamous opacity is a hallmark of the gallery system. It is viewed widely as a key source of power, but perhaps the path to becoming the next mega-gallery is sorting out how to make transparency your competitive advantage.

This may be nowhere near as far-fetched as I am sure it strikes some dealers. Consider for example the untapped potential of the young, newly wealthy tech industry executives, who seem resistant to nearly every attempt to convert them into contemporary art collectors. This frustrates even some top art dealers, who consistently manage quite well to convert young bankers or captains of other industries. A great deal of speculation exists as to why the tech industry does not seem to be interested in collecting contemporary art. Consider for example a central argument in Alice Gregory's article in the *New York Times* titled "Does Anyone Here Speak Art and Tech?"

> To those used to start-up culture, with its utopian transparency and meritocratic ideals, the art world's barriers to entry are discouraging and confusing. Parties are exclusive. Works are not always sold to those with the most money. Images are often not online. Invoicing can take months. There is, to borrow a term from the lexicon of tech culture, a preponderance of inconvenient "friction."[15]

In a great rebuttal, where he mocked the "problem" of techies not being interested in culture as really being about "successful technology executives somehow failing to

buy expensive art by living artists at New York galleries and at art fairs," Reuters's Felix Salmon picked apart Gregory's argument that, as he put it, "the opacity of the art world contrasts starkly with the openness of the tech world."

> Talking about the utopian transparency of start-up culture makes about as much sense as talking about the constructive deliberations of Congressional debates: start-up culture is in fact one of the very few areas which is *less* transparent than the art world. You need to be invited to a tech party; gallery openings, by contrast, you just turn up to. If you want to buy the work of a certain artist, then with a little bit of diligence and persistence you can probably manage to do so somehow. And it's downright easy to phone up the gallery and at least find out how much that artist's works cost. If you want to invest in a certain start-up, by contrast, doing so is pretty much impossible unless you know the right people. And valuations aren't kept quiet so much as they're kept absolutely secret.[16]

Salmon argues that "the real reason that tech types don't buy art [is] they're busy investing in each other's start-ups instead." But that would only make sense if the techies only viewed collecting art as an investment. To me, Salmon seems a bit blinded here by his great disdain for art fairs ("There's certainly no *richesse oblige* to the activity of buying art at art fairs," he writes), but he does not address how art fairs are where many artists and galleries increasingly make a significant percentage of the money that enables them to continue making art and presenting art and that increasingly funds huge portions of the entire commercial art gallery ecosystem. I believe Gregory's point deserves more consideration than Salmon's slightly snarky dismissal gives it. Outside how venture capitalists operate (which arguably drives the opacity Salmon describes more than true start-up culture does), the value that techies place on transparency is legendary. Consider this (admittedly older) discussion of the position on transparency that drove the creation of Facebook:

> For [Zuckerberg], Facebook is primarily a social movement, not a publishing platform: as he tells it, he is motivated not by money (he consistently refuses to sell up) but by a passion for radical transparency. Sharing our data and making our lives publicly available to each other turns us, he believes, into better people. A narrower gap between public and private reduces the potential for hypocrisy and connivance, making it harder, for example, for people to cheat on their partners.[17]

The Internet is bringing radical transparency to every sector of our lives, whether we like it or not. It may do more than merely help convert tech executives or other "millennials" with similar values into art collectors to harness that transparency in

selling art. It may be a big component of the next mega-gallery's path to success in increasing the contemporary art market overall.

Are You a Trusted Source for Information?

Information is the true currency of the contemporary art market. Beyond the kind of information that helps you close deals though, consistently trustworthy answers to simple questions like "What exhibitions in the area should I see?" or "What have you heard about artist X?" can keep clients coming back to you for more. This requires staying informed, of course, but it builds your credibility, which will then extend to your advice on what they should purchase from you. Offering such information to your clients as a service, without being asked, in the form of an exclusive round-up of the biennials or other major events you attended, again takes time and may not always relate directly to your program, but communication-by-communication you will be convincing them that you are a key player in the market. Customizing such information for their personal collections will further win you their loyalty.

Are Your Employees Leaders?

Mega-galleries have a reputation for hiring the best of the best. That reputation in turn attracts other talented sales directors and artist liaisons to that gallery. Everyone with ambition wants to work for a winning team. Building that team of course costs money, but structuring compensation to motivate rigorous sales (via unusually competitive sales commissions), even if it temporarily cuts into profit, or offering other enticing opportunities (such as curatorial responsibilities) can help you become the gallery that more capable people want to work for. Many mega-galleries have filled positions from smaller galleries who closed, sometimes even inviting the owners themselves to join their operation, often securing the best from their roster in the bargain. This is infinitely easier to pull off if you maintain good relationships with other dealers as you build your empire.

Do You Have a Presence at Major Industry Events?

As Hall notes, "One of the easiest steps you can take to establish yourself as an industry leader is to make sure you're present at major events." For the contemporary art market, of course, this means gaining a strong presence at the top art fairs, but it also means networking at major biennials, museum openings, and other social events where everyone who's anyone is expected to be in attendance. Getting the best invitations may require some strategic planning of its own, but this is where the "seize the microphone" strategy can pay off. Creating their own celebrity was a strategy nearly one quarter of the companies in Denny's book combined with their other attack ideas. Of course, most of them did so by contributing real value to the community dialogue.

Some Specific Strategies Used by the Top Mega-Gallery

The admittedly fuzzy points above are provided as quick reality checks. If you are not already doing most of these things, you have a fair way to go before you are likely to enter the stratosphere of mega-galleries. More concrete lessons, though, can be learned from the art dealer credited with blazing the mega trail. In 2012 *The Art Newspaper* traced how the Gagosian Gallery launched its global network in four phases:

1. **North America:** The first proper gallery opened in 1981 in Los Angeles, mainly selling works by East Coast artists such as Richard Serra and Eric Fischl to West Coast collectors. A New York outpost opened four years later—Gagosian was one of the first dealers in Chelsea, although he left the area for SoHo in 1988. He opened an uptown gallery in Sotheby's former Madison Avenue space the following year, and bought the West 24th Street property in 1999.

2. **London:** A major contemporary art center from the late 1990s, thanks to the YBA phenomenon and the opening of Tate Modern in 2000. That year, Gagosian opened a small space on Heddon Street. This was replaced by the 14,000 sq. ft Britannia Street space in 2004 (when he also opened a third space in Manhattan). Gagosian consolidated his London presence in 2005 with a small gallery in Mayfair.

3. **Europe:** Gagosian opened a string of *smaller spaces in niche European markets* between 2007 and 2010. The plan appears to have been to *dominate these local markets through proximity to major collectors* (such as Dakis Joannou in Athens), *to cement relationships with valuable artists* (for example, Cy Twombly, whose studio was near Rome) and to *mine old European collections* for major secondary-market material.

4. **Emerging markets:** The most recent phase is expansion into *emerging markets*, with the opening of the first non-Western gallery in Hong Kong last year, and consolidation in the more traditional ones: Gagosian is scheduled to open a larger space outside Paris this year and is said to be considering a third, larger space in London.[13] [emphasis mine]

Key strategies here include opening additional spaces where major collectors live to keep them close; opening spaces where it will win you the loyalty of artists you wish to keep happy or are courting; matching the size of additional spaces to the size of the potential market in those locations (that is, don't open a massive space in a new location just because the rents there make that feasible; it likely will not impress

enough people to make it worth it); and positioning yourself to make money both when the economy is good and when there is a downturn.

Other keys to Mr. Gagosian's historic success are found in a profile of him that appeared in the *New York Times* at the height of the market uncertainty brought on by the recession.[12] In general, most insiders agree he was simply born to do what he does so well, and it is not likely anyone else could copy his model. But that does not mean his strategies cannot be studied and/or copied. Already legendary by 2009 were tales of how Gagosian took Polaroids of artwork in collectors' homes while they were out of the room, so he could offer those works, unbeknownst to their owners, to his other collectors, assuming everyone has a price, which often enough proved true. He also has a reputation for being very demanding of his extremely talented staff:

> [In 2009], he sent an e-mail ultimatum to staff members that was quickly a blog sensation, threatening to fire anyone who wasn't moving the product. "The luxury of carrying under-performing employees," he wrote, "is now a thing of the past."[12]

The breakthrough strategy attributed to Mr. Gagosian's success was talking to rich businessmen about art in terms they were very comfortable with. Whereas Joseph Duveen convinced the Gilded Age industrialists to purchase the Old Masters by waxing poetic about their aesthetics and historical importance, reportedly Gagosian "made it a business deal and business guys were more comfortable with that. . . . It was like they were buying a building, or shares of I.B.M."[12]

Much of what Gagosian casually does in his quest to poach other galleries' artists is financially impossible for many of them to easily counter. One public example is illustrated in a profile published by *New York* magazine in 2013. Its author, Eric Konigsberg, retells a phone conversation between Gagosian and the private art dealer Alberto Mugrabi, who were strategizing on what to buy at an upcoming evening sale at Sotheby's in London: "[Mugrabi] suggested Gagosian bid on an Andreas Gursky photograph of Dubai ("the blue one") that he thought was unlikely to sell above its estimated price range—"especially if you want to try to lure this guy in." Gagosian was eager to represent Gursky, and has since signed him."[17]

His ultimate secret weapon, though, may be that he seems to think the same way his top collectors do, making it very difficult to imagine another dealer inserting themselves into their transactions:

> "Temperament-wise, Larry's got a lot more in common with some of his collectors—the uncouth, winner-take-all big shots and the foreign oligarchs—than he does with other dealers," says a man who has bought and

sold dozens of major artworks through transactions with Gagosian over the past two decades. "He can be extraordinarily eloquent and ridiculously charming, with, say, a curator from the Modern—especially if the curator is there with a rich collector. He can woo artists, but it's a great effort. What comes naturally is being a bully. Most of the time, he talks like a thug: 'Tell him I'm *very* interested.' 'Why would I want to do *that*?' Or, 'That's a million-dollar picture: It's colorful, it has tits, and the guy's a good painter.'"[17]

One final quote from Konigsberg's profile gets to the heart of how different Gagosian's model is from the Leo Castelli model, and perhaps why his dominance represents a justifiably worrisome shift in the industry even as it admittedly offers grand opportunities to a chosen few:

> Many artists have thrived from the relationship. Cy Twombly, for example, was considered the painterly equivalent of a midlist author when he came to Gagosian—shunned by the New York Establishment and major collections, he had moved to Italy and was not producing much new work. "I think Larry helped Twombly enormously, and it was exciting to watch," says Richard Serra. "He helped get that work out into the world. He gave him new potential and possibilities to show, and the last years of his life were remarkable."
>
> For younger artists—John Currin, Richard Phillips, Tom Sachs— their names take on a heightened level of value. "Larry makes their work worth more, in the same way that he sold a dollar poster for a fifteenfold profit when he put it in a metal frame," says the artist Mark Kostabi, who first met Gagosian in the early eighties and quickly sold him more than 100 of his works. "He doesn't want to be the first person to discover major talent. He wants to be the second. But he became the context. He's the frame."[17]

This approach erodes the effectiveness of two of the key elements of the Leo Castelli model: loyalty and, subsequently, the motivation for smaller dealers to provide nurturing support if an artist struggles for a while in making the best artwork they can, which in reality can sometimes be years. The appeal of the higher price points that signing up with Gagosian can bring to ambitious artists is clear, as is the appeal of showing throughout his international network of gallery spaces. That some of the dealers who Gagosian's poached artists left had accomplished absolutely amazing things for their careers was still not enough for them to maintain those

partnerships. The "heightened level of value" was too appealing. The motivation for smaller dealers to offer nurturing support in an environment where mega-galleries are continuously expanding their rosters, then, understandably dissipates. No one wants to be another dealer's farm team.

There are several variations on how to building a mega-gallery (profiles of their owners, with details of how they climbed up the ladder, are listed in footnotes 18–22), and I have a great deal of admiration for some of them. But Gagosian's approach is forcing each of them to respond, to some degree at least, on his terms. All of them are to some degree forcing every other dealer to respond in kind and redefining the tone, heart, and methods of the business of selling contemporary art. It is tempting to agree that all this is ethically neutral and to focus on the bright side of this change—a larger contemporary art market—but it is impossible to see it as enabling the gallery system to remain as nurturing as it has been, at least in our romantic memories of Castelli's era.

SUMMARY

The contemporary art market has always been particularly competitive from my vantage point. There are an estimated 500–600 galleries in New York, and even as big as the overall market here is, the fight for resources (artists, collectors, space, art fair participation, press, prestige, influence, etc.) has always been tough in my experience. What the hyper-competitive era brought in by the rise of the mega-gallery has brought to the equation, though, is a sense that no matter how hard you work to keep your collectors and artists happy, you still have less control over the way you must now run your business. Unless you actively expand your business at a pace that limits the time you used to spend with your artists, or your family, you cannot even keep up with the competition, let alone beat them. As we will explore in Chapter 5, the trickle-down effect has led some very committed art dealers to call it quits.

Still, plenty of others are fighting the good fight, either finding ways to work around or directly challenge the mega-galleries or plotting their path to that upper echelon themselves. The contemporary art market remains big enough to accommodate a wide range of models, and the mega-galleries have done more than most to expand the overall size of the market, but it is my position that the tone of the contemporary art gallery world must, first and foremost, foster an environment in which earnest support for contemporary artists enables them to take risks, at their own pace, and build the confidence to create the best artwork they can. Otherwise, what are any of us really doing?

3

The Rise of the Art Fair

WHAT HAS CHANGED?

For art fairs, the numbers tell the story, as Georgina Adam noted in *The Art Newspaper* in 2012: "In 1970, there were just three main events (Cologne, Basel and the Brussels-based Art Actuel). But the number has mushroomed in the past decade: from 68 in 2005 to 189 in 2011."[1] In early 2015, and excluding art fairs that do not present contemporary art, I counted over 220 international art fairs (see Appendix A for their months, locations, and websites). Add in fairs that do not include any, or much, contemporary art and the number is closer to 300. Indeed, a new art fair is announced seemingly every month now, making any exact number a somewhat limited data point.

How one segment of the art industry that barely existed a few decades ago could grow so quickly is attributable to numbers as well, but these are harder to calculate. As any dealer who has done an art fair knows, there is no reliable way to tally the amount of art sold by all the dealers participating in them. Not only do dealers spin how well they are doing at fairs, ever conscious of the impact that the perception of how well they are doing can have on the reality of how well they are doing, but because fairs are predominantly opportunities to meet new clients, who may not buy at that first encounter but do later on, knowing exactly which sales to attribute to a fair is not a simple calculation. Still, the *TEFAF Art Market Report 2014* said that dealers had reported 33 percent of their total sales came via art fairs in 2013.[2] For

some people, the rest of the numbers the report supplies on dealer sales are controversial, given they need to be qualified in so many ways, including "33 percent of how much?" (dealers are not very forthcoming with accurate sales totals in or out of art fairs) and how they are felt to distort what is happening outside of New York. Indeed, any global total of dealer sales strike many insiders as educated guesses at best.

A number easier to estimate, though, because costs like travel, accommodations, shipping, and booth fees are much more public, is how much it cost galleries to support so many art fairs a year. The 2014 TEFAF report noted that dealers had to shell out €1.9 billion (or $2.5 billion) to participate in fairs in 2013. How this relates to why art fairs have proliferated still requires a bit of speculation. I know from talking with many dealers that some galleries had very good art fairs in 2013 and 2014, while others had not so good ones. Galleries with six-figure or higher average price points generally reported much better returns on their art fair investments (see Chapter 5 for more information on how the top and emerging levels of the market reportedly did much better than the middle of the market during these years). Then again, larger galleries most likely paid much more for larger booths, more staff, more shipping, and so on. The overarching conclusion we can draw, though, given how galleries are doing more art fairs than ever before and have been for several years now, is that they view doing so as worth the extra hassle and expense.

Dealers who have been around for a few decades will tell you that fairs were not always thought to be as potentially profitable as they are today. If they had been, the market would have arguably supported many more of them much sooner. When I worked my first art fair in 1994, as an assistant to another dealer, breaking even was viewed as a huge accomplishment. The goals of an art fair then were to network and advertise. Indeed, even today, galleries do not always break even at fairs, let alone make a profit. Most dealers complain a great deal about how arduous the fairs can be, and despite great booms in the art market in the past, this many fairs never popped up before. So how did we get to this place where so many fairs exist now, and dealers feel so compelled to participate in them? What follows is a mix of admittedly subjective observations and more verifiable conclusions on what art fairs have come to mean to the contemporary art market since the recession in 2008. In short, three additional factors (beyond the potential money to be made) seem to be at play in the rise of the art fair: (1) a perception that fairs can be not only profitable—for organizers, if not always dealers—but that they are also easy to launch; (2) a transfer of power from the galleries to the fairs themselves; and (3) a growing shift in where collectors prefer to buy art.

Easy to Launch

Some dealers will point to the 1994 Gramercy International Art Fair (the groundbreaking effort launched by four art dealers and held in New York's Gramercy Hotel)

as the beginning of the rise of the art fair, but it would take nearly ten more years before the hundreds of imitators we see today would be created. Moreover, by that time, the Gramercy International Art Fair had morphed into The Armory Show, one of the world's major art fairs with its own growing list of satellites. For me, the spark that truly ignited the current explosion of art fairs happened in 2003, the year that Art Basel held their second edition of Art Basel in Miami Beach (ABMB) and, more importantly, the year the New Art Dealers Alliance (NADA) held its first satellite fair at the same time a few blocks away. Up until that moment, most new gallerists understood the importance of getting into art fairs for raising their profiles, meeting new collectors, networking with other galleries, etc. Yet a basic assumption among dealers I knew then had been that it was probably a better use of your time and money to continue to lobby the selection committees of the major fairs than to risk too much at the handful of smaller international fairs that existed at the time, believing they would not contribute too much to your prestige or collector list but would still cost you a chunk of change, as sales were likely to be low.

After that weekend in December 2003, however, breathless reports of what happened began trickling back across the gallery world. Many of the thirty-five young galleries there had sold out their entire booths during the first few hours, and several reportedly made more money over the next four days than they had in their galleries over the previous six months. All of a sudden, the potential benefits of smaller art fairs were seen in a whole new light. As news spread, the perception became that a new or smaller art fair could also be a means of making boatloads of money virtually overnight. Although their first edition basically included any gallery who had expressed interest in participating, by the time NADA began accepting applications for the Miami fair in 2005, they received more than five times the number of applications than they had spaces available.

In addition, like the Gramercy International Art Fair, the NADA fair had been conceived and launched by a group of young gallerists, without much real experience in such productions. That fact, plus the previously unimaginable financial success of NADA, seemed to convince a number of other dealers and entrepreneurs alike that virtually anyone could launch an art fair. By 2013, ABMB had at least fifteen bona fide satellite fairs orbiting it (not counting less formal events that were organized that weekend), and reports were that sales at most of them were very satisfying for their participants.

Today entirely new art fairs are continuously launched by dealers or others with no previous experience. Many of them do fairly well in gaining press, selling out booths, and attracting collectors their first time out as well. In May 2014 a small new fair called NEWD was launched in the Bushwick district of Brooklyn, NY, a neighborhood where many artists have studios and several galleries have popped up,

but that most collectors are still unfamiliar with. A particular promotional challenge its young organizers (Kate Bryan and Kibum Kim) took on was launching a fair that coincided not with another major fair, but rather with the popular Bushwick Open Studios event. Although they had some experience working in galleries and auction houses, neither Bryan nor Kim had any previous experience organizing a fair, and yet their first time out, the press for NEWD was strong, their presentation was given very high marks, and reports were that sales were quite respectable.

That is not to say an art fair does not still require a great deal of work and planning; just that there is no particular up-front experience required. My co-owner in Winkleman Gallery, and co-founder in the Moving Image art fair, and I can confirm it requires hundreds of hours long past when normal gallery work is complete to produce an even smaller fair. When we launched the Moving Image art fair, we took the experience we had participating in other fairs, asked as many fair organizers as we could for advice, and then essentially made up the rest. Also, and still somewhat amazingly to me, the first edition of Moving Image, in New York in 2011, took place only six weeks after the first invitations to galleries went out. In Chapter 9, we'll look more closely at the logistics, opportunities, and challenges for dealers who launch their own art fairs. They remain a great deal of work, but how straightforward it can be to launch a new one has contributed to their proliferation.

A TRANSFER OF POWER

Looking at the art market today, it is perhaps easy to forget that in the very early days of the Great Recession, the world's top political and business leaders were shocked at how quickly some of the giants in global finance collapsed. Huge corporations went belly-up, people were genuinely very worried about their futures, and even if you still had plenty of money, with so many others in the world losing their jobs or losing their homes, for a while it came to be seen as insensitive to buy luxury goods, at least in a context as conspicuous as an art fair. In December 2008, many dealers at the fairs in Miami went home very disappointed; 2009 was even worse for some of them. That this turn of events was even possible came as a bit of a shock to many younger dealers who had only opened their galleries after the turn of the millennium, so strong had the market been up through 2007.

The power that any art dealer wields can be measured to a very large degree by the strength of their relationships with the people who buy a lot of art. Being able to pick up the phone and have the world's most important collectors actually take your call is what in essence separates those who will truly succeed in the gallery business from those in the "also-ran" category. These close relationships are carefully nurtured and fiercely guarded, but in the early days of the recession, when art

dealers could not even get collectors' personal assistants on the phone, the gallery world responded in part by panicking and handing some of their hard-earned power over to the fairs.

Speaking at the Talking Galleries symposium in Barcelona in November 2013, Clare McAndrew noted in her presentation "Tomorrow's Art Market: Where Will It Be?" that galleries had reported significant drops in foot traffic over the past several years. McAndrew said, "It's just more difficult to get people out of their homes and their offices. People are quite happy to buy online and at auction and stuff but not happy to go and visit a gallery as much maybe as they used to. Obviously fairs are a big thing. The market's become this event-driven vehicle, and ... buyers' loyalties have shifted to the fair itself rather than to the gallery, which is an issue that dealers are facing."

It is difficult to get any art fair organizers on the record about this shift of loyalties, but the perception is that it is real and that it came about in part because of VIP passes. During the early days of the recession, when dealers who had been used to making money hand-over-fist at the fairs, particularly in Miami, saw a noticeable drop in the numbers of top collectors in attendance, they put pressure on the fairs to do something about it. After all, they were paying top dollar to participate. Keep in mind that the art fair model, before the age of opening-day feeding frenzies and countless satellites, had been that the organizers produced the fair and the galleries personally invited their collectors. It had never really been part of the deal that the dealers openly held organizers responsible for ensuring that a certain volume of certain collectors showed up, let alone that they spent money at the fair.

Still, in an effort to try to please the panicked dealers, the art fairs began experimenting with more impressive and glamorous VIP programming to encourage top collectors to return. Depending on whom you ask, this led to or merely coincided with what happened next, but everyone agrees the fairs ended up victims of their programming's success to some degree. Because many of the galleries counted the exact same top collectors among their "VIPs," they all sent the same few hundred collectors the VIP passes the fairs had doled out to them, with the result being that VIPs receiving dozens of extra passes were happy to distribute them to their friends or colleagues at work or even their chauffeurs, many of whom did not collect art, but nonetheless showed up at the various VIP events and occupied the VIP lounges at the fairs. When dealers complained that the VIP events were overrun with people there for the party and not for the art, the fairs next responded by asking the galleries to forward them their VIP lists, so they could collate them, send out the passes themselves, and thereby eliminate duplicate passes being sent to the same collectors. This worked better for keeping the VIP programs exclusive, but now the fairs possessed the best contact list of top collectors in the world, certainly better than their average

participant, and could reach out to them with any message they chose. In short, where collectors were previously viewed as clients of the galleries, increasingly they had become clients of the fairs. The relationship had shifted.

This is not the only factor leading to the shifting loyalties. Two others include the sheer number of galleries that exist now (and the corresponding inability of any human to know them all) and the shorthand that has evolved in determining where a gallery stands in the overall pecking order based on which fairs they do and where their booth is located in them. We will examine the implications of that for smaller galleries in Chapter 5, but will note here that this method of ranking galleries seems to be becoming more pervasive the more time galleries spend at fairs. It also heightens the perception that a gallery must be of a certain quality to be accepted into a certain fair. "Gallery X does Frieze London and Art Basel in Miami Beach" is a statement that tells insiders quite quickly a great deal about Gallery X's prestige and influence, or so it is increasingly assumed. This shorthand, whether entirely accurate or not, has become one way collectors have learned to manage their limited time in cities with many satellite fairs. It is assumed that you will see a certain level of quality at Fair A and much less so at Fair B, which in turn makes collectors who see themselves as more discerning gravitate toward Fair A and systematically associate a higher level of quality with any gallery participating in it than they do galleries relegated to Fair B, even though the reality is that both fairs include a range of galleries. As a result of such shortcuts, though, many collectors you meet during the fairs in Miami now can tell you which fair they purchased something from but not necessarily which gallery. In this way, the fair has become the brand that collectors trust, the brand that sells the art, displacing the gallery to a large degree.

All of this leads many dealers to feel extreme pressure to get into the more prestigious fairs. That in and of itself is not new (dealers have always wanted their galleries to be seen only in the highest-quality contexts), but combined with how dealers are reportedly making more of their annual sales via fairs, it can create a particularly excruciating tension in their own branding efforts. You feel you simply must do a fair in Miami, because you really need the money, but your first (or second) choice did not accept you and now you have to weigh the hit to your prestige that participating in Fair C might cause versus the hollow echoes in your bank account that not doing any fair at all will ensure. Add to this that no matter how hard you lobby them, some of your collectors would not be caught dead at Fair C, and the power that the fairs (and their selection committees) have over a gallery's financial well-being becomes even more starkly obvious.

Most detrimental of all, though, is how viewing the fair as "the brand they trust" makes collectors less reliant—in the middle and emerging sectors of the market

anyway—on developing a personal relationship with the dealers they meet there. A collector in Miami saying "I bought this painting at NADA" has communicated all they need to about its perceived quality and probable price point to contemporary art market insiders. Which gallery at NADA they bought it from might tell them more, but increasingly it does not matter as much as it used to. None of which prevents a dealer from working to develop that relationship regardless, but it makes that relationship more difficult to cement via that interaction, which used to be one of the main points of participating in fairs.

A Growing Shift in Where Collectors Prefer to Buy Art

The transfer of power from galleries to fairs corresponds with another shift whereby collectors increasingly buy art via means other than walking into a gallery space, which only a few decades ago was virtually their only option. To underscore this shift, below I borrow a table of data developed for a slightly different issue in Chapter 5 but which still relates to this. In a survey I posted online, 108 anonymous collectors from North America, Europe, Japan, and South Africa (at least a few of whom I know, from their emailing me behind the scenes, are regularly listed among the world's top 200 art collectors) submitted the following responses to the question "What percentage of the art that you collect now do you find in a traditional art gallery visit (as opposed to online or at a fair)?"

How much art do you buy in a traditional art gallery visit?	Responses
Less than 10%	14.8%
10-25%	15.7%
25-50%	13.9%
50-75%	22.2%
75-90%	25.9%
All of it	7.4%

Because it was designed for a different context, I admittedly did not think when I posted this to ask them to differentiate between art fairs and other non-gallery channels, but still, nearly half of the respondents indicated that today they buy less than half of the art they collect by walking into a gallery.

This next table shows the progression in the number of art fairs mega-gallery David Zwirner has done each year since 2006 (as listed on their website):

Year	Number of art fairs
2006	5
2007	5
2008	7
2009	3
2010	7
2011	9
2012	15
2013	15
2014	20

Except for the dip in 2009, which reflects a response to the start of the financial crisis (keeping in mind that decisions on which fairs to do need to be made many months in advance), Zwirner has very steadily increased how many fairs they do each year, to where they are virtually doing two a month. This is despite the author of a profile on David Zwirner concluding that, "Selling at fairs ... is perhaps his least favorite element of art dealing. 'This is the most commercial part of what we do,' he said. 'It's almost perverse.'"[3]

Why Zwirner would constantly increase his participation in his least favorite element of art dealing is answered in the profile by the author concluding that for Zwirner, fairs are "immensely profitable," but another mega-gallery owner put it even more succinctly. Larry Gagosian explained (to CBS News journalist Morley Safer) that he participates in art fairs because "For me it's a place to sell art. It's a place to make money. The art fair has become a huge part of our business."[4]

One component of this shift away from buying art in galleries that is not often discussed is how it corresponds, quite necessarily, with the growing globalization of the contemporary art market. Walking into a gallery to make a purchase is infinitely more convenient when the gallery is local. In an interview for this book, New York-based collectors Joel and Zoë Dictrow, who were ranked among the world's top 200 collectors by *Artnet News* magazine in 2015 and who have been collecting contemporary art since long before the proliferation of fairs, insisted that visiting local galleries is still important to them, but clarified how New York galleries do not represent some of the artists that interest them:

Consider us old-fashioned; we go to see art exhibitions at galleries and museums. Visiting galleries still is the main way we make discoveries and follow the careers of artists whose work we acquire. Though we usually need to see work in person to make acquisition decisions, exceptions happen. There have been instances in which we've made a commitment to acquire an artwork on the basis of a respected gallery sending us JPEGs. Usually, we know the artist's work very well, but not always.

We have several artists in our collection that we have only seen at art fairs because they are not represented by New York galleries. Recently Peter Davies and Katherina Grosse are two artists whose work we've acquired because we "discovered" them at art fairs.

Other collectors, often with incredibly busy schedules, freely cite how much more practical fairs are for them in trying to keep up with so many galleries popping up. Fairs enable them to quickly get a snapshot of what the market trends are, see which artists are selling well, meet new dealers, and hopefully even learn something new about contemporary art, all vetted by experts in the field. Obviously the full scope of art being made and shown in galleries, but not brought to fairs for logistical reasons, makes this a limited snapshot of the overall market, but with up to 300 galleries per fair, there are currently no other means of seeing this much work for sale in person this conveniently. Moreover, many of the dealers outside New York I talked with for this book insisted that "fewer purchases by collectors walking into your physical space" is virtually an irrelevant issue for them. How fewer can you go than "next to none"? Theirs has always been a business of mostly taking the offer to the collector. Hearing New York dealers complain about decreasing foot traffic often leads them to simply roll their eyes.

It is clear that this shift has not eliminated the need for gallery spaces, though. Not only do artists still want exhibitions and major fairs still require dealers to maintain a physical space, with regular hours and a certain number of publicly accessible exhibitions every year to participate (see Chapters 5 and 9 for how that is changing somewhat among the satellite fairs, though), but many important collectors still value the exhibition experience enough that it is not viewed as going anywhere anytime soon. In an interview for this book, New York-based mega-collector Glenn Fuhrman said of his and his wife Amanda's collection:

> We still buy almost everything in the traditional sense. For a number
> of reasons we haven't been able to travel to the air fairs the way we used
> to. The art fairs have gotten less important, because you now get JPEGs of
> everything, and even for the New York dealers, sometimes I'll go see the
> work before they get shipped, so you can go see them in New York. And so

there hasn't been a ton of things that I've bought at art fairs of late. I still think the preference is to still be in a more cultivated environment and see the work and discuss it with the dealer.

Indeed, in an essay titled "Great art needs an audience," the art critic Blake Gopnik chided "art dealers who believe galleries are no longer necessary," arguing quite convincingly that "art acquires its market value because it has cultural worth." Gopnik also quotes Art Basel director Marc Spiegler on the issue:

> "What artist wants to show with a gallery that can't offer them exhibitions?" says Marc Spiegler, the director of Art Basel. This fair, incidentally, only admits dealers with physical spaces. "We stand for a gallery-centered vision of the art world," Spiegler says—although I'd say that fairs themselves risk undermining that vision.
>
> Spiegler also suggests that an impressive new space can coax new and different work out of artists who might otherwise repeat themselves. And even though the gallery may no longer be the place where art gets sold, dealers still need to have one as a social space for clients to visit, and for the prestige.
>
> Spiegler points to the "geopsychographics" of gallery space: "The space and architecture that a gallery chooses, and its location in the city, tells you a lot about its approach. Some collectors may never come to the gallery itself, but they still want to know it exists."[5]

It is difficult sometimes, when the bills are pouring in more quickly than any checks from sales, to justify maintaining a space that "collectors may never come to," but most dealers have simply accepted it as a cost of doing business (not all, though; we'll examine some "post-brick-and-mortar models" in Chapter 7). For many dealers, presenting exhibitions in their space is their business to them, and the fairs are merely a means toward keeping them open. Whether you like them or hate them, and despite some speculation that we had reached the saturation point (which we will examine below), new art fairs do continue to launch nearly every month, and if the end to that is coming, as of now there are still over 220 Contemporary Art Fairs a year.

How the Rise of the Art Fair Is Impacting the Industry

Accepting that art fairs are perhaps a necessary evil does not mean dealers cannot play a role in making them "less evil." In the strategies section below, we will look at a few strategies for managing and/or maximizing the benefit you get from participating in fairs, as well as how their organizers can perhaps make them less stressful.

To fully understand the issues in play here, let's first examine the impact that the rise of the art fair is having on dealers, their artists, and their relationships with their collectors, as well as their influence on the globalization, and standardization, of the contemporary art market.

Impact on Dealers

For New York dealers, at least, the rise of the art fair represents a different way of doing business entirely. An article in the *New York Times* in 2013 titled "For Art Dealers, a New Life on the Fair Circuit" provided a good illustration of how:

> In just the past few months Gordon VeneKlasen, a New York art dealer, flew to Hong Kong for that city's first global art fair; gave a party for 50 at Harry's Bar in Venice; installed an exhibition at his gallery in London; spent three days schmoozing American collectors in San Sebastián, Spain; and then jetted off to Switzerland for one of the biggest events of the art-world calendar, Art Basel.
>
> Mr. VeneKlasen, 51, who has been a dealer in Manhattan for 25 years, recalls a simpler time, just a decade ago, when he could sit in his gallery on East 77th Street waiting for buyers to step through the door.
>
> "It was a much gentler life," he said. "You were in your gallery, and people came to you. The travel was for very special purposes, and it was not constant. Now, they have us marching."[6]

Similar to how mega-galleries are seen to be forcing other galleries to expand more quickly than they might otherwise (see Chapter 2), it is the sense of resentment in phrases like "they have us marching" that pinpoints one significant change here. Running an art gallery used to be among the most personally satisfying and individualistic endeavors imaginable. Not only were dealers their own boss (other than answering to their artists and their collectors, that is), but because there had been far fewer fairs, a good deal of their time could be spent thoughtfully researching art and trends and plotting how their gallery participated in the culture of their time. The pace of participating in so many fairs has not only left much less time for such lofty (but personally satisfying) endeavors—arguably also contributing to a subtle, but clearly unfortunate homogenization of the art that more represent—but fairs have also made dealers beholden to a much wider group of other players, like selection committees and fair directors. Their personal business decisions are now judged by a much larger and powerful jury that has considerable influence over their fortunes. As a result, the business has become much less individualistic.

Even for dealers located in places that never afforded them the luxury of waiting for people to come to them, the increase in the number of fairs they now feel compelled to do represents a significant change in what it takes to run their gallery, including greater cash flow (because you have to pay the fairs up front), additional staff (for fairs, plus to cover the gallery when they are away for fairs), more travel, less time available for studio visits or collector visits, more time away from their families, and increased personal stress from such a hectic schedule. At a panel discussion on art fairs sponsored by the Fine Arts Committee of the Entertainment, Arts and Sports Law Section of the New York State Bar Association and hosted by Sotheby's Institute of Art in May 2014, the mid-level art dealer Elizabeth Dee noted that "her annual budget for participating in art fairs now hovers around $250,000 compared with a range of $25,000–$35,000 a decade ago."[7] This increase corresponds with normal overhead increases as well. The rise of the art fair has simply made running an art gallery more expensive across the board.

The fairs are also influencing other business decisions, especially for mid-level galleries. When their artists' prices reach a certain price point (generally considered to be above $25,000), an expectation rises from both that artist and their collectors that dealers must present that artwork at the larger fairs. This comes in part because art at such price points is viewed as worthy of the more prestigious context the main fairs represent, but it is also a practical sales consideration. Collectors tend to spend at different price points depending on the fair they are visiting. In an interview for this book, NADA director Heather Hubbs confirmed that dealers who have brought higher priced artwork to NADA fairs have "found it challenging." Even if collectors happily spend a small fortune on a single artwork at the main fairs, she noted, when "they come to NADA, they are not expecting to pay that price, so it's hard to have super-high-priced work at NADA because they are not there expecting that. They are there for discovery, the deal before it becomes huge."

Mind you, NADA is considered, hands down, the best of the satellite fairs in Miami, and yet still collectors expect not to pay above certain prices for what they purchase there. This expectation can drive mid-level galleries to do whatever it takes to get into the main fairs. We'll examine more closely the range of pitfalls in that decision for mid-level galleries in Chapter 5, but as the influential Belgian collector Alain Servais noted in an interview for this book, this drive to "be present at the main fairs" is seriously impacting the smaller galleries:

They're really killing themselves or drying themselves up doing art fairs. They've got to pay up front for everything, and they never know: it's success or failure. They put their life on the line every time. And they're hoping they will make a step up and it will become recurrent, and the real

pity is they end up bringing the same artists who sell like hotcakes to each fair and in my opinion the quality of their presence at the fairs decreases. It's a vicious circle of standardization.

Impact on Artists

There is no question that artists far and away prefer having their work presented in a gallery context over an art fair. As Chuck Close once quipped, "I think that, for an artist to go to an art fair, it's like taking a cow on a guided tour of a slaughterhouse." Even if a gallery chooses to present work by a single artist in their fair booth—thereby better contextualizing it, unlike in gallery exhibitions, where artists are hoping for good sales, good press and the dialogue that can emerge about their work over its duration—the top metric for the "success" of any artwork at fairs is generally whether it sold or not. I have been discussing the fair context with artists for well over fifteen years now, and while there has evolved a subtle acquiescence to the fact that fairs are increasingly where the art sells now, having artwork not sell at a fair has two consequences beyond lost revenue. First is the stress it puts on the artist's relationship with the dealer who failed to make the sale in this "slaughterhouse" with no other redeeming quality other than its facilitation of quick transactions. Second, and more importantly, it risks influencing what the artist decides to create moving forward.

In a 2012 article in *The Guardian* newspaper, artist and arts consultant Afshin Dehkordi questioned "the influence of fairs on artistic practice," citing two examples where the impact was obvious:

> [A]n Iranian artist-curator commented that Western curators were coming to Iran on shopping trips, chaperoned to the same artists' studios, buying work wholesale to feed a new appetite for contemporary Middle Eastern art from wealthy overseas private collectors. Over time, he observed artists adapting their work to match the tastes of buyers – a bit of calligraphy here, a woman in a chador there . . . cue sale. [...] Or as one fine art photographer confessed: "I churn out editions of this particular series for the art fairs; it sells, it pays for my art practice."[8]

There is a chain of pressure here that leads back to the artist's studio. To get into the best fairs, dealers often need to propose something major that will gain the approval of the selection committee. To please the collectors who visit their fair booths and often object if the dealer is presenting work they already saw at their gallery or, heaven forbid, at another art fair, dealers need access to a steady supply of "fresh" artwork. Combined, dealers struggling to break into the bigger fairs (which also make decisions based on how well your past booths looked at other fairs) simply must propose new, attention-grabbing artwork to stand out for selection committees

and please their collectors for every fair they do. Even if dealers do not directly pressure their artists to constantly give them new, outstanding work for each fair, artists can see that it is the other gallery artists who do supply it that are presented at the fairs most often.

Many art fair organizers are aware of this pressure, but have not yet figured out how to minimize it. Annette Schönholzer, who was the director of New Initiatives at Art Basel when I interviewed her for this book (but has since resigned that post), concurred that "a gallery who wants to be accepted into some of these art fairs, including Art Basel, obviously has to convince their artists to bring particular work." Moreover, she noted how the specific sectors that are most amenable to admitting new, younger galleries at Art Basel are so competitive that the selection process puts "more pressure on the artists to deliver something special, spectacular, unique, and site specific."

Impact on Collectors and the Dealer-Collector Relationship

Above we looked at how the shifting of loyalties from galleries to fairs has made the art fair context less fertile ground for developing new, close relationships with collectors, but the pressure of maximizing the potential of the very expensive real estate they occupy for four or five days at a fair is frequently leading dealers to sabotage themselves in that regard as well. Asked how he thought the rise of the art fair has changed the art buying experience, Glenn Fuhrman told me many collectors feel they now have "a shorter period of time to make decisions":

> Certainly at the art fairs it has gotten that way, and I think to some extent there's potential for some backlash on that. I mean it used to be at art fairs, it was clear you had to make a decision, but you could have it on hold for a couple of hours or a day. I've been at art fairs where I've said, "Can you hold this for me for just an hour, so I can walk around and think about it?" and they've said "No. You either want it or, if you don't take it, I'm going to sell it to somebody else."
>
> Those are examples, I would say, of very short-sighted dealers. Most dealers, if you say "I need a couple of hours to walk around and think about it," they're going to say, "Fine." But even the fact that there was somebody who said "No, you can't. You have to decide right now" was to me a statement of a total change in the market and the process, and a bit less caring about the collector and who ultimately bought the work, as opposed to just making a sale.

Another, more subtle form of pressure on collectors rises from the increased globalization of the contemporary art market and how international an audience the major fairs attract, in terms of both the participating galleries and other attending

collectors. As we will discuss below, it can take a gallery doing a fair in a foreign country several years or more to build enough confidence among collectors there for that fair to turn profitable for them. While this seems a particularly expensive process for dealers doing international fairs, who frequently grumble how too many collectors only support their local artists, Annette Schönholzer explained this from the collector's point of view:

> [Because of] the way that collectors start collecting—often regionally and then nationally—going international is a huge step. You have to imagine that if you take collecting seriously that it means a lot of time and engagement and learning and expertise and personal relationships with local artists in the best of cases. I recall an Argentinian collector telling me that whilst they were growing this amazing national collection, even the step into Latin American was huge because all of a sudden everything you thought you knew about art was questionable, and taking the steps of going, "OK, I'm going out there and starting to really collect internationally . . . I am going to trust my gut feeling of what I see, I'm going to make those choices, I'm going to *pay* for those choices," is a huge challenge for people on a personal level.

Influence on the Globalization and Standardization of the Contemporary Art Market

There is a bit of a chicken-or-egg component to sorting out the influence that art fairs are having on the globalization of the contemporary art market. On one hand, many major fairs require applicants to have an international roster of artists, so they are clearly influencing programming in that regard. On the other hand, dealers frequently learn of new artists they are interested in at the international fairs, as do collectors. It does seem obvious that the explosion of fairs around the world has made it easier for dealers to meet more international collectors. As Schönholzer put it, "I do think international fairs are one of the ways that dealers can try to enter new markets that otherwise would not be possible to do. If you want to start selling to Latin American collectors, you can go to Miami Beach, but chances are you only meet a small portion of the collectors there because everyone is competing for their attention. But if you go to the Rio art fair, or if you go to Bogota, or one of the younger generation art fairs, that's where you can meet more."

Globalization is only one component of fairs' influence. Another, for better or worse, is standardization. Let's face it, if you see photography flying out of the booth across from you at Fair X, while all the expensive-to-ship sculpture you brought is being ignored, it cannot help but inform what you bring to Fair X the following year. In a piece on the highly regarded art blog, *Hyperallergic*, Editor-in-Chief Hrag Vartanian

recently asked "Is All the Stuff at Art Fairs the Same-ish?"[9] To many dealers, even those working hard to balance the integrity of what they present at fairs with the reality of why they do them, it was a rhetorical question. Not only can they tell you the price points and perceived quality of what you are likely to find at many art fairs, they can easily predict the percentage of abstract painting versus video you will find there as well. After several years, each fair seems to exert a degree of conformity despite their committees' best efforts.

Here again, though, we have a bit of a chicken-or-egg question in play. As Schönholzer explained, some standardization is a matter of necessity:

> Art fairs do have a fairly large influence in standardizing the way you put things on display. I think that's just part of exhibiting at an art fair. To a certain degree, part of the role of an art fair is to try to create an equality in the way that things can be put on display. Creating certain sized booths, certain type of lighting, carpet, design . . . creating a situation within which then the gallery can express their own specialties of either their artists or how they actually tend to curate their shows.

Heather Hubbs echoed this advantage of some standardization, relaying how, because many of NADA's galleries are often doing an art fair for the first time, there is some "training" involved. (She shared that Sam Keller, former director of Art Basel, had once joked with her, "You train them how to participate, and then we take them.") Hubbs also noted how a standardized format, including a list of things you can or cannot do, not only enforces some of the best practices in how inexperienced galleries install their work or run their booths, but also helps new collectors as well. She tells of an overheard conversation between collectors who raved about a satellite fair with standardized booths being so much better than one many insiders would have rated as much higher quality, because they found the latter fair's looser format too messy and confusing.

Fairs have some control over minimizing too much standardization in how they also require participants in different sectors to adhere to certain guidelines. Schön-holzer noted:

> Art fairs also drive the way that exhibitors display things by creating different sectors. Quite frankly, that's part of the reason why art fairs have sectors to help diversify, to create focus, to avoid having 300 galleries over-hanging their walls or filling their booth space with sculptures or whatever, which clearly wouldn't benefit the artist or collectors.

So how do struggling dealers process all this information into a strategy for optimizing their art fair expenditures? More immediately for many dealers, perhaps,

how do you get into the more desirable fairs or, once in, what must you do to stay in them? To find out, I sat down with Annette Schönholzer and then later with Heather Hubbs, whose fairs are arguably the world's top contemporary art fairs for more established galleries and top fairs for emerging galleries, respectively. Given how fierce the competition is to get into these fairs, if you follow their advice for any other fairs, you will likely be in good shape. In addition to how to get in and then stay in, the strategies section below also looks at the importance of matching your art fair goals to your resources, fair fatigue, and the growing sense that biennials are the best art fairs.

STRATEGIES FOR NAVIGATING THIS CHANGE
How to Get In

I covered the basics of these next two sections—"How to Get In" and "How to Stay In"—in my first book, but that was written before the art fair had taken on the do-or-die significance it can have for dealers today. So I want to reframe this a bit, with very precise advice from the art fair organizers themselves about questions I hear dealers debate all the time, to help communicate a more concrete impression of what works and what does not work when attempting to muscle your way into the fair of your choice. In a nutshell, the same basic advice any dealer gives to artists about how to get into a gallery applies to how to get into a fair: do your homework on what fairs or sectors within fairs match your program; submit a killer proposal; and make a personal connection with the fair, particularly with the members of the selection committee.

Most fairs are very happy to discuss their application process at length during their slow periods. I have directly asked the directors of major fairs that our gallery applied to, "What should I do to ensure our application stands out?" All of them were very generous with their advice, but again, I timed my inquiry considerately. Part of doing your *homework* to learn which fairs match your program may involve simply reaching out to the various fairs' directors and judging (by their enthusiasm about your application) what your chances are. They will all be courteous and encouraging, but there will be telltale hesitations in their voice if you truly stand no chance of being accepted. In the same way dealers understand why a blue chip gallery would not likely work with an emerging artist, be realistic about the likelihood of your being accepted into certain sectors of the more established fairs, and who your competition for those slots probably is. Here's a clue: if the fair was very interested in having you apply, they would make sure they warmly invited you to apply, beyond simply sending you an email announcement because you had applied before. Otherwise, chances are your application will be one in a large stack of others from galleries fighting for the same few openings.

Carefully reading the sector descriptions and application instructions for any fair is another important part of your homework. Here again, the fairs are always very friendly about explaining anything in their instructions you may not clear on. Noting that the differences between the various sectors at Art Basel should clue you in as to which is right for you, Annette advised, "I think it's important to read carefully what the regulations are and what those opportunities are for the different sectors. If you are applying to Survey rather than Positions and Nova in Miami, it's a big difference. It gives you different ways of displaying who you are as a gallerist and putting your artists on that platform. I don't think it's wise for any first-comer, young gallery to try to get into the main gallery sector first. It's just that you are setting yourself up for a disappointment, unless it's a gallery that everybody has been trying to draw in and has been resistant."

Art Basel in Miami Beach and the NADA Miami art fair are both extremely hard to get into. As Heather told me, "Miami has gotten harder and harder because it has gotten better and better." In short, the galleries already accepted into these fairs are "bringing their A game," and you stand little chance of displacing them if you do not propose something their committees will view as an "A+." Every fair you ask will assure you that submitting a *killer proposal* is the most important part of getting accepted. While I am not convinced that is the case for every fair (as we will discuss below, networking is sometimes more important for even the top fairs), there is no doubt that a sloppy or uninteresting application is a huge waste of your time and the committee's time. And wasting the committee's time is one surefire way to guarantee you will never get into a fair.

As Annette told me, "Let's not forget there are up to three times as many applications as there are spaces available, so it's important that your application is actually submitted the way the art fair asks you to, and I think that would be the case for any art fair. Don't try to surprise the committee with a mock-up or something that may not be possible for them to review when they have to do their selections. Although you might think you are going the extra mile, that might be the wrong mile to go." Basically, the advice is to make sure the format requested is *exactly* what you send. Heather shared the same advice, but added, "When a gallery applies to the fair I can tell if they spent half an hour on [their application]. It's obvious. You can tell if somebody really spent a lot of time, really put the effort in, and did something great." You can take from that that half an hour is not even close to the amount of time the galleries competing with you for those booths are spending on their applications. A killer proposal will be well-considered, look professional, be well-written, have excellent images, and communicate that you are serious about bringing something extraordinary to this fair. If it is not all those things, save yourself the application fee.

No art fair application instructions will tell you this, but Heather and Annette both emphasized, as Annette put it, that a *personal relationship* is everything" in this arena. Like nowhere else in our industry, getting into an art fair is about who you know. Wait. Scratch that. It's actually more about who knows you. As Heather told me, "Making sure the committee knows who you are is huge; especially when it comes to a competitive fair. A fair that gets a lot of applications, that is hard to get into, if they don't know you, they don't know your program or your artists, your chances are super slim. Unless you are coming from a place far away, and you are the only application, then they might give you a little bit more of a look and be willing to do some more research. But otherwise, I think they kind of need to know more about you, because it's just too hard. And if you have someone on the committee who is lobbying for you or two people lobbying, or three people lobbying for you, that just always increases your chances."

Having served on a selection committee for a fair, I can confirm that proposals from galleries that no one on the committee knows, especially if they are located in major art centers, rarely receive more than a cursory review. The thinking is, given how social the art world is, and how much energy everyone spends networking, if you were doing something interesting, someone on the committee should have heard of you. Making sure they have heard of you, by visiting the committee members' galleries, introducing yourself, asking them questions about the fair and the application process, and ensuring you add them to your email list, so that when your application comes up for review it is not the first time they have encountered your name, is simply a requirement.

A few other things about how to get in should be considered here. First, there is a perception among some younger galleries that the major contemporary art fairs let the longtime participants bring whatever they like (including secondary market inventory of questionable relevance in this context, but which they know they can sell), whereas the only way newer galleries can hope to get in is by proposing presentations suited to their outlying sectors and even then only by proposing something that really stands out. By their nature, such proposals are often more difficult to sell. The conclusion from this that I have heard is that the fairs rely on (some have said "exploit") the younger galleries to bring in "street cred," while the more established galleries simply get to cash in.

Annette told me that at Art Basel this topic was discussed by the selection committee, openly and matter-of-factly. They admit up front that galleries doing those outlying sectors are taking a risk, but they expect galleries only to submit such proposals because they truly believe in those artists. They also expect dealers to understand this is business:

I don't mean to sound cynical. But I've seen young gallerists go to their limits in a Statements booth, and by doing so obviously creating something that you *really cannot sell*. A great, great piece, but really not sellable, and by the end of the fair they are on the verge of a nervous breakdown, going, "What am I going to do now? I haven't sold it." And you look at their booth and think, "Wow. You really went all the way, but that was your choice, you know. We can give you a platform for your artist, but we can't sell the work for you."

She clarified that the problem was not only that these sectors exist and some dealers do not account for the true risk, but that they exist now at many fairs. Art Basel was the first to create them, and that did help create an entry point for younger galleries, but now many fairs have them, and so some younger galleries are proposing booths they really cannot sell as often as three to four times a year. As I see it, this pattern stems from galleries feeling so desperate to get into the major fairs that they seem to delude themselves into thinking such proposals might be more sellable just because they will be viewed by major collectors or curators at a major fair, when very little really changes about what is sellable and what is not in such contexts.

I suggested to Annette that many younger dealers may look at the various sectors, again desperate to get into the fair, and think "any of these sectors will do." She agreed but added that if you read the sector descriptions carefully, "you can make an assessment of where you think you can show your strengths best. But again, it's a combination. For the solo sectors, often a committee will get more excited about a particular installation, which is easier than for a list of artists they have never seen before. So you can get their attention, but there is a risk with getting their attention, because then you have to follow through."

Another issue to understand better is related to the fact that many fairs are expanding, opening up branded fairs in new, somewhat less-tested markets. The perception some galleries have about those new fairs is that by spending the money to do them, they will improve their odds of getting into the major fair in a more tested location. For example, it was assumed that during the first years of Art Basel in Hong Kong, not only was it easier to get in there than it was in Basel or Miami Beach, but by doing Hong Kong you increased your odds with the committees for Basel or Miami Beach. I asked Annette about that directly. Unfortunately, it almost works the exact opposite:

My recommendation is don't go to Hong Kong because you think it's easier to get into than Art Basel in Basel. Sure, maybe you gain more exposure to management of the art fair and to the committee, etc. because you are there, but Asia is a really tough market. I mean that shouldn't be your main reason for doing it because the competition [for Basel and Miami Beach] is

going to become even more fierce because more and more Asian galleries are going to want (and rightly so) to come to Basel and to Miami in the future.

How to Stay In

If you want to see an art fair organizer become really animated, ask them about the things participating galleries should avoid doing at a fair if they ever hope to get back in again. We are no different about Moving Image, I should note. Fairs are insanely intense, high-pressure and very social events with so many moving parts, so many personalities, and so many things that can and do go wrong, that any dealer who cannot play and work well with others becomes a distraction that often is simply not worth it. Of course, the reality here (as elsewhere in the art world) is, as Heather put it, "Obviously if you are a desired gallery . . . your program is strong and you are desired in the fair . . . and you are an asshole, people are going to put up with it a little bit more, which is sad." And which is true, but dealers have been blacklisted from fairs for overestimating just how desired they were.

Both Heather and Annette had similar lists when I asked them what kind of things dealers do that keep them from being invited back. Heather's first:

> One is not being nice. Another is just overhanging, doing a terrible install. A really sloppy install; it's not well received. Also doing something completely different than what you proposed, without saying something, is a big no-no. No one likes that. We've had internal problems between galleries occur, outside of us, but maybe at the fair, and sometimes getting that feedback is a problem. If somebody complains or says: 'By the way, you should know that A, B, C, with this gallery that did the fair happened.' You have to play well with others. Which is surprising how many people don't. . . .
>
> Oh yeah, and not paying. Not paying is really bad, especially with us [NADA fairs are organized by a non-profit organization]. Because we just can't afford it. And we're cool, we're really lenient. We have a set schedule. If you need a payment schedule, whatever, we are fine with it, we can work with you. But you have to say something.

Not playing well with others was high on Annette's list too:

> We are open to anyone's complaints, but some people have better ways of voicing their frustration than others. Although I understand the emotional side of everything, and we all get emotional under pressure, it's just not a wise thing to yell at a show manager in your booth at any time, whether during your install or during the show when you are disappointed about your

sales, or whatever. I think we try to stay fair, and I doubt anybody has ever been excluded from the fair because they had a moment.

I think it's fair to state your opinions. Do it in writing. Do it when you have slept on it. It is important for art fairs to hear if they are doing a good job or not. It is important. But it's a question of how you do it.

Annette also focused on presenting only what you had proposed and had been accepted by the committee (otherwise "that would be the beginning and end of your relations with the art fair"). She said fairs understand that dealers have to work with and satisfy their artists, but as Heather also noted, the key here is to keep in touch with the fair about any changes well in advance, and not to simply show up with something that surprises them.

Not getting back in to some fairs, may have nothing to do with your behavior or the quality of your booth, particularly if you participated in one of their entry-level sectors. Annette noted that the nature of those sectors creates up to seventy percent rotation of their participants each year. One strategy to consider here is a stepped approach to Art Basel, laying out a three-to-four-year plan whereby you get accepted into the "123" sector first, move to the "456" sector next, and all the while look and behave like you belong in the Art Gallery sector, so when you apply for it in year three, your odds are considerably better. Unfortunately, only about ten percent of the Art Gallery sector changes year to year, though, so a strategy that anticipates remaining longer in sector "456" is probably a good Plan B.

Match Your Goals to Your Resources (Or, Understand What You're Getting Into)

Two ideas that galleries might keep in mind emerged while discussing how dealers can best match their art fair goals to their resources with the fair directors. Heather shared a very eye-opening observation that emerging galleries (or mid-level galleries trying to ramp up their art fair presence) should take note of:

> The trend I've seen is when [new galleries] start off, they don't too [many fairs] until maybe little bit into it. Year two or three they start doing two to three art fairs a year, but I feel like by about year five some of them are doing six to seven fairs a year. I don't know, but it is like there is a turning point, when they do [a] bunch for a while, and they start cutting back to about four or five.

I discuss this turning point in Chapter 5 under the context of a possible "peak fair" realization. That is, for galleries with staffs of three to six people, I suspect there

is a maximum number of fairs a year the average gallery can do before the disadvantages outweigh the advantages, no matter how profitable each fair may look on paper. The strain on staff (leading to turnover), the lack of attention to gallery artists and exhibitions, and other factors conceivably make any more fairs than five a year an overall liability, even if they still make money. It's a theory.

In discussing whether the belief that doing an art fair in a European country often takes an American dealer at least three years to see a profit (because of the time it takes local collectors to warm up to them and their program) was even longer for the markets in Asia, Annette confirmed that it seems to be, but warned against thinking that was the only consideration here:

> For Asia, you have to do more than that, and that is why we occasionally ask a gallerist who wants to participate in Art Basel in Hong Kong . . . Are you in it for the long haul? Are you willing to go an extra mile? It's not enough to show up at the fair. I think those dealers who have become more successful in the region are the ones who really do the mileage, they travel, you know, throughout the year, they follow up and meet the people that they met at the fair. They don't do everything by email, they show up on their doorsteps, and they create a relationship. We all know everything in the art market is very, very much about relationship and trust. In Asia, culturally speaking, trust is the major driver in all business interactions—it is the trust with each other that drives the deal.

In other words, do you have the resources to develop the relationships it will take to make an investment in an art fair in Asia truly pay off? It will likely require more of an investment from you than the cost of a fair or two. Matching your goals to your available resources is therefore a key strategy in where you expand your art fair efforts.

Fair Fatigue

As noted above, there is speculation that we have indeed reach the apex of the rise of the art fair, and things will begin cooling down from here. In January 2015, in fact, Scott Reyburn reported in the *New York Times* that "art fair 'fatigue' may resolve itself." His evidence isn't entirely convincing, but hope springs eternal:

> Dealers and collectors have been complaining for years that there are too many art fairs. "Well, the heyday of art fairs seems to be over," Skate's Art Market Research proclaimed on Jan. 19, reporting that 1,032,792 people attended the world's top 20 art fairs in 2014, a 7.4 percent decline from the previous year.

The Art Newspaper's 2015 calendar lists 269 fairs, nine fewer than last year. An additional absentee, announced this month by the Florida-based organizers David and Lee Ann Lester, will be their American International Fine Art Fair, which specialized in traditional art and antiques.[10]

Reyburn noted that the closing of the Lester's fair is attributable predominantly to a shift in taste away from antiques into Impressionist, Modern, and contemporary art, which does not sound like the death knell for the fairs we have been discussing. A drop in attendance at the top twenty art fairs could reflect simply higher attendance at the bottom 200-plus fairs, as well. In short, it seems too early to send condolences to the art fairs just yet. Even if David Zwirner drops back to only fifteen art fairs a year, discussing strategies for managing "fair fatigue" still seems a good use of time.

When Hurricane Sandy devastated the Chelsea gallery district in 2012, Art Basel director Marc Spiegler walked around to the galleries cleaning up their muddy spaces, including many of us who had never participated in his fair, asking for suggestions on what the fair, whose Miami Beach edition was less than two months away, could do to help make getting there and doing the fairs easier for the galleries. I told Marc I wasn't sure, but I very much appreciated his interest and concern. Indeed, it reflected well on the Art Basel organization that they were so proactive in looking for ways to help, and so in our interview I asked Annette what might be done to alleviate "fair fatigue." As with Sandy, there were no easy answers, but Annette was happy to brainstorm with me. At first she was hard-pressed to think of anything, but then something quite significant came back to her:

> Well, I think as a fair organizer, what you try to do is you try to make the process of applying, of getting there, being there . . . we try hard to make that the most pleasant experience we can make it. It's work, right? It's work. . . . I'm not sure if art fairs can take the burden off of the galleries. I think we can make whatever is in our power a more pleasurable experience, but we can't take on the responsibility for those who choose to do ten art fair a year. I mean that's really what we are talking about with fair fatigue, right? Besides, the art world has become such a busy place. I think we are all exhausted about all kinds of things. . . .
>
> Speaking about costs, especially for young galleries, there is one thing I do want to add. Art Basel did lower the price for [the] Positions [sector] again [this year]. But it's this interesting phenomenon, you know, it always feel like a drop on a hot stone for gallerists, because the day after they forgot already that you have lowered the price. It's like you get a standing ovation, you are the good guy, and by the time the fair is over everybody's demanding a further price reduction.

Lowering the price of an art fair certainly counts as a big thing art fairs could do to alleviate fair fatigue, but as we will discuss more in Chapter 9, very few fairs have anything close to the profit margins most dealers believe they have, so I would not hold out much hope for that becoming widespread. Still NADA offers a "Projects" option, which Heather described as "very small, very inexpensive booths at the fair, and they been very successful." Sometimes, simply having any viable excuse to be where the fairs are is all it takes for dealers to maximize their revenue in that context.

That brings me to another thing I think more fairs might work on that we are already experimenting with in the art fair we co-founded. The model for Moving Image was designed to give dealers as much flexibility as possible in when they felt they needed to be at the fair. We do this with a carefully structured schedule and a forwarding service to let participants know as soon as someone makes an inquiry about their artwork if they are not present. This idea emerged from an experience we had visiting the former German fair, Artforum Berlin. We were only visiting the fair. We did not have a booth. But unlike friends of ours paying full price to participate, we were free to enjoy the VIP events such as private collection tours or parties, visit museums, visit other galleries, and so on, and we sold a pleasantly surprising amount of artwork in the process. Several of our gallery friends who were stuck in their booths all day had sold nothing by the end of the fair. Clearly there are risks of losing sales because no one was in the booth, but our Berlin experience suggested that keeping dealers tied to their booths is something art fairs might try to find ways to be more flexible about. We can report that many art dealers have sold work at Moving Image even though they never set foot in the fair building.

Aside from not doing so many fairs, there are some simple things dealers might try to make the experience less taxing, as well. Annette put the essence of the main one quite simply: "I think that sometimes galleries can do themselves a favor by getting themselves organized in groups, you know, in shipping, things like that." We have tag-teamed on shipping with other galleries for years, and while the savings can be nice, there have also been times when the logistical headaches of co-organizing schedules and such made it even more fatiguing, so it would definitely be a case-by-case solution. In the end, perhaps the best way to not get so fatigued is to pace yourself, despite what seems like a can't-miss opportunity. What good are you really doing your artists or your gallery if, by the third fair in as many weeks, you're not at your energetic, persuasive best? There are diminishing returns in every endeavor.

One final thought on fair fatigue involves how the rise of the mega-gallery made me wonder whether we might see a parallel rise in fairs: something like a mega-fair.

I asked Annette what size she thought was the biggest Art Basel would ever expand to and she replied, "I think that the golden formula has been no more than 300 galleries per fair, no matter where it is." We discussed how the expectation is often that, for the price of admission, one should be able to see everything at a fair, and how if the fair is too big, it creates a negative impression among visitors. For Moving Image, we experimented with a larger fair, only to have collectors tell us it was too much. So we've settled for a total duration of video works that one could conceivably watch in about four hours. In short, a good way to lower fair fatigue is probably to keep any given fair's size to a manageable minimum.

Biennials Are the Best Art Fairs

The general perception for years has been that there is a significant difference between art fairs and the growing list of international biennials (which have been viewed as a much less commercial context for presenting contemporary art), but major collectors are not convinced of this. In a report in the *Financial Times* on the Talking Galleries symposium in Barcelona in October 2014, Georgina Adam wrote:

> "There's no point in pretending any more; biennales are as commercial as art fairs," was a point stressed by curator Mark Coetzee, at the Talking Galleries symposium in Barcelona this week. . . .
>
> Coetzee is director and chief curator of the Zeitz Museum of Contemporary Art Africa (MOCAA) which is being built on the waterfront in Cape Town and due to be completed in 2016. The $120m building is funded by former Puma chairman Jochen Zeitz, now a director of luxury-goods group Kering.
>
> In fact, added Coetzee, "99 per cent of our acquisitions are made in biennales. Fairs cannot provide the scale of works we want, nor the critical importance; artists push themselves more for biennales." [11]

During the Q&A of my own presentation at that symposium (on strategies for midlevel galleries; see Chapter 5), Mark had asked me directly whether dealers shouldn't focus their efforts on attracting the attention of the big biennial curators rather than doing so many art fairs. In May 2015, Alain Servais reiterated Mark's claim about biennials, and threw in museums for good measure, in an interview with Andrew Goldstein on Artspace:

> The artist will give his best for a museum, which he will not do when it comes to sending a work to an art fair. I'm speaking from experience. I was once speaking to an artist in New York about how it's really tiring to

see "art-fair art," if you know what I mean—art with a lot of sugar and a lot of whatever is necessary in that market to sell. The guy said to me, very candidly, "You're right, because I was at the booth of my gallery at Frieze New York and I considered my work . . . it's not that I'm disowning it, but I must recognize that I did it for selling."

. . . When you get to the biennial level, then, the artist will try to give their best. That's when you can judge them in some way.[12]

When Goldstein asked him to spell out how exactly buying art from a museum or biennial works, Alain said simply, "You look at the little texts on the walls. If it says, 'Courtesy of X Gallery,' what does it mean? It's for sale! So I call the gallery from the museum, I send them a little picture, and I say, 'How much is this piece?' And that's why I want to go to the opening of the Biennale."

While it is hard to dispute that little texts on the wall do indeed usually mean the art is for sale through that gallery, my response to Mark Coetzee had been simply that it was viewed as impolite for galleries to insert their commercial concerns into conversations with biennial curators, and that many dealers respected at least the veneer of a distinction between the two contexts. On further reflection, though, I should have added that he and Alain represented a certain class of collector who may indeed buy big, important works from biennials, but, even if thoroughly exploited, the total number of sales that represented could not possibly keep the world's contemporary art dealers in the black, so what might be gained needs to be weighed against what the dealer might lose. Having a biennial curator choose one of your artists may undoubtedly be the best context you can possibly hope for to make a sale, but overtly courting that for commercial purposes will likely backfire at some point.

SUMMARY

Many contemporary art dealers feel compelled to participate in more art fairs than ever before. It is therefore a fortunate thing that there exist more art fairs than ever before, and seemingly new ones are launched every month. It is unfortunate, however, how feeling the need to do so many fairs has often negatively impacted art dealers, their artists, and their relationships with their collectors. Many observers are also concerned about the influence the demand for artwork to take to fairs can have on what artists make in their studios.

Accepting that in an era when foot traffic in galleries seems to be decreasing and collectors are reportedly buying less from traditional gallery visits, art fairs offer dealers an option for making the sales needed to keep their galleries open.

Therefore, strategies on how to get into the best art fair a dealer can, as well as be invited back, are important for those struggling to navigate this burgeoning terrain. Art fair organizers are generally quite generous with their advice to potential participants, so dealers should not be shy about asking for guidance. There are also some common-sense things any dealer can do to try to keep a productive balance between the demands of their gallery and taking their show on the road.

4

The Evolving Roles of the Private Collector

WHAT HAS CHANGED?

nfluential private collectors tend to be very wealthy. Many of them became wealthy by being very good at what they do. Captains of industry or simply very smart business people, they often compete, and clearly succeed, in cutthroat business arenas day in and day out. Many of them have traditionally invested in collecting art as a way to step outside of the daily pressures of their professional ambitions. I have frequently been told by collectors that visiting galleries and discussing art was an opportunity for them to slow down and think about something other than spreadsheets or corporate takeovers. Collecting was how they relaxed. Between 2008 and 2015, though, the relaxing atmosphere of collecting contemporary art began to change on many fronts. I am sure it remains more relaxing than many of the wealthy collectors' day jobs, but I would argue that during this time there was a sea change in the culture of collecting contemporary art. This change emerged due to several factors, including increased access to information online; increased competition for bankable artists' work; the "corporatization" of the contemporary art scene; the way art fairs accelerated the pace of collecting; and how much more money in the system grabbed the attention of new entrepreneurs hoping to get some of it.

To understand the specifics of this cultural change and how it affected the collector-dealer relationship, it perhaps makes sense first to discuss the role of private collectors within the overall context of the contemporary art world, and their

relationships (or lack thereof) to the other players in that system whom dealers interact with and often need to accommodate. We often think of dealers as needing to please two sets of "clients"—artists and collectors—and that balancing those two sets of clients' often mutually exclusive interests is one of the profession's toughest challenges. In fact, dealers are attempting to please a wide range of other players, including curators, critics, museum directors, consultants, executors of estates, foundation directors, art fair selection committee members, and even the general public. To understand the evolving roles of the private collector fully, it makes sense to examine the changing relationship between collectors and some of these other players. Below we will examine how private collectors' interactions with museums, art criticism, other collectors, and dealers have changed over the past several years. Throughout, we will also touch on how these changes have caused, or been brought about by, evolutions in the art market. Finally, we will discuss strategies for managing the impact these changes are having on dealers' relationships with collectors.

Museums

Historically, the active role of private collectors within the contemporary art scene, beyond being merely buyers, has often been that of patron, most publicly identifiable as such by serving as trustees for museums and nonprofit institutions, where they are asked to provide guidance in how to meet the organization's mission; to help with fund-raising (either by encouraging others to donate money or by doing so themselves); and possibly to gift prized pieces from their collections to the institution. How well informed a private collector was about contemporary art or their personal capacity for connoisseurship may have made them a more effective patron, and how influential their collection was may have made them a taste-maker within certain spheres, but generally the conventional wisdom was that directors and especially curators were the "authorities" on the newest art coming out of living artists' studios, and that trustees looked to them for guidance on it, which often subsequently influenced their private purchase decisions. While it may be difficult to separate the sour-grapes-style feedback from more meaningful observations, between 2008 and 2015 insiders increasingly noted (one might say "complained about") how many collectors, even brand-new ones, no longer felt the need to seek out such guidance.

Beyond just making their own purchasing decisions, however, private collectors also increasingly began openly to exert authority throughout the entire museum system in unprecedented and sometimes controversial ways. Most alarming perhaps, some would argue, was how this exerted authority contributed directly to a more blatant blurring of the line between the commercial and noncommercial sectors of

the contemporary art world. A good example of such alarm over this blurring was "Skin Fruit," the 2010 exhibition at New York's New Museum of artworks from the private collection of Dakis Joannou, a Greek collector who was not only a trustee of the museum, but who had the artist Jeff Koons (who is a close friend of his and whose work is well represented in the collection) serve as the exhibition's curator.

New Museum director Lisa Phillips dismissed the objections over this planned exhibition, which began long before it opened, by saying "We're not the first to do an exhibition of a private collection, and we won't be the last."[1] But in covering the controversy, the *New York Times* noted how this exhibition was pushing the boundaries of what was considered the acceptable risks of "renting out the reputation" of the museum. More specifically, in the *Times* article, Erik Ledbetter, director of international programs and ethics at the American Association of Museums, discussed his association's guidelines for borrowing and exhibiting artwork from a collector, and "Skin Fruit" appeared to violate them significantly:

> The guidelines stress the potential for conflicts if board members become lenders, Mr. Ledbetter said. He offered these "cautionary flags": a show devoted to one collector; a show in which the collector is a board member, donor or underwriter; a show in which the museum gives away or pools curatorial judgment with the collector.
>
> "Any one of those things can be managed," he said, "but when you layer them on top of each other, it's more complicated."
>
> The New Museum show raises all the association's cautionary flags except one: Mr. Joannou is not underwriting the exhibition.[1]

The outcry over this exhibition was considerable. Journalist Tyler Green was among the exhibition's most indomitable critics, writing that it was turning one of New York's most respected and traditionally experimental museums into "the trading floor's go-to place for shopping list validation."[2] Artist William Powhida's satirical drawing on the exhibition, "How the New Museum Committed Suicide with Banality," made the cover of the arts publication *The Brooklyn Rail* and helped raise the controversy to nearly epic status in New York's museum history. His drawing, which featured cartoon heads of the various players involved in the controversy, included a caricature of Joannou saying, "The Miami model? Why build my own space in New York when I have already funded the New Museum. You're funny" (www.william-powhida.com). By "the Miami model," Powhida was referring to private collections in the Florida city that have been opened up to the public, such as those owned by the Rubell family, the De la Cruz family, and the Margulies family. (That model is frequently held up as an example of patronage *par excellence* in the contemporary art world.)

In Powhida's drawing, unlike the imagined quote from Jannou, the speech bubble by Lisa Phillips's caricature contains something she actually said in an interview with Tyler Green before the exhibition opened:

> I've talked to a number of collectors and that's the primary appeal of working with a museum, that there would be research and scholarship that would be done on their collections. . . . I guess I just have to repeat myself and say a redefinition of public-private partnerships has to be explored. Museums often can't compete in the marketplace very effectively and there are tremendous expenses. . . . [3]

Phillips seemed a bit exasperated about having to defend the museum's decision in that second part, but her explanation is actually at the heart of this sense that collectors no longer play by the old patronage rules and that the new ways of thinking about the "public-private partnership" must be explored for museums to continue to fulfill their missions. The other pertinent part of her quote here is how museums "can't compete in the marketplace," an acknowledgement that many contemporary art museums are priced out of acquiring the contemporary art they might have purchased or commissioned before the market got so hot and collectors snapped it up so quickly. It is only by showing the work already in private collections that they can contextualize it for the public the way they exist to do. That does not entirely answer why the work in the exhibition had to come from only one private collection, but it does seem to be a key part of this shifting reality.

The strong reaction against the New Museum show also included resentment about the message it was sending about the role, or authority, of the museum curator of contemporary art. As Ledbetter had noted, giving away or pooling curatorial judgment with the collector (or his selected proxy) is a cautionary flag that there might be a conflict. More than just that, though, the New Museum has some of the best curatorial minds in all of New York. Why an outsider, and an artist with much more limited experience curating, would be considered a better choice to work on the "research and scholarship" aspect of presenting this collection ruffled many a feather and ultimately left many unimpressed. *New York Times* art critic Roberta Smith called it "blatantly unmagical curatorial thinking,"[4] and *New York* magazine art critic Jerry Saltz wrote, "What especially irks me is that the curating tells us more about Koons than it does about contemporary art, and he says it better in his own work."[5]

As far back as 2008, rumblings about a rising "interference" by museum trustees were making the news. Former editor and publisher of *ArtNEWS* magazine Milton Esterow published a long list of complaints that museum directors were anonymously sharing with him about trustees pushing museums to "adopt a more corporate mindset." Indeed, the way business norms were increasingly influencing museum choices

was high on their list. In effect, the formerly genteel world many collectors were used to escaping to through their interest in art was giving way as a new type of collector entered this realm:

The arrival of hedge fund managers on boards has not always been welcomed. "They say there has to be a reciprocity of benefits," said a museum director. "If they're giving money and time, they think they deserve something. It might be advice on the art market or advance word on exhibitions where artists' reputations are catapulted. It's a climate that borders on self-dealing in a way Wall Street insiders would understand. It's a subtle minuet played out with squeezes around the arm rather than around the throat."[6]

Esterow also provided a list of "strings" that museums directors said were being increasingly attached to the financial aid or time their trustees were traditionally expected to provide freely in their role as patrons. The list included:

- "I'll give this if you do this."
- "Looking over the director's shoulder."
- "They interfere with everything from how work is installed to marketing."
- "They try to get curatorial control."
- "Making decisions over exhibitions."
- "Wanting to come to staff meetings."
- "Allowing an artist's dealer to pay for part of a museum exhibition, which can—but not always—be a conflict of interest."
- "Insisting that the donated works have to be all together."
- "Pressure to exhibit artists whose works they collect."[6]

Private conversations I have had with museum curators confirm that they feel tremendous pressure to act on trustees' opinions, even when they disagree strongly with them, in much of the work they do. Nearly all of them will share anecdotes of certain trustees whose confidence in their opinions far outweighed their knowledge of contemporary art as well. Again, some of this may be sour grapes or simply the venting anyone in a stressful job needs to do from time to time. The *ArtNEWS* piece ends on a note similar to Lisa Phillips's acknowledgement that museums simply need to adapt to this new financial and patronage reality. In his article, Esterow quoted Peter Marzio, the long-standing and respected director of the Houston Museum of Fine Arts (until his death in 2010), who seemed to embrace such developments in his

relationships with collectors with a spirit of appreciation and good cheer, or at least a grain of salt:

> There isn't a major museum that wasn't built by collectors. If you're fortunate, they are your trustees. They have a point of view and it may not agree with yours, and that's what's fun. As to complaints, all of that may be true in individual cases. But this is the real world. What makes a great director, compared to an also-ran, is how you balance all those interests.[6]

More succinctly perhaps, museums who want private collectors' support must adapt to what this generation of private collectors wants in return. Seemingly gone are the days that collector-trustees were happy to play a more passive role in the curatorial aspects of "guiding" the museum to success. A confidence in their opinions, often over that of the museums' trained curators, has created tensions in the museums as they resolve this new dynamic. Dealers (who, again, need to please both curators and collectors) may lose favor by choosing sides in this turf battle, so it is perhaps best to stay on the sidelines.

Art Criticism
In a 2014 survey for this book that I posted online, 108 international self-declared "contemporary art collectors" answered the question "How much attention do you pay to art criticism (in newspapers, magazines, or online)?" as follows:

RESPONSES FROM 108* INTERNATIONAL CONTEMPORARY ART COLLECTORS ON HOW MUCH ATTENTION THEY PAY TO ART CRITICISM			
I read and it influences what I collect	. . . but it doesn't influence what I collect	Totals
A lot of it . . .	11.0%	42.2%	53.2%
A moderate amount of it . . .	4.6%	33.9%	38.5%
Barely any of it . . .	0.0%	8.3%	8.3%
Totals	15.6%	84.4%	

*Admittedly a small sample size, but via behind-the-scenes emails I know a fair number of them were among the top 200 collectors in the world or very active collectors.

 The good news for art critics seems to be that a majority of these collectors read "a lot" or "a moderate amount" of art criticism. The bad news, perhaps, seems to be that it influences what they collect very little. This corresponds with what New York collectors Joel and Zoë Dictrow (who were ranked in the top 200 collectors

in the world by *Artnet News* magazine in 2015 and who have been actively visiting galleries and buying contemporary art around the world for over 30 years) said in an interview for this book:

> We are always interested in the opinions of critics, collectors, and certain dealers that we respect. Most criticism is not very interesting to us. Some of it is too academic for us, especially in art magazines. We listen but don't rely on the opinions of others for acquiring emerging art. Our own eyes, hearts, and minds are our guide.

Similarly, the New York collector Glenn Fuhrman (who, with his wife Amanda, is among the top 200 collectors), confirmed this position in a separate interview for this book, while shedding additional light on the issue described above about museum curators:

> Honestly, I've never really paid a lot of attention to art criticism. I don't mean it from a perspective of hubris or arrogance, it's more just that I've always relied on my own eye and my own heart and things that move me or I really like. Ultimately, we are buying things we love and want to live with. My personal experience has been, with no disrespect to professionals in this space, that critics and curators as well sometimes come around later, especially when it comes to contemporary art , and the few times I've heard curators talk about very contemporary art, it hasn't necessarily been a compelling argument or one that resonated with me. Thankfully, I've never really relied on it.

This lack of interest in art criticism in the survey confuses me a bit, actually. It used to be that after our gallery received a positive review in the *New York Times* or a similarly prestigious publication, we would see an influx of collectors, new to us but often well informed with deep collections, come into the gallery carrying a clipping of the review or call to inquire about this work they had read was worth seeing. It also used to be that we could count on a nice uptick in sales after such reviews for most exhibitions. Between 2008 and 2015, though, that kind of commercial boost from art criticism definitely became much less reliable in my experience.

Indeed, in an interview about why he chose to switch his respected Brooklyn-based commercial art gallery, Interstate Projects, to a not-for-profit space, executive director Tom Weinrich cited this shift as part of his rationale:

> As for the critical attention his gallery's exhibitions have garnered, Weinrich stated that the relationship between praise and sales is "completely disconnected at this point." He added: "I don't know how that happened or when that happened, but it feels like that has happened recently. A *New York Times* review or an *Artforum* review doesn't necessarily portend selling any

work, the selling of the work just seems like it comes from back channels in a weird way, that's the way it's gone."[7]

Of course, many art critics would argue that this is irrelevant to what they do. Theirs is not a profession involved in increasing the sales of the art they review. However, theirs is a profession involved in providing insights into the *value* of art, and the less attention the only people who can afford to buy the art that will eventually be gifted to the museums pay to their opinions, the less influence they exert in ensuring that the value of the legacy this generation collectively chooses to preserve is as high as it can be. Indeed, despite it obviously being something they would rather not discuss, most of the top art critics cannot help but get dragged into the inescapable art story of this era: the historically booming contemporary art market. In a 2014 article in the *Washington Post* about yet another record auction, Philip Kennicott wrote:

> And the critics, once again, bristled at writing yet another story about yet another epic sale. Jed Perl of the *New Republic* wrote: "At Christie's and Sotheby's some of the wealthiest members of society, the people who can't believe in anything until it's been monetized, are trashing one of our last hopes for transcendence." Peter Schjeldahl of the *New Yorker* said that for a critic to argue about the insane prices being paid today for art would be to "don a clown costume and to join the circus," but he put on the costume long enough to note that, "the present art market plainly won't quit until it hits the end of the line," which he defined as "psychosis" and "ruinous passion."[8]

It is clear they care about the market, if only in how it is drowning out their efforts to sway public opinion about particular artworks' value.

Dealers used to view a positive review for their exhibitions as a win-win. It made the artist happy, and it often brought new collectors into the gallery. Toward that end, younger dealers in particular would court the favor of art critics any way they could. Reviews were selling tools for one set of clients, and prizes you helped secure for another set of clients, rolled up in one. If art criticism now only pleases or influences one set of clients, though, how much of a dealer's increasingly limited time and effort does it make sense to devote to soliciting critics' attention? That may depend primarily on how important reviews are to your artists or the role you feel they play in validating the historical importance of what you are doing in your gallery.

Other Collectors
During these years, well-established collectors also began sounding off about how the previous order of things in the contemporary art world was being upset by brash

behaviors among new private collectors. In mid-2011, New York- and Miami-based collector Mickey Cartin raised a good number of eyebrows by writing an op-ed for *Artnet* magazine that blamed an "indiscriminate demand for production" for a dispiriting increase in the "mediocre material" in the Chelsea galleries he visited. He even drew a distinction between "collectors" and "consumers" of contemporary art:

> For some reason, there are many wealthy people who are driven to pay very large sums of money for things that are of so little value. If it is not so apparent in the galleries, just go to an art auction and watch how consumers behave. . . . The consumer does not realize that the true value of a work of art has nothing to do with its price. They do not understand that art is valuable because it challenges, inspires, and enables us to see ourselves in much more interesting ways. I am one of those ideologues who believe without hesitation, but not blindly, that art makes the world a much more fascinating place. Consumers could care less.[9]

Near the end of 2011, British super-collector Charles Saatchi penned a scathing diatribe for the UK's *Guardian* newspaper titled "The Hideousness of the Art World" in which he railed against the "Eurotrashy, Hedge-fundy, Hamptonites; . . . trendy oligarchs and oiligarchs; and . . . art dealers with masturbatory levels of self-regard" who were ruining the joy of collecting contemporary art for everyone else:

> Do any of these people actually enjoy looking at art? Or do they simply enjoy having easily recognised, big-brand name pictures, bought ostentatiously in auction rooms at eye-catching prices, to decorate their several homes, floating and otherwise, in an instant demonstration of drop-dead coolth and wealth. Their pleasure is to be found in having their lovely friends measuring the weight of their baubles, and being awestruck.[10]

And New York collector Adam Lindmann, who by 2012 had opened his own gallery on Manhattan's Upper East Side, had seen enough from the both sides of the art market by early 2015 to note in a *New York Observer* column that

> What's missing today is connoisseurship, and original thinking. People can't be bothered. They don't have time for it or they simply don't care. No one has patience for listening and learning; high stakes art selling relies on creating the feeding frenzy that triggers an irrational impulse buy. The market is fueled by pure hustle; the most successful dealers are the ones who are best at selling the sizzle, because no one gives a damn about the steak.[11]

In the cases of Saatchi and Lindmann, plenty of people behind the scenes (and a few openly) criticized them for throwing stones in glass houses. Saatchi had been

criticized in an article in the same newspaper five years earlier, during the previous boom, for a track record of "buy[ing] up an artist's works wholesale and then dump[ing] them, thereby ruining a career."[12] Similarly Lindmann was roasted in the press back in 2011 (before he opened his gallery) for announcing in a *New York Observer* column that he was boycotting Art Basel in Miami Beach that year to avoid being "seen rubbing elbows with all those phonies and scenesters, people who don't even pretend they are remotely interested in art?"[13] (only to later be spotted at that very fair). One of the most critical—some said overly personal—responses to Lindmann's column came from *New York* magazine art critic Jerry Saltz:

> His column is larded with that us-and-them attitude. He keeps mentioning the parties he's been invited to but won't be attending ("What's the fun of being invited to so many things?" he sighs). He then pines for the days when "comparing values and tastes was made easy [for collectors] since you could value-shop different galleries and end up comparing a million-dollar Neo Rauch in one booth with a million-dollar Mark Tansey in another." Finally, here, he's tipped his hand, absolutely equating art with capital rather than with deep looking. [14]

All in all, the tone of the collecting world has clearly changed. What had been a refined refuge from the daily pressures of their professions has evolved for many into an equally stressful combat zone. The artificially frenzied context of the art fairs has most likely been a leading factor in this, as has the heightened awareness everyone has of what everyone else is doing that the Internet has fostered. While one obvious antidote here would be a widespread return to the practice of collecting art primarily by visiting galleries, as we'll see below, that will not be an easy modification to the way things are heading.

Dealers

Meeting and establishing a strong personal relationship with important collectors is the quintessential metric of success for so many of the activities that dealers spend a great deal of time and money on, from pricey networking opportunities to expensive promotions like art fairs. Getting important collectors to know and trust you is a long-term strategic advantage over other dealers. Of course, establishing a personal relationship and conveying your own value as a dealer is often much easier face to face, and particularly on your own turf, where you can direct the conversation toward the art on your gallery walls or in your inventory, where you can control the environment in which the art is viewed, or where you can simply relax and be yourself. Encouraging important collectors to actually visit their gallery, therefore, is an important goal for nearly any art dealer. Sure, each time one walks through the door

represents another opportunity to make a sale, but the farsighted dealer also sees it as a good opportunity simply to strengthen their relationship.

In that same vein, ambitious collectors have long understood that it was in their best interest to develop close relationships with the most powerful art dealers, who decide which collectors hear first about available artworks on many collectors' wish lists. Because at least a few of the younger dealers opening spaces will grow into the most powerful dealers of their generation, many top collectors have often cast a net as wide as they can in this endeavor. As one collector I know put it, he realized early on that to build the collection he wanted he needed to become a "collector of art dealers." Indeed, exclusive control over information that could be found nowhere else has not only customarily made art dealers lots and lots of friends—at the higher levels of the art market it has given some the kind of social power that heads of state would be jealous of:

> Private dealer Richard Polsky says that in many cases, when collectors buy from Mr. [Larry] Gagosian, what they're really buying is Mr. Gagosian's cachet: "You cannot underestimate the egos of the people who buy from Gagosian. Most would rather overpay to be part of his world, and he counts on that mystique to draw clients to him."[15]

Back down on earth, though, many dealers who have closed their galleries since the recession have cited "a lack of foot traffic" as one of their main reasons (just Google "foot traffic in art galleries" and you'll see the numbers are roughly eight to one in favor of reports of too little over a sufficient amount of foot traffic).

I tend to think this is a much more complex complaint for dealers than it would be for storefronts where any visitor might be expected to make a purchase. Indeed, by "foot traffic" dealers mostly mean informed visitors, existing collectors, or visitors open to becoming collectors. A reality in the major art centers, where new galleries open up all the time, is that the longer a gallery has been around, a decrease in foot traffic is likely very normal, unless they break into that "must see" category or consistently get great press. Short of that, hope for an increase or even a steady flow in foot traffic likely depends on locational factors, like other galleries opening nearby, or tourists who may or may not be informed in the way that would realistically result in sales. Much of the informed traffic a gallery will get when it first opens comes from those curious to learn about the new space and its program. As no program can be all things to all people, many originally curious visitors will decide that this or that gallery is simply not for them and hence not return frequently. To put it even more bluntly, the collective art world often concludes that they can live without visiting certain galleries on a regular basis, either because they have not liked what they have seen there or the gallery has not achieved the prestige that other galleries

have. Galleries tend to retain a devoted core audience and, again, reach beyond it only via great reviews or other locational factors. As noted above, though, even great press seems to have a decreasing impact on sales.

Furthermore, much of the foot traffic most commercial art galleries have always had (and the form that continues more than the form lamented) comes from visitors who cannot afford or who have no intention of buying the art on view. They are there to view the art. Therefore, an increase in foot traffic, per se, is not actually what would save a gallery from closing. Although there are "encouragement" aspects to steady streams of visitors (that is, good attendance can enliven the mood in a gallery and make the odd collector who does come by feel that much more impressed or engaged), when most dealers think of "foot traffic," they are thinking primarily of people who might actually purchase something, specifically buyers who are perhaps new to them and will hopefully become long-term clients.

How much busier everyone seems to be today is one explanation you will hear for decreased foot traffic of this form in galleries. My sense of it, though, is that it is more the result of two other developments. First is the historic number of galleries that exist, not only therefore dispersing the die-hards who pride themselves on keeping up with the contemporary art gallery scene, but possibly discouraging those in many arts centers, who feel overwhelmed by the swelling volume of spaces, from subjecting themselves to a seemingly endless task. More than all of these, though, it is the Internet and social media in particular.

During a panel discussion[16] at the Art Los Angeles Contemporary fair in 2015 with Jonathan T. D. Neil, director of the Sotheby's Institute of Art, Los Angeles, the sometimes polarizing art collector/dealer Stefan Simchowitz compared collectors' increased direct access to information about artists' work through social media to the central theory behind Martin Luther's reformation of the Christian religion (which, you will note, did not spell the end of the Roman Catholic Church, even as it significantly cut into its adherents). In response to Neil suggesting that "someone has to adjudicate the [online] opinions . . . someone has to sift through them and decide that some are worth paying attention to and others aren't worth paying attention to," Simchowitz said:

> The audience adjudicates . . . it's a form of cultural Lutherism. Martin Luther basically comes out. He says you can have a one-to-one relationship with God. I can sit in the field and pray. I don't need to walk into the cathedral that they spent a million dollars on to build and make a tithe to the priest, the bishop, or the cardinal. I can go to the field. I can get a cup of coffee, and I can be with God. . . . That's what's happening with social media.

Again, Simchowitz has voiced some very polarizing opinions about the contemporary art market, but on this point I suspect he is at least partially correct. What dealers have relied on to sell art for hundreds of years is the perception that they are an "authority" on what is important, on what collectors would be prudent to buy now or not buy at all. They controlled exclusive access to the information collectors could not find elsewhere. Dealers have been, in Simchowitz's terms, the priest or the cardinal in their cathedrals, and only through them could collectors get the information or art they sought. Collectors often still need to curry favor with dealers to gain access to works by highly sought-after artists, of course, but among the factors slowly pulling apart that monopoly, none has accelerated change like Instagram and other social media, progressively putting artists in direct contact with new collectors, thereby giving both of them leverage in their relationship with dealers; or, as some people are speculating, accelerating their facility to forgo any relationship with dealers. There are several reasons that does not seem imminent at all, but that does not mean dealers can take those relationships for granted.

Other Factors

There are several other factors bringing about changes in the dealer-collector relationship I should mention again in this context. In Chapter 3 we discussed how a shift in collector loyalties from galleries to art fairs has made those expensive promotional events less useful in cementing close relationships with collectors. The globalization of the art market discussed in Chapter 1 has increased how far away your best new collectors may live, thereby increasing your costs in going to visit them, something often essential in staying close with them. As we saw in Chapter 2, the consolidation of art market power by a handful of mega-galleries, as well as the consolidation of top artists under fewer and fewer rosters, has contributed to a growing sense that "collecting dealers" need not include as wide an array of them as it previously might have. Combined with how collectors' roles and interactions with the wider spectrum of art world players are evolving, these factors all contribute to my sense that dealers might want to explore new strategies for developing or maintaining strong relationships with collectors.

STRATEGIES FOR NAVIGATING THIS CHANGE

Dealers socialize with collectors in a variety of contemporary art world settings including, but by no means limited to, the arenas of the art market. Understanding how collectors' roles across the contemporary art world have evolved can help dealers avoid landmines and perhaps adapt their relationships with collectors to these changes. Below we will look at strategies for thinking about this from two vantage points: (1)

influencing without authority and (2) presenting the gallerist value proposition more compellingly.

Influencing without Authority

In highly structured corporations, many mid-level managers can simply dictate to the people who report to them what they want them to do. To become really successful and climb the company ladder, though, they must develop persuasive skills and other strategies for eliciting buy-in from colleagues who do not report to them. This set of skills and strategies is typically called "influencing without authority." In the context of the evolving dealer-collector relationship, the concepts behind some of these same strategies may help dealers influence collectors, who may see a host of reasons to buy art outside the gallery system or who are less and less compelled by the "authority" argument to develop close relationships with dealers, to reconsider those decisions. Again, a strong personal relationship with collectors is a proven strategic advantage over other dealers.

You can find countless approaches to influencing without authority in the business press, but most of them concentrate on how best to structure your PowerPoint presentation or better understand why people are resistant to change, concepts not particularly useful here. The perspective I have found that strikes me as best suited to the contemporary art dealer's current circumstance is that of Jo Miller, CEO of Women's Leadership Coaching, Inc., who focuses instead on the main sources of influence in any context and explains how these are best used, or dismissed, when no recognized authority is backing you up. In her essay "Influencing Without Authority—Using Your Six Sources of Influence,"[17] Miller examines the following sources, which we will briefly discuss in the art market context below:

1. Positional influence
2. Expertise influence
3. Resources influence
4. Informational influence
5. Direct influence
6. Relationships influence

Positional influence is what the mid-level manager has over the people who report to him; it comes with the job title. Miller calls this source of influence "over-rated" because people waste years waiting to have it officially bestowed on them, "when they could be influencing in other, more immediate ways." Waiting is the deadly decision

here. In Chapter 2 on mega-galleries, there is a discussion on "seizing the microphone," which essentially asserts that you do not need to wait to be crowned as an industry leader to speak up and share your ideas. As someone who has now received many formal invitations to share my ideas, all traceable back to someone finding my blog in a search result, I can attest that had I waited for someone to bestow the authority to speak up on me, I would still be waiting. (I will note that I have met great collectors through my blog as well.) This is not to advise any other dealer to launch a competing blog, mind you, as much as to second Miller's point that a lack of positional influence should not stop you from asserting the value of your ideas, your program, or your value as a market intermediary in as public and far-reaching a forum as possible.

Miller describes **expertise influence** as the kind that "comes with your background, experience, qualifications and career accomplishments." She notes that the ultimate power from this source comes not merely from having it, but from people knowing that you have it. Most dealers are good at advertising their professional associations or highlighting good press for their gallery on their websites or social media, but surprisingly few include their personal bios on their websites. You know who does, though? Look in the bottom of any page on gagosian.com and you will see a link titled "About Larry Gagosian," which is completely separate from the link "About the Gallery." The bio you will find following that link includes a very nice, large photo (so you won't mistake anyone else in the gallery for the owner) and lists his major career accomplishments, awards, and philanthropic interests. Most people in the art world might assume everybody knows who Larry Gagosian is and what he has done. Larry doesn't assume that, which is part of what makes him who he is.

The key to understanding the strategic potential of **resource influence**, which Miller explains is "the ability to attract and deploy the resources you require to get your job done," is how negotiating for and effectively using resources tends to lead others to entrust you with ever more resources. An example here might be the collector who casually asks if you could help them acquire a work by the hottest artist in the Western hemisphere, or resell a work from their collection for the maximum price the market will bear. Many younger dealers will give up after several failed, frustrating attempts at developing their skills or the right contacts in this competitive sideline of the business, but as we will discuss a bit more in the following section on the dealer "value proposition," pulling it off once will not only ensure similar requests will pour in but will also strengthen your overall reputation in the market, which helps sell your own artists in the primary market.

In the contemporary art market, **informational influence** is very similar to resource influence. Information is, after all, the market's most prized resource. Miller notes that the under-appreciated value of keeping tabs on the endless minor details of your industry is how it increases others' reliance on your decision-making abilities.

Fresh museum trustees may be confused by curatorial decisions that do not seem to jibe with the understanding of contemporary art they developed blending the values of their profession with the information they assembled touring a number of art fairs, but demonstrating that they can trust your decision-making abilities can make you a hero in two of the domains where you, at least, need to please others.

Dealers are more likely to need **direct influence** with their staff (or, sometimes, artists) more than with collectors. As opposed to positional influence, which essentially boils down to ordering people to do things, Miller explains that direct influence is being "firm, fair, direct, and confidential" in addressing someone's inappropriate behavior. In addition to changing such behavior, when done well the respectful use of direct influence can gain dealers a great deal of respect in return, which collectors will pick up on in dealing with your staff. That, in turn, will influence their opinion of your trustworthiness and professionalism as well.

Finally, and particularly pertinent to our objective here, Miller describes **relationships influence** as the opposite of trying to be a "lone influencer." Customized for the art market, her main message is:

> When you take time to build great relationships across the human fabric of your [industry], you are less likely to need to resort to cajoling or persuading others to get things done. Instead of being the sole driver of an idea you can achieve a lot more by collaborating with people who know you and trust you.

Among the tools useful in getting collectors to want to get to know you, there are few better calling cards than another dealer's recommendation. We all have opinions about each other's programs, but I can always find plenty of good things to say about other dealers who have been generous or helpful to us. Don't mistake this for sentimental, warm-and-fuzzy blather. In a machine greased by social interaction, it's strategy. Everyone wants to know the person that everyone else likes.

Presenting the Gallerist Value Proposition More Compellingly

It makes no difference which mega-gallery wins the twenty-first century contemporary art market death match if—while we are all distracted by the repercussions of their bludgeoning ways—new intermediaries step in with innovations or services that enable them to take the business away from gallery owners entirely. Not only are social media and online channels nipping at gallerists' heels, and auction houses making audacious incursions into the primary market, but with as much money at stake as there now is in the contemporary art market, unimagined challengers are sure to be right behind them. The white cube gallery model most gallerists fell in love with and adopted is less than 100 years old. It is silly to imagine it's the only

model that can serve artists well (which I know is hard to stay focused on at times, but truly is the fundamental purpose of the business we're in). To maintain the gallerist model's relevance, to both artists and collectors, may require messaging the gallerist value proposition more effectively.

Conversion strategy expert Peep Laja has one of the best explanations of what a "value proposition" is on his website Conversionxl.com:

> A value proposition is a promise of value to be delivered. It's the primary reason a prospect should buy from you.
>
> In a nutshell, value proposition is a clear statement that explains how your product solves customers' problems or improves their situation (relevancy), delivers specific benefits (quantified value), tells the ideal customer why they should buy from you and not from the competition (unique differentiation).[18]

Each gallerist should ruminate and develop their value proposition for their own business, of course, but if collectors in particular are opting out of the gallery experience, perhaps the entire industry needs to update how we explain why they should buy from us. The mechanics of writing a value proposition serve as a good clarification of what is meant by all this, as Laja's recommendations demonstrate:

> There is no one right way to go about it, but I suggest you start with the following formula:
>
> - Headline. What is the end-benefit you're offering, in one short sentence. Can mention the product and/or the customer. Attention grabber.
> - Sub-headline or a two-or-three sentence paragraph. A specific explanation of what you do/offer, for whom and why is it useful.
> - Three bullet points. List the key benefits or features.
> - Visual. Images communicate much faster than words. Show the product, the hero shot or an image reinforcing your main message.
>
> Evaluate your current value proposition by checking whether it answers the questions below:
>
> - What product or service is your company selling?
> - What is the end-benefit of using it?
> - Who is your target customer for this product or service?
> - What makes your offering unique and different?

Use the headline-paragraph-bullets-visual formula to structure the answers.

Laja offers other specifics, but notes that the "key role for the value proposition is to set you apart from the competition." Why should a collector buy from a gallerist rather than directly from an artist or via an online website or at auction? We know what we do adds value to the transaction. We know the things we do to make collectors' and artists' lives easier. But because of how quickly things are changing in the contemporary art market, many dealers are perhaps less compelling when they discuss what sets them apart from many of the newcomers. It is hard to discuss what you don't really know.

This is an issue. In an article published on *Inc.,* Karl Stark and Bill Stewart, co-founders of Avondale, a strategic advisory firm, argued that to "create a compelling value proposition, you have to know your three C's: competencies, customers, and competitors."[19] Again, we know how we add value (our competencies); we know what artists and collectors need (our customers); but, understandably, we grow more and more fuzzy when it comes to the explosion of new competitors. We will examine online art selling channels (which can be partners as well as competitors) in depth in Chapter 6, but here let's look at what amounts to a value proposition for the profession on the website of the Art Dealers Association of America (ADAA):

- **ADAA Membership**
 Membership in ADAA is by invitation of the Board of Directors. In order to qualify for membership, a dealer must have an established reputation for honesty, integrity and professionalism among their peers, and must make a substantial contribution to the cultural life of the community by offering works of high aesthetic quality, presenting worthwhile exhibitions and publishing scholarly catalogues. ADAA is dedicated to promoting the highest standards of connoisseurship, scholarship and ethical practice within the profession, and to increasing public awareness of the role and responsibilities of reputable art dealers.

- **What Do ADAA Galleries Do?**
 ADAA's members function as an important component of the U.S. art community, providing the means by which artists reach their public and collectors gain access to works of art. Exhibitions by ADAA members provide the first view of new works by both young and established artists and present works by previously neglected artists as well as works by acknowledged masters. (www.artdealers.org/about/mission)

This includes **competencies** ("must have an established reputation for honesty, integrity, and professionalism . . . and make a substantial contribution to the cultural

life of the community") and identifies its **customers** ("providing the means by which artists reach their public and collectors"); but there is no mention of **competitors**. Of course, this was not written to be a value proposition exactly, but I suspect the lack of any mention of "competitors" results from the long-standing fact that, until recently, its members' only true competitors were each other.

Stark and Stewart advise: "Know your competition, their strengths and weaknesses, and develop a value proposition that meets the needs they are unable or choose not to address." For galleries' artists (one set of "customers"), the range of their needs most competitors cannot address as well is wide, including regular exhibitions of their actual artwork; a focused context defined by the reputation of the dealer and the other artists in the program; a presentation/installation design they can weigh in on or entirely control; a publicized period of time the actual work is available for viewing, with regular business hours; a context in which art critics can view the actual work and possibly write about it, etc. You may notice that "actual" appears repeatedly in that list, illustrating that one of the key things that sets galleries apart from any online competitor is that we provide a context where neither the viewer nor the art is virtual. It would be nice if that in and of itself were a compelling distinction, but increasingly it matters only in specific instances. Many longtime collectors report growing ever more comfortable making buying decisions from emailed JPEGs if they have seen the artist's work in person before; at certain price points, not even that really stops them. Online representations undoubtedly offer very convenient means of sending and acquiring information, and it is understandable how that information is helpful in making certain decisions. But let's not confuse any of that with the experience of seeing an artwork in person. One is about business; the other can be so much more.

As for collectors, as noted above, discussing their needs that galleries' competitors cannot address as well is complicated by how collectors themselves are evolving. If they feel less and less need to rely on a dealer's "authority" on contemporary art (other than those they view as consistently picking market "winners") and become more and more ambivalent about the physical experience that gallery exhibitions offer, what competencies can dealers emphasize, or develop, that address their other needs enough to make a difference? There is a platitude in the business that most emerging and mid-level galleries have only a handful of actual collectors who truly support them. This is often discussed as a negative (or a warning to artists to consider the consequences for their careers if they work with that gallery), but what if this were framed instead, as they say in software, as a feature rather than a bug? What if dealers openly developed a roster of core collectors in the same way they do a roster of artists, offering them extended services (such as collection management, museum correspondence, exclusive newsletters with market analysis,

or recommendations for other artists based on their tastes)? It could be a blending of art dealer and art consultancy services. In return, the collectors would quite literally commit to buy enough from the gallery to fairly compensate the dealer for such services.

Many of us do much of that in various ways already anyway. Perhaps standardizing it and, more importantly, describing it as a competency that adds value might convince more collectors to form close relationships with a dealer or more dealers. Nothing in this idea would stop them from buying from other galleries, but it could help bring collectors and dealers back into closer partnerships. It's an idea, anyway. I toss it out as a means of hopefully sparking a dialogue on similar thinking, not because I am convinced it alone could solve all these issues. Along the same lines, another observation I would like to share came from Annette Schönholzer, former Director of New Initiatives at Art Basel, during a conversation about the state of the contemporary art market (in an interview for this book). Annette said:

> If you go to Asia, if you go to China, if you talk to gallerists there, the gallery might run the gallery, a foundation, a freight handling company, a residency program, and maybe an interior design company. And in the West we go "this is crazy," because only one of the five things this gallery is doing is actually being a gallerist. And this kind of diversification, of fluidity in doing business that is so foreign to us, is common all over Asia. And it works because they don't have to rely on one single thing to cross-fund what it is they're doing.

In Chapter 5 we will discuss a few other "complementary businesses" that art dealers have maintained to fund what it is they are doing, but across the board I feel the "value proposition" of the gallery may need to be more clearly articulated to collectors, and possibly to the entire art world as well.

Finally, I cannot leave this topic without adding that, as noted above, the sheer number of galleries that exist now exacerbates all this as well, and not only in numbers. It's the Wild West out there, and so, unsurprisingly, business practices vary wildly, possibly dissuading collectors from trusting an industry that seems to have no standards. No one has the right to tell anyone else they should not open or should close their gallery (sales of my first book might plummet, and I'd be quite displeased about that), but as Annette also told me:

> I don't think that the gallery scene is very good at regulating itself. There's no benchmark for how you get in or out. If you have enough money, you can put your space in a great location, make yourself more visible, all

these kinds of things, but again, in the end . . . nobody really, openly points a finger at the other person.

I took this to be Annette's polite way of saying some of the problems the gallery system is experiencing come from inexperienced (or experienced) dealers making mistakes (or committing crimes) that reflect poorly on the entire industry, and it behooves the industry to clearly condemn such behavior. From an established uptown gallery indicted for knowingly selling forgeries; to a mid-level gallery who faked certificates of authenticity to sell works from a foundation they then reported stolen; to a young dealer who, rather than make amends when they resold a collector's painting they were holding, had someone create a very bad duplicate of it they tried to pass off as the original (all true stories); and countless others, a collector looking for evidence to support their suspicion that buying from a gallery was a risky venture would find plenty. In an age when transparency is increasingly being demanded by consumers, a compelling value proposition may also require explicating how dealers are systematically developing and adhering to ethical business practices. Many associations, art fairs, or other public-facing opportunities for promoting a gallery already decline to work with dealers who do not adhere to the "honesty, integrity and professionalism" standards that reflect poorly on us all when not followed. Although no individual wants to be that dealer who points fingers, there must be ways to distance the ethical dealers from the practices that weaken our collective value proposition.

SUMMARY

The size of the contemporary art market has grown to historic proportions partly via an influx of new private collectors with views on how the market and non-commercial institutions should operate that differ from those who defined the smaller circle of art patrons a generation before. Confident in their own judgment, the new collectors are notably ambivalent about the opinions that museum curators, critics, or other "authorities" hold, particularly when making purchase decisions for their own collections. For dealers who have traditionally traded in being an "authority," this poses new challenges in developing close relationships with these collectors, a strategic advantage in building their gallery that has become all the more crucial as online channels, auction houses, and other players make new inroads as intermediaries in the primary market. Whether through development of new competencies that meet collectors' and artists' needs, diversification of the services that fund their gallery, or delivering a more compelling value proposition, gallerists clearly need to respond to the evolving role of the private collector in the contemporary art world.

5

The Mid-Level Gallery Squeeze

WHAT HAS CHANGED?

S uccess in many businesses relies a great deal on the impression other people have of how well you're doing. This is particularly true in the gallery business. Collectors and artists alike will gravitate toward the galleries they believe are moving up in the world and shy away from those viewed as being in trouble. This impact of perceptions explains perhaps why many mid-level dealers who were still struggling by 2014–2015 didn't want to admit that, even though 2013 annual sales estimates suggested that they were collectively having difficulty. Making it all the harder to admit any difficulty was the fact that top-level galleries and emerging galleries were reportedly doing as well as they had been in 2007, if not better. Even though something seemed to have gone particularly wrong in the middle of the contemporary art market in 2014, having word get out and confirm such problems would only exacerbate them for mid-level galleries. And so many mid-level galleries continued to project an aura of success, even when those closer to their realities knew that was not true.

But what do we mean by a mid-level gallery? Definitions of gallery levels are not easily agreed upon in the industry. Few of the directors of mega-galleries that I've talked with would agree they were part of a mega-gallery, perhaps because it has negative corporate connotations. Likewise, quite a number of dealers I would classify as mid-level would argue they are top-level because they honestly view themselves that way, or they believe in the "fake it until you make it" method of reaching your goals.

The following definitions are based on a conversation with Josh Baer (New York publisher and art advisor, as well as former gallery owner) and Elizabeth Dee (New York gallerist and co-founder of the Independent art fairs) that I had in preparation for a panel discussion we participated in at Art Basel in 2013 titled "The Place of Mid-level Galleries in the Age of the Mega-gallery" (watch here: https://www.youtube.com/watch?v=ZstP0Tzl8gY). I have enhanced these definitions a bit since that panel, based on research for this book:

- Mega-gallery: an influential gallery with multiple international locations, deep pockets, a roster of at least forty artists, and a public perception that they're continuing to expand their enterprise (see Chapter 2).

- Top-level gallery: an internationally influential gallery, possibly with more than one location, a varying numbers of artists on their roster, and yet a public perception that expanding their enterprise is not their top priority.

- Mid-level gallery: [see below].

- Emerging gallery: a gallery that is less than ten years old; initially (at least) having less international influence and a varying number of artists or perceived ambitions; defined predominantly by how new the gallery is, but also generally by having a roster of emerging artists and usually being the owner's first gallery.

These definitions are still likely to be disputed, but none will stir as much debate as how to define a mid-level gallery. I am holding off on providing my working definition of that level for just a moment to first discuss the range of perceptions that play into this categorization and why it's often one dealers cringe to have applied to them.

A gallery might be considered mid-level because:

- They are no longer considered an emerging gallery (because they are older than ten years), but are not yet considered top-level, but are viewed as on their way.

- They are older than ten years, have failed to gain enough influence or power to enter into the top level, and are viewed as not likely ever to achieve that.

- They choose to focus on emerging and mid-career artists because of the dealer's personal curatorial preferences or aversion to competition, and becoming a top-level gallery is not high among their goals.

- They are older than ten years and operate in relative obscurity (meaning they do not participate in any/many art fairs or get much press), but continue to stay in business nonetheless.

Many of the leaders in the contemporary art world will acknowledge the importance of a healthy mid-level gallery system. Their reasoning will run from believing in the artist support network mid-level galleries provide to understanding that as older top-level dealers pass away and their galleries close, a younger generation needs to be ready to step in (and hence pay for the larger booths at the major art fairs or become the members of the senior gallery associations). Others will note, perhaps nostalgically, that they remember how the mid-level phase of running a gallery—when the press often turns its attention to younger galleries and many mid-level dealers are not yet influential enough to amass significant power—can be the toughest in which to stay focused and motivated. There is an even more romantic take on what makes mid-level galleries important, which includes the belief that they are an essential part of the gallery ecosystem, where artists who have passed their "emerging" phase, but not yet entered their "blue chip" phase, can continue to have the opportunity to experiment and develop their work while receiving commercial gallery support. This view informs much of my definition and personal admiration for mid-level galleries.

All romance aside, though, one important distinction between mid-level galleries and top-level galleries that often keeps mid-level galleries from reaching the higher tier is reliable access to the two resources most critical in achieving that goal: money and, perhaps the most important resource money can buy, time. Through the many conversations I have had with dealers in researching this book, I have come to the conclusion that the most common factor that separates mid-level galleries who stay at that level from those who begin to appear as if they're becoming top-level galleries is how much money and time they can spend to keep their two sets of clients (artists and collectors) happy and still confident in the gallery's potential to meet their wants and needs going forward.

Another factor that determines which galleries are viewed as mid-level versus top-level is to a large degree beyond any dealer's control. How consistently they can secure a place in the world's top art fairs and where they're located within those fairs is the most public measure of a gallery's influence. Getting into Art Basel's sectors designed for new participants, for example, can indeed help a gallery move up the ladder, but unless they eventually gain acceptance into the main section of the fair, the perception will be they are still in their mid-level phase. Some galleries who do continuously get into bigger fairs' main sections may still be viewed as mid-level because of their placement in the less desirable sections of those fairs' floor plans. The politics that come into play among the selection committees of those fairs, comprised mostly of the mid-level dealers' direct competitors, can therefore contribute to the perception that a gallery is still mid-level even when there are not any other discernible differences between their operations and those of the top-level galleries.

Pulling all those factors together then, the working definition of a "mid-level gallery" we will use in this chapter is

> A gallery older than ten years; which generally has about eight to twenty-four artists on their roster who mostly fall within the "emerging" to "mid-career" range; which is still usually struggling to secure good placement in the major art fairs; and which often has limited resources to take the steps that could change their position.

The Reality of "the Squeeze"

The notion that there is a "squeeze," or significant and particular pressure, on the entire sector of mid-level galleries is one that some will dismiss by pointing to the number of them still in business. *Why would anyone think there's anything new about some of them closing and some of them continuing? Isn't this simply business as usual?*

There are some indications that it's not. First, of course, are those 2013 sales estimates, which have been published widely in the arts press and beyond. As noted above, the perception that mid-level galleries are struggling can become a self-fulfilling issue for dealers at that level. Furthermore, among the New York galleries who were open in 2008 but have since closed (as recorded on the "R.I.P." section of the blog How's My Dealing?[1]), the vast majority of those closing would have qualified as mid-level. Of course, this may be normal in any period, given that top-tier galleries are more stable than those with less influence. But a large number of emerging galleries have opened up since then and plenty of them seem to be doing just fine, which suggests the market overall is not the problem.

It may be helpful here also to consider two factors unique to the mid-level gallery that affect nearly all their business options. The first is related to expectations surrounding the price points for much of the artwork in the mid-level market. Not only do mid-career artists expect to charge more for their artwork than the standard prices for emerging artists' work, but collectors also expect dealers to work continually to raise the prices for the artists whose work they have purchased. Unlike other businesses where your first step in "moving product" that doesn't sell quickly is to lower its price, dealers can lose the trust of collectors who learn that someone else got a similar artwork for significantly less than they paid for it, or that artwork they had hoped would steadily appreciate has gone down in value instead.

The second factor transcends the kind of concerns that would apply to most other businesses. As the market evolved, a growing number of dealers who felt happy or at least comfortable in the art world before the recession, and who were by all accounts still doing financially OK in 2013–2014, cited significant changes in what is now required to continue to be a successful dealer as their main reasons for choosing to

close their spaces. One might suspect this was merely a "sour grapes" explanation if their rationales were not so consistent and their financial situations were not widely considered to be fairly secure. Themes of how the evolving market was impacting the quality of their relationship with their artists or even the quality of contemporary art in general were common among their explanations for the closures. The following are excerpts from how four emerging-to-mid-level galleries, which most insiders felt were commercially sound, explained their surprising decisions to close around this time.

Galerie VidalCuglietta in Brussels noted in the August 2013 email announcement they sent out that "After many strong exhibitions projects and participations to the best international art fairs, and above all, after building solid relationships with amazing people such as, artists, collectors, galleries, curators, institutions and art lovers . . . we have decided to close the gallery. . . . There are many reasons for this radical and unexpected decision and they all converge to this specific moment where fundamental choices and decisions have to be made to continue to exist as we want to."

In an interview that Kristen Dodge of New York's DODGEgallery gave shortly after announcing the closing of her Lower East Side space, she said, "The job of an art dealer is to sell art, and to place that art with meaningful collections whenever possible. The job of an art dealer is to grow the careers of artists, build dialogue around their practice, and solidify their longevity both practically and historically. The job of an art dealer is to bridge the enormous gaps between artists being unknown, artists being known and artists staying known." [2] Even with this matter-of-fact grasp of the business, and sharing that her gallery was in "good health," Kristen noted how the changes in what it took to succeed were behind her decision: "I'm not interested in chasing the business to art fairs all year long, handling secondary market works, and growing the gallery to a place where we are forced to make decisions that contradict my reasons for being in it in the first place." She went one step further to indicate how little room the current system seems to leave for concerns other than money: "However, there came a point when we were looking at The Next Level and from where I was standing, it looked pretty clear to me that the motivation of money (whether out of necessity or ambition) is trumping the integrity of art."

Among the most successful of the gallerists to share similar sentiments was Nicole Klagsbrun, who after thirty years in the business sent ripples through the New York gallery world with her declaration that "I'm not sick and I'm not broke. I just don't want the gallery system anymore. The old school way was to be close to the artists and to the studios. Nowadays, it's run like a corporation. After 30 years, this is not what I aspire to do. It is uninteresting." [3] She went on to note that the current "structure of the system is overwhelming." Citing an "endless sea" of event-based obligations like fairs and biennials that leave no time to reflect or think about quality, let alone how best to help one's artists build their careers, she concluded that the

result is, "The standard of the art goes down, but there are always buyers and, if you don't take part, you're not successful."

Finally, as of this writing, the latest high-profile mid-level gallery to announce they were closing seemingly had the type of career that would have guaranteed a top-level future, having served on the Art Basel selection committee for many years and co-founded the Art Berlin Contemporary art fair. Described by Artnet as "shocking," Joanna Kamm's decision to close the Berlin-based Galerie Kamm echoed those of other dealers who began galleries for reasons that went beyond simply making money. Artnet reported, "Last year, Kamm announced that she would suspend her participation in all art fairs internationally in order to place renewed focus back on the gallery program itself. She subsequently expressed a frustration with being torn between her passion—working with the artists themselves—and the financial pressures of running an international gallery today."[4]

Once more, the themes of not enough time and too much focus on money run through their explanations for why the gallery business was no longer right for them. Of course, not every mid-level dealer has chosen to close, and in 2015 there are both a number of reasons to be optimistic about the future and, correspondingly, a renewed determination among many mid-level dealers to find ways to overcome the particular challenges prevalent in their sector of the contemporary art market. Still, the "mid-level gallery squeeze" has loomed large in the art press[5, 6, 7], many mid-level galleries have indeed closed, and many mid-level dealers I have talked with have said off the record that things remain challenging. Below we will examine more closely some specific challenges for mid-level galleries, and look at how some dealers are strategizing within or around them. Some of these were indeed challenges for all galleries during this time, but several of them have additional twists for the particular circumstance of mid-level galleries.

STRATEGIES FOR NAVIGATING THESE CHANGES

In addition to listing these challenges in the words dealers would typically use to discuss them, below I attempt to identify the core traditional business issues in play for each (in parentheses), so as to later discuss strategies for them in such terms. The challenges facing mid-level galleries in 2014–2015 included:

- Relatively slower sales and the loss of a key consumer sector (cash flow)

- Rising rents in gallery districts (overhead)

- Threat of poaching by bigger galleries and new questions about loyalty (long-term planning, possibly cash flow)

- Perception of speculation vs. connoisseurship fueling many collectors' decisions (sales techniques, programming choices)

- Art fairs vs. gallery spaces where collectors increasingly make purchases (overhead, sales techniques)

- Internet challenging dealers as source for exclusive information (promotion techniques, long-term planning)

Relatively Sluggish Sales and the Loss of a Key Consumer Sector (Cash Flow)

As discussed before, the *TEFAF Art Market Report* survey is controversial because its methodology is not viewed as clearly articulated (and therefore it is presumed to be potentially less rigorous than it should be), and yet its results were reported widely in the arts press and beyond, which helped form the perception that mid-level galleries were seeing relatively sluggish sales compared with the top-level and emerging galleries. As noted above, such a perception itself can present a challenge to mid-level galleries. Specifically, the *TEFAF 2014 Art Market Report* survey of galleries "indicated that . . . in 2013, the mid market showed lower growth than the lowest and highest ends." The conventional read on why this was the case in 2013 has been that blue chip contemporary artists were selling very well, presumably because their markets were seen as sound and the wealthy saw art as a stable place to put their money, while at the lowest end there was a great deal of speculative buying, because the price points (generally under $5,000) made it easier to buy with little more than a hope that the work would one day appreciate, but not really worry too much if it didn't. In the middle, though, where an artist's prices range from $5,000 to about $70,000 but their place in art history was still relatively questionable, collectors seemed to be taking a more cautious approach.

Here are the TEFAF numbers that helped create this perception of the contemporary art market:

> In 2013 . . . the top end of the market, where dealers generated sales of over €10 million, reported an average increase of 11 percent. . . . The share of sales in the lowest end (less than €3,000) was 11 percent higher in share than 2012, while the segment from €3,000 to €50,000 saw the largest fall year-on-year (of -16 percent).[8]

These statistics are based on a survey of 5,500 dealers from the US, Europe, Asia, Africa, and South America. As the report's notes on data sources revealed, "Response rates varied between countries and sectors, but on aggregate came to approximately 12 percent." These lower-than-average survey response rates likely reflect that

dedication to opacity that art dealers are infamous for. Still, the general percentages seem to accurately reflect both anecdotal evidence and highly public indications of how well any given gallery is doing (such as building out a new location, opening an additional location, hiring more staff, or other things it takes money to do).

The TEFAF numbers also indicated that in 2013 the overall art market had rebounded to nearly its highest peak ever (in 2007) and that contemporary and Modern art were doing exceptionally well in this rebound. The report noted that contemporary mega-, top-level, and emerging galleries reported increases in sales of about 12 percent over 2012. Assuming a rising tide raises all boats, however, it was surprising that artwork priced at the level sold in most mid-level galleries ($5,000 to $70,000) reportedly saw a year-on-year decrease in sales (of 16 percent).

Among the dealers and art fair organizers I've spoken with about this, speculation on why the mid-level galleries might still be struggling when galleries in higher or lower levels were not in 2013 frequently came back to the notion of the loss of a mid-level consumer sector. In short, the theory goes that part of what helped expand the mid-level market leading up to its peak in 2007 was that upper-middle to lower-upper class professionals had begun to buy contemporary art in large numbers. Often referred to as "the doctors and lawyers," these professionals had invested in the stock market, done well there like most other people, purchased their second or third home and their third or fourth car, and were increasingly drawn to the glamorous, event-driven culture of collecting contemporary art. Of course the doctors and lawyers would also purchase plenty of emerging art, like most other collectors, because it was a relatively impulse buy, but they had added an extra boost to the middle market through their sheer numbers. Generally priced out of the blue chip artworks, they were nonetheless quite competitive within the mid-level segment.

Then the recession came in 2008, and purchases of luxury items like art were the first extravagances to go while everyone was trying to assess their financial futures. While many in the financial sectors, technology industries, or real estate began to feel more secure as the recovery took hold, and so began to buy art again, the doctors and lawyers remained uncertain about their finances and didn't return to collecting. Indeed, professionals in both industries were still struggling in 2014, as these quotes confirm:

Doctors

"At the same time, salaries haven't kept pace with doctors' expectations. In 1970, the average inflation-adjusted income of general practitioners was $185,000. In 2010, it was $161,000, despite a near doubling of the number of patients that doctors see a day."

–*Wall Street Journal*, August 29, 2014

Lawyers

"Nationally, 11.2 percent of [law school] graduates from the class of 2013 were unemployed and seeking work as of Feb. 15, up from 10.6 percent in 2012. Only 57 percent of graduates were working in long-term, full-time positions where bar admission is required, which is an increase of almost a full percentage point over 2012."
–American Bar Association, 2014

Again, many mid-level galleries are still in business despite the dual challenges of a key consumer sector not buying during this time and the perceptions created by reports of their relatively sluggish sales. The fact so many remain in business suggests we have not encountered a truly existential threat to the entire middle market, but these dual challenges do contribute to a significant business problem for this sector, which is unreliable cash flow. Specifically, a hard-working dealer can often still make ends meet and keep the doors open despite sluggish sales, but it's difficult at this level to take advantage of the key opportunities that come along, when they do, if cash flow is a continuous problem. And so the following strategies for the challenge of "relatively sluggish sales and the loss of a key consumer sector" focus predominantly on improving cash flow.

Cash Flow Strategies for Mid-Level Galleries

Consider the following case example as an illustration of how insufficient cash flow can be a particular problem for mid-level galleries struggling to become top-tier galleries or simply to improve their fortunes.

Case Example 1: It's mid-August.

Your gallery finally got off the waiting list and accepted into Art Basel in Miami Beach (ABMB), which takes place in December. But the participation fee is due immediately. Because you had been on the waiting list several times before, but never before invited to participate, you weren't really expecting to get into ABMB this time either, and so you hadn't set aside the considerable amount of money it costs to do the fair.

But this is a "can't-miss" opportunity to raise the profile of the gallery. If you can be seen to be moving up in the art world, the resulting confidence among your collectors and artists will help you reach that next level.

So you call your gallery angel, a doctor, and ask her to help, by buying something from one of the artists she supports. But she tells you that her practice is suffering at the moment, and so she's scaling back on her art patronage. She passes on the opportunity to make a purchase and help you out.

You then turn to the collector you sold a major artwork to at some art fair over the summer, but who still hasn't sent you a check. Their assistant tells you they're on holiday in Ibiza when you call. Apparently they lost their mobile phone on the beach.

It's the slowest part of the sales year for your gallery. But your overhead has **not** gone on holiday.

The ABMB participation fee is due.

Below are several strategies for improving cash flow to be able to take advantage of art fair opportunities as they come along, followed later by strategies for improving cash flow for mid-level galleries in general.

Art Fair Opportunity Cash Flow Strategies

Factoring

Factoring is the practice of selling your accounts receivable (that is, your invoices) to a third party (called a *factor*) at a discount. Essentially, they give you the money now, minus their commission, and then they follow up with the collector for payment on the art. This can be helpful with collectors who notoriously take a long time to pay, but it also adds a middle man into the dealer-collector relationship.

The Frankfurt-based company, Foundation, specializes in art world factoring. On their website (www.foundationtm.net) they describe themselves as a "supporting partner" particularly for emerging and mid-level galleries. To be eligible to use their services, a gallery must first apply for membership (which includes a US$200 fee) and pay annual membership fees ($150). Each invoice a Foundation member wishes to sell becomes a "ticket," and upon approval of the ticket, the member receives 100 percent (for *small* tickets, defined as invoices totaling between $1,500 and $3,499) or 90 percent (for *large* tickets, defined as invoices totaling between $3,500 and $20,000) of the invoice (minus a "handling fee" of $150 for small tickets and 3.8 percent of the total invoice for large tickets) within forty-eight hours. For large tickets, the balance comes after thirty-five days.

Using a $10,000 sale as an example, then, a mid-level gallery wishing to use this service will need to pay $350 to apply and become a member and then pay 3.8 percent of the sale (or another $380), for a total of $730. Of course the application fee is only paid once, and the membership fee is annual, but in this example, a first-time member would lose 14.6 percent of their commission in order to receive $4,270 within two days. (Remember, most consignment arrangements with contemporary artists are 50 percent of the sale price, and so the gallery would get to keep only $4,270 from this sale after factoring fees [$10,000 – 50 percent to artist = $5,000 - $730 factoring fees = $4,270 to gallery.) That percentage would drop the next

time they used the service, of course, presuming they did so before the annual membership fee was due, but unless the artist was willing to split the 3.8 percent handling fee, the gallery's still losing a significant percent from their half on each such ticket.

The business reality here, of course, must be considered in terms of how much good getting that money quickly could do for the gallery. If another opportunity, such as being accepted into a major art fair, would need to slip through their fingers because a collector takes too long to pay an invoice, factoring could indeed be very valuable. According to a recent report on Foundation in *The Art Newspaper*, the company has "more enquiries than [they] have been able to process."[9] But in an industry known to be resistant to contracts, factoring still seems to have some convincing to do. In the same article in *The Art Newspaper,* Heather Hubbs, the director of the New Art Dealers Alliance, said, "I have not heard of anyone using this specific service, nor others like it." She went on to voice what many in the industry feel, though, saying "any support a small gallery can get is extremely helpful and useful."

One-Time Backer for an Art Fair Opportunity

Many art galleries have financial backers who invest in the business and either remain silent partners or participate in its operations. The number of gallery backers who are silent is, of course, nearly impossible to gauge, but there are enough cautionary tales about epic—even business-ending—disagreements between dealers and their active or silent backers to make most young gallerists quite skeptical of such arrangements. As noted in my first book, *How to Start and Run a Commercial Art Gallery*, the key to any such arrangement working well is a clear, solid exit strategy in a signed contract.

Special one-time backing arrangements, however, can resolve immediate cash flow problems and help dealers seize opportunities that they may otherwise have had to pass on. In this context, a backer agrees to front the money needed to participate in a fair, for example, with the terms for repayment carefully spelled out in detail. Assuming sales will be made at the fair, the repayment arrangements might vary from the full gallery commission from each sale going to the backer until the debt is repaid to, perhaps, half the gallery commission from each sale goes to the backer until the debt is repaid, or some other similar agreement.

Of course, getting the backer to agree is the first step. As the case example above indicated, even those inclined to support the gallery may not always be in a position to do so or be willing to share the risk. But one approach here that I have seen work well is to offer the prospective backer a chance to be personally involved in the fair. Certain collectors are curious enough about the operations of the "glamorous" contexts of art fairs that, given an opportunity to be a "dealer for a day," they will take it. Consulting them on installation designs, involving them in the planning meetings,

or having them actually work the booth often provides an intriguing enough "peek behind the curtain" for them to sign on. Many dealers reading this may at this point think, "No way. It's tough enough already at fairs without having to mix in the complex situation of selling while entertaining a valued collector to support the gallery." To that, I would suggest most collectors who agree will quickly recognize just how much work it is and not wish to spend too much time being a dealer, so this pitch may still be worth trying.

Booth Collaborations

Currently many art fairs are accepting proposals from two galleries for a joint booth idea, often one presenting an interesting curatorial perspective (perhaps with a rising emerging artist juxtaposed with one more historically recognized, or a thematic installation). Not only do such booths gain media attention, but they obviously cut the costs for both galleries considerably. The advantages here extend to include that with such proposals being popular with many fair's selection committees (at the moment anyway), such collaboration can improves a gallery's chances of getting into the fair. It can be a win all the way around.

Talk with the Fair Organizers

I presented some of these ideas at a Talking Galleries symposium in Barcelona in late September 2014, including the case example above. In the audience just happened to be Annette Schönholzer, former director of New Initiatives for Art Basel, and during the talk she noted that such cash flow issues are indeed something many fairs are willing to work around for the galleries they wish to have participate. Telling the fair that invited you from their waiting list that it may take you some time to raise the participation fee is something they have heard before and are often able to be patient about. In other words, rather than pass on the opportunity, explain your situation to the fair and learn what might be possible for payment arrangements.

Overall Cash Flow Strategies for Mid-Level Galleries

During my research, many dealers (of various levels) reported that for six months of the year they do not sell enough art in their physical gallery to even cover their monthly "brick-and-mortar" space expenses. What had seemed to be a more spread-out selling season in years past has now been consolidated, in large part because of the increase in art fairs, auctions, gallery weekends, and other such events. In New York, the better months for selling out of the actual gallery tend to be mid-September through mid-December and then March through June. The other six months, sales drop off, and the galleries exist off the money they made during the better months.

This has led to an increased interest in ways to increase cash flow during the slower sales months (overhead continues even if the sales don't) or in general. Below are some of the strategies mid-level contemporary art galleries in particular are using or at least considering to order to improve their overall cash flow.

Secondary Market Sales

Developing a niche in the secondary art market can be the best long-term cash flow solution for mid-level galleries dedicated to a program that doesn't always keep them solvent. Doing so requires expertise and can require investment capital, but all the dealers I consider mentors, whose programs are challenging to sell and who yet continue to promote the artists they believe in, report that they can only afford to do so because they are also active in the secondary market.

Magnus Resch, founder of the collector database Larryslist.com and author of the book *Management von Kunstgalerien* (which is slated to come out in English in 2015) noted in an article in Artnet that : "[For new galleries] to be viable in the long term, it requires the revenue potential of more high-end dealing. Successful galleries cannily use secondary art market income to cross-finance the capital and time invested in building up young artists. And they do this right from the start. Growing with the artists is a nice idea. But if they don't grow you die. So better diversify."[10]

The catch here, of course, is again time and money. Any secondary market niche that is easy to develop will likely involve plenty of competition, and the dealer with the deepest pockets can often secure the best inventory. Even working entirely via consignments to build an overlooked (i.e., obscure) genius's market basically from scratch (and hence with less competition) can take years of significant work. Then again, recognizing that no matter how hard you work on your primary market sales they are just not likely to happen for six months of the year can free you up to spend that downtime developing the connections and knowledge needed to compete more effectively in a niche secondary market that can eventually turn quite lucrative and support the primary market program.

Complementary Businesses

Knowing that their "brick-and-mortar" expenses are only technically paid for via the sales in those physical spaces six months of the year, some galleries have begun exploring other means of making income through those spaces to help increase cash flow during the slower sales seasons. Not each of these following examples was necessarily started specifically to increase cash flow (that is, they may have been simply part of the gallery's overarching vision), but they each illustrate a side business that complements the standard primary market gallery model run out of the same space.

My favorite complementary business in a gallery space is the art bookstore in STAMPA gallery in Basel, Switzerland. Not only does STAMPA participate in some of the best art fairs in the world, including Art Basel, but their bookstore is also considered the finest in their city. Definitely part of the gallery's initial vision, the bookstore specializes in "publications on art, photography, architecture and design as well as videos, artists' books and editions." The genius of this complementary business in my opinion is how it helps slow gallery visitors down, which is a growing concern among dealers whose clients increasingly just pop in and out while gallery hopping, which is particularly problematic for programs that benefit from longer viewings or more in-depth discussion about what's on exhibition.

Another popular gallery complementary business (albeit one that no longer exists) was Passerby, the full-fledged bar at the front of the space where New York dealer Gavin Brown was previously located in the Chelsea district of Manhattan. Not only an easy destination for entertaining collectors and artists, the bar continued operating long past regular gallery hours, but served as a constant promotional tool for their current exhibitions. While not as integrated into the genteel gallery model as a bookstore, perhaps, Passerby did help establish Gavin Brown's gallery as an alternative context, which lent credibility to some of the less traditional exhibitions he has since became world-famous for presenting.

Interstate Projects is a younger gallery in Brooklyn that executive director Tom Weinrich has supported, in part, through subleasing sections of his overall space out as artist studios. Located in the relatively less expensive district of Bushwick, where many artists already have studios and a strong artist community has developed, Interstate is a good example of perhaps the most direct complementary business a primary market gallery can run: one serving the needs of contemporary artists. I should note that in mid-January 2015, though, Interstate Projects announced that it was switching from a for-profit to a not-for-profit exhibition space.

Another complementary business dealers are increasingly starting (and one we will examine in much more depth in Chapter 8) is a new art fair. Although they are run by large corporations now, many of the world's top art fairs, including Art Basel and the Armory Show, were initially founded by art dealers who saw a need for the networking and sales opportunities that art fairs can provide. As discussed in Chapters 3 and 9, setting a fair up is a relatively straightforward process, but as a business it can take a few years to turn profitable. My partner Murat Orozobekov and I (initially together with Wendy Olsoff and Penny Pilkington of New York's PPOW gallery), launched the Moving Image art fair in 2011. Organized out of the same space as the gallery, the fair has since evolved to where it helps pay a significant amount of the collective overhead expenses.

Time-and-Place-Specific Solutions

When the recession hit in 2008, and it felt as if someone had cranked closed the faucets of our gallery's cash flow, we made a conscious decision to turn them back on by launching an editions/multiples collaboration with another gallery, using the hypothesis that while few people were confident enough about their futures at that point to buy much art at typical mid-market prices, artworks in large editions, ranging from $100 to $600 each, should continue to sell well. Of course, any such venture would depend on the quality of the editions, but I can report that our editions sold very well indeed (many selling out entire editions of 100), and the effort resulted in exactly what we needed at that time: it kept money continually coming into the gallery, even if only in smaller amounts.

The time-and-place-specific thinking that led to the editions collaboration was also the realization that we knew plenty of collectors who liked to acquire new works on nearly a monthly basis, but their accountants were warning them against any large purchases. We deduced that works that would fall within the range of their normal monthly expenses wouldn't raise the accountants' eyebrows. Also key to our decision was that we didn't want to undo the hard work we'd done to build the markets of our artists by lowering their prices. Considering the responses we were getting from collectors, it was clear that little of our artists' usual work was likely to sell for the time being, so we offered them lower-priced work in editions that were obviously a bit outside the artists' usual practice. This kept the artists' names out there, gave them and the gallery some (versus no) cash flow, and kept us busy and more optimistic during a time when many other galleries were closing. The satisfaction for me in that episode was analyzing the realities of our collectors' situations and then matching that with our goals for our artists' careers and the gallery's needs.

Rising Rents in Gallery Districts (Overhead)

Every time a gallery moves, whether because they want to or they have to, they see a huge outflow of cash for moving costs, build-out costs, new business cards and stationery, advertising the move, and so on. When a gallery is thriving and wants to move to a bigger space or better location, the psychological impact of shelling out the moving expenses is usually overshadowed by excitement and the potential increase in sales that being seen "moving up" can bring with it. When a gallery is forced to move, because their current location becomes unaffordable, all those expenses can be somewhat emotionally defeating, especially if they are forced into a less-desirable space or neighborhood. Moreover, for mid-level galleries already selling less than their higher- or lower-level colleagues, being forced into an inferior gallery space can dissolve that "successful" aura they are working hard to project.

Rents in the traditional gallery districts of a large number of major cities went through the roof between 2012 and 2014. In London, rising rents in the East End forced a number of galleries to relocate[11] or to close.[12] San Francisco's tech boom caused a real estate feeding frenzy that displaced or closed an entire generation of mid-level galleries.[7,13] Mid-level dealers I've spoken with from Berlin to Barcelona have cited quick-paced gentrification and the resulting sky-high rents as forcing them to seek out new locations. And in New York, Chelsea district galleries saw rents double when many of their leases expired in 2013,[14] while even in the more-affordable Lower East Side, rents still increased by as much as 33 percent.[15] As *The Art Newspaper* reported, the mid-level galleries (again, older than ten years, the average length of many New York commercial real estate leases) were hit particularly hard by rising rents:

> Rents are rising everywhere. Prices have more than doubled in Chelsea and have risen by around 30 percent to 35 percent in the Lower East Side, dealers say. Middle-level dealers have been hit hardest. Larissa Goldston moved from an upper- to a ground-floor space in Chelsea last year, but is now without a home because the building was torn down to make way for a new residential tower. "Can I afford a gallery space in this landscape and this market? It's complicated to be in the middle ground," she says.[15]

What further distinguished the impact of rising rents for mid-level versus top-level or mega-galleries, in New York at least, was how many older galleries had learned their lesson during the gentrification-influenced migration out of SoHo a decade before and bought their buildings or spaces outright in Chelsea, when it was a grimy warehouse district and buildings were affordable. Now, not only are top-level galleries not being forced to move again, but the increased capital their owned spaces represents further enables them to make choices or offers to clients that many mid-level galleries cannot hope to match.

Strategies for Addressing Rising Rents

Perhaps the most attractive strategy for many mid-level galleries facing undesired moves because of increases in their rent is one of the complementary business ideas noted above. While it may be impossible to incorporate a bookstore, bar, or studio space into their current location, being forced to move does open up the latitude to choose the next space with one of these sideline businesses in mind. Even if another business does not make sense, however, a forced move remains an opportunity to re-imagine what the gallery can be and how it can operate. Below are two strategies (one more concrete than the other) that being forced to relocate often spur dealers to

consider, as well as a vision many have talked about for years approaching possible realization in San Francisco.

"Post-Brick-and-Mortar" Gallery Models

While no clearly superior example of a "post-brick-and-mortar" gallery model has emerged that addresses all the disadvantages of not having a permanent exhibition space, there has been a great deal of discussion, particularly among mid-level galleries facing rising overhead and shorter in-house selling seasons, about what that might look like. The thought process here essentially focuses on unfortunate realities like a big decrease in foot traffic in the gallery, sales increasingly happening more via art fairs or online channels, and the six-month period when the physical space is often literally not paying for itself. "If the majority of my sales are at fairs, why am I paying all this overhead for a space fewer and fewer people bother to visit?" is a common refrain.

In Chapter 7, we will examine more closely some of the post-brick-and-mortar models that various dealers are trying out, but among the more cynical responses to the concept of a "post-brick-and-mortar gallery" is that it boils down to former dealers now operating as consultants but still wishing to participate in art fairs. And that may eventually emerge as a viable model. While the major art fairs still require participants to maintain a program in a physical location, the directors of some of the satellite fairs I've spoken with indicate they're softening up their position on that requirement. In short, we may be entering a period in which it is not having a physical space alone that determines whether a dealer can participate in an art fair, and so as a strategy to rising rents, this option may deserve more experimentation. Again, we will explore such models in more depth in Chapter 7.

Relocating to Another Region

The histories of the contemporary gallery districts in major art centers like New York or London have included regular cycles in which dealers were forced to migrate out of a neighborhood that they had paradoxically played a major role in gentrifying. (A great analysis of the factors that force gallery migrations, at least in New York, is found in Ann Fensterstock's book *Art on the Block: Tracking the New York Art World from SoHo to the Bowery, Bushwick and Beyond* [Palgrave Macmillan Trade, 2013].) In New York, the current real estate climate has left very little in affordable undeveloped neighborhoods in Manhattan, and even Williamsburg and Bushwick in Brooklyn or the Lower East Side and Upper East Side neighborhoods in Manhattan are becoming or are already too expensive to encourage much more migration beyond the galleries already located there.

So one strategy we are seeing more dealers try recently has been to relocate a mid-level gallery to an entirely new region of the country. Examples of locations that dealers previously located in Chelsea opted for instead include Los Angeles (which is a growing art center but perhaps still not yet a top one, and certainly less expensive), Hudson (in upstate New York), Kansas City, and Miami. Reports from dealers who have relocated to each indicate they're doing well in their new locations and indeed enjoying the lower expenses. Moreover, there can be some strategic advantages beyond lower overhead to such a move. In more out-of-the-way places, where there is less—if any—competition, dealers can work with more high-profile artists than they can in the highly competitive major art centers. Building your dream program, because the artists you wish to work with have no other representation for miles, can make a big difference in how happy you are as a dealer, as well as which collectors you can attract at the international art fairs. Furthermore, because many major fairs seek geographic diversity in their exhibitors list, being the best gallery from a smaller art region can make it easier to get accepted into the fairs than being just one of several good galleries in a major art center.

The "Minnesota Street Project" Model

From the beginning of the recession in 2008, many generously minded people from other industries advised struggling art dealers to collaborate on a new destination location, so as to lower their collective overhead and benefit from sharing their collective audiences. Even when it was suggested that a patron might lend financial support to such an effort, generally the response from dealers was to note how individualistic galleries are, let alone how competitive. In short, they were not interested. Having watched this discussion for a while now, I'm convinced things simply haven't gotten bad enough in most art centers for galleries to give this model a try.

Things have gotten bad enough in San Francisco, though. Rising rents have all but wiped out a generation of mid-level galleries in that city. And so it is not surprising perhaps that the first major attempt to implement such a collaborative model is currently underway there. Called "The Minnesota Street Project" (minnesotastreetproject.com), it is the brainchild of collectors Deborah and Andy Rappaport (a respected social entrepreneur and retired tech-industry veteran, respectively). Set to open in early 2016, the Minnesota Street Project's goal is to provide "affordable spaces and compelling programs to encourage the creation and appreciation of contemporary visual art in the city of San Francisco." The vision for their 35,000-square-foot warehouse is to house art studios, art galleries, nonprofit arts education entities, and other exhibition spaces, as well as a café and retail spaces. Their longer-term plans

include the development of another nearby facility to house additional studios, art storage facilities, and artistic workshop spaces.

Threat of Poaching by Bigger Galleries and New Questions about Loyalty (Long-Term Planning, Possibly Cash Flow)

It is often the case that a mid-level gallery has a balance in their program of some artists who sell very well and others for whom they are still developing a market, or even some artists who will likely never sell well, but who are important to the curatorial context the gallery is building. It is understood by dealers that the artists who sell well are crucial to the ability of the mid-level gallery to invest in the efforts that can help them reach the next level: efforts like more expensive art fairs, higher-quality promotional materials, paying production costs for artworks, hiring more staff, etc. When mid-level galleries lose even one of their better-selling artists (and the income for their business that artist would bring), it can have a huge impact on their plans, if not their ability to remain in business altogether. Even when it doesn't involve a huge financial impact for mid-level galleries, having their top artists poached still involves a potential loss of prestige. The hole it can leave in their often carefully built curatorial context can also present a major new challenge in rebuilding.

Most dealers at any level are quite matter-of-fact about poaching, at least publicly. "It's a normal part of the business" they will say when asked, even as they otherwise note how personal their relationships with their artists tend to be. In a context of sluggish sales in the middle sector of the market, combined with upper-level galleries very obviously growing their empires by adding new highly bankable artists to their rosters from other galleries' rosters in order to afford their expansions (see Chapter 2), a number of high-profile artists who moved from their mid-level to a top-level or mega-gallery in New York in 2013–2014 helped generate the perception that poaching had reached a new, rampant level and posed a serious, if not existential, threat to mid-level galleries. Why this threat might be viewed as "existential" relates to the core concept of the Leo Castelli model, and how it is based on the premise that all strategic and many financial choices in marketing an artist's work feed into the intention of both artist and dealer to grow successful and old together. This is, of course, a somewhat romantic notion, but the degree to which the artist and dealer believe in it also influences the risk a dealer is willing to take on in promoting new, unknown artists. In short, it explains why many dealers will make business decisions that only make sense in a very long-term view.

For example, a dealer who believes his relationship with an artist will last for many years may agree to finance an exhibition that is less likely to sell very much, but highly likely to grab a good deal of press for the artist, thereby increasing her name recognition in ways a more salable exhibition may not have accomplished.

These kinds of exhibitions (sometimes referred to as "statement shows") are often very popular with the press. Make no mistake, though; statement shows often represent a lost opportunity for gallery and artist to earn money during that exhibition. The dealer is willing to postpone the opportunity to see a return on what it costs to present that body of work because the hope is that getting great press will profit both artist and dealer much more down the road when the artist is more well known. However, should this artist take her press and run to a larger gallery before those later opportunities to profit come along, the first dealer is simply out of that money. Multiply that risk across a roster of artists, and the nature of what types of exhibitions galleries are willing to present begins to change unless there's more reason to expect the working relationship to last.

More than that, if galleries lose the motivation to experiment with ways to get attention for their mid-career artists who have not necessarily benefited from an initial buzz, because doing so only leads the bigger galleries to then come along and poach them, the entire mid-level model becomes unattractive. Dealers previously willing to do the hard work of nurturing artists during their post-emerging/pre-bluechip phase, because of faith that one day it would all be worth it, no longer have any motivation to play this role in the gallery system if their artists will systemically get poached after they finally build a solid market for them. Enough of this, and the mid-level gallery ceases to exist . . . or so the theory goes.

In the spirit of full disclosure, I should note that I had perhaps helped generate the perception that this new flurry of poaching presented an existential threat to mid-level galleries with a number of posts on my blog (that were subsequently cited more than a few times) in which I was responding to artists moving from mid-level galleries, that I knew depended on sales from their artwork, to bigger galleries. I happened to know the impact of those moves on those mid-level dealers was significant, but the semi-apocalyptic narrative I derived from these anecdotes and conversations with some of those dealers eventually began to tug at the back of my consciousness. How rampant, really, was poaching among galleries between 2008 and 2014? More importantly, did it really represent the existential threat to mid-level galleries that it seemed to?

To find out, I researched the movement of artists in and out of the rosters of thirty-two high-profile New York galleries. By "high-profile" I mean galleries who would normally participate in one of the major fairs that take place in New York or have high-profile artists currently worth poaching (or worth it to the press to write about a poaching). There are an estimated 600 galleries in New York, but the kind of poaching that has been sending shockwaves through the entire gallery system has typically happened more among these high-profile galleries (that many galleries aspire to become) than the lower-profile ones. Taking as a baseline number then, and

in lieu of any more concrete metric, that roughly sixty New York galleries take part in any one of the major international fairs held in New York City, the thirty-two galleries included in the research represent a sample size of 50 percent of the total population in question. (Clarification on methodology: My reasoning for focusing on this subset of "high-profile" galleries is that even if a mid-level gallery is not currently part of this subset, a new culture of rampant poaching from larger galleries would still pose the same threat to their eventually reaching the next level.)

Of the thirty-two galleries I researched fourteen were mid-level galleries, fourteen were top-level galleries, and four were mega-galleries. For each gallery I created a spreadsheet comparing their 2014 rosters (as presented on their current websites) with their 2008 rosters (as presented on the archived 2008 version of their websites viewable in the "Way Back Machine" [https://archive.org/web/]). I then researched each artist who had either left or joined each roster, thoroughly reviewing their CVs on their personal artist websites and all their other galleries' websites (including those outside New York), researching any press about their movement, and reading the archived news sections on the websites for both New York galleries for articles on newly represented artists or any promotion of the artists assumed to still be part of the roster when published. It took quite a few months. In the end, the data suggested a number of very interesting trends, not all of them reflecting well on the mid-level dealers I had sought to champion. I chose New York obviously because of personal access to more insider information here. Much of what these galleries' websites did not reveal I have been able to learn through direct conversations or through the grapevine.

Here it behooves me to clarify my findings with particular care. Even where I have firsthand knowledge from dealers or artists that artist X was indeed poached by gallery Y, I recognize that humans have all manner of reasons for exaggerating or leaving key information out of their accounts of such circumstances. Therefore, I will note that the following information only assuredly represents the movements of artists from one gallery to another, and even where it would appear obvious that the artist strategically moved from a smaller gallery to a larger one, I am not definitely asserting that "poaching," per se, was involved. Mind you, I go to this length in making this disclaimer because, despite how many dealers will insist that poaching is just another normal part of the business, few of them seem comfortable discussing it in the same way they would discuss shipping costs or preferred insurance companies, let alone admit they had poached an artist from a gallery they knew depended on his or her sales. Moreover, my goal here is not to point fingers, but rather to identify patterns and eventually to discuss strategies for handling poaching.

Therefore, no names of artists or galleries will be used, only an anonymous ID indicating the level I assigned to each gallery (using all the criteria outlined in the gallery level definitions above) and an arbitrary number. Before presenting the data

that would indicate poaching trends, however, let's first look at movement of artists in and out of these galleries' rosters more generally. In the tables below, MG = mega-gallery; T = top-level gallery; and M = mid-level gallery.

Increase in size of roster and retention of artists among 32 high-profile New York mid-level, top-level, and mega-galleries from 2008 to 2014

GALLERY ID, BY LEVEL	Percentage increase in roster size	Percentage retention of artists on 2008 roster
M1	67%	40%
M2	-14%	74%
M3	-8%	68%
M4	2%	60%
M5	-18%	29%
M6	0%	29%
M7	46%	63%
M8	7%	53%
M9	41%	54%
M10	42%	59%
M11	13%	74%
M12	8%	61%
M13	40%	38%
M14	23%	48%
MG1	16%	84%
MG2	51%	66%
MG3	53%	56%
MG4	35%	67%
T1	8%	74%
T2	21%	71%

GALLERY ID, BY LEVEL	Percentage increase in roster size	Percentage retention of artists on 2008 roster
T3	21%	76%
T4	7%	67%
T5	-3%	71%
T6	23%	63%
T7	26%	67%
T8	19%	60%
T9	-3%	62%
T10	17%	81%
T11	0%	72%
T12	9%	63%
T13	12%	72%
T14	0%	68%
Average	**18%**	**62%**

Breaking things down by gallery level here, between 2008 and 2014 the increase in the number of artists on the gallery roster among the sampled mid-level galleries averaged 18 percent; for top-level galleries, the increase averaged 10 percent; and for mega-galleries it averaged 39 percent, which is consistent with the distinction made above between how top-level versus mega-galleries prioritize the rapid expansion of their empires. Breaking down by level the percentage of retention (that is, the artists each gallery had represented in 2008 that they still represented six years later), the mid-level galleries averaged a 54 percent retention rate; the top-level galleries averaged 69 percent; and mega-galleries averaged 68 percent. Again, none of these particular results can be interpreted to reflect anything significant about poaching. There can be any number of reasons for artists leaving a gallery, including death, a career change, personality clashes, and so on. Rather, these averages represent merely the overall context in which artists switched or left galleries during this time, whether via poaching or not.

However, when mapping which artists left one gallery to work with another, especially when it would seem from their CVs and press that the gallery being left

would feel a significant impact from that decision (mostly financial, but also perhaps prestige-related), a general impression of how many such movements would strike one of the dealers involved as "poaching" or close enough begins to emerge. Here again, though, I feel it is important to choose my words with care. The table below should not be interpreted as evidence of poaching, but rather my interpretation of the months of research and analysis into when the move of each artist was likely to have had a significant negative impact (or not) on the gallery being left. Again, though, clearly there is only so much I can tell even from the materials I reviewed or the conversations I have had.

Percent of change in gallery rosters likely having a negative (or no negative) impact on 32 high-profile New York mid-level, top-level, and mega-galleries from 2008 to 2014

GALLERY ID, BY LEVEL	% of change in roster likely having negative impact on another New York gallery	% of change in roster likely having negative impact on this gallery	Total % of change in roster involving negative impact on some gallery (1st column + 2nd column)	% of change in roster likely not involving negative impact on any other New York gallery
M1	25%	4%	29%	71%
M2	9%	9%	18%	82%
M3	0%	31%	31%	69%
M4	0%	6%	6%	94%
M5	0%	23%	23%	77%
M6	13%	13%	26%	74%
M7	0%	13%	13%	87%
M8	15%	15%	30%	70%
M9	7%	14%	21%	79%
M10	22%	0%	22%	78%
M11	29%	14%	43%	57%
M12	5%	10%	15%	85%
M13	14%	10%	24%	76%
M14	17%	17%	34%	66%
MG1	13%	0%	13%	87%

GALLERY ID, BY LEVEL	% of change in roster likely having negative impact on another New York gallery	% of change in roster likely having negative impact on this gallery	Total % of change in roster involving negative impact on some gallery (1st column + 2nd column)	% of change in roster likely not involving negative impact on any other New York gallery
MG2	50%	5%	55%	45%
MG3	21%	12%	33%	67%
MG4	39%	6%	45%	55%
T1	23%	31%	54%	46%
T2	21%	0%	21%	79%
T3	50%	10%	60%	40%
T4	25%	6%	31%	69%
T5	21%	26%	47%	53%
T6	13%	7%	20%	80%
T7	47%	11%	58%	42%
T8	13%	18%	31%	69%
T9	4%	4%	8%	92%
T10	33%	17%	50%	50%
T11	21%	29%	50%	50%
T12	20%	27%	47%	53%
T13	31%	8%	39%	61%
T14	30%	35%	65%	35%
Average	20%	13%	33%	67%

The most surprising result here for me was how the totals suggested that, on average, only 33 percent of all moves by artists between these galleries likely had a negative impact on one or the other involved gallery, as opposed to the remaining 67 percent of moves that would appear to have only had a negative impact on the involved artists (we'll examine that notion in more detail below). Then again, 33 percent is still negative enough to warrant discussing strategies for how to minimize the impact of such moves when they happen, which we will do below.

Breaking down these numbers by gallery level, we see that the average percent of change in each gallery's roster that was likely to have a negative impact on that gallery was 13 percent for mid-level galleries; 16 percent for top-level galleries; and 6 percent for mega-galleries. In this context alone, mid-level galleries would seem to have less reason to complain than top-level galleries about losing artists. Of course, these numbers tell us nothing about the percentage of total sales the artists leaving the respective rosters brought in for each gallery. As noted above, many mid-level galleries have some artists who sell well and often many others who they are still just building a market for, meaning they can less afford to lose their best-selling artists than arguably can a top-level gallery, which generally has many more artists selling well. Finally, as expected, when a mega-gallery signs any artist, the likelihood of them moving would appear to drop considerably.

Let's return to the negative impact these findings suggest were felt only by artists. To help understand the landscape here, I looked at the data in two contexts. First was a comparison of the percentage of artists who seemed to have just been dropped with the percentage of artists from each gallery who were likely poached or somehow otherwise ended up with another New York gallery, to get a sense of whether galleries were dropping more or fewer artists than they were having poached. Second was to calculate what percentage of all the artists on each gallery's 2008 roster were presumably just dropped by that gallery, to determine across levels which gallery sector was dropping artists the most or least. I will expand on what I assume each context means below, but first the numbers:

Percent of artists presumed just dropped vs. percent of artists with another gallery by 2014 (including those presumed to have been poached)

GALLERY ID, BY LEVEL	Artists no longer on roster and with no other New York gallery by 2014 (presumed to have been just dropped)	Artists no longer on roster but with another New York gallery in 2014 (including those presumed to have been poached)
M1	83%	17%
M2	86%	14%
M3	44%	56%
M4	88%	12%
M5	62%	38%
M6	75%	25%
M7	0%	100%

GALLERY ID, BY LEVEL	Artists no longer on roster and with no other New York gallery by 2014 (presumed to have been just dropped)	Artists no longer on roster but with another New York gallery in 2014 (including those presumed to have been poached)
M8	67%	33%
M9	50%	50%
M10	100%	0%
M11	60%	40%
M12	78%	12%
M13	71%	29%
M14	56%	44%
MG1	100%	0%
MG2	50%	50%
MG3	29%	71%
MG4	67%	33%
T1	33%	67%
T2	100%	0%
T3	50%	50%
T4	88%	12%
T5	50%	50%
T6	80%	20%
T7	60%	40%
T8	50%	50%
T9	92%	8%
T10	0%	100%
T11	43%	57%
T12	33%	67%
T13	80%	20%
T14	29%	71%
Average	61%	39%

Looking at these numbers by gallery level, the average percentage of artists represented by mid-level galleries in 2008 who were dropped and still had no other New York gallery by 2014 was 66 percent. The average for top-level galleries was 56 percent, and for mega-galleries it was 62 percent. For each level, the percentage is more than 50, suggesting that artists who are dropped by New York galleries have a tough time finding new ones. Again, there can be any number of reasons galleries drop an artist, but I feel safe in assuming the number one reason among younger and mid-level galleries is that the gallery had been unable to find enough buyers for their artwork.

As these results became apparent during my research, I began to wonder whether the loyalty it takes to maintain the Leo Castelli model, which I had assumed was waning predominantly among a new generation of ambitious artists, had not instead first or correspondingly dissipated among a new generation of ambitious art dealers. To help shine some light on that, I looked at the findings solely from the point of view of how many artists were dropped from each gallery's 2008 roster. In other words, rather than retention, what was the dismissal rate among galleries in each level, and what role might that also play in the evolution of the contemporary art market? The phrasing in the table below might sound a bit harsher than each individual decision these galleries made would warrant, but remember one central idea behind the Castelli model had been that galleries would support their represented artists, though thick and thin, for the long haul.

Percentage of artists on each gallery's 2008 roster who appear to have been just dropped

GALLERY ID, BY LEVEL	Artists on 2008 roster just dropped
M1	28%
M2	29%
M3	17%
M4	33%
M5	47%
M6	53%
M7	0%
M8	29%
M9	12%

GALLERY ID, BY LEVEL	*Artists on 2008 roster just dropped*
M10	17%
M11	10%
M12	27%
M13	23%
M14	23%
MG1	3%
MG2	3%
MG3	4%
MG4	6%
T1	8%
T2	14%
T3	7%
T4	25%
T5	16%
T6	18%
T7	9%
T8	14%
T9	37%
T10	0%
T11	12%
T12	9%
T13	15%
T14	9%
Average	**17%**

Now here I must admit that I have been as guilty, if not more so, of dropping artists as any other New York mid-level dealer I know. At the time, each such decision seemed essential to meet our goals for the remaining artists on the gallery roster, but in hindsight it is clear that I had simply rushed into representation with some of them, which is a topic we will discuss more below. Ultimately, though, seeing the numbers above suggested to me that if the Leo Castelli model has indeed given way to recent developments in the overall marketplace, some of the blame can be laid squarely at the feet of dealers themselves.

Breaking the numbers down by level, the percentage of artists on 2008 rosters just dropped by mid-level galleries averaged 25 percent; for top-level galleries it averaged 14 percent; and for mega-galleries a mere 4 percent. There are other considerations here, including that mid-level galleries are often still actively taking on emerging artists with little to no existing market, whereas top-level and mega-galleries tend to only sign up highly bankable artists. But the "throw them all against the wall and see which ones stick" method of representing artists is not consistent with the romantic notion of "we are in this together, for the long run" that many dealers will insist defines their gallery.

It should also be noted here that of the high-profile poachings in 2013–2014 that originally led me to view this as a serious threat to the mid-level gallery ecosystem, each dealer who had been left had done a truly phenomenal job in promoting those emerging artists. They were the first dealers in New York to exhibit them, often with early-on head-scratching among the culturati and less-than-stellar sales, and yet they stuck to their guns and kept promoting these artists into the limelight, until larger galleries took notice and eventually wooed them away. In other words, they did what we applaud the best dealers for doing: discovering important artists and convincing the world to take notice.

I know these decisions are often difficult for artists, and the top-level and mega-galleries often have the resources to make it appear a no-brainer that such moves are wise, but whether it began with the new generation of dealers or the new generation of artists, the concept of loyalty at the heart of the Leo Castelli model seemed increasingly quaint and antiquated by 2014. Here again, I began to suspect my objectivity was being influenced by my admiration for the galleries and dealers who had been left. So I conducted an online survey, promoted via Facebook, Twitter, and my blog, which resulted in 1,380 self-declared artists responding from over 31 countries across North and South America, Europe, Asia, Australia, New Zealand, and the Middle East.

One of the questions in the survey sought to gauge whether "loyalty" to their galleries still mattered to artists. Each of the artists responding was first separated by whether they had current gallery representation or not. Of the respondents, 60 percent

(or 835) of the artists had no current gallery representation, while 40 percent (or 545) of them had representation with at least one gallery. The loyalty question was framed slightly differently for the two groups. For artists with gallery representation, the question was "In general, how important is the concept of 'loyalty to the gallery' to you in your relationship/s with your gallery/galleries?" Their responses were

RESPONSE	Number	Percentage
Extremely important	86	25.1%
Very important	150	43.9%
Moderately important	83	24.3%
Only somewhat important	15	4.4%
Not at all important	8	2.3%

For artists without gallery representation, the question was phrased "In general, how important is the concept of 'loyalty to the gallery' to you in a relationship with a gallery?" Their responses were

RESPONSE	Number	Percentage
Extremely important	79	17.3%
Very important	202	44.2%
Moderately important	107	23.4%
Only somewhat important	43	9.4%
Not at all important	26	5.7%

Of the artists with current representation, then, 93.3 percent of them considered "loyalty to the gallery" moderately to extremely important, whereas among artists without representation only 84.9 percent did, which is understandable perhaps; why would artists who don't have galleries feel any loyalty to them in general? Overall, though, these responses suggest that artists still consider loyalty an important part of the artist-gallery relationship. How many of these same artists had perhaps been "disloyal" by permitting themselves to be poached by another gallery is not something I asked, but the disparity in the percentages of artists who viewed loyalty as "important" versus the percentage of galleries that had "just dropped artists"

between 2008 and 2014 in New York suggests again that the Leo Castelli model had been abandoned more by dealers than by artists, and in particular by mid-level dealers scrambling to survive the Great Recession.

On the other hand, the impact on mid-level galleries when their best-selling artists are poached can be much more significant than it is on larger galleries. Mid-level dealers I've spoken with have shared that even one best-selling artist deciding to leave their roster had greatly changed how they viewed their relationships with all their artists. Moreover, even the threat of poaching can make mid-level dealers spend resources on defensive measures that they might have otherwise spent growing the gallery. Below are strategies for addressing poaching from both the notion of what role loyalty plays here and how to minimize the impact when poaching does occur.

Strategies for Approaching Loyalty and Poaching Issues

Loyalty Strategies: Encourage More Loyalty Among Young Gallerists

Because of the amount of money in it at the moment and the total number of dealers seriously seeking a chunk of that money, the contemporary art market has become hyper-competitive at the same time that all of life, and the way information moves around in it, has quickened to historic speeds. I view this new competitive and complex landscape as contributing to how many younger and mid-level dealers have repeatedly lost patience with their curatorial visions. The highly visible success of a few galleries at those levels, combined perhaps with the ego it requires to open a commercial art gallery in the first place, has made it difficult for less-successful dealers not to conclude it is their program's fault that they are not also successful in this climate. This has led to what appears to be an accelerated cycle of trying on new artists and then letting them go if sales do not follow quickly enough.

Letting artists go was certainly more the case for Leo Castelli than his myth now would suggest, but as the survey above indicates, artists still value loyalty, seemingly more than many dealers do. Therefore, perhaps one defense against poaching is for dealers to more consistently demonstrate that the loyalty they wish to enjoy is a two-way street. If an artist sees their dealer just dropping other artists from the gallery roster, it will occur to them that they could be next. This contributes to the increased resolution among artists that if a good opportunity to jump ship comes along, they should take it. If the current model is to survive, dealers who have been in the business longer, and who frequently mentor younger dealers, might need to make a bigger point of encouraging more loyalty to the artists younger dealers sign up, explaining that the long-term benefits of such relationships, for both the gallery and the contemporary art scene at large, depend upon this kind of commitment.

Loyalty Strategies: Reconsider How "Representation" Is Discussed and Offered

My point in the paragraph above is not that a gallery should continue to represent every artist it ever signs up even if the relationship is obviously not working out, but rather that perhaps the rush to offer artists "representation" needs to be reconsidered. Younger galleries are often quick to offer artists representation as a means of protecting their initial investments in promoting their work. *What if I take their work to a fair, we sell out the booth, and other, bigger galleries come along and snap them up, because I haven't offered them official representation?* Another concern is that by not offering the security of representation, the artist will view the gallery's commitment as halfhearted and feel it's wise to explore other opportunities. Both those concerns rise from the unrealistic expectation that when the partnership is "right," the artist and dealer will know it because they essentially "fall in love" at first sight and that any less fantastic start is a warning sign the partnership is not "the one." This rather romantic notion comes both from the Leo Castelli model myth and the desire on many artists' part to find a dealer who is completely devoted to them and their art.

What seems to be needed as a measure against dealers signing up so many artists they will simply drop later is perhaps a middle phase, where it is clearly stated how much the gallery is going to invest in the artist and it is clear the gallery expects to make that money back (by making money for both of them), but that official representation should only be entered into when both parties are confident the partnership is sound. Yes, the risk remains that an artist will agree to representation with a different gallery during this "trial" period, but with a clear dialogue about how much the gallery is behind or ahead in a return on its investment, the conversation about any such defections can be less destructive for the gallery being left.

This would require, of course, more detailed bookkeeping about expenditures in promoting each artist than many galleries currently do. What percentage of the gallery website is rightly considered an investment cost in promoting that artist, for example? If an artist decides to sign up with a different gallery, knowing the total amount invested in the artist can facilitate a more productive conversation on what can be done to help the initial gallery recoup its investment (more on that below). Yes, this approach would sap some of the romance from the artist-dealer relationship, but it is having romantic notions like those smack headlong into reality that ultimately makes artists more skeptical of the gallery system, and ultimately creates even more problems around trust and loyalty.

Loyalty Strategies: Forget Loyalty

It should also be considered, as the art market grows increasingly complex, that perhaps things have changed forever, and the more romantic elements of the Leo

Castelli model are no longer viable. I discussed the loyalty issue during my presentation at the Talking Galleries symposium in Barcelona in October 2014. During the Q&A, a collector in the audience said, "I have been collecting for 30 years. I think that very bluntly, we speak of the 'art market' . . . it's a market of art, and you should not forget that if it's a market there are a number of rules which are common to all types of markets . . . and I don't think that 'loyalty' exists in any type of market."

I would counter now (at the time, the presentation was winding down and I wanted to be sure the collector had time to express his opinions, so I didn't disagree) that the question of loyalty is between an artist and his or her agent, the dealer, and that many of the issues they work out in that relationship transcend the selling of the art on the market. Often they are curatorial in nature, or even personal. And so it is not entirely within the realm of the art market, per se, that such questions emerge. But I do acknowledge that perhaps ideas around loyalty need to evolve as the market becomes more complex and competitive. I titled this subheading "Forget Loyalty," but knowing how much value artists place on it, I'm not sure entirely forgetting it makes dealers effective agents for artists.

Still, the future of the artist-dealer relationship would seem to be one that includes more formalized agreements (that is, more contracts), which if used correctly will enhance, but not entirely replace, the way loyalty makes the partnership more effective. Part III of this book delves more deeply into how contracts are being reconceived to address evolutions in the art market and in particular the artist-dealer relationship.

Poaching Strategies: Discuss This Upfront

Like any issue that frequently leads to discord in the dealer-artist relationship, establishing a dialogue with your artists about poaching early on is a good strategy for avoiding it or making the most of it if it does happen. In particular, establish that you are always open to discussing any dissatisfaction that may develop to keep lack of communication from generating suspicion or resentment where none was warranted. Even more specifically, discuss up front how you would prefer to handle things if the artist should later decide to leave to work with another gallery. Having an agreed-upon process will enable a much more productive parting of ways.

Here I should clarify that by "productive" I generally mean for the dealer, not the leaving artist, who by this point has a new agent looking out for their best interests. The dealer being left has other artists and collectors to explain the departure to, as well as a financial interest in the leaving artist's market: to make the most of it that they can. In short, the dealer being left often needs to wrap up sales in progress and sort through how to recoup money spent on production or framing or other such

investments that they deserve to receive back. A "productive" departure is one in which all that is seen to, and the gallery being left retains some level of access to the artwork by this artist desirable enough to have been poached.

Poaching Strategies: Stay on Friendly Terms

Staying on friendly terms with an artist leaving the gallery is smart strategy, as well as professional courtesy. To help close pending sales or even arrange ongoing access to their work in the future if you can secure it, keeping your eye on the long-term goals of the gallery requires putting aside any hurt feelings and not saying or doing anything that might give the leaving artist good cause to cease all contact.

To people in other industries, this may seem rather obvious. Indeed, on the public front of it, most dealers are quite good at issuing press releases or telling reporters how the artist and gallery remain on good terms, but because of the very intellectually intimate and personal relationships that develop between dealers and artists, behind-the-scenes emotions can run high when a long-supported artist agrees to sign up with another dealer. Not letting those emotions get the best of you is important to remember. There will be many details to work out in such situations, and keeping everything on friendly terms will be worth it in the long run.

Poaching Strategies: Alain Servais's FIFA Idea

Brussels-based collector Alain Servais, whose published ideas on the evolution of the art market we discussed in Chapter 2 and who has lectured on "an ecosystem of resistance" within the art world, has proposed one of the most intriguing and possibly most productive of ideas for handling poaching between galleries. The *New York Times* summarized this idea in a 2013 article on this "time of turbulence" for dealers:

> To prevent gallery behemoths from enticing successful artists away from smaller colleagues, the Belgian collector Alain Servais has proposed a system inspired by the way FIFA, the governing body of soccer, regulates the trade of players, with clubs paying compensation and transfer fees.[16]

The idea here in more detail is that a gallery who poaches an artist would reimburse the gallery who had invested in developing the artist's market to the point that another gallery would want to poach them. This could be in a cash amount or in an agreement to let the first gallery retain some access to the artist's work. For example, the first gallery could be consigned one major work and a few minor works from the studio each year for a number of years, to help them recoup their investment and keep face with their collectors who had been counting on their carefully built relationship with the first gallery to secure them an acquisition.

Many of the dealers that I have discussed this idea with initially insist it is unworkable, because there is nothing motivating the galleries able to poach an artist to agree to it. Even should gallery associations add such a practice to their ethical standards, there would be nothing that forces a leaving artist to comply, short of a contract. There is nothing stopping individual galleries from establishing this idea as a "best practice," however. A mid-level gallery I know who had had a number of artists poached from their roster (and felt a significant impact from it) noted that they were planning to poach an artist from another gallery of somewhat lesser stature. In talking through how someone has to start somewhere with implementing such a standard in the industry, this gallery agreed to offer the gallery they were poaching the artist from access to a certain number of works over a number of years to aid in the transition. If more galleries do this, it can become the norm.

Poaching Strategies: Defensive Partnerships

As noted in Chapter 2 on mega-galleries, even some larger galleries have had to make defensive moves to protect their relationships with their artists from the ambitions of mega-dealers expanding their empires in part by poaching well-selling artists from them. Emmanuel Perrotin explained his decision to open a third space in New York (as reported by *The Art Newspaper*) as defensive:

> New York dealers poach other galleries' artists so aggressively it may as well be a blood sport, and Perrotin feels the pressure. "My dream is to be able to keep my artists and to not feel so much the shadows of someone who wants to take what you have. It's not an egomaniac situation. I don't want to be the biggest; I just don't want to lose. So I need to make a move."[17]

For mid-level galleries just able perhaps to maintain one location, defensive strategies might include partnering with like-minded dealers in a different art center, to provide each other cover from the larger spaces. Paris-based dealer Jocelyn Wolff, who self-identifies his space as a mid-level gallery, discussed his partnering with Berlin-based gallery KOW in such terms during his lecture at the Talking Galleries symposium in Barcelona in 2013: [18]

> I co-founded a gallery in Berlin, somewhat as a protective shield to avoid seeing my most successful artists being stolen by other galleries. It was my response to the success of some of my artists, to build the project in a partnership with friends.

In his presentation, Wolff also shared that he frequently collaborates with other galleries at art fairs, which is perhaps a simpler way to test how well a partnership might work than a full-fledged gallery collaboration.

Poaching Strategies: Buy Their Work

If all that seems too warm and fuzzy for a commercial industry or your preference in conducting business, the best strategy for handling other galleries poaching your artists is to buy as much of your successful artists' work as you can. Not only can "putting your money where your mouth is" convince collectors how important you think the artist's work is, but as the saying goes, "dealers make money from the art they sell; they make fortunes from the art they keep." If you own a significant amount of the work, when mega-gallery X comes along, poaches your artist, and adds a bunch of zeros to their price points, you won't feel quite so bad about it.

Perception of Speculation vs. Connoisseurship Fueling Many Collectors' Decisions (Sales Techniques, Programming Choices)

"You sell the inventory from an emerging artist's first solo exhibition to your top collectors during that artist's second solo exhibition," a Chelsea dealer had told me back in 2000, before I first opened my gallery. He explained that it was common to have ample inventory left over from an emerging artist's first show, because it was often only the second show that convinced seasoned collectors both that this artist was on his way toward a solid career and that this gallery was going to stand behind him and keep investing in his market. Mind you, this was before the boom (which arguably started in earnest in 2003 or so), when emerging artists' first solo exhibitions selling out became more common in New York. Up through the leaner market of the 1990s, the notion among top collectors had been that it was smart to take one's time, research the work, ask plenty of questions, and wait to see if the work "stayed with you" before making a purchase. For this Chelsea dealer, this slow-paced process was fine. After all, his top collectors were connoisseurs, who could be counted on to eventually see the importance of the artists he believed in, if given enough space and information.

Fast forward to 2007, when the contemporary art market was again red-hot, and it was not unheard of for an emerging artist's first solo exhibition to sell out even before it opened. A bit of pre-show buzz via an introduction at a popular art fair, matched with perhaps news of an upcoming museum group show, and all it might take to sell the entire show before the private reception was emailing out JPEGs and the price list. Many of these eager buyers were not the more contemplative connoisseurs the Chelsea dealer had counted on, but rather speculative collectors, who often planned to resell quickly (or "flip") the art at auction (where the profit they made would be part of a highly reported-on public record).

Then, of course, 2008 brought the Great Recession, but the selling practices and the metrics for what it meant to be "an artist to watch" (that is, an artist to cash in on) had been firmly established and widely documented online for any interested

party to research on their own. When the market crept back to life a few short years later, an accelerated method, if not significant volume (more on that later), of making a lot of money by buying and then flipping emerging art seemingly began to change the culture of collecting contemporary art itself. In a nutshell, the perception became that connoisseurship had given way to speculation for this new generation of contemporary art collectors. The press picked up on this growing perception, matched it with some statistics, and before you knew it everyone was talking about the new plague of art flippers. "Lund Painting Sold for 1,500% Gain as Art Flippers Return" proclaimed a headline in Bloomberg in May 2014, whose article went on to explain, "Fueled by a flood of new collectors, flipping art has intensified recently as works by untested artists resell for escalating prices."[19]

If indeed the culture of collecting contemporary art was shifting away from an emphasis on connoisseurship toward one on speculation, this represented an additional burden for the already beleaguered galleries in the middle of the market, and particularly for sales of works by their mid-level artists. Blue chip artists are essentially assumed to be well on their way to the canon, and so the lasting value of their artwork is taken for granted. In other words, when buying work by a top-level artist, the main connoisseurship questions are assumed to have already been answered. The importance of those artists' work is considered well vetted and clearly established. As such, wealthy people view it as a safe place to put their money. For emerging artists, connoisseurship issues are also considered less important, because emerging artists' price points are low enough that both speculators and connoisseurs can buy it without much worry. For mid-level artists, with higher prices than emerging artists, but fewer guarantees that they are headed for the canon than blue chip artists, speculative buying is much less common, and so appealing to connoisseurship becomes a dealer's only real option for selling the work. When connoisseurship largely gives way to speculation in the way new collectors are approaching their buying decisions, then mid-level galleries are at a distinct disadvantage.

This alone could explain the evidence that while top-level and emerging galleries saw increased sales in 2013, mid-level galleries saw a decrease, but there is more to this complex situation than the early 2014 headlines revealed. Later in the year, two studies came out that suggested this new age of flipping was a bit overstated. In August 2014, the *New York Times* published the article "Barbarians at the Art Auction Gates? Not to Worry" in which they revealed the findings of two studies they had commissioned, which splashed a bit of cold water on the rampant flipping narrative:

> [T]he data indicate that contemporary works appearing at auction within three years of their creation are not coming to auction faster than in the past, and that such flipping remains very much the exception, not the

rule. Though more works come up for sale each year, the percentage of these works was essentially the same last year, less than 2 percent, as in 2007.[20]

Follow-up articles in the arts press did not add much clarity to the situation, unfortunately, simply republishing these studies' findings with dismissive, even obvious, headlines (such as "Flipping Art Is Not a New Phenomenon" [*Artnet News*, August 18, 2014]) but without contributing any significant analysis to the either the *Times* report or the timing of the earlier headlines and their influence. Indeed, here again, perception had already begun to affect the reality of business for mid-level galleries. As a mentor of mine used to remind me, the plural of "anecdote" is not "data," but I'll share two true stories all the same as an indication of how the perception that speculation was the lucrative way to collect in 2014, as promulgated by the year's earlier headlines, had already begun to be a self-fulfilling prophecy.

The First Story

A mid-level dealer told me of a conversation with a long-known collector she could count on for two to four purchases every year. This is a dealer with a strong mid-level artist roster and a selling style that relies a good deal on appealing to connoisseurship to place the work. The same was true in her approach with this long-known collector. When reaching out to the collector in 2014, however, the dealer was told that the collector was holding off making his usual purchases of mid-level-priced work to save up to buy one of the "hot" artists (not in her gallery) who were doing so well at auctions these days. He said he would be a fool not to get in on this game, given how much money there appeared to be in it. This signified to me that the problem now wasn't only getting new collectors to understand the value of connoisseurship in building an important collection, which was becoming challenging enough, but that even the collectors who had once understood that were now being seduced by the sirens of speculation. If this became more widespread, mid-level dealers wouldn't stand a chance.

In my first book, I interviewed Joel and Zoë Dictrow, New York-based collectors who have been visiting galleries on a very regular basis for over thirty years and who rank among the Top 200 Collectors in the world according to *Artnet News* in 2015. They kindly discussed a number of issues with me for this follow-up book, including what impact they see this recent surge in speculative buying having on galleries and collectors alike:

> Compared to the high number of aspiring and actual artists, there are very few galleries with notable reputations. This new speculative environment will, no doubt, hurt many people. Artists will be exploited. They will see their careers go from hot to cold in the space of a few years because this speculative market is fundamentally a youth culture. Acolyte collectors of the

buzz-hounds who market art this way will be hurt because they will spend money without knowing or caring about the art, and will be stuck with the art that can't be sold at any price. They acquire art only with their ears, thinking only of art's investment potential. When the art market inevitably falls as all markets do, galleries that bought into the premise that art will keep going up in value will suffer and the hot artists' work will be un-salable. Once there is a shake-out and investment-type collectors no longer are acquiring art, the market will normalize. Unfortunately, we saw that happen in the late 1980s.

The Second Story

New York-based collector Glenn Fuhrman, who with his wife Amanda are also ranked among the world's top 200 collectors, shared a story with me in an interview for this book as well. Working in finance, Glenn said he is frequently approached by colleagues in the industry who are interested in becoming involved in collecting contemporary art as he is well known to be. In three such cases he introduced inquiring colleagues to one of New York's best art consultants and explained how it's good to begin collecting with some expert advice on how one should go about it. Later on, that consultant told Glenn that those three introductions had each explained within a few minutes of their first meetings that they wanted to collect the kind of work that was likely to increase substantially in price over the next year. No amount of discussing the other rewards of collecting seemed to sway them from this position. The consultant also reported that she told the three referred colleagues that she was not the right consultant for them. Glenn tells this story not just as an example of how speculative goals are driving wealthy people toward collecting, but how formerly successful appeals to their interest in connoisseurship currently don't seem to resonate like they used to, at least with these specific examples if not many others.

Whether the rate of flipping has reached a historic high or not, the impact of the perception that it has was already at work in changing things for mid-level dealers. Perhaps only anecdotally, sure, but still enough to consider what strategies can be used should you encounter a similar situation in your business. Below we will consider a couple of ways to respond to the perception that speculation is the best way to collect contemporary art now.

Strategies for Responding to Speculative Versus Connoisseurship-Based Collecting

I only have two strategies to discuss here, and whichever appeals to you the most more or less cancels out how effective the other one may be in your case. Personally, I would love to see more dealers work with the first strategy, even as I appreciate that it's more difficult and less likely to succeed. My reason for preferring the first,

though, is that the more galleries embrace the second strategy, the less room there will be in the commercial art system for the kind of work that is not easy to flip. As noted above, mid-level galleries only survive if they can balance out well-selling artists in their roster with those they are perhaps supporting for more personal and less business-minded reasons. There is no glory, or sense, in going out of business by standing on some sort of paradoxically anti-commercial principle. Then again, many of my favorite galleries manage to get that balance just right and over time are even able to nudge their collectors toward the less obvious choices. This is where dealers contribute to the cultural legacy of this generation, much more so than moving currently fashionable product around. Not that contributing as such has to be part of every dealer's mission, but it can be, if they choose to make it so.

Share the Facts

One of the two studies commissioned by the *New York Times* discussed above was titled "Flipping Art at Auction: Business as Usual." It was authored by Fabian Bocart, PhD, Quantitative Research Director of the Belgium-based company Tutela Capital, and by art historians Alexandra Labeyrie and Ohana N'Kulufa, who concluded that flipping is not currently at unusual, let alone historic highs. In their report, however, they also named four of the top emerging artists who were bringing the highest prices at auction in 2008. Only one of those artists had not seen dramatic decreases in their auction estimates by 2014. In other words, the long-known collector discussed above who felt he "would be a fool" not to get into the speculative contemporary art game might consider instead how statistically, and hence financially, foolish it can be to get into that game the way he was hoping to do (that is, by saving up to buy one of the buzz-heavy artists). The odds are certainly not in the majority of players' long-term favor, regardless of how they play that game, but single purchases at that level of the market are extremely risky.

Whether sharing such information would lead that collector to continue supporting that mid-level gallery or not is of course anybody's guess, but one of the services many collectors count on art dealers for is sharing what they know about how the art market truly works. Moreover, having such information to share gives mid-level dealers a better response to such feedback than merely surrendering their sales pitch to such goals. Personally, I would walk a collector through such information very gingerly, knowing it might hint of sour grapes, but competing in this evolving market means not letting the mega-galleries or the auction houses own the narrative.

Get In the Game

A very good mid-level gallery I know, which is admired for its strong conceptual program, shared their conscious choice a few years back to begin representing some

young painters, very specifically to help with their cash flow. They felt it would be imprudent not to recognize what was selling well at the moment and what was not. They didn't make a dramatic change to their roster, but simply supplemented it with some artists making work in the same general genre as those being snapped up so quickly at the moment, and by all accounts that strategy has worked out very well for them.

As much as I note above that I advocate the first of the strategies in this section more, I have criticized other galleries at other times for not anticipating a coming sea change in the art market quickly enough to adjust and survive. There is no doubt in my mind that the gallery here who supplemented their roster did so with exquisite timing. Moreover, they continue to promote their full roster and remain among the galleries I respect the most. The only downside to this strategy, as mentioned above, is how it essentially cancels out one's ability to use the other strategy as well. I imagine there could be a way to split the difference and employ both, and again, the second strategy has proven more productive in the short-term for more galleries than the first one, but there are other factors entering the arena that make the first strategy seem more prudent in the long run to my mind. We'll discuss more of those in Chapter 6 on online selling channels.

Art Fairs vs. Gallery Spaces Where Collectors Increasingly Make Purchases (Overhead, Sales Techniques)

In an online survey I posted to which 108 anonymous collectors from North America, Europe, Japan, and South Africa responded (at least a few of which I know from their emailing me behind the scenes are regularly listed among the world's top 200 art collectors), the following responses were given for the question, "What percentage of the art that you collect now do you find in a traditional art gallery visit (as opposed to online or at a fair)?"

HOW MUCH OF THE ART YOU COLLECT DO YOU BUY IN GALLERIES?	
Less than 10%	14.8%
10-25%	15.7%
25-50%	13.9%
50-75%	22.2%
75-90%	25.9%
All of it	7.4%

Even as statistically insignificant as these findings may be, they stand as an indication that very few contemporary art galleries who eschew fairs and/or online channels entirely are reaching their full potential market. As noted in Chapter 3, there are more than 220 art fairs around the world each year that cater to dealers of contemporary art.

Not to pick on them, but because they were kind enough to archive which art fairs they have participated in over the past nine years on their website, let's consider the trend in the number of art fairs mega-gallery David Zwirner has done each year since 2006:

Year	Number of art fairs
2006	5
2007	5
2008	7
2009	3
2010	7
2011	9
2012	15
2013	15
2014	20

This steady increase in the number of fairs (save the obvious dip when the market nosedived in 2008, the year many decisions had to be made about which fairs to do in 2009) is perhaps the strongest indication of their growing importance in reaching this gallery's goals. More to the point, perhaps, mega-dealer Larry Gagosian once explained (to CBS News journalist Morley Safer) that he participates in art fairs because, "For me it's a place to sell art. It's a place to make money. The art fair has become a huge part of our business."[21] Of course, the behemoth mega-galleries are engaged in an epic global battle for market share, which may partly explain this spike in fairs for them, but while twenty fairs a year is more than most mid-level galleries can afford, they still feel great pressure to increase how many fairs they do each year and, if they are trying to get to the next level, how many international fairs they do in particular.

The cost for mid-level galleries trying to compete in this arena is not limited to the obvious additional expenses, like booth fees, travel, artwork shipping, and accommodations. What playing this game costs mid-level galleries includes

additional staff (and the better they know your gallery and program, the better they will perform for you, either at the fair or back in the gallery when you're gone, so temporary help is not necessarily the best solution here); additional pressure on their relatively smaller roster of artists to produce enough work for the increased number of fairs; and additional time on the road, away from their gallery, their artists, and their families. Still, as we discussed above, in addition to the money that can be made at the fairs, which fair a gallery gets into and where they are located within that fair signals to the market's insiders how well they're doing in the gallery hierarchy game. Stay at the same level too long and your best-selling artists and most supportive collectors may begin to get antsy or bored.

But here is where desperation can lead the mid-level dealers to a particularly tricky paradox. Despite the obvious costs (both professional and personal), many mid-level dealers believe that to succeed they need to do whatever it takes to get into the better fairs. They've seen it happen for other galleries and so are convinced that their fortunes will change if they can just get their foot in that door. The logistics and politics of this goal can lead to a vicious and very costly circle, one that has led a few high-profile mid-level galleries to close:

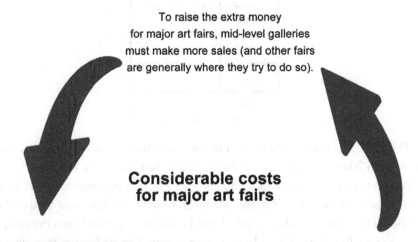

To raise the extra money
for major art fairs, mid-level galleries
must make more sales (and other fairs
are generally where they try to do so).

**Considerable costs
for major art fairs**

To gain attention of major fairs'
selection committee, many mid-level
galleries must propose booths
very difficult to sell.

Higher-priced artwork
is very difficult to sell outside
the major art fairs

Driving the circle is the fact that more fairs, and in particular the major fairs, are very costly. Therefore, a mid-level gallery needs to raise extra money to pay for the more expensive fairs, and the most obvious place to turn for more sales is some other additional fair. In other words, to participate in a high-profile fair, they take on the expense and risk of another lower-profile fair. That is not as straightforward as it might seem. As noted in Chapter 3, Heather Hubbs, the director of the very popular New Art Dealers Alliance (NADA) fairs that have taken place in Miami, Cologne and New York, explained that despite the widely acknowledged quality of galleries they assemble for each of their fairs, collectors seem not to buy artwork over a certain price point at any of the NADA fairs. There seems to be a cap in collectors' minds for how much they will spend on any given work outside the major art fairs. The final twist in this circle is that to get the attention of the major fairs' selection committees, a mid-level gallery often needs to propose a presentation that stands out, which can often mean presenting work that isn't as easy to sell. In the end, then, for the opportunity to get one's foot in the door of a major fair, a mid-level gallery may need to take on the added risk and expense of doing still more other fairs, where they cannot sell more expensive work, just so they can present work that stands a smaller chance of selling in this higher-profile context. All in all, it can be a huge financial risk.

And so there is a paradox: not doing the major art fairs is a risky proposition, especially for a mid-level gallery that wants to get to the next level, and yet doing the major fairs is a risky proposition, because of what it takes to get in and actually participate in them. How to strategize around this paradox is perhaps most helped by considering the three factors below:

Resist Pressure to Do Major Fairs Until You're Ready

This pressure will come from your artists and collectors, but it will also come from the major fairs themselves if you're making the kind of inroads that grab their attention. This pressure from the major fairs is understandable, in addition to being flattering. The major fairs are businesses and need to cultivate their future clients the same way galleries do. None of them will say on record what allowances they make for younger or mid-level galleries they really want in their fairs, but favored dealers who have been approached will, sharing that up to and including free booths have been offered to them.

But as noted above, some very good mid-level galleries have closed because of the pressure it takes to run a "successful" international gallery by maintaining a strong presence at the major fairs. Other mid-level galleries spend a fortune to participate in a major fair, only to not get back in again. The point of any fair should be to network and to see a reasonable return on your investment. Do the fairs that make that possible for you, even if that means holding off on "doing whatever it takes" to get into the major fairs.

Choose Fairs Based on Long-Term Goals, Interests, and Capabilities

Many of the international fairs considered "major" or important (because they've been around longer, include a large number of galleries, or receive large numbers of visitors) tend to have more regional audiences. These may include many important and active collectors, but in these contexts it often requires an investment of three to eight years for unknown galleries to earn enough trust among enough collectors in that audience to begin to see profits from these fairs.

This or that fair may eventually become a great event for your gallery, but how realistic is it for you to invest that much time? Moreover, once you have a strong collector base in that international location, how realistic is it for you to travel and visit those collectors outside the fair week? The top collectors anywhere expect personalized service, and the dealers who can afford to visit them will have the advantage. Experimentation is unavoidable when learning which combination of fairs provides you the best return on your investment (ROI), but building a market for your artists in a region far from home takes long-term commitment. Consider your interest in such a commitment for each location before spending too much money merely to show your face there.

Peak Fair Strategy

While experimenting, many mid-level galleries will ramp up to as many as eight fairs a year, only to eventually scale back on average to the five or six that work best for them, according to Heather Hubbs, director of the NADA art fairs (see Chapter 3). And it's not just sorting out the ideal level of ROI at the individual fairs themselves that brings them back to this number, but also learning that for many of them, given the resources they have, five to six fairs seems to permit the right balance between time spent at fairs and time spent focusing on gallery exhibitions. Knowing that five or six is the "peak fair" number for most mid-level galleries, one strategy is to experiment within that range to start off with, rather than taking on the expense and stress of eight fairs and possibly confusing the results with the corresponding logistical challenges. In other words, if a gallery does eight fairs, which is two more than they can reasonably balance with their physical space's program, how do they attribute any poor performance to one of those fairs rather than to the possibility that they were simply stretched too thin to do it well?

Internet Challenging Dealers as Source for Exclusive Information (Promotion Techniques, Long-Term Planning)

There is no way to sugarcoat this: contemporary art dealers are intermediaries, middlemen (or women) between the supplier (the artist) and the consumer (the

collector). Intermediaries are only considered essential in any business if the service they provide is viewed as valuable enough by the supplier or consumer to justify their commission or fee. There are many services beyond simply discovering and promoting important artists that art dealers provide for both sets of their clients, and heavily involved collectors as well as very busy artists generally understand that, but one of the tools for increasing the efficiency and profit margin of any business system is disintermediation, or cutting out as many middlemen as possible. For some business-minded artists, then, selling directly to collectors can be the most profitable way to operate their studios, if they can manage it in between meeting all their other goals. Indeed, the complexity of maintaining the relationships needed to keep an artist's market strong, plus the hours spent keeping up to date on who is buying what or which way the secondary market winds are blowing, has provided contemporary art dealers a cushion of intermediary comfort for many decades. That is changing in bits and pieces, mostly due to how the exchange of market information that dealers used to ensure they were the locus of, and thereby control, is more readily available to more people via the Internet.

Indeed, perhaps the most valuable service art dealers have provided traditionally has been to put their knowledge of the market and their hard-earned relationships with powerful players in the art world to work in promoting their artists. They have also traditionally worked to protect their artists' markets, as well as the investments of their collectors in those artists, by being actively involved in their secondary markets. Offering to resell work through the gallery or, failing that, staying well informed of their auction results and secondary buyers, art dealers have proven their value as intermediaries by lending their connections and knowledge to the interests of their artists and collectors who traditionally may not have had much in way of means to influence the secondary market. The Internet has begun to change that too.

In May 2014, artist Wade Guyton made headlines by printing multiple copies of a previously unique digital work right before it was due to be resold at a carefully organized auction of contemporary art at Christie's in New York. In an article titled "Wade Guyton May Be Trying to Torpedo His Own Sales," art critic Jerry Saltz thought out loud about what was behind this move by the artist:

> Wade Guyton's smallish but beautiful black, blue, and red *Untitled* is estimated to sell for between $2.5 and $3.5 million tonight, and rumor has it that there's a guarantee of $4 million. Guyton makes his art on inkjet printers and photocopiers, and last week, he began printing scores of new paintings from the same 2005 file that produced this one, perhaps an attempt to erase the singularity of this painting and torpedo its price. He took pictures

of this process and posted them on Instagram. You can go to his account (@burningbridges38) and see copies of the painting rolling out of his printer and spread out all over his studio floor. These images have gone viral. Suddenly the piece at Christie's is identical to dozens of others. The uniqueness has gone away.[22]

If indeed Guyton had widely publicized his ability to take away the uniqueness of any his works that were being resold at auction as an effort to torpedo that sale, it wasn't clear how well it worked. The lot went for more than its high estimate, selling at \$3,525,000. Might the Guyton have sold for even more had he not raised so many questions via his Instagram posts? Who knows for sure? All we know is that the sale itself was extremely successful (fourteen new records for contemporary art were set at that sale), but as Saltz noted, the Guyton was rumored to be guaranteed at \$4 million. Still, the message was loud and clear. Artists now have more means to have their voices heard, and even perhaps influence prices in the context of the secondary market, than ever before.

But pricing is not the only information contemporary art dealers have historically traded in. What work is available or what even exists has long been something interested buyers could only learn through the gallery system. That too is changing. In an article titled "Why the World's Most Talked-About New Art Dealer is Instagram," *Vogue* magazine summed up the challenge for galleries of all levels here:

> Now able to sell works themselves, artists are nudging the dealer out of the way while promising to demystify fine art and increase accessibility; challenging what has long been seen as an industry shrouded in pretense and exclusivity.[23]

Of course, as noted above, not all artists can balance the creation and promotion/sales of their work as well as some may, and so the usefulness of the art dealer intermediary remains valued widely enough that there are still far more artists hoping to work with a gallery than there are galleries to represent them. But even within that more traditional artist-dealer relationship, the Internet is bringing about some tricky new challenges for contemporary art dealers. Consider the case example below:

> *Case Example 2*: One of your artists, who has sold well through the gallery, recently opened an Instagram account that connects with his Twitter and Facebook accounts. He loves to post images of new work or even "works in progress" from his studio.

Increasingly you're getting calls from people you don't know who want to buy works that you have not even seen yet yourself. Nice problem to have, except you have agreements with this artist's main collectors (who support not only this artist but others in your program) that you will show them all new work before anyone else sees it.

These new online collectors are "friends" with your artist, which tells you very little about how close they are to your artist. Still, they sometimes know more about the new artwork from online discussions than you do, including that the work is still in the studio and hence not already "sold." But you don't know anything about them, including how solid a placement their collection might be for your artist. When you ask them about their collections, they get a bit offended and you've heard back from your artist that his "friends" are now upset, which he's also upset about because he felt he was doing the right thing by directing them through the gallery.

In short, the Internet is contesting the authority that every art dealer has enjoyed up until this time. The specific challenge here is how to manage this flow of information completely outside your control, or in classic business terms: how to influence without authority. The strategies below assume this will become a bigger and bigger issue.

Discuss Social Media Promotions with Your Artists

Dealers are likely not getting back exclusive control over the online information about their artists' work. Whether this needs to happen (and therefore argues for more detailed contractual solutions or not) may still need to be determined, but the agreement most dealers now have with artists about selling work through the gallery should still inform how artists promote their work through online channels. An easy way to have this conversation is to ask your artists to "hashtag the gallery" or, in perhaps less jargony language, "link back to the gallery's online channels" (such as the gallery's website, Facebook page, Twitter account, Instagram page, etc.) for all images of work that the gallery has or will have on consignment. Explain that what begins as a set of questions from one of their online "friends" can lead to difficult situations if the online collectors don't know up front that the artist only sells through the gallery and has long-standing, supportive collectors with certain expectations. Linking online images to the gallery consistently helps eliminate such problems for the artist and dealer. In addition, because most information used to flow through the gallery, but now much of it doesn't, certain practices you might never have felt compelled to share with your artists (such as the fact that you sold some of their work in

the past on the condition that you would share new work with that collector before anyone else saw it) might now need to be shared. You can't blame an artist for not complying with an agreement they knew nothing about.

Follow Your Artists Online

When someone calls the gallery and inquires about the price of your artist's new "blue painting," the last thing you want to have to admit is that you had no idea there was a new blue painting. If you followed your artist on Instagram, though, you would have known—at least as much as the caller knew. The fact is that even as the sharing of information online presents certain new challenges to art dealers, it also offers new advantages. Keeping up to date on what's going on in your artists' studios can be much easier, for example, particularly for those who live in other locations. If your busy schedule does not afford you the time to be on the Internet that much, perhaps have someone in the gallery monitor the artists' accounts and summarize for you any key information you might benefit from knowing. The bottom line is that the information is increasingly out there. There's really no excuse for not knowing it.

Get Yourself Online and Maintain Your Accounts

It does your artists no good to "hashtag the gallery" if, once interested parties click on the link, the information is out of date or insufficient. Social media may be a fad, but it is currently how many people (including collectors) spend a good deal of their time. Here again, busy dealers can have someone else in the gallery keep their accounts active and up to date; younger staff members tend to do so quite efficiently. Also, the potential here extends beyond the advantages for the artist the interested party follows back to your online channels. Managed well, each such opportunity can increase awareness for your entire program.

SUMMARY

Many of the challenges discussed in this chapter affect galleries at every level, but they often present specific challenges for mid-level galleries and contribute to the current perception that galleries in the middle sector of the market are struggling more than those in the high and low sectors of the market. This is potentially a problem for the entire market, as the middle sector performs some of the most un-rewarded tasks in keeping the overall market healthy. From supporting good artists who may be struggling to get their practice back on track to the services they provide in building a stronger cultural community in their locations, mid-level galleries form an essential part of the overall market's ecosystem, and it behooves all market players to collaborate on ways to re-strengthen this sector. The strategies discussed

in this chapter are things mid-level dealers themselves can do, and there have been high-profile measures taken by gallery association and major art fair leaders to raise awareness of these challenges, but until the people buying art can be persuaded to support this sector of the market, it remains at risk. The middle being squeezed is a theme through all markets, however, so the solutions here may actually come from outside the art world. Dealers working in this sector would be wise to keep an eye out for such innovations in other industries.

6

Online Art Selling Channels Gain a Foothold

WHAT HAS CHANGED?

In 2008, having a "solid online strategy" for a contemporary art dealer generally meant having a good website with an easy-to-remember domain name, a strong presence on Artnet, and perhaps a gallery page on Facebook that promoted upcoming events. Actually selling contemporary art online was a very rare occasion. By 2015, though, there were many more new considerations for a "solid online strategy," including having a presence on Twitter and Instagram at the very least; a gallery Tumblr site perhaps; a prominent presence on Artsy, Artnet, and Artspace; pages with videos on Vimeo and YouTube; savvy usage of Paddle8, FirstDibs, Amazon, Artviatic, etc.; and even perhaps proprietary ideas about turning one's own website into an e-commerce platform. Online business consultants whom an art dealer might hire to advise them about strategies and best practices had to admit that what they said at any point would very likely be significantly outdated six months from then. Nowhere in the art industry were things moving as quickly and confusingly as online, especially when it came to knowing how to combine all this to increase sales.

Indeed, in March 2015, London-based art dealer and art market pundit Kenny Schachter linked from his Facebook account to an article on the *New York Times* website about the online art market and declared "art sales and the internet isn't working now and won't—until there are paradigm shifting changes in technology. Sure it's deal for prints and photos or resale to people in the know; but, other than

communicating what is out there to be seen, it ain't gonna happen anytime soon, nor should it." Schachter is well known for perhaps unconventional opinions, but not for being conservative about the art market or its future directions, making this declaration a good indication of the way many art dealers most likely still feel about the potential the Internet has to revolutionize the contemporary art market. Indeed, many dealers don't see the revolution coming any time soon, nor do they wish for what the Internet did to the music or book industries to happen to the art industry. The fact that what they wish for may be clouding their assessment of what's actually happening here shouldn't be discounted.

In an interview about her 2015 edition of the *TEFAF Art Market Report,* economist Clare McAndrew noted that the "big trends" she noticed in the art market in 2014 were the art fairs and the online market.[1] Her new report put the estimated total for online art sales in 2014 at about €3.3 billion, or $3.5 billion. An earlier report published by the specialist insurance company Hiscox, *The Hiscox Online Art Trade Report 2014,* had estimated total online art sales for 2013 to be about $1.57 billion and predicted that would "rise to $3.76 billion in 2018."[2] In their 2015 report, which came out right before this manuscript went to my editor, Hiscox had estimated the global online art market had risen to $2.64 billion in 2014 (still under the TEFAF estimate) and projected it would reach $6.3 billion by 2019.[3] All of which demonstrates either that the online market is rising more quickly than experts have anticipated or, again, how the opaque nature of the art market makes it difficult for experts to agree on how to measure such totals.

Even splitting the difference to guesstimate that the global online art sales total for 2014 was between $2.5 and $3 billion, this is still less than 10 percent of the estimated overall art market for that year, suggesting that there is time before contemporary art galleries go the way of music or book stores. Indeed, the Hiscox 2014 report concluded that for the foreseeable future, "physical galleries and auction houses are likely to thrive, as their online component becomes another important part of the customer journey— . . . it is not so much about where the sale takes place, but rather how an online strategy could influence potential buyers to transact."[2]

And yet, $2–3 billion (and growing) is enough money that any ambitious art dealer should not entirely discount the potential of online channels to help them increase sales. Toward that end, and as McAndrew noted, it may require looking at online sales in the contemporary art market from a new perspective to make total sense of it:

> The development of the online art space is very much themed towards the democratization of art, bridging the gap between the elite world of top collectors and the general public, and making art more accessible. However,

many of the highest-spending top collectors of art do not need any alternatives to the top auction houses and galleries so online sales at the high end are still very small. For art buyers below the highest levels, the online art space certainly makes art more accessible.[1]

The next section of this chapter is designed to deconstruct the business logic of online sales channels as a means of helping art dealers, who may not have much experience in this realm, make better strategic decisions for their business. Later on we'll look at specific online art selling business models, discuss some of the various channels' strengths or weaknesses, and finally delve into specific online business strategies for contemporary art dealers. For the purposes of this chapter, "online art sales" will refer specifically to situations that involve a third party and not merely an art dealer closing a sale after calls about the images on their own website or by emailing a client JPEGs, which I'll assume are straightforward enough activities for most readers. As McAndrew also said in her interview, "The online space has added whole new layers of intermediaries to transactions, some of which are intermediaries to intermediaries in the offline market." It is predominantly these online intermediaries we'll consider in this chapter.

Basic Principles and Perceptions of Online Art Businesses

Before we look at the growing list of art selling websites or social media channels disrupting the contemporary art market, let's discuss a few of the basic perceptions that exist about selling art via online channels. The arguments that any online art sales channel will make for why their platform will contribute to your success fall into two basic categories: (1) buyers' convenience and (2) buyers' comfort/access. While these are often conflated, the *convenience* argument is generally one made for more established fine art buyers: they can search and find the art they know they want (even if they don't know you're selling it) more easily online than they can by randomly visiting many physical spaces. The *comfort/access* argument is one made for newer fine art buyers, who may be intimidated by the legendarily icy reception or arcane rituals they have experienced or even only heard are common in physical galleries or high-profile auction houses. Moreover, the *comfort/access* argument is often used specifically in relation to younger wealthy consumers who demand instant access to the things they want, and, we are told, simply will not tolerate being told they are on a gallery's waiting list. They would rather spend their money on other things than risk such humiliation.

The conventional wisdom among art dealers, though, remains that there is no need to ever post the art they have a waiting list for or their "best art" to any of the online channels. They can sell it easily enough without an intermediary, and so why

would they share the commission or even publicize it that way? For secondary market sales, in particular, having any work linger online without being purchased (getting "burnt" in the eyes of potential buyers, as the saying goes) is highly undesirable. Likewise, it is assumed that top collectors have the kind of direct access to dealers that makes competing with other collectors online unnecessary. They can simply call or email the gallery and seal the deal without any fuss, and possibly even enjoy interacting directly with the dealer (stranger things have happened). Both these factors have contributed to the wide perception that the art available on any online channel is not in high demand or of the highest quality, nor do these channels appeal to the top collectors. These opinions further contribute to many art dealers' hesitance to post artwork they wish to be viewed as being the highest quality to any online channel, making it perhaps a self-fulfilling cycle.

Therefore, the arguments many online channels make about *convenience* may not matter much to dealers or top collectors when there is high demand for work by particular artists, suggesting any online sales strategy should focus on artwork that is harder to sell and collectors who are still gaining prominence. That being said, at least one new online channel has begun to turn those very perceptions to their competitive advantage. ArtRank (www.artrank.com) posts only one artwork every forty-eight hours or so by an artist in "high demand," with a listed price that usually falls below the established auction records or professed market price; a very convenient "Buy Now" button; and a first-come, first-serve policy that appeals to collectors who perhaps cannot get those popular artists' dealers to return their calls. This is perhaps the first truly *disruptive* model among the online art sellers, but its reported success suggests it may not be the last to try this model.

We'll return to ArtRank below, but to understand what to look for (or avoid) in potential online sales partners for your business, it's important to first understand a bit about the basic principles of online businesses in general. The long and short of it for most online start-ups these days is that they initially spend a great deal of energy trying to gain the attention of investors/venture capitalists for the funding they will require to get their digital dream off the ground. Another thing many of them have in common is that the real business strategy behind much of what they do is selling their platform as soon as they can for as much profit as they can bring their investors and themselves. One of the key concepts that venture capitalists seem particularly drawn to, and hence one that makes it into many a hopeful online entrepreneur's PowerPoint deck (for making sales pitches), is the notion of "disruptive innovation." Coined by Harvard Business School professor Clayton Christensen, *disruptive innovation* describes "a process by which a product or service takes root initially in simple applications at the bottom of a market and then relentlessly moves

up market, eventually displacing established competitors."[4] Faith in this process is so widespread across American businesses now that Christensen has twice been awarded the "Number 1 Management Thinker in the World," and his best-selling books are virtually required reading in Silicon Valley and beyond.

Another way of describing *disruptive innovation* is that a new company finds a simpler, cheaper, more efficient way to do what established companies have been doing and eventually takes enough business away from those companies to put them out of business. For online art selling channels, the initial theory was that they could disrupt the gallery system because they would not have the overhead it would cost brick-and-mortar galleries to get their artwork before millions of untapped potential buyers. The reality so far, however, has been that many online art channels spend millions of dollars on promotions and developing software, only to find they cannot figure out how to turn a steady profit without catering to the current gallery establishment. Furthermore, it is precisely this initial notion of "displacing established competitors" that likely accounts for at least part of many experienced art dealers' initial ambivalence or outright hostility toward online art sales channels, which becomes its own challenge for these entrepreneurs if or when they decide to change their original concepts and propose collaborating with galleries instead.

Promoting one's start-up to venture capitalists by claiming you have "the disruptive innovation" that is going to revolutionize a particular market has a way of making it into that industry's press and grabbing the attention of existing businesses. Aside from the hostility generated by any suggestion that this or that disruptive innovation might eventually put the established gallery system out of business, not many start-ups targeting the art market have managed to actually disrupt very much. Other than ArtRank, perhaps, I would argue none of the current online channels have accomplished true disruptive innovation in the classic sense. Not only are none of them showing signs of successfully displacing established competitors, but many have actually been forced to start catering to those established competitors, alongside insisting they never intended to displace them or be their competitors, which probably comes as a surprise to a few of the venture capitalists who initially wrote some of them checks.

I would also note here that some critics are beginning to question whether disruptive innovation is truly the business panacea Christensen has been selling it as since 1997. Jill Lepore, for example, in an extensive examination in the *New Yorker* of how ineffective disruptive innovation tends to be as a strategy over time, concluded it is clear now that it is not a good strategy for every industry. "When the financial-services industry disruptively innovated, it led to a global financial crisis," she noted as one example.[5]

Moreover, when several of the current generation of online arts channels were launching, in or about 2011, many of them were promoting their "innovative" approaches by suggesting that art galleries were too intimidating to reach the wider field of younger potential consumers of fine art. A good example of how such opinions made it into the press is found in a 2010 *Interview* magazine piece on Paddle8, which, although it actually now is an online art auction platform, launched initially with a series of primary market exhibitions:

> Despite its name, Paddle8 is not a web site that hosts auctions. The core of the site is a curated online group exhibition. Each month, Paddle8 invites a high-profile individual from in or around the art world to create a show, with 20 exclusive artworks available. . . .
>
> Founded in 2010 by Alexander Gilkes, formerly the Global Marketing Director and charismatic auctioneer of Philips de Pury, and entrepreneur Aditya Julka, Paddle8 comes from **the latter's experience as a new collector buying art from intimidating galleries** but craving the type of community they can engender. "[The world of art auctions] can be very clubby and esoteric," says Gilkes. The site aims to educate, and welcome collectors to the club—and **maybe loosen up the art world along the way**.[6] [emphasis mine]

Describing the existing gallery system as intimidating or the art world as needing to loosen up likely did not endear many of these start-ups to the very businesses many of them would later conclude (when millions of new art buyers failed to flock to their sites and buy art there) were their most likely viable source of ongoing revenue: the established art dealers. As I write, the majority of online art selling channels have tweaked their models to cater to or partner with the very brick-and-mortar galleries they initially set out to disrupt. That may be changing soon, though; this is an area of near constant change.

Compared with previous generations of online art selling channels, the current field deserves credit for their commitment to experimentation. I strongly believe the work they are doing will eventually benefit artists and collectors and will hopefully increase the overall size of the art market. The wisdom in online channels continuing to evolve is not entirely understood by the industry yet, though. In a particularly blunt op-ed about the state of online art channels published on *Artnet News* in late summer 2014, editor-in-chief Benjamin Genocchio took a somewhat confusing swipe at Artsy, one of the higher-profile online art sellers, writing, "Like most people, I can't even work out what Artsy is anymore, as it changes and evolves at a rate of what seems like every five minutes in search of a business model."[7] This obvious hyperbole was confusing not only because Artnet has its own online art selling initiatives,

leading many to question the op-ed's objectivity, but also because the very nature of any successful online business is to evolve.

Indeed, in his book *Viral Loop*[8], which explores a common component among the most successful online businesses, Adam L. Penenberg offers anecdote after anecdote within the same theme: an online entrepreneur throws some new service out onto the Internet, having designed it to solve this or that problem (even if the problem was simply the need for entertainment), and becomes successful by being savvy enough to perceive and then adapt to how online visitors are actually using the service. In short, many of their original ideas for their online businesses were not at all how customers ended up using them. PayPal, for example, was originally developed to enable people to pass money from their bank account to that of another person via Palm Pilots (a PDA, or personal digital assistant). PayPal's eventual evolution and subsequent explosion of usage on eBay was not something its creators had initially imagined. Had they stubbornly stuck to the idea that what they had created was only designed for handheld devices, and continued to promote and develop for that concept, they would have missed becoming one of the most successful companies of the era.

Penenberg makes a really convincing argument that the online businesses that listen to and evolve with their users stand a greater chance of succeeding, suggesting that perhaps the most important thing you should consider before spending money on an online art selling channel is how well this company listens to and responds to its customers and partners. If what they're telling you in their sales pitch does not ring true to your experience and you tell them that, yet they insist you just need to give it a try and the sales will come through, I would ask several other art dealers first about their experience with them. Don't let them dazzle or provoke you, even with obviously sincere faith in their disruptive innovation model. Just because they believe they're revolutionaries doesn't mean anyone else is actually going to join them at the barricades.

Having said that, do pay attention to the values that are leading many innovators to experiment with new models for selling art online. In this digital age, when the brightest "millennial" entrepreneurs have literally grown up with the Internet, values like transparency and fairness are just not strategic positions, but often firmly held beliefs. I think it is foolish to assume these beliefs will give way to business realities entirely as they evolve. These values are as much a result of the information age as they are forming it, making it important to not simply dismiss them as youthful folly lest you miss not only a good opportunity to expand your business, but position yourself in a way that discourages younger potential clients from trusting you. For example, as discussed in Chapter 2, the concept of transparency (something the art market is known to have gone out of its way to avoid historically) was perhaps

the most important factor driving Facebook founder Mark Zuckerberg's thinking in developing his social network:

> For [Zuckerberg], Facebook is primarily a social movement, not a publishing platform: as he tells it, he is motivated not by money (he consistently refuses to sell up) but by a passion for radical transparency. Sharing our data and making our lives publicly available to each other turns us, he believes, into better people. A narrower gap between public and private reduces the potential for hypocrisy and connivance, making it harder, for example, for people to cheat on their partners.[9]

Not every new channel has perfectly aligned their stated values with their particular twist on some online business model, but again, the impressive array of experimentation going on at this point is often being driven by sincere principles that seem incrementally to be changing how artists believe art should be sold, which is something no primary art dealer can afford to ignore. Let's now look more closely at some of the current online art selling business models.

Online Art Selling Business Models

Noting that their categorization reflects significant evolution within the online art selling field, the 2014 Hiscox report defined six separate online art selling business models, which are paraphrased below (they did not revise any of those categories for their 2015 report). Some channels are hybrids of these categories, but in general I think they cover the field well. The first three and the last model serve predominantly the secondary market, although that is changing in interesting ways. Models four and five are often tailored to the primary market.

1. Online-only auction: auctions that don't have a physical space and hence buyers often cannot inspect the work before bidding

2. Bricks and clicks: auctions with both physical spaces and online methods for bidding and possibly paying, with increased probability the work is available for inspection before the sale

3. Online auction aggregator: platforms that provide online bidding for physical auction houses

4. Online gallery/marketplace: any non-auction platform (either part of a physical space or a gallery that exists entirely online) that lets buyers immediately purchase artworks sight unseen using a "click to buy" function

5. Inquire to buy: a variation of the online auction or online gallery that lists details and prices (and usually, but not always, images) that requires

interested buyers to make an inquiry to the seller, rather than clicking to buy or bidding online

6. Peer-to-peer: any platform that connects buyers and sellers directly with each other, but usually still requires a fee for this service

In an article in the *New York Times* in March 2015, Scott Reyburn calculated, "There are now more than 40 specialist dot-com companies selling or facilitating the sale of artworks, primarily in the $1,000 to $50,000 range. And those sales are growing."[10] **Appendix B** lists all the online art selling channels I could locate in early 2015 that could conceivably offer contemporary art galleries some advantage in using them (several of them sell art far beyond the $50,000 price point), their areas of specialty, locations, and their current business model. I would expect some of these models to continue to evolve. As quickly as things are moving in this arena, I would also expect that Appendix B will be somewhat out of date by the time you read it.

Because this book is devoted to the primary market, the following discussion focuses on the "online gallery/marketplace" and "inquire to buy" models, but it should be noted that some online-only auctions do not exclude primary market consignments. Artnet, for example, regularly invites primary market gallery owners to consign artworks for their online auctions. The terms by which they solicit consignments include:

- No charge to register as a seller

- $25 listing fee per piece

- Artnet takes 10 percent commission of the selling price

- Seller is anonymous until the point of sale. Once there is a successful bid, the seller is put in contact with the buyer

- The auction results do not go into the Artnet database, so if something doesn't sell, it doesn't get "burnt"

- If something doesn't sell, they relist it for free

- You can post artwork when you like

Galleries' posting of primary market artwork to auction sites is currently a controversial practice, especially among artists, but even as many dealers strongly object to how the major auction houses are encroaching on the primary market, savvy use of online auctions to place work that is not selling out of the gallery or in fairs is very likely going to increase. I will note how curious it seems that Artnet, who sells data on brick-and-mortar auction results, whether the works were "burnt" or not, but does

not enforce the same transparency for their own online auctions. I understand that appeal of that, but it remains a curious discrepancy.

We will examine the "peer-to-peer" model below as well. Even though it currently serves the secondary market, some of the most interesting and potentially game-changing innovations in the online realm are happening there. Finally, as we examine some example platforms, keep in mind that experimentation and evolution are simply part of how online channels do business, meaning these models are very likely to keep changing.

Online Gallery / Marketplace

Again, what distinguishes an "online gallery" from the other models is its "click to buy now" functionality. Given this is the quick and convenient online shopping experience in which tomorrow's art collectors have been raised, I am grateful to those experimenting with it in the contemporary art market, not least because at least someone else is forced to sort through the trickier logistical issues for selling artworks in this model (such as specialized inventory storage needs, crating and shipping methods that meet online sales expectations, returns policies, level of demand for condition reports or certificates of authenticity, etc.). Below we'll look at two platforms arguably at the opposite extremes within the online gallery model: Artfinder and ArtRank.

Based in the UK and led by CEO Jonas Almgren, one of the founders of the short-lived (but for my gallery, anyway, profitable) VIP online art fair, the current iteration of Artfinder (www.artfinder.com) was launched in 2013. It is among the newest players in the online gallery category and is indicative of an increasing blurring of hierarchy and silos within the online art market. Specifically, Artfinder features artworks presented by a range of commercial galleries, editions publishers, and nonprofit institutions, plus work presented directly by artists themselves. In early 2015, they had yet to convince many of what would be considered the world's top galleries to sign on, with a total of 123 gallery and nonprofit spaces listed as partners compared with nearly 5,700 individual artists on the site, suggesting that artists were finding the platform more productive that art dealers were, or perhaps that dealers preferred a context without individual artists selling their work alongside them. Artfinder also has a "Sale" page, with works discounted as much as 75 percent, another contextual situation that many art dealers would likely prefer not to be associated with.

The Artfinder platform does assure uniqueness, one of the strong preferences held by online art buyers, according to the Hiscox report. While more-established art selling platforms may argue that of course they only showcase unique works of art, by addressing this directly, Artfinder seems to be targeting the wider potential market

of new art buyers, who likely gain confidence by having that spelled out clearly on the site. Artfinder highlights their "14 day no risk money back guarantee" as well, another factor that Hiscox noted "ranks highly in establishing buyer confidence."[2] Other features on the site, including pages titled "Start your art collection," "Hang art like a pro," and "Buy art on an art fair," confirm that they view leading new art buyers by the hand as a central part of their business strategy.

While other online channels will say they are interested in developing new markets for their partners, most of their energies and the tone of their sites seems focused on maintaining credibility within the top sector of the established contemporary art market. Artfinder may have room to grow in its gallery partner list, but if they can truly deliver on converting art lovers into art buyers, they may have the ultimate advantage over the long haul. In late 2014, Almgren told *Bloomberg Business* that in less than two years Artfinder had "sold art to about 10,000 customers from 55 countries."[11]

Based in California and very briefly called "Sell You Later," ArtRank (www. artrank.com) changed its name shortly after being launched in February 2014. To say it made a splash is an understatement. News outlets around the world have done major feature articles about it, and art world insiders have all but put pictures of its founder, former art dealer Carlos Rivera, on their dartboards. The platform's initial service—providing algorithmic-based forecasts on the markets of hot emerging artists within a structure much more associated with the stock market and using categories ranging from "Buy Now <$10,000" to "Sell Now/ Peaking" to "Liquidate"—continues to be highly controversial. According to an article in the London newspaper *The Guardian*, "ArtRank isn't the first service to offer market insight (the pricing database Artnet Worldwide springs to mind, alongside ArtTactic, the market trends firm that recently estimated the art market is controlled by 150 people with resources to spend $20m on a single work of art); it's just the first to rank artists as starkly as a stock-pick."[12]

Limited to ten subscribers at a time, who pay $3,500 a quarter, ArtRank's premium service (that is, access to each quarter's analysis weeks before everyone else gets it) has a long waiting list. In early 2015, however, ArtRank unveiled an online "instant private sales" component, open to anyone with an Internet connection, that smartly capitalized on the self-contained ecosystem its ranking reports permitted. Called "#buytoday," and promoting only one work of art three times a week from the list of artists it tracks, its online sales pitch includes the type of information other online sales channels provide—concise bios of the artists, quality images and essential details, and the retail price—but ArtRank does two things no other online gallery/marketplace model has yet found a way to do. First, it gives potential buyers, through its archive of forecasts, a good sense of how much demand there is for each

listed artist's work, but it doesn't make them outbid other interested buyers on the secondary market the way auctions do, driving the price up and muddying the true market value. Second, it reveals information that many potential online art buyers say in the Hiscox report that they wish they had easy access to: comparable pricing. Each listing includes the primary market price for the work, the #buytoday price (which has always been lower), as well as, again, a sense of where this artist's overall market is heading, so buyers can make a much more informed decision about the price.

Much of the controversy surrounding ArtRank centers on its highlighting the commodity value rather than the cultural value of the art. I feel the rancor Carlos Rivera incurred by launching ArtRank is misplaced. While he is indeed earning money by contextualizing emerging art in this way, Rivera's much more of a true believer than his critics seem to give him credit for. Having been what he admits was "a pretty terrible gallerist," he understands full well the frustration of watching non-stop headlines about inexplicable record auction prices, particularly in the emerging sector of the contemporary art market, taint an art dealer's ability to focus more attention on the cultural value of an artwork.

I interviewed Rivera in early 2014 and then followed up with him again in 2015. When we first talked, a year before ArtRank launched #buytoday, he told me, "I think the ideal art market model online is actually allowing people to buy good works of art, democratizing what's available. But you can't go online and buy a good [redacted hot-selling artist's name]. Those are held or on reserve, and they're on reserve for better collectors than you and I. And I don't know how to properly democratize that in responsible ways that would disallow flippers from buying it, but there's got to be a way, and that just hasn't been figured out yet." With #buytoday, I believe ArtRank sorted out a fair bit of that challenge, and may be one of the sites leading the entire online market toward greater transparency. It is a much smaller operation than many other online channels, so whether its size becomes a factor in its longevity remains to be seen.

Inquire to Buy

Unlike channels using the online gallery/marketplace model, an "inquire to buy" channel doesn't have a "buy now" option, but rather some online means of letting interested buyers inquire about the artwork. The advantage for potential partners with the channel is they don't have to split their sales commissions, but usually they need to pay some subscription fee to have a presence on the platform. Below we'll look at one "inquire to buy" channel that serves galleries (Artsy). Appendix B includes only one other "inquire to buy" channel (Barnebys), but it serves auction houses and it's difficult to imagine just how it might influence any individual art dealer's online decisions.

In early 2015, Artsy (www.artsy.net) was getting perhaps the lion's share of attention in this category, at least among US galleries. There is a level of prestige associated with being on Artsy for galleries because, initially at least, a presence on the platform was by invitation only. Also, they threw legendarily glitzy parties, stocked with high-profile art world celebrities, which received plenty of coverage in the arts press.

They also had an interesting story behind what made them different from other online art selling channels, which also brought lots of mainstream press. The Artsy platform's integrated Art Genome Project has been compared to the online music listening platform Pandora, which recommends new songs you might like based on what you tell it you currently like. As arts journalist Dan Duray described it in a thorough review of online platforms in early 2014, "If a user tells Artsy he likes 'irregular curvilinear forms,' Artsy would then find other artworks that offer them, by the likes of John Bock and Alexander Calder."[13] With over a thousand categories, including "art historical movements," "subject matter," and "formal qualities," the Art Genome Project is designed to encourage new discoveries among visitors, which is particularly appealing for dealers with emerging artists.

Like many online channels, Artsy also has editorial coverage of the art world, and particularly of the art fairs, many of which they have partnered with to create online digital fair catalogs. In full disclosure, Moving Image, the art fair I co-founded with Murat Orozobekov, has partnered with Artsy for our online catalog for many years now. Artsy is also heavily involved in art education, permitting instructors to download tens of thousands of select images from their site for educational purposes, among other initiatives.

Artsy provides its gallery partners with an online interface where they can add images and data for each artwork, post information about their exhibitions, and edit any of their gallery information as they need when works sell or they move, and so on. In mid-2013, Artsy stopped charging a commission for sales made via inquiries from their site (something they had to rely on galleries to report) and switched to a gallery subscription model that they have said is finally bringing them steady revenue. There are three levels in the subscription model (prices current as of March 2015):

1. *Artsy Standard* (about US$400/month), which includes a gallery profile page that partners maintain themselves, unlimited artwork listings, ten genomes added to your artwork inventory per month, email alerts, and use of their iPad app, Artsy Folio

2. *Artsy Preferred* (US$600/month), which includes the full standard package, plus four editorial features a year, an increase to thirty genomes per month,

preferred placement of partners' exhibitions or art fair booths across the platform, and monthly analytics reports

3. *Artsy Premium* ($1400/month), which includes the full standard and preferred packages and "guaranteed promotion on the site's highest-traffic pages, extensive editorial coverage, and private sales services via Artsy's team of Specialists," but is available by invitation only

Converting grandfathered galleries who previously paid Artsy only if they sold artwork via their site to monthly subscribers has reportedly gone well, although not every such dealer I have spoken with said they would sign up. In New York, where many arts platforms are born, there has been a strong tendency among dealers who initially received free promotions or listings on websites not to agree to pay when such platforms later decided to start charging, as many a *former* arts channel entrepreneur can attest. Often the dealers' rationale is a lack of evidence that the free promotions they were happy to try had actually led to sales. They also knew there was no shortage of other start-ups willing to promote them for free, as well. As of this writing, though, Artsy does seem to have done a good job convincing a large number of galleries of the value of their paid services.

Artsy's promised editorial coverage for higher-level subscribers is a bit controversial, though. While they are not considered a "news" channel, per se, Artsy's articles do read like the objective journalism you find elsewhere, and so some people have grumbled that they represent a conflict of interest. Artsy doesn't deny that their coverage favors certain subscribers, however, which seems ample disclosure for the context.

Peer-to-Peer

The basic idea behind the "peer-to-peer" model is cutting out the middleman. While this could mean cutting out the art dealer and connecting buyers with artists or other collectors, with most of the online platforms introducing an additional intermediary into the mix, it can also means simply that the channel exists to connect any buyer to any seller and stay out of their way as much as possible, as well as protect their identities as much as possible. Indeed, Kenneth Schlenker, co-founder and CEO at ArtList—one of the peer-to-peer channels we'll look at in this section—explained the principles behind his site's innovative approach to privacy in the comments section of a story about the platform:

[M]any of the existing art start-ups treat art as a public consumer market. In fact, fine art is a private market—where information is not transparent, and access and reputation matter. Technology is making the art market more

transparent, but won't make it a public market. We're building technology that makes transactions on this private market faster, more secure and fair.[14]

ArtList (www.artlist.co) reportedly grew out of conversations emerging from another online initiative, Gertrude (www.gertrude.co), the goal of which was to facilitate international salon-style events designed to educate fledging collectors and introduce them to the mysterious ways and hard-to-approach people deep inside the opaque contemporary art world. In an article in the *New York Times* in June 2014, Gertrude curator Astrid de Maismont noted, "We're not selling artwork; we're selling the experience."[15] About six months later, however, their online art selling channel launched and the salons were, temporarily at least, put on hold.

ArtList seems to be for secondary market sales of contemporary artwork (1940 to today) only. Anyone wishing to sell on their platform must guarantee they have clear title to each work posted (meaning that they must legally own the art, and not merely have it on consignment from the artist). There's nothing stopping an art dealer who focuses on the primary market from using ArtList for their secondary sideline sales, but unlike Artsy or Artnet or other platforms that facilitate primary market sales, ArtList specifies in their terms of service that "sellers" list artwork "from a recognizable artist in the secondary market." That said, the exact wording suggests there may be circumstances under which primary market work is accepted:

> The artist should either: (a) have a **traceable secondary market**, with several artworks already presented at a major auction house or (b) be represented by an **established art gallery** (view our list) or (c) have a **strong demand on primary market** (for example—with waiting lists, or no available work on the primary market).

There are some innovations in the ArtList model that look poised to influence how other online art sales will happen moving forward. First is how, despite being a true "peer to peer" selling model, it presents a combination of public (or "click to buy") and private (or "inquire to buy") listings. Any registered, verified visitor can make a "click to buy" purchase, but only interested buyers approved by the seller will receive more information about an "inquire to buy" transaction. Sellers choose which method they prefer for each listing, based on how public they wish their desire to sell that artwork to be. Potential buyers given more information on "inquire to buy" listings must agree to the terms of the website, confirming they will not publicize that a work is for sale.

Next, ArtList encourages buyers to supply as much verification information as they're comfortable doing, because "Completing your profile will make sellers more likely to deal with you (that is especially true for access to private artworks)." As on

eBay and other online channels, your ArtList public profile becomes more reassuring the more you're validated by the site and its other visitors. They have a range of initial verification methods, including one that many people think may become universal in the not too distant future: In addition to submitting a copy of your driver's license or supplying information such as your phone number or email address, ArtList also asks you to verify yourself via your Facebook or other social network accounts. Social network accounts may increasingly prove to be the most trusted verification method moving forward, even possibly replacing government-issued passports (or so the speculation goes), because of the number of other verifiable people agreeing that your account does belong to you and are who you say you are, which is more difficult to quickly produce than a fake document.

Also innovative is how they try to enforce privacy. In addition to the terms each registered visitor must agree to, "inquire to buy" images sent to approved inquirers are watermarked with that requester's name. This is designed to discourage a dealer from forwarding the image to countless potential buyers just to test the waters and possibly burn the piece in the process. As standard as this method of discouraging fishing expeditions is likely to become, I suspect there are so many images of any given artwork online these days that this method may not prove as effective as it's designed to be. ArtList also puts front and center answers to several of the primary concerns potential online art buyers said make them hesitant in the Hiscox report, including guarantees on delivery, provenance, condition, and authenticity. Holding the buyer's payment in escrow until the work has been received and confirmed in good condition, ArtList goes out of its way to ensure buyers will be "fully satisfied."

Finally, ArtList has seamlessly built artist resale rights into their business model, making their inclusion much less discouraging than any other online channel I know. While all online channels will enforce regional resale rights where they exist, ArtList splits every 10 percent commission they earn on sales with the artist, sending the artist checks for works sold via their channel twice a year. The seller collects the full amount they agreed to sell the work for. While this is another example of online businesses reflecting millennial values, several insiders I've spoken with believe this is a potential detriment for ArtList, as some sellers may not wish artists to be informed they had resold their work. As I believe every artist has a right to know where each work in their oeuvre is located (if only so they can request a loan for exhibitions), I would agree that artists' interests here outweigh those of any particularly private collectors.

Another peer-to-peer channel worth looking at is ArtViatic (www.artviatic. com). Based in Monaco and launched in 2013 by former Wildenstein Gallery

vice-president Antoine Van De Beuque, ArtViatic focuses on more expensive works, including high-end contemporary art, but also including Impressionist and Modern artwork. Only works that are priced at €150,000 or above and that are included in the artist's catalogue raisonné or have a valid certificate of authenticity are accepted. At this price point, it is not surprising that ArtViatic offers a higher level of service options, including the opportunity to have a private viewing of the artwork in various locations convenient to the potential collector, including Monaco, Paris, London, New York, Geneva, Singapore, and Hong Kong. It's also not surprising that payment options on ArtViatic do not include credit card transactions. Wire transfer or ArtViatic's private escrow account are the only options.

ArtViatic also has its team of experts evaluate and approve any work submitted for a listing, which they note will only last four months for any given work. At these higher price points, letting any artwork sit online for too long can create and perpetuate impressions that it's overpriced or perhaps not a great example of this artist's work. Free estimations for sellers unsure what their artwork's current market value is are also available.

Any seller can try ArtViatic at no charge for four months—again, the maximum duration of any listing—so long as their experts agree the work being listed meets their criteria. After that initial "First Access" offer, all sellers or any buyers must subscribe to the "Premium" offer priced at €3,500/year. In addition to the guarantee of private negotiations among a very exclusive clientele, ArtViatic has partnered with an insurance company offering its paid subscribers bespoke solutions for artwork sold via the site, an arts storage company offering state-of-the-art warehousing, and "discreet" art handling services so that word will not get out about what the sellers are unloading.

Cutting Out the Art Dealer Altogether

All the channels discussed above are open to contemporary art dealers, but many new online channels (and by "many" I mean over 250 and counting) have popped up that let artists sell their work directly to buyers. This may not pose the immediate threat to the profession some reports suggest it does, but it makes sense for any art dealer to understand how these channels work and what it could mean for their business. The 2014 Hiscox report notes that the "reputation" of the art seller remains very important to online art buyers. In the brick-and-mortar gallery world, this is as true today, if not more so, as it's ever been. While auction houses may be nibbling away at the mega-galleries' primary market dominance, the artist-to-collector sites we will look at below are hardly a concern for the top dealers. What is likely to emerge with them are requests from artists who have had some success on these sites

for different representation models with emerging or mid-level galleries that wish to work with them. Dealers are likely to respond with changes in their consignment or representation contracts that enable a different representation model but bring other assurances to the gallery (an issue we'll explore in more detail in Part III of this book). In that way, even the existence of these sites may begin to change the artist-dealer relationship.

There are dozens of approaches among websites that exist to let artists sell direct to collectors (despite the number in its URL, this link lists over 250 such sites: www. artsyshark.com/125-places-to-sell/). Some are devoted to genres or media, others are geographical in focus, and many of them combine listing and social networking functionalities. Some of them are open to both art dealers and unrepresented artists. Far too many of them make claims of being "a leading destination" for "important collectors" for that to be true of all them, or at least for that to be understood the way it generally is in the commercial gallery world.

Virtually every conceivable combination of the word "art" with another word is represented among their brand names, including ArtBomb, ArtCollectorMall, Art-Pharmacy, Artplode, Artsicle and ArtZolo. The names without "art" in them are just as varied and often just as reassuring. We'll discuss strategies for building your own proprietary online channel, but my point in listing some of these names here is that the time to decide on and buy a domain name (or two) may be now, should you choose to use something other than your current business domain name to brand and promote such an effort.

Aside from those many channels, one much more effective and potentially game-changing online platform is increasingly cutting the gallery system out of contemporary art transactions: Instagram. As noted in Chapter 5, *Vogue* magazine published an article in 2014 titled "Why the World's Most Talked-About New Art Dealer is Instagram,"[16] but many art dealers were even then still unsure how sales were happening there or what kind of threat to them it really posed. In April 2015, Artsy published part of a survey they conducted on who was buying artwork from Instagram. Their results suggest the channel's potential should not be ignored:

> According to a recent survey of collectors on Instagram, an incredible 51.5 percent have purchased works from artists they originally discovered through Instagram. More importantly, this discovery led to an average of 5 purchased works by artists originally found on the app! Although respondents are all active on Instagram, and nearly half have collections of 100+ works, these are significant findings. Collector and social media expert Karen Robinovitz . . . commented, "Collecting art is an addiction and Instagram is the dealer and pusher that enables it."[17]

As noted in Chapter 2, unrepresented artists are not the only people who can maximize the capabilities of the addictive platform. The widely publicized news that actor Leonardo DiCaprio had purchased artwork that he saw on Instagram (in an installation view of a gallery's booth at a satellite art fair), simply by calling the gallery, should encourage every dealer to see how the platform indiscriminately works for whoever makes it work for them. Experimenting with what kinds of images posted by galleries best motivate collector action would seem to be among the contemporary art market's best responses to this potential.

STRATEGIES FOR NAVIGATING THIS CHANGE

Much the way many dealers will experiment with combinations of art fairs in different locations to find the right balance to match their promotion and selling goals, experimentation with various online art selling channels seems to make sense for most as well. Although online channels are nowhere near as expensive as the average art fair, they represent enough investment (including many hours spent posting data to them) that it makes sense to come to some basic business decisions about what you want from such channels before signing any contracts. Many online channel subscriptions are yearly, which may be more time than you wish to pay for or be associated with a platform that turns out to be counterproductive.

While it may chafe the neck of certain art dealers to frame their online art selling strategy this way, I'm going to work through the issues involved using the framework shared by Infopia vice-president of marketing Ralf VonSosen in an article on HammerTap, an eBay research website devoted to helping online sellers make more sales more often.[18] I truly understand why being associated with contexts like eBay or similar commercial channels is anathema to many fine art dealers, but if you could sell as much art as you wanted without resorting to online options, you would not need to know anything about how online sales actually happen. If you do want to know, there are some universal concepts that seem to apply. VonSosen breaks them down into three admittedly vaguely phrased categories:

- How to utilize all e-marketplaces and online selling channels

- How to drive the acquisition and ownership of customers

- How to optimize profits through branded merchandising and sales

How to Utilize All e-Marketplaces and Online Selling Channels

Personally, I would rephrase that concept more as "How to decide which online selling channels to use," because the basic questions VonSosen asks sellers to consider and then combine into single answers here are "Who is my target customer?" and "Where do they buy?" In short, in addition to focusing on certain categories of art

within certain price ranges, most channels target specific types of collectors. Which channels are right for you, therefore, depends as much on who you wish to sell to as it does on how that channel's business model works for you.

As mentioned above, for example, Artfinder seems to target buyers with little to no experience in buying contemporary art, who are looking for lower price points. Artspace, on the other hand, promoted its platform for a while by noting that it specifically targeted regional collectors associated with regional contemporary museums. These are well-informed patrons who may not be among the top 200 collectors in the world, but who actively support contemporary art and, being in places without many galleries sometimes, very likely spend a good deal of time keeping up with what is happening in the art market via online sources. Artspace's collectors also are likely comfortable with medium-range price points. ArtViatic, on the other hand, targets international high-net-worth collectors and would not make sense, or even be available, for anyone selling artwork for less than $200,000.

So among the first questions to ask any online channel would be:

- Who are the collectors who buy from your site?

- Where do they live?

- What is the average price of the artwork that actually sells on your site?

- What's the most expensive artwork ever sold via your site?

- Which mediums do your visitors buy the most/the least?

- What requests for additional services and/or information do your visitors make most often?

- What are your plans to address those concerns?

All online channels have (or should have) detailed analytical data they can share with you. If they won't answer these questions in ways that help you decide whether to use them, the odds are they know their answer won't persuade you. (You can verify one basic metric they will likely report to you via the website Compete [www. compete.com], where you can see the number of unique visitors any website receives per month.) As the HammerTap article notes, though, most online shoppers use a combination of websites to find what they're looking for or to compare prices. You may need to post your inventory to a mix of channels or post certain types of art to certain websites, based on price range or medium. If you post the same art to different channels (something some channels permit, while others require exclusivity for any listing), remember that potential buyers may be comparing prices across multiple channels, so it is important to maintain consistent pricing in order to build trust.

How to Drive the Acquisition and Ownership of Customers

Both the Hiscox report and VonSosen insist that the more time collectors spend on an online art selling channel, the more likely they are to make a purchase. Sites that have means of keeping customers engaged, therefore, are more likely to lead to eventual sales. As VonSosen also notes, "It is much more expensive to acquire a new customer than to sell to an existing customer." In general, this means the same thing online that it does offline: your overarching goal, as VonSosen phrases it, is "transforming transactions into relationships." This can get tricky with some online channels, as they may be invested in keeping any buyers as *"their* clients," even though things they do can reflect on you in the minds of buyers unclear on the delineation of roles or responsibilities on the channel.

Therefore it is important to know how much information an online channel is willing to give you about any buyer or what they let that buyer know about you. We all address or talk with new clients differently at first compared to how we communicate with our loyal, valued clients. While it is not always a big deal, treating a return client like a new client can be a make-or-break issue in your relationship. In political campaigns, for example, it is understood that a candidate never says "Nice to *meet* you" to anyone in a crowd of voters or potential supporters. The phrase they are trained to use is "Nice to *see* you," just in case they had previously met that person but simply couldn't remember with so much going on. Feeling forgotten is a lasting negative impression for many people online as much as it is offline.

So, among the next questions to ask a prospective online channel representative, particularly ones who consider the buyers *their* clients and wish to keep it that way, include:

- What information will I receive about a buyer?

- How will I tell returning clients from new clients?

- How do you/can I communicate with someone who has bought work from me about new work available?

- If the channel handles shipping and handling, what information will you provide me about any issues that come up? (In short, they're representing you . . . how do they separate out issues that originated with you from issues that you had no control over?)

- Does this channel require exclusivity for any listing or are you free to list artwork on other channels?

If their answers suggest you will not easily be able to transform transactions into personal relationships, tell them directly that's a concern of yours. Art selling is

a very relationship-driven business. Part of the increasing interest in "peer-to-peer" or "inquire to buy" channels is how they facilitate a direct relationship between the buyer and the dealer. Tell any channel who insists the online clients are *their* clients that that helps you make your decision to go elsewhere.

How to Optimize Profits through Branded Merchandising and Sales

Getting your inventory up on an online art selling channel is all about having new clients see it there. In other words, it is about increasing your business's visibility. Sure, every art selling channel will boast hundreds of thousands of visitors a month, but there are likely hundreds of other art dealers on the same site, sometimes offering works by the same artists you are, or even the same artwork in the case of editions. Within the context of any retail environment, sellers still need strategies to stand out or gain attention. Standing out among your competition in retail environments in a way that encourages visitors to buy from you and remember you is the realm of *merchandising,* which, when done well, as the header above promises, optimizes your profit potential. This is not the same as "branding" an artist, but rather a matter of grabbing more attention in a context where other sellers are also working to gain attention.

Some online channels offer ongoing merchandising opportunities, for additional fees. Artsy, for example, promises their *Preferred* and *Premium* level subscribers additional attention via editorial coverage and priority placement. Any of the online channels will also advise dealers that continually adding new content increases their visibility as well, but be sure to ask them how that leads to more visibility. Do they offer a filter for users to discover newly added content themselves, or do they promote it in a special section of the site? Does your level of service include such promotion? For channels that allow unlimited content, continually updating your listings is simply a best practice, but for those that will charge you for additional content, you may need to delete existing content to stay within your allotted amount. Make sure you understand how to delete existing content on a given site (not all of them make it easy).

Themed exhibitions or auctions are another merchandising option many online art selling channels offer. Beyond another excuse to send yet another email out to their list, branded online art sales have a good track record of generating buzz. Even among the brick-and-mortar auction house sales, there has been an increase in events with concise and carefully crafted branding. In short, themed sales give the channel something new to talk about and arts publications something new to write about. Themed sales timed to correspond (some might say, to exploit the promotions of) prestigious events at museums or biennials are also fairly common, as are the time-tested, attention-grabbing claims of something being "new [and improved]." Asking any online seller you are considering using how they select works for themed sales is therefore smart research.

In every online merchandising opportunity, the main message you are promoting is that this artwork (and perhaps particular pricing offer) is worth the visitor's attention, but you are also promoting the message that you are a trustworthy art seller with other important, interesting art for sale. As VonSosen puts it, your goal is to "help customers identify and find additional value in your offer." In short, you're selling art, but you're also always selling yourself. Making sure the channel's merchandising options permit you to highlight both messages is therefore critical. It does you more good if a themed exhibition is designed to encourage visitors to learn more about other art you are selling. Some channels may argue that they have chosen to downplay which gallery is offering an included artwork to help brand the overall themed sale or exhibition or lend it credibility. This is not a very convincing argument to my mind; content providers should be fully acknowledged (and linked back to) at every possible opportunity, otherwise they are working to promote the channel and not the other way around.

Toward maximizing your merchandising opportunities via any online channel then, here are some additional questions to ask a potential partner:

- How much content does my subscription permit me to add?
- What's involved in deleting content, if I want to stay within my allotted amount?
- Do you highlight newly added content? If so, how?
- What opportunities will I have to be included in themed exhibitions or sales?
- How will my business be represented in any themed exhibitions or sales?
- Can I propose/curate a themed exhibition or sale?
- Can I contribute or propose editorial content?

Beyond what the channel offers, there are some best practices any online art selling subscriber can follow to ensure they are maximizing their profit potential, including matching your product to the right channel, imposing consistency of message across all channels, and coordinating what you are promoting on your business website or at art fairs with what you are promoting online. If you are featuring new work at an art fair that has partnered with an online channel for their art fair catalog, they will likely request you forward images for that catalog presence. The most compelling images the online channel receives are often the ones they choose for their catalog home page or in their own promotional efforts, with full credits of course. Sending multiple versions of very high quality images—some of just the art, perhaps some of humans looking at the art—can increase the likelihood the online catalog will advance your goals over those of the other dealers participating in the fair.

Proprietary eCommerce Channels for Art Dealers

Another frontier I expect more intrepid art dealers to venture into as online sales increase is trying their hand at hosting their own private eCommerce site. A good example of a dealer who had a brick-and-mortar gallery before launching a successful eCommerce "gallery" is Jen Bekman, whose site 20x200.com has had some ups and downs since launching in 2007 with the slogan "It's Art for Everyone," but in general is the prototype any new eCommerce sites by dealers will be measured against. It is a sophisticated online shopping experience, and frequently hosts sales with philanthropic objectives.

There are potential downsides to galleries launching eCommerce sites, including possibly discouraging collectors from feeling they need to visit your physical space; entering into a more complex sales tax situation; costs associated with setting up and maintaining the site; and possible legal or security issues around private information, especially for international customers. Still, dealers have most of the data required to populate an eCommerce site on their websites already, or in their inventory management system. Moreover, with so many dealers reporting decreasing foot traffic and there being only so many art fairs a year you can do before your dog forgets you, I do expect a few dealers sitting in empty galleries to give it a go.

A basic decision to make about setting up a private eCommerce platform includes whether to use a self-hosted solution (that is, you buy an eCommerce application, but put it up on a web server you choose and pay for separately) or a hosted solution (that is, the application you pay for is hosted by that company on their server). One advantage to having an eCommerce company host your site for you is not needing to rely on your own IT team (meaning, often, your gallery assistant) to maintain or diagnose problems with it. A key disadvantage may be a lack of flexibility in how certain pages look (many of them use a generic final payment page, which may not fit your business's brand or identity). The advantage of a self-hosted solution is of course that you know where your data reside, and you have access to the code, meaning you have more control over customizing it (assuming you know how to do that).

Popular examples of self-hosted eCommerce solutions include WooCommerce (www.woothemes.com/woocommerce) and Magento (www.magento.com). Popular examples of hosted eCommerce solutions include Shopify (www.shopify.com), Volusion (www.volusion.com), and Bigcommerce (www.bigcommerce.com). Pricing for hosted solutions start as low as $20–$30 per month for their standard plan; about $80 per month for their premium; and the sky is the limit for their "enterprise" solutions, which are customized to fit your business, but designed for the kind of "high-volume" business no art dealer is ever likely to need. Examples of self-hosted solutions pricing include roughly $80 for a standard package and $150

for a "developer" package. WooCommerce's designer package comes with layered Photoshop files, making it easier to customize the look and feel of the site.

No major art gallery I know has yet launched their own publicly accessible eCommerce platform. There still remains a certain stigma to it in the genteel gallery world, not to mention it is time consuming. Moreover, online shopping experiences are designed to maximize the number of items sold, which may make sense across hundreds of galleries (or in the case of sites focused on multiples, like 20x200.com), but it may not make as much sense for an individual gallery selling mostly unique works of art to build one for their inventory alone. If nothing else, an eCommerce site might be a much less expensive way than art fairs to customize a unique experience in your quest to reach a more global audience.

SUMMARY

While still a fraction of the overall contemporary art market, sales from online platforms are rising every year and represent enough potential that every dealer should begin to consider where their business can benefit from their proliferation. Secondary market dealers currently have a wider array of options online, but some of the online auctions are more actively courting primary market work, usually for themed presentations. Any dealer considering using an online platform should carefully match the art they post there with the visitors who buy there and the price points at which they spend. Asking online channels questions about their users' demographics, what information they will receive (and when) about interested buyers, the logistics of putting work up (and taking it down) from their site, and merchandising opportunities should help dealers make those choices.

Surveys, like those informing the Hiscox reports, suggest that the longer collectors spend on any online art selling channel, the more likely they become to purchase artwork there. The surveys also indicate that having a good experience buying art online increases how much collectors are willing to spend on subsequent online purchase, meaning that sites with "sticky" features (that is, features that keep visitors on their site or keep them coming back) stand to increase their subscribers' success in selling there.

The surveys also indicate that condition reports, certificates of authenticity, and considerate return policies all increase collectors' confidence in buying art online. If a platform does not automatically offer such reassurances, ask them how you can do so on your pages. Making sure your online presence is carefully coordinated to supplement and reinforce your offline efforts, whether in your gallery or at an art fair, is smart as well. Finally, online channels can help expand your global reach at a cost much lower than international art fairs.

PART II

New Roles and Challenges for Art Dealers: Factors Within Each Dealer's Control

O ne of the realities that tends to get lost in the race to succeed in the commercial art world is that there is no universal definition of "success." Just because many top- and mid-level galleries feel the pressure to "grow or go" or to behave more like a mega-gallery does not mean that one model provides the only valid option. "Success," by definition, is meeting your goals. And while your clients (both artists and collectors) will judge you on how high you climb up the ladder, which ladder you choose to climb is up to you. There are many of them in the global art market. Yes, sales are one good metric of success for any commercial art gallery, but "sales of what?" must be asked in this context. If you are selling paintings like hotcakes, but your mission was to promote video art, are you still a "success"? I would argue that in a broader context it is how well a gallery fulfills its mission that becomes the best measure of its success.

Part II of this book examines strategies for selling contemporary art within contexts that transcend the mere "grow or go" mentality that seems to overshadow most everything else in the current contemporary art market. Looking at factors that each individual dealer has more control over, with an emphasis on alternative means of achieving your goals, the next three chapters explore practices that opposition or ambivalence toward the mega-gallery track have led many dealers to follow instead. While there are many ways to categorize the spectrum of goals that contemporary galleries have, the following four should hopefully serve well to

frame the discussions to come. These apply to dealers selling art, as well as dealers running art fairs (as we will discuss in more depth in Chapter 9):

CATEGORIES OF CONTEMPORARY ART DEALERS' GOALS

- Strictly selling: they have no particular or lasting theme in their programming; they promote artists they like and can sell; and will stop promoting artists they cannot sell.

- Niche programming: their mission is to promote artwork within a particular medium or movement or by artists from a specific geographical region or time period.

- Artist centric: their goal is to promote a particular group of artists (sometimes within a common movement or from the same geographical region, but sometimes simply a group they like and wish to support); they may even support these artists as a group, regardless of how successful any individual artist in the group may be.

- Cultural producers: these dealers focus on experience, creating a context in which artists' work is contextualized within a larger view of culture at large. They have a wide range of attitudes toward selling.

There is a bit of mixing and matching among these categories in the strategies of any individual contemporary art dealer, of course, but we will refer back to these as discrete goals in the following three chapters. In Chapter 7, we will look at post-brick-and-mortar dealers, who use or entirely eschew the white cube space as it suits their needs, rather than maintaining one on a full-time basis. The collaborative concepts and events discussed in Chapter 8 often end up throwing together dealers (usually gallerists) who have a mix of different goals as well, which might contribute to their varying track records of success. The ones that are succeeding stand as further evidence of the growing sense that in this current climate smaller galleries cannot afford to go it alone. Finally, in Chapter 9 we will discuss the opportunities, as well as the million and one details involved, for dealers launching or buying existing art fairs to help meet their goals. In each chapter, we will begin by looking at why dealers are thinking about this concept and then examine the mechanics of doing each, all in the context of how the evolving contemporary art market is making such options more attractive, or necessary, than they were in 2008.

7

The Post-Brick-and-Mortar Dealer

WHY DEALERS ARE THINKING ABOUT THIS

The notion of a "post-brick-and-mortar gallery" started popping up frequently in conversations about the possible future of art dealing after the 2008 financial crisis. The rationale for this interest in exploring how one might operate a "gallery" without a permanent physical location is based on a combination of the developments we discussed in the previous chapters; namely, how foot traffic in many galleries seems on the decline, how some galleries make a significant percentage of their annual sales via art fairs, and how the Internet often makes communicating with a dealer more immediate and efficient for collectors than a visit to a gallery. These have all led dealers sitting in empty galleries to reconsider the value proposition of a physical space, especially where it amounts to considerable overhead. In cities where rents are skyrocketing, like New York, San Francisco, and London, interest in the potential of this concept has become understandably high.

The business downsides to not having a physical space include not being able to easily offer your artists regularly scheduled exhibitions, which may lead them to leave your gallery; not being eligible for many art fairs that require participants to maintain a physical space with regular hours (although there is more and more discussion about that changing); and missing walk-in opportunities to meet potential new clients. Beyond business downsides, though, there are cultural downsides to consider here as well. As we discussed in Chapter 4, New York-based art critic Blake

Gopnik noted in a recent article in *The Art Newspaper* that "art dealers who believe galleries are no longer necessary have forgotten an essential reason why works are valued." Specifically, Gopnik argued:

> Fundamentally, art acquires its market value because it has cultural worth. The central sales pitch of any auction catalogue, for instance, revolves around its objects' art-historical excellence. . . . And the culture, of course, can only embrace something it has good access to. We need to see the art before we can proclaim it excellent. The real reason galleries need to exist isn't to help their owners' bottom lines or to coax work out of artists; it's not about those artists' profile and pride; it's not even about collectors and clients. It's about the general public—or at least a dedicated public of art lovers—who in the long run, maybe the very long run, will be the most powerful players in the art game.[1]

His position on the importance of exhibiting art was summarized as "the truth is that the art that's on view, and for sale, doesn't mean much unless there's a public there to receive it." While that certainly seems true from our current standpoint, I would note that within the entire history of making one's living from selling art, the open-to-the-public, white cube gallery space is a relatively recent invention. In that sense, it stands to reason that other models that are yet to be adopted or even imagined may serve art, artists, and dealers just as well if not better.

Therefore, it is not surprising that, in addition to "post-brick-and-mortar galleries," by early 2015 a serious discussion began to emerge about what might be termed "post-brick-and-mortar dealers." To some insiders who have been around for a while, I am quite certain that phrase sounds like another way of saying a "private dealer who used to have a space but closed it," just as I am sure many people who hear the phrase "post-brick-and-mortar gallery" assume it is another way of discussing "a private dealer who used to have a space, closed it, but still wants to get into art fairs." To some degree, both sentiments are based in a demonstrable truth; as mentioned above, many major art fairs, where more and more art sales happen, retain strict bans on dealers without physical spaces. What is also true, though, is that the global contemporary art market has expanded to historic size, a new generation of intermediaries are forcing their way into the primary market (including online channels, auction houses, and a few hybrid collector/online-channel dealers), and so what perhaps seemed merely wishful framing by dealers who could not make their physical spaces work in the past might actually represent the beginning of a much wider range of viable models for art dealers who, rather than being tied to a physical space twelve months a year, use a white cube, or don't, only as it suits their goals,

but still continually deal in contemporary art via means that fewer and fewer people will consider significantly different from those used by dealers with physical spaces.

Indeed, an April 2015 article in *The Art Newspaper*, somewhat hyperbolically titled "Dealers abandon bricks and mortar galleries for more flexible models," examined how the current environment (which seems to be leaving less and less room for anyone other than the mega-galleries or mega-gallery wannabes) has led many dealers to seek more flexibility:

> "While the galleries and artists active in this top segment are profiting hugely from the expansion of the market, galleries in the middle and lower segments are profiting much less, or not at all," says the economist Olav Velthuis, an associate professor of sociology at the University of Amsterdam.
>
> Over the past decade, rents have risen and gallery attendance has fallen, while profit margins have shrunk and pressure to take part in art fairs and to stage exhibitions has increased. "Let's call it the Walmart effect: it's what Home Depot did to local hardware stores and Amazon did to bookstores," says Michael Plummer, a principal at Artvest Partners and managing director of the Spring Masters New York fair. "The same thing is occurring in the art industry, just 15 to 20 years later."[2]

The article concludes that "as the art market continues to consolidate, more dealers will abandon bricks and mortar." Of course, before complete abandonment, there is likely to be a fair bit of experimentation with hybrid models. Even a gallerist whom nobody would confuse for a "post-brick-and-mortar dealer," for example, because he also has fifteen spaces in seven countries around the globe (yes, I mean Gagosian), has done "pop-up" shows in locations where opening a full-time brick-and-mortar gallery clearly did not make sense to him but having a temporary physical presence did, including Moscow, Rio de Janerio, and St. Barth's. It is not much of a leap from that logic to the choices other dealers are making to operate without a full-time white cube at all. Gagosian opened a pop-up in those places to seduce collectors who lived there, but who clearly also had the means to travel to New York (or London, or Rome, or . . . wherever) if they wanted to. Yes, his overall model is sagaciously serving both types of collectors (those who prefer the gallery experience and those who like the art to come to them), but while plenty of other dealers are also serving collectors who prefer the gallery experience, what is to say a new kind of dealer focusing on the arguably growing segment of collectors who prefer the artwork to come to them will not be viewed as just as visionary or important to the contemporary art scene and just as deserving to be in the fairs? I personally see that day coming.

Among the only really viable models, so far, for a "gallery business" that does not include a full-time physical space are pop-up galleries and mobile galleries. Below we will look at examples and the mechanics of each of these. Then we will examine examples of models that forgo a full-time gallery yet still do not fit easily within the traditional definitions of private dealers, independent curators, or art consultants. Retaining the spirit of a gallerist, and certainly the credentials within the commercial art gallery world that distinguish them from most independent curators or private dealers, this breed of influential post-brick-and-mortar market innovators includes dealers like Mari Spirito, Jeffery Deitch, and Jay Gorney. We will look at how each of them is contributing to a redefinition of what it means to be a "dealer," independent of the previous distinctions drawn primarily by whether one maintained a full-time brick-and-mortar space or not.

THE MECHANICS OF DOING THIS
Pop-up Galleries

Back in 2009, when quite a few businesses around the world went under, leaving a glut of available retail spaces, the *New York Times* did a long article about the pop-up galleries that were multiplying in London at the time. Very inexpensive rents or even no rent at all were being offered to artists, curators, and budding dealers alike who would transform the empty spaces into temporary galleries, only to then disappear or relocate somewhere else (hence the name "pop-up"). The gist of the article was that pop-up galleries were a win for those on both the art and the real estate ends of such deals. Indeed, Simon Tarrant, one of the artist-turned-pop-up-dealers interviewed, noted that while it was a "dream come true" for artists without galleries:

> [T]he arrangement also offers obvious benefits to a landlord concerned about high upkeep costs or their alternative, dereliction. In an agreement typical of many being struck, Mr. Tarrant said he would pay for all utilities and return the property in the same or better condition than when the collective moved in.
>
> In addition, he has agreed to hand over 15 percent of the proceeds from any artwork sold, and, although he is not required to, has plastered and painted the walls. And in its new role as a gallery, the building has been attracting a constant flow of visitors, two of whom, Mr. Tarrant said, had already expressed interest in renting the space.[3]

By 2014, when real estate in London and many other major art centers had returned to being very expensive again, there was not much news at all about this

alternative model. So maybe the first takeaway about pop-up galleries is that their success is perhaps even more tied to the ebbs and flows of the real estate market than brick-and-mortar galleries are. But not entirely.

As a concept, pop-up galleries predate the 2008 recession by quite some time. The earliest successful pop-up gallerist I personally knew of was Kenny Schachter, who currently runs a gallery/project in London called "Rove," which nicely sums up one of his central principles in how to sell art. A 2006 article in the UK newspaper *The Independent* explained how a decade earlier "Schachter became one of New York's first "guerrilla gallerists," taking short leases on abandoned SoHo stores to mount ad-hoc group shows with titles like The Death of the Death of Painting":

> "Even though the art world was in the bust cycle, it was still hard to find a way in. Kenny was really approachable and he drummed up huge interest. He was a brilliant promoter. Walking into his spaces felt very democratic— more like a party than a gallery."[4]

The second takeaway on pop-up galleries then is that, unlike many brick-and-mortar galleries, their success can greatly depends on the dealer maintaining a high level of energy in the space and being very approachable. Promoting them as one might a party is often also a key to their working well.

Inspired greatly by Schachter, I launched my own series of super-short guerrilla exhibitions in 1999 under the name "hit & run," which took over empty storefronts or warehouses for a total of five pop-up galleries in New York and London. We promoted "hit & run" much the way rave parties had been promoted back in the day. Although its website showed the dates and other pertinent information about the event, you only knew where it was actually being held if you were on the email list and received the address just before the opening reception. This wasn't entirely an attempt to seem exclusive—it helped promote the event long before we were able to get the lease signed for the space. In 2001, when the available warehouses in New York began to dwindle, I opened a permanent space, but I still remember quite fondly the energy and excitement of turning some abandoned building into an exhibition and performance space. (Below, I will share the mechanics of my approach to producing pop-up exhibitions.)

A dealer who began with pop-up shows eventually "graduating" to a full-time space is nothing new in the contemporary art world, but when it happens the other way around, people seem to take notice. In 2009, after the recession had led many galleries to close in New York, dealer Amy Smith-Stewart grabbed a great deal of attention when she herself closed her physical gallery space on the Lower East Side and re-launched her business entirely as what the *New York Times* dubbed a "roving

gallery" and declared that it had "[blown] holes in the very concept of the art gallery itself":

> Pop-up art exhibitions are popular in London and have been springing up more in American cities, but it is unusual for an established gallerist to give up her space and embrace the concept as a business model.
>
> While the act of constantly relocating the gallery is an opportunistic response to the empty retail space typical of a recessionary economy, it is also a form of performance art.
>
> "When you have a gallery with a particular location, a particular address, people take it for granted," Ms. Smith-Stewart said. "That's the way it has been, because collectors come to you, they know how to find you. That's why galleries cluster. But, totally antithetical to the model, I'm more interested in the discovery of art—not only going to see art, but going to find art."[5]

Amy's roving gallery lasted from September 2009 to May 2012 and included a total of eight very well-received pop-up exhibitions. (She left the gallery business and was hired as the curator of the esteemed Aldrich Contemporary Art Museum in Ridgefield, Connecticut, in 2013). In an interview she kindly did for this book, Amy discussed what led her to change her business model in 2009, despite a new interest in relocating to full-time storefronts in the Lower East Side among remaining New York galleries, as well as the advantages and challenges of a pop-up gallery.

> After speaking with many of the gallery artists, and in alignment with my prior background as a curator, I felt compelled to approach things differently. There were so many galleries, so many exhibitions opening simultaneously, it was just impossible to consistently draw the audience and critical attention we desired. I felt that perhaps a more strategic, site-specific or project-determined approach, by discovering an alternative type of space, collaborating with an artist as both a gallerist and a curator, would be more exciting and offer up different ways of working within the commercial art system.

Next I asked if she would elaborate on a comment she made to the *New York Times* about how she had "felt confined by the traditional gallery model":

> I felt constrained financially and creatively. The physical space was constricting, and moreover the rhythm of the traditional model is crushing with its rapid pace, while at the same time it can become monotonous cycling

through the roster. It's also a seasonal business with fall and spring being the most desirable times for artists to have solo shows with winter and summer shows as lulls. This is what has made the art fairs like Miami and Basel so significant over the years as ways to offset winter and summer losses,

She then turned to some of the specific challenges that all gallery dealers face that the roving model could help solve if current contemporary art market restrictions could be changed:

The art fairs have also driven audiences away from galleries, as so many wonderful shows go unseen, making critical attention in the press and having a presence at major fairs mandatory. I thought the pop-up model with an art fair component would address all these issues. Although at the time the big fairs required an address. That might have changed now. I also think having a more effective online component/presence that in real time could support the pop-up model could be the future for certain sectors of the gallery market coupled with placement at the right fairs.

We also discussed how there can be unexpected expenses associated with the pop-up model that any dealer considering it should know up front. Sure, Amy noted, "you are not trapped by a lease," but the build-out costs can be significant depending on how polished a space you find and "liability concerns cost you more, as extra insurance has to be acquired if the space isn't up to snuff." Finally, I asked her what advice she would give to a dealer considering a pop-up gallery model. She identified three components that she views as essential (and just so happen to echo Schachter's observations):

Collaboration: it is the only way to make things happen. I had amazing artists to work with and incredible interns to help realize these projects. Risk averse: you have to be willing to take very real chances. Adventure seeker: there are many challenges to overcome along the way, but I found the most successful shows take on a life of their own. And it's this very unpredictability that makes this model so exciting and addicting.

So what are the considerations here? What do you need to know, buy, and do to produce successful pop-up gallery exhibitions? A good deal depends on how polished you want the experience to be for visitors, but if you are going to do a series of pop-ups, you will likely want to collect a "pop-up kit" of things you will need each time, including clamp lights and bulbs, miles of extension cords, portable furniture, tools, industrial strength cleaning supplies, miles of curtains (perhaps to hide eyesores you cannot easily build around), and so on.

Below is a slightly edited excerpt from a blog post I wrote back in 2009 about what doing the "hit & run" exhibitions had taught me to think about and prepare for in quickly securing and then converting an empty space into a "gallery" (I point you to the blog post[6] also for the advice contained also in the comment thread). It was written more for the independent curator interested in producing exhibitions, who would not likely already have the resources one accumulates running a gallery, but much of the same factors apply in reverse. I began by explaining how hard it was to locate a space I could rent, and then listed ten things I learned about producing pop-ups:

Originally, I tromped all around Soho and the Lower East Side for weeks, calling all the numbers on vacant buildings, but rarely getting anything even approaching a considerate response. Determined, though, I called the landlord of my apartment building (also in Soho), which happened to have two commercial storefronts on the ground floor, and asked him for advice. I couldn't use his two spaces (they were too small), but I asked him what his concerns might be if approached by an artist or curator wanting to get a space for an exhibition, so that I could be ready to counter any such resistance in my next round of calls.

My landlord offered some really great advice, which (along with several other things I learned back then) I'm happy to pass along to anyone wanting to give it a go today:

1. The number one objection landlords have to such a request is liability. For a very reasonable price, though, you can get "Event" insurance. The place I got mine from was: www.insurevents.com. So when you approach a landlord who objects because of liability concerns, tell them you already have an insurer and can comply with their full requirements. They will ask for a copy of your policy, and ask to be designated as also insured, so you cannot just say this. Even if they don't raise this objection, you still want to get the insurance for your own peace of mind.

2. Tell them by making the space ready for an art exhibition, you will return the property in better condition. This is actually very appealing to a landlord concerned about dereliction.

3. You will most likely need to pay for electricity in a vacant space and may need to call the electric company to have the service turned on and the bill for the duration of your occupancy sent to you.

4. Ask for the terms of the occupancy in writing to protect yourself and to reassure a hesitant landlord that you're responsible. Here is the wording drawn up by one of the landlords I paid a fee to get a space in the Lower East Side (yes, you might have to pay for some spaces, but that's entirely negotiable, and clearly you should not be paying the full rent, or why bother):

Landlord will lend the south store in the building at {address} to {dealer} the days of {month, days, year} for the purpose of an art exhibition titled {show name}. The fee for the rental is {$$$} and will be paid in advance.

Landlord is not responsible for any damage whatsoever of any kind. Landlord will be held harmless for any damage or claims with respect to merchandise, equipment or persons. Tenant must be fully insured as of the days key are accepted for the Premises.

Landlord has the right to enter the Premises at any time for any reason.

5. [A few of the next items, again, were specifically addressed to emerging, independent curators or even artists wanting to do a pop-up show. Much of this may not apply to experienced gallerists, but I also do not expect every reader of this book to be one.]

You may need help the first few times with promotions (you will have enough to do sorting out how to produce the exhibition in this way). Having someone else worry about press releases and potential sponsors, etc., was the smartest thing I ever did the first time out. Eventually I learned to do those things myself, but the first time around it was overwhelming.

6. Try to get a sponsor for refreshments (i.e., booze). We had great luck getting vendors with new products to promote to donate cases for our events.

7. Make sure the (other) participating artists understand that you're not Gagosian and that they're expected to help with delivery and installation costs. Do what you can, obviously, by cashing in favors, but this is not a time or place for anyone to fly their inner diva flag.

8. Begin advertising even before you're sure what space you have . . . get the word out, get people excited, commit yourself to doing this. Set up a blog with images and such (it's free!). By making it public, you'll find you're less willing to back down, less willing to take "no" as an answer, and more creative in solving problems.

9. Cash in favors! From whitewashing the space, to drink tickets for the after party, to help in building your blog or website, to installation or shipping . . . all your friends and family can pitch in. Ask them to help. They'll probably have a blast doing so.

10. Have fun yourself. If you do, so will others attending and that can spread interest like wildfire.[6]

Another source for great detailed information on setting up a pop-up gallery just about anywhere is found on the website of the Australian organization, Empty Spaces (emptyspaces.culturemap.org.au/popupgallery). As Amy noted, this model could be culturally and financially very successful if art fairs and online channels would recognize pop-up galleries as legitimate clients. There are certainly headaches involved with it, and perhaps (currently at least) limitations in what you can do for your artists without a permanent address, but my pop-up gallerist days were among the most exhilarating I have had as an art dealer.

Mobile Galleries

A "mobile gallery" is a gallery on wheels, generally either a truck or a van, that can be driven to multiple locations and then opened up to the public. In April 2014, the *New York Times* did a story with the absurd headline "Just Like Taco Trucks, Art Takes to the Road," which, despite perhaps misattributing what sparked interest in this non-brick-and-mortar model, included some insightful interviews with dealers who have found it a good alternative:

> On a recent Saturday, Elise Graham and her 23-year-old son, Aaron, pulled a 12-foot van into a parking spot on West 14th Street in Greenwich Village, swung open the back doors, lowered the aluminum stairs, and welcomed visitors inside their mobile Rodi Gallery.
>
> Around the United States, art is on the roll. Inspired by the success of food trucks, gallery owners like the Grahams, who are based in Yorktown Heights, N.Y., have been taking their show on the road. For the last year, they have traveled to populated spots like the meatpacking district of Manhattan, the Peekskill train station and Astoria Park in Queens. This Saturday, they are parking in the center of Bushwick Open Studios, a three-day festival in Brooklyn.[7]

Among the reasons mobile gallery dealers have cited for choosing the model were "trying to avoid the confines—and politics—of the gallery system; to help people think about art in different ways; or to reach more communities, especially those

with young and old people who tend not to visit art districts." Interestingly, there is a higher-end/lower-end parallel to how Gagosian opened his pop-up galleries in Rio or St. Barth's for much the same reason: a perceived need to bring the art to the audience. Like pop-ups, though, the birth of the mobile gallery can be traced back to well before the 2008 recession:

> This is hardly the first time American artists have gone mobile. Before opening a gallery in the East Village, Gracie Mansion staged her "Limo Show" in 1981 in a rented limousine, parked in SoHo, where she invited passers-by into the back seat for Champagne while she pitched her friends' art.[7]

I personally know plenty of artists who have parked trucks packed with art in places where art enthusiasts were sure to pass by. It used to strike me as looking a little ridiculous; like they were simply trying too hard. Still, the art market, the political climate, and my own perceptions have evolved to where a quality mobile gallery that might have been easy to dismiss in 2008 might more presciently in 2015 be recognized instead not only as a much more profitable model, but in several ways more culturally relevant than many brick-and-mortar galleries clearly making choices driven more by an over-developed market system than an earnest enthusiasm about the art they represent. In other words, there is a simplicity, if not quite purity, to the mobile gallery model that can also make the brick-and-mortar gallery system look as ridiculous as I am sure many dealers regard a mobile gallery to be.

Coming through a period when cutting costs was many smaller dealers' only salvation, hearing the total overhead costs for the average mobile gallery is simply depressing. That is due, even more perhaps than savings on rent and similar storefront costs, to the generous community spirit mobile galleries seem to both embody and inspire. Elise Graham of Rodi Gallery kindly shared information about her mobile gallery for this book. I pressed her on whether the costs quoted in the *Times* article of $395 per month accounted for business expenses like their website and so on. Not only is the answer, impressively, "yes," but Elise seems as creatively resourceful as any dealer I know, telling me:

> I would not be driving a step van truck showing artwork by artists whose works have little real market value. I would guess that the $395 a month is a fair number. Remember that we only operate for nine months of the year. So many things were donated or provided at a discount by people who believe in what we are doing. The website was done by a Cooper Union friend of [her son and partner in the gallery] Aaron's; the renovation of the truck, which I believe should have cost us several thousand dollars, was done by a friend who also believes in what we are doing.

Her responses to several of my other questions ultimately revealed more to me about the predispositions I have developed as a gallerist than they did clear-cut limitations in the mobile gallery model, although I would still insist there are a few. Obviously some art will not fit in the truck, but the same is true for any brick-and-mortar gallery, strictly speaking. Many viewers may be uncomfortable climbing up into a truck, and weather is undoubtedly an issue. More importantly, artists might not feel comfortable having their work exhibited in what would undoubtedly strike many as a less-serious or less-desirable context. Then again, exploring this has made me wonder whether the first artists asked to hang their work in a white cube space, rather than a fully furnished salon, immediately trusted that context either.

Elise also challenged my entire framing of "the mobile gallery versus the brick-and-mortar gallery," including what I have long considered unavoidable business concerns for contemporary art dealers:

> We have not applied to any art fairs. We don't have any plans to do so. Part of our mission is to operate outside of the commerce-driven (no pun intended) model. That being said, we have parked in the street in front of the Affordable Art Fair. We like to park in places where we think there will be passersby interested in looking at art.

Again, my instinct is to view this mostly as a hopeful rationalization, but there is a sentiment in Elise's answers that I do not hear from as many brick-and-mortar gallerists as I used to before the recession, at least not the ones who haven't yet closed. It is more than refreshing. It struck me during our interview that it might be the very essence of what a gallery system squeezing out some of the dealers most devoted to contemporary art needs to remind itself of: that the system exists to serve great artists, but only because they are creating great art. As Elise told me:

> We don't much see Rodi Gallery as an outgrowth of a brick-and-mortar gallery as much as [an] example of what an artist(s) can do by taking the exhibition of their work into their own hands. Before we had Rodi I showed my work in a friend's basement, in an empty store, and in the woods. We think the cultural significance of a mobile gallery is only what it suggests to artists—you are creative, apply that to ways you can get your work out into the world without the constraints of a complicated, hierarchic, money-driven system.

Now that I have waxed poetic, though, let me concede some other obvious downsides of this model. Several of them were highlighted in the *Times* article, including how, as discussed in Chapter 3 on art fairs, perceptions about context greatly limit the price point collectors are willing to pay there. Moreover, galleries have evolved

in many ways to meet collectors' needs beyond a single purchase, which mobile galleries cannot easily do:

[Ann] Fensterstock [a lecturer on contemporary art and the author of *Art on the Block*, a history of New York art galleries, said] that the truck model has limitations. "It doesn't make for return business; it doesn't make for contemplation of the art by spending time with it; it doesn't make for building a strong commercial place out of which the art gets sold."[7]

But it obviously can work for some visions, so let's also look at some of the basic mechanics of operating a mobile gallery. First of all there are dual build-out concerns because the "gallery" must be designed to display the art well but also transport it safely. Clever use of space behind walls in a mobile gallery might help solve this, but they would also reduce the total square footage visitors could occupy. Many mobile dealers minimize their logistical challenges (such as parking restrictions or restrooms) by partnering with other events. Rodi Gallery, for example, reported partnering with the Bronx Art Space, the Bronx Museum of Art, Art in Odd Places, Fresh Kills in Staten Island, and others. Beyond logistics, obviously, partnering on events can also bring a built-in audience. Finally, depending on the size of the mobile gallery, more of the comforts a dealer might want are feasible. According to the *Times* article, Berge Zobian, director of the Providence, Rhode Island-based Gallery Z, has tricked out his mobile gallery, the "Artmobile," with "44 linear feet of exhibition space, a stereo system, security cameras, projection monitors and even a bar for making coffee."

While I do not expect the mobile gallery model to revolutionize the contemporary art market any time soon, I respect the spirit of the dealers' not letting financial or even space constraints stop them from bringing art to the public. The market can use more true-believer dealers, in my opinion. But such dealers can also work from the inside of the commercial contemporary art market in a realm beyond any single gallery context, per se. The sheer scale of the global market has enabled dealers to conclude that a full-time brick-and-mortar gallery was not entirely essential to accomplishing their goals but still maximize their connections and influence in the art market to reach their personal definition of success.

Indeed, next we will quickly examine some new models and practices being developed by highly respected art dealers, former gallerists all (at least for the time being), who do not let their current relationship with a white cube define or limit how they promote and sell contemporary art. I will apologize in advance if the following descriptions end up conflicting with career choices they make in the future. Each of them keeps evolving, it seems. At this point in early 2015, when the market is as complex and corporate as it has ever been, all three of them are an inspiration in

how they are navigating the changes. Two of them (Spirito and Deitch) transcend the role of "dealer" into the realm of "cultural producer," but no one doubts their market savvy or credentials. The third (Gorney) is perhaps the best example of someone actively redefining the limits of what a post-brick-and-mortar dealer is permitted to accomplish within the contemporary art market by players who previously would have closed doors to him.

Mari Spirito

Mari Spirito is a good example of a post-brick-and-mortar dealer who blends non-profit funding with commercial art market savvy to produce the artist projects she believes in. With twelve years' experience as the director of New York's influential 303 Gallery, Mari knows the ins and outs of the contemporary art market as well as anyone, but since 2011 she has focused on Protocinema, an international nonprofit organization she launched in Istanbul and New York, that also operates from a post-brick-and-mortar position. As explained on its website (protocinema.org):

> Protocinema creates opportunities for emerging and established artists from all regions, in cities where their work has yet to have much exposure. Protocinema seeks to open up dialogue and improve mutual understanding between individuals. Protocinema is a transnational organization, free of "brick and mortar." Protocinema was named to embody motion and cognition, after a Werner Herzog observation, in which he refers to The Chauvet-Pont-d'Arc Cave paintings as almost "proto-cinema" in style of representation—capturing a sense of movement, "not unlike the futurist paintings of the early 20th century whereby a figure was captured moving through space and time."

A recent example of a project Protocinema collaborated on, with the Broad Art Museum at Michigan State University, illustrates how she makes use of her connections with the art market to commission projects she feels are important. Marie explained in an interview in late 2014:

> Protocinema is doing a partnership with the Broad Art Museum at Michigan State University. We'll do an intervention initiated by Ahmet Öğüt, where he and five other artists will make sculptures that function as collection boxes, or coin operated machines, and we're collecting money and selling the art works to raise money for the Debt Collective, which is a movement that came out of Occupy Wall Street, where they buy back student debt.[8]

Several dealers who have left the gallery world recently cited how the market had evolved to be inconsistent with the personal reasons they were attracted to the business in the first place. Some have settled into traditional alternatives, like private dealing or consulting, but Mari stands out for blazing new trails in response to having similar objections to where the gallery system was taking her professionally and personally:

> I had already been working at galleries for 20 years, and I wanted to figure out a way that I could still work with artists and make exhibitions while going back and forth between Istanbul and New York. I founded Protocinema because it was what fit my preferred lifestyle. I found a job to fit my life, instead of a life to fit my job.[8]

Jeffrey Deitch

No one defines "cultural producer" in the contemporary art market context like former (rumored future) gallerist Jeffrey Deitch. Best known for the relentlessly innovative program at his New York gallery, Deitch Projects; his legendary beach parties and concerts during Art Basel in Miami Beach; projects that aggressively blurred the line between fine art and popular culture; and most recently a somewhat controversial stint as the first major art dealer to run a major museum (as director of the Museum of Contemporary Art in Los Angeles), Jeffrey has put his money where his mouth is like few other gallerists in the preeminent sphere of the art market he occupies. Indeed, in a live interview with New Museum curator Massimiliano Gioni in early 2015, Jeffrey said, "I don't really care about money. Money is something to do more crazy projects with."[9]

In a profile published by *New York* magazine, painter Kehinde Wiley observed the following about his former dealer, who, despite organizing some the hardest parties to get into in the art world, remains always rather quiet and calm at them:

> "He very clearly crafted his image around being this agent-provocateur citizen of the world. He reminds me very much of the flâneur: He's in society and not engaging. But there's a fork in the road where the flâneur is able to take all that knowledge and mobilize it, but never is it about personal agency. Sort of like the Wizard of Oz."[10]

After he resigned from LA MOCA in the summer of 2013, speculation about Deitch's next move ran rampant. News first came he was opening a huge gallery in the Red Hook district of Brooklyn, then perhaps one on a pier on the Hudson in Manhattan, but as of yet no concrete plans for a new gallery space have been announced. The fact that where he may (or may not) open a new gallery generates so

much interest is a testament to his continued influence in the art market. Even without a physical gallery or museum director post, he is able to make headlines by, for example, re-creating the 1980s nightclub Area in a gallery run by his former protégée Kathy Grayson, firmly reestablishing his star power at Art Basel in Miami Beach via a talk with director Spike Jonze one year and then a much-talked-about party with singer Miley Cyrus the following year, and publishing (with Rizzoli) a 1996–2010 history of Deitch Projects in 2014. He also weighed in on how museums need to adjust to new realities in his interview with Gioni:

> Regarding the problems of the [widely panned] Björk retrospective [at the Museum of Modern Art], Gioni asked, "Is there such a thing as too much audience, or a moment when Bob Dylan does the Christmas carol?" Deitch responded that museum audiences are changing, and that it is high time MoMA adjusted to the Coachella crowd. "This is a very interesting challenge to the art world," Deitch said. "The elite no longer control the audience."[9]

The power he still wields at the heart of the art market, even though he has not operated a commercial gallery in five years, suggests to me that dealers perhaps underestimate how their influence within the art world and art market systems can continue even after they close their space. Of course there is only one Jeffrey Deitch, and he may very likely reopen his gallery, but then so too can any other dealer who musters up the courage and resources.

The recession wiped out multi-national corporations with teams of executives being paid huge salaries. A mom-and-pop-shop gallery that needed a little breathing room after the crisis should be entirely understandable to anyone. And yet, I have seen talented dealers slink away after closing their spaces, embarrassed by the weight of a public failure, and feeling defeated by an evolving market that simply is not as nurturing as it used to be, for artists or true-believer dealers. There are several I personally would love to see give it another go. Of course, as this chapter is intended to illustrate, their reincarnation need not be another brick-and-mortar gallery, but then again, it could. The choice is up to them. I realize another example of someone closing their space and still having the art world waiting on pins and needles to see if they reopen it, perhaps someone who does not have Jeffrey's star power, might seem a more inspiring choice here, but I chose Jeffery Deitch because I believe, despite his ups and downs, that his most potent gift remains his faith in Jeffrey Deitch.

Jay Gorney

In the *Art Newspaper* article on dealers opting out of brick-and-mortar galleries, respected former New York gallerist Jay Gorney argued, "It's easier to do a

multiplicity of things now that the contemporary art world has got so much larger. There are more opportunities for independent curators, art advisors, and people working in non-traditional ways."[2] With his strong reputation serving him well, Gorney seems to be breaking the mold in terms of what the mainstream contemporary art market will permit a post-brick-and-mortar dealer to do, including participating in significant art fairs:

> Gorney ran his own gallery from 1985 to 2005, before becoming a director at Mitchell-Innes & Nash gallery in New York. Since leaving last year to launch an independent dealership and advisory firm, Gorney has taken part in art fairs, including Independent Projects and the Outsider Art Fair, and continues to serve as a special advisor to the estate of the late US artist Sarah Charlesworth. He is planning an exhibition of works by the abstract painter Deborah Remington at Manhattan's Wallspace gallery in June. This diversification is taking place at a time when "having a bricks-and-mortar gallery is an increasingly challenging thing to do," Gorney says."[2]

It is particularly his acceptance into notable art fairs that distinguishes Jay's activities from those of other "former" gallerists. I will note that both fairs he has participated in as such, Independent Projects and the Outsider Art Fair, are dealer-organized art fairs. As I note in Chapter 9, fair organizers who are dealers themselves often understand better what other dealers are going through and tend to adapt their models to market conditions. They do this not out of sympathy, mind you, but to ensure that the quality of a dealer's vision and not merely their current address is the deciding factor in their participation.

FINAL THOUGHTS

I do realize that post-brick-and-mortar art dealing is not what many current gallerists want for themselves or their artists. Presenting exhibitions and maintaining a continuous dialogue with the public, critics, artists, and collectors is what being a dealer means to them. The examples of alternative models described in this chapter were selected to illustrate that what "success" means for any dealer is up to them and is not defined by the clash of the mega-galleries absorbing so much attention in the contemporary art market, at least in New York. Furthermore, sometimes it takes looking at things from a very distant point of view to see what your options truly are. So I want share again a quote that appears in Chapter 4, from an interview for this book with former Director of New Initiatives for Art Basel, Annette Schönholzer, who observed how in the evolving market, Western gallerists may want to reconsider how they define being an "art dealer" altogether:

If you go to Asia, if you go to China, if you talk to gallerists there, the gallery might run the gallery, a foundation, a freight handling company, a residency program, and maybe an interior design company. And in the West we go "this is crazy," because only one of the five things this gallery is doing is actually being a gallerist. And this kind of diversification, of fluidity in doing business that is so foreign to us, is common all over Asia. And it works because they don't have to rely on one single thing to cross-fund what it is they're doing.

8

The Evolution of Dealer Collaboration Models

WHY DEALERS ARE THINKING ABOUT THIS

I have learned a number of things that strike me as rather profound from collaborating with other galleries over the years. The final chapter of my book *How to Start and Run a Commercial Art Gallery* was titled "Peerage: The Art Gallery Community" and looked at gallery associations and other means that galleries have of joining forces to help meet their goals. In that chapter, I discussed how writing a mission statement for the newly formed Williamsburg Gallery Association that we and other Williamsburg galleries were trying to launch in 2002 kept running into snags. In essence, the more involved we tried to make our mission statement, the more we disagreed about it. What we eventually concluded was that the association should limit its activities (and hence its mission) to the goals that we members had each previously identified as priorities for our individual businesses but realized we all shared, like raising awareness of our programs, bringing more visitors and particularly collectors into our spaces, and supporting the arts in our community. We realized we should avoid adding any new goals that had not universally been part of our respective individual visions before, such as joint curatorial projects or a spectrum of political activities. There might be opportunities for such collaborations in the future, but they should not form the basis of our charter or be included in our mission statement. We had banded together primarily believing there was strength in numbers in attracting traffic, not because there was any need to rethink or reframe our programs.

Another concept I learned via a gallery association, which has informed my thinking about the contemporary art market ever since, was how every gallery in a particular market stands to benefit more from collaborations that increase the overall size of the pie than any individual one of them can by myopically protecting their little slice of it. There are accumulative benefits to encouraging more market activity in general, even if it means sharing your current collectors with other dealers. The competition between collectors that can spark a waiting list, for example, can usually only occur if there are enough active collectors to create that very desirable situation. The final and perhaps most profound things I have learned from collaborating with other galleries were, first, how many of the problems that I thought I alone was facing were fairly common, and second, how much I generally like other art dealers. I suspect there is something about what attracts them to the gallery business that makes me like most of them, I don't really know, but I realized that despite all the competition in our industry, it remains a community of often like-minded people who, given the opportunity, will truly enjoy each other's insights, as well as company.

In short, I am a fan of gallery collaboration opportunities for both business and personal reasons. Apparently I am not alone in that. Since 2008 there has been a considerable increase in the number of gallery collaboration events around the globe as well as several new models springing up. How much of that is due to dealers banding together in response to the financial crisis versus dealers being persuaded by the success of collaborations already established in 2008 may be unclear, but interest in collaborations has risen so high that there was a lively panel discussion devoted to them at the Talking Galleries symposium in Barcelona in October 2014.[1] That discussion was dedicated to "joint events," such as gallery weekend events in certain cities, and below we will discuss the insights its highly experienced panelists shared. Indeed, this chapter will focus on those types of collaborations, but we will briefly examine two additional categories of specific gallery collaborations that dealers have seemed to embrace more recently as well, including teaming up (either permanently as business partners or temporarily for a combined art fair booth or other business objective) and events created via outside facilitators (where an independent party involves galleries in their event). None of these models is entirely revolutionary in and of itself. Various dealers have joined forces, with various results, for nearly as long as galleries have existed, but a theme that emerged during the Talking Galleries panel discussion was that in the current climate, unless a dealer owns a mega-gallery or runs a highly niche program, it is nearly impossible to go it alone in many smaller markets, and indications are the same is becoming true in larger markets.

In the mechanics section below, we will discuss specific reasons galleries may wish to collaborate, or not, within any of these three categories (beyond my personal

epiphanies listed above, that is), as well as elaborate on some of the politics involved where events cannot or will not accommodate every gallery who wishes to participate, particularly in the context of how the contemporary art market is evolving. We will also examine specific examples of each category, including political issues, timing issues, and hard lessons learned by some organizers. Let's first discuss some of the high-level issues that can make or break gallery collaboration efforts.

Cautions and Issues in Gallery Collaboration Efforts

The main concept we kept coming back to in writing the Williamsburg Gallery Association mission statement—that we were joining forces first and foremost to bring more people into our individual galleries—seems to be the essence of what makes a successful collaboration event as well (the unspoken part of that concept being: why else would business competitors help each other?). When collaboration efforts fall apart, it is quite often because the organizers lose sight of that central, overriding goal. Any number of participants may have any number of reasons for attaching their personal agendas to an event, often quite sincere about how it will "help" all involved, but if there is a guiding principle for evaluating any gallery collaboration, it should probably be: does it help drive traffic into my space or help me increase sales? If not, it is a charity event, and of course may still be something you are interested in, but the sales pitch that it will "help your gallery" is unlikely to prove true. I say any idea that does not drive traffic or increase sales is a "charity event" because most collaboration efforts cost dealers money (with a few exceptions in some locations, which we will discuss below). Many of them actually cost quite a bit of money, which can put struggling dealers in a "damned if you do, damned if you don't" position at times. A "Gallery Weekend" event, for example, can cost thousands of dollars, but not being part of it can cost a gallery prestige.

Another paradox of gallery collaborations is how often both the need for them and the success of them depend on infrastructure. For example, galleries have developed collaborations in response to local arts institutions ignoring them (hoping to lure curators and museum directors into their spaces with a high-profile event), only to find that enticing even the public can depend on getting the local arts institutions involved as partners; a chicken-or-egg situation. How far apart collaborating galleries are can require them to hire event transportation, like shuttle buses, in some locations as well. How such transportation operates can become a political issue too. When our gallery was located in Brooklyn, we used to participate in an annual event, paying the same amount of money as every other gallery, only to receive a small fraction of the traffic that galleries near the shuttle bus drop-off point were getting. We could rationalize it as "any increase in our traffic at all was only due to our participation," but

when other dealers who had been packed to the rafters wanted to increase the event's budget in following years, we wanted to discuss alternative bus routes.

In contrast to over-engineering problems, some events can become victims of their own success, where the party atmosphere they achieve brings so many people that their true target audience gets lost in the crowd or begins to shy away. Introducing VIP schedules can help in such situations, but knowing where to draw the line (because some VIPs may prefer the energy of the overwhelming party) becomes a question. Of course, too many people would be a nice problem to have for many events. An event's ability to build an audience can require everyone involved to maintain a long-term perspective in measuring its success. I have attended event planning meetings where one dealer insists that the effort is not going to succeed until everyone invests more in it, but buy-in from other galleries often depends on a rational argument for how the budget matches realistic projections on returns. All of these issues continue to wind through the discussions below on how various collaboration events are often structured, paid for, and evaluated.

THE MECHANICS OF DOING THIS
Joint Events
As noted above, there was an extremely helpful panel discussion at the Talking Galleries symposium in Barcelona in October 2014 that examined joint gallery events in depth. Titled "Joint Gallery Events vs. Going Solo," it included panelists with decades of experience between them, including:

> **Annamária Molnár** (Moderator), director of Ani Molnár Gallery, president of the Hungarian Contemporary Galleries Association (2011-2014), Budapest.
> **Dorsey Waxter**, partner at Van Doren Waxter, president of the Art Dealers Association of America, New York.
> **Łukasz Gorczyca**, co-director of Raster Gallery and Warsaw Gallery Weekend, Warsaw.
> **Hans Knoll**, director of Knoll Gallery and former president of the Austrian Galleries Association, Vienna.
> **Jochen Meyer**, founder of Meyer Riegger Gallery, Berlin Gallery Weekend, and abc fair, Berlin.

You can watch a video of the entire discussion on Talking Galleries' website (www.talkinggalleries.com/?p=3719). Among the type of events Annamária listed under the umbrella of "joint event" were gallery weeks/weekends, late-night openings, talks or events linked to other major art events (such as art fairs or biennials), and projects such as professional visitors' programs. The point was made that

the discussion would not include art fairs that galleries might have collaboratively launched. Annamária further categorized such events based on how they were founded and/or funded, including "bottom-up" events organized by a group of galleries seeing a need to band together; government-backed events in locations where civic officials are interested in promoting their arts and cultural institutions, whether commercial or not; and gallery-association-led events. I elaborated on a list of such events Annamária presented at the panel in the table below, which includes as many additional joint events galleries are participating in around the world as I could find via search engines. I am sure it is woefully incomplete, but it does include good examples of most types of such events. Like most things in the contemporary art market at the moment, I am also sure it is subject to change.

International Joint Gallery Events

EVENT	Location	Website
Amsterdam Art Weekend	Amsterdam, The Netherlands	amsterdamart.com
Gallery Weekend	Athens, Greece	thegreekfoundation.com/events/gallery-weekend-2014
Art-nou	Barcelona, Spain	art-nou.com
Barcelona Gallery Weekend	Barcelona, Spain	barcelonagalleryweekend.com/en
Art Berlin Contemporary	Berlin, Germany	artberlincontemporary.com
Gallery Weekend Berlin	Berlin, Germany	gallery-weekend-berlin.de
1st Thursdays Dumbo	Brooklyn, NY	brooklynartproject.com/page/1st-thursdays-dumbo-gallery
Williamsburg Gallery Association 2nd Fridays	Brooklyn, NY	wburgga.tumblr.com/2ndfriday
Brussels Art Days	Brussels, Belgium	brusselsartdays.com
Poppositions (art fair)	Brussels, Belgium	poppositions.com
BBC Brussels Cologne Contemporaries	Brussels, Belgium / Cologne, Germany	bccontemporaries.com
Gallery Weekend Budapest	Budapest, Hungary	galleryweekendbudapest.com
Budapest Contemporary	Budapest, Hungary	kortarsgaleriak.hu/en.html

EVENT	Location	Website
First Thursdays	Cape Town, Johannesburg, South Africa	first-thursdays.co.za
Gallery Weekend Chicago	Chicago, IL	galleryweekendchicago.com
Gallery Weekend Cluj	Cluj, Romania	iaga.eu/news/article/46
Copenhagen Art Week	Copenhagen, Denmark	copenhagenartweek.dk/en
Cracow Gallery Weekend	Cracow, Poland	cracowgalleryweekend.pl/en
3rd Thursday	Detroit, MI	artdetroitnow.com
Art Dubai Week	Dubai, UAE	artdubai.ae/art-week
Art Gallery Week (Hong Kong)	Hong Kong	artweek.hk-aga.org
Art Istanbul	Istanbul, Turkey	artistanbul.org
Arbat Fest	Kazakhstan	artbat.kz/en
Brown's London Art Weekend	London, UK	londonartweekend.co.uk
Art Weekend LA	Los Angeles, CA	artweekendla.com/
Apertura	Madrid, Spain	artemadrid.com/apertura-programa
Gallery Weekend Mexico	Mexico City, Mexico	galleryweekendmexico.com
Mumbai Gallery Weekend	Mumbai, India	mumbaigalleryweekend.com
Art Book Swap by NADA	New York, NY	newartdealers.org/Events?event_id=23
Masters Drawing New York	New York, NY	masterdrawingsinnewyork.com
Choices: Paris Gallery Weekend	Paris, France	choices.fr
Gallery Night	Providence, RI	gallerynight.org
First Friday Rochester	Rochester, NY	firstfridayrochester.org
First Thursday Day Art	San Francisco, CA	firstthursdayart.com
Latitude Platform for Braziian Art Galleries Abroad	São Paulo, Brazil	latitudebrasil.org

EVENT	Location	Website
Videobrasil	São Paulo, Brazil	site.videobrasil.org.br
Art in Motion	Singapore	agas.org.sg/aim_event.acv
Vienna Art Week	Vienna, Austria	viennaartweek.at
Curated by_vienna	Vienna, Austria	curatedby.at
Vienna Gallery Weekend	Vienna, Austria	viennagalleryweekend.com
Warsaw Gallery Weekend	Warsaw, Poland	warsawgalleryweekend.pl
Villa Raster	Warsaw, Reykjavik, Tokyo, Toronto	villaraster.com

Annamária also listed the possible goals and/or advantages of galleries collaborating in joint events, including to:

- create a discussion platform, as well as an integral part of the local art eco-system
- contribute to the city's artistic development and growth
- form community in the sphere of culture
- reach critical mass of art on display to draw attention and create a buzz for the general public, mass media, and art professionals in an increasingly event-based art world
- attract masses of non-collectors into art events and galleries to catch their interest and educate future buyers/collectors
- concentrate at least one weekend a year on galleries' activity
- create a hub worthy for visiting for international collectors

Again, you can watch the entire panel discussion online, but here I want to highlight some of the points raised that stood out for me, particularly in the context of how the market is evolving. It was noted a few times that perhaps the gallery world's most successful joint event, Gallery Weekend Berlin (launched in 2004), was conceived out of frustration with the growing dominance of art fairs. Jochen mentioned at one point that one of Gallery Weekend Berlin's founding dealers was in the audience, and I suspect he may have been the gentleman who offered the following comment during the Q&A part of the panel (if it wasn't him, the commenter still produced only nods from the panel):

Can I say something? The gallery weekend in Berlin was also created almost ten years ago, apparently also as a polemic situation against the dominance of the art fairs. Over the years, from 2000 or so, the dominance of the art fairs in the market has been so obvious that the galleries of Berlin that started this weekend event wanted to bring back the audience and the critics and, if possible, the museums to see the exhibitions which were carefully created in the galleries, and where there were very, very few visitors. We have the feeling that everybody would go to the art fair but nobody would come to the galleries. And that I think was a very important issue for creating the Berlin gallery weekend.

The number of visitors that Gallery Weekend Berlin brought to their city, not counting residents also attending the event, totaled 20,000 in 2014 according to Jochen (who also made my favorite statement during the discussion: in describing how Berlin museums and nonprofit arts institutions often eschew their city's galleries, he declared, rightly, that "Galleries are also cultural institutions"). It should also be noted that not only can joint events be a reaction against fairs, but fairs often facilitate dealers' learning about such events in the first place. Łukasz credited his gallery's participation in international art fairs, where they could meet and learn from other dealers, with leading them to launch Warsaw Gallery Weekend.

The success of Gallery Weekend Berlin has inspired a fair number of other cities to adopt the model. Speaking of this trend, Łukasz and Hans both observed that doing so successfully requires customizing the model to your city's particular circumstances. Specifically, Łukasz recommended looking to cities with markets similar to your own, rather than the major market hubs, for better insights into how to build your events. A good example of taking that concept to an even more productive level is the Villa Raster program (villaraster.com), founded by Łukasz's gallery, which organizes joint projects between galleries in his hometown of Warsaw and those in cities with comparable gallery scenes (such as Tokyo, Reykjavik, and Toronto).

There is a wide spectrum in funding structures for joint events. While not entirely parallel events, the difference between Gallery Weekend Berlin, which costs each participating dealer €7,000, and Vienna's joint event "Curated by" (in which international curators present exhibitions in Vienna's leading contemporary art galleries), which each participating dealer receives €9,000 from the Austrian government to produce, caused a strong reaction during the panel.

Dorsey discussed an interestingly niche joint event in New York that her gallery participates in called Masters Drawing New York (masterdrawingsinnewyork.com). It would only include contemporary art galleries who also deal in Old Masters, but it

still provides an good template for building a joint event around a particular medium. Roughly thirty galleries participate in the January event, which Dorsey noted was chosen because it is a good time to invite clients into a cozy gallery setting, where they can take their time to view and discuss the work. The number of participating galleries was also carefully limited so that visitors could manage to visit all of them over the course of the event at a pace consistent with the type of art on view. Taking your city's social and art world calendar, the global art world calendar, and your target audience's lifestyles into consideration when planning an event was another recommendation Dorsey emphasized.

Given it is arguably the highest-profile gallery joint event in the contemporary art world, let's look at Gallery Weekend Berlin to examine more closely some of the logistical issues involved in producing such efforts. Before we do, it should be acknowledged here that with Gallery Weekend Berlin's high profile comes a correspondingly high degree of criticism. Indeed, the event is controversial because although Berlin has roughly 450 commercial art galleries (according to *Lonely Planet*), only about fifty are invited to participate in the joint event. Jochen explained at the panel that this decision was made, and despite the criticism is still considered the right choice, because they have a small administration budget (indeed, as we will see, their program is so elaborate it requires finding sponsors to fund it, despite its high fee) and because an application process would require a selection process, an appeals process, and an entire system of procedures the organizers, who all have their own galleries to run, simply could not manage. He also noted that what is perhaps more central to the criticism is that the event organizers want to promote galleries who operate in a similar gallerist model and to maintain the quality of the event, which of course is why it is so popular with the world's top collectors.

The program that Gallery Weekend Berlin produces with each participant's €7,000 (and sponsorship funding from companies like Audemars Piguet and BMW) includes five days of museums and private collection tours, guided gallery tours, performances, extended gallery hours, and an elaborate gala dinner for 1,000 people. Participants report that it is far and away their best sales weekend of the year, which contributes to resentment among dealers who are not invited, but also encourages all Berlin galleries (even those not on the list, but still hoping for some spillover traffic) to put on their best exhibition in that time slot as well. Whether what they consider their "best" exhibition is increasingly influenced by the amplified sales potential the event creates is another question the event raises, but each of the panelists producing gallery week/weekend events insisted that there remained a significant difference between such events and art fairs.

During the Q&A portion of the panel, there was a question about whether the panelists felt an important component of such events was their potential to

attract foreign collectors and curators and in that way contribute to promoting local and regional artists in the international market. Łukasz acknowledged how such events can open a valuable international discourse, but added, "we should be aware of the local scene, because we are not interested only in exporting tons of Polish artists abroad—it doesn't work like this, it makes no sense—we need to have a stable local culture which will support all of this, not only the few top artists, but also, let's say, the middle class of artists." In mentioning the growing number of gallery weekends, Łukasz's response made me wonder, much in the way we discuss how many more art fairs the contemporary art world can stand, let alone support, whether a saturation point for such events is not approaching as well.

Finally, during the Q&A, the last audience member to ask a question posed the following:

> I know that every city has a different history and reality, and it's clear that all these events maybe are necessary, and most of them probably successful, but I wonder what happens after the event . . . if we are all the time organizing events, will people go to see art if there is not an event associated to it?

Annamária commented that it was a very good question, but none of the panelists responded. There is a good deal of frustration with how the art world has become so event-based and, particularly among dealers, with how sales are increasingly only probable in conjunction with some events, raising the overall costs of doing business even if you do not mind the additional time events required. The better the contemporary art world gets at throwing parties, perhaps the more we train our audience to view such events as a signifier of quality, making any art viewing experience outside an event more suspect in that regard.

Teaming Up

Predictions at the beginning of the recession were that many art dealers would only survive by joining forces and combining programs. The history of art galleries is littered with examples of dealers making that choice in and out of financial downturns, but whether because they saw plenty of other dealers surviving just fine after 2008 or because the current generation of dealers would prefer to go under than compromise on their individual visions, nowhere near as many dealers teamed up as observers had forecast. Still there are examples of dealers teaming up that we can examine, including merged gallery programs, new companies jointly launched and/or owned, and one-time collaborations initiated as a defense tactic against larger galleries or simply to test the waters of possible future collaborations.

In New York, the most noteworthy of post-recession gallery mergers did not take place until 2015 (although shifts in the market that began in 2008 arguably contributed to their decisions). This merge also introduced a merger model that garnered some attention. When influential Chelsea dealer Zach Feuer and Lower East Side firebrand Joel Mesler (owner of Untitled gallery) announced they were merging, not too many people were shocked. They were already collaborating on a gallery called Retrospective in the upstate New York town of Hudson. What took a few people by surprise was the decision to maintain two locations in the same neighborhood with varying names. As *ArtNews* reported, they were opening "Feuer/Mesler and Mesler/ Feuer, two spaces on the L.E.S. that will share programming, artists, and resources:

> "The idea for the merger here is it allows both of us to increase our square footage," Feuer said in a phone call with Mesler and *ARTnews* on Tuesday, "and it doubles our contacts with collectors, curators, museum people—all relationships." Each dealer will have an office at one of the gallery's two locations—with Mesler, and Mesler/Feuer, operating out of Untitled's current space at 30 Orchard Street. Feuer will have his office at Feuer/Mesler, a new, 3,500-square-foot loft space on the second floor of 319 Grand Street.[2]

They may have received as much attention from other dealers wondering "how are they going to work that out?" as they did for the new power-gallery they were launching, but their choices also reflected the rise of the mega-gallery, the impact of the globalization of the art market, and possibly a few of the other themes in this book. Their consolidation on the Lower East Side underscored what others had been saying about the context that Chelsea has become:

> The move says much about the dynamics of New York's gallery districts, as Chelsea becomes ever more expensive, with mega galleries like David Zwirner and Hauser & Wirth taking over ever more real estate there. Hauser & Wirth recently announced that they will build a new, 7,400-square-foot, multistory building designed by Annabelle Selldorf next door to what will soon be Feuer's old space on West 22nd Street. Meanwhile, well-established galleries like Marianne Boesky and Salon 94 have been opening up branches on the L.E.S., which was once home only to fledgling dealers.[2]

In discussing their joint decisions, they described them as "less about New York City gallery district politics than international practicalities":

> "What made me start thinking about [a merger] was that I couldn't be everywhere at once," Feuer said. "We did the Hong Kong art fair and it was

the same time as this huge Mark Flood show we did, the Insider Art fair, so I had to miss" that. Now, he said "there are better logistics. We can be in two places at once, which was really hard to do beforehand. The business isn't just us sitting in our office all day, this is a job that's 30 or 40 percent travel, and it's going to make the job a lot easier."[2]

Another post-recession example of smaller galleries teaming up strategically located spaces in different cities to help combat poaching by larger galleries. As discussed in Chapter 5, Paris-based dealer Jocelyn Wolff partnered with Berlin-based KOW "as a protective shield to avoid seeing my most successful artists being stolen by other galleries. It was my response to the success of some of my artists, to build the project in a partnership with friends."[3] Wolff also noted how he sees collaborations at art fairs as a good way for dealers to test a potential partnership.

Indeed, teaming up on art fair booths has ostensibly become the preferred laboratory for a range of gallery experiments. Most major fairs now accept joint applications. Beyond the opportunity to stand out curatorially—for the selection committee, hopefully for collectors, and very often for curators or critics who complain of fair fatigue perhaps more than anyone else involved—a joint fair booth is a quick, intense opportunity to gauge how well you and another dealer might work together on other business ventures. As the cliché goes about couples not getting married until they have traveled together, few contexts will reveal personality incompatibilities like the high-stress marathon an art fair is for dealers. Hearing each other discuss the work on view, close a deal, address staff, and resolve problems can tell you quickly where your styles mesh well or are destined to conflict. If the warning signs are all wrong, you head back to your respective spaces when the art fair is over.

Another challenge that many smaller dealers are facing alone, but may not need to, is the dominance that mega-galleries have in securing museum exhibitions for their artists. As noted in an unsettling report by *The Art Newspaper* (and as discussed in more depth in Chapter 2), "nearly one-third of the major solo exhibitions held in US museums between 2007 and 2013 featured artists represented by just five galleries."[4] Among the factors the report noted:

> In the run-up to a major solo show, galleries often provide curators with access to archival images, pay shipping costs, pre-order hundreds of catalogues and help to finance the opening reception, according to sources. "If a major museum is flirting with a show, we'll play ball as much as we have to," says one director of a medium-sized US gallery.[4]

If a gallery wants to "play ball," but their cash flow makes promising too much a risky pitch in an early discussion with a curator, they may miss an opportunity to

reassure a curator they can count on your support if they propose an exhibition of one of your artists. Collaborating in advance with other dealers who work with your artists on commitments, such that any one of you who discusses a possible museum exhibition with a curator knows already the others are willing to pitch in (and how much), so that you can walk into any meeting with a curator with more confidence, can help lower the percentage of shows going to artists whose galleries are known to have the funding to support museum exhibitions. Of course, such conversations can happen after an initial conversation with a museum, but timing may be a crucial factor in such negotiations. Any means of collaborating to help combat the mega-galleries' dominance is worth exploring.

Outside Facilitators

The best example of an outside facilitator bringing galleries together, in a collaboration that was reportedly very successful for all dealers involved, remains for me an exhibition co-curated by Omar Lopez-Chahoud (independent curator and artistic director of Miami's "Untitled" art fair) and artist Franklin Evans in New York in 2010. I wish we could see more like it. Here was their idea, as described by a New York newspaper that covers the gallery neighborhood in the Lower East Side:

> There has been some excitement here on the Lower East Side around the big group show, *Lush Life*, which opens (officially) this evening at nine different galleries around the neighborhood. The conspirators behind the show, visual artist Franklin Evans (a rising star with an installation currently on view at MoMA PS1) and renowned independent curator Omar Lopez-Chahoud, were inspired by the 2008 Richard Price novel of the same name. The events in the book play out as a crime story—but Price's focus is on the radically different cultures that exist side by side (and often collide) within the L.E.S. community. They are using the book's nine chapter headings as themes for each gallery. Over 60 artists have been invited to participate.[5]

The press for this multi-gallery exhibition (which brought together a range of galleries, from well-established ones with multiple international locations to tiny emerging ones) was overall very good (the *New York Times* wrote of it, "Heaven knows the tired old New York art world could use a fresh story or two. This summer it gets one"[6]). But it also helped energize and legitimize a neighborhood which at that time was still trying to prove itself worthy of the art world's attention, or as Annamaria phrased in in her panel presentation, it presented a "critical mass of art on display to draw attention and create a buzz for the general public." It takes a very persuasive facilitator to convince two galleries to collaborate on a project like that, let alone nine, but the curators of "Lush Life" had a very compelling idea, and

reportedly the only galleries who were not thrilled with the results in the end were those who were not invited to participate.

FINAL THOUGHTS

I want to leave this topic with two final example of how galleries have collaborated recently, one New York effort and one international effort. When Hurricane Sandy devastated many ground-floor galleries in the Chelsea district of New York, the Art Dealers Association of America and several other galleries were tremendously generous in helping those of us affected. From raising money, to getting companies to donate replacement furniture or supplies, to convincing the mayor to take a tour of the damage the storm had caused and meet the dealers, to even volunteering themselves (some examining artwork and helping the shattered gallery owners triage a salvage strategy, others quite literally getting down in the mud to drag out archives of destroyed materials), the way our fellow dealers pulled together to help their own was the most gorgeous and moving experience I have had as a member of this community. I remain extremely grateful to all the volunteers who helped us. Of course, we have all since gone back to being hyper-competitive and strategic businesspeople, but for a while there in October of 2012, the gallery world in New York showed its true colors and they reflected them well.

That same year, and perhaps more importantly, a joint collaboration was launched by four international galleries (gb agency, Paris; Hollybush Gardens, London; Jan Mot, Brussels; and Raster, Warsaw), designed to help educate the next generation of contemporary art dealers. Based in Amsterdam and organized by the de Appel arts center, the Gallerist Programme is an impressive demonstration of why (as I said above) I really tend to like other dealers. Here's what they do (deappel.nl/learn/gallerist/)

> The Gallerist Programme aims to encourage and contribute to the discourse on gallery practice by creating an environment for investigation and discussion for young (and aspiring) gallery owners.
> The curriculum combines seminars focused on art historical reflection of the gallery practice with workshops and case-studies that delve into the practical and administrative aspects of current day affairs.
> The Gallerist Programme takes course over 10 months through 6 intensive workshop weeks that includes the development of a project at Liste Art Fair Basel.

In addition to lecturing once for the program in Amsterdam and visiting their project at Liste, I have encountered individual current and former students from the

program at art events around the world. Each time has been total pleasure. They seem to find the smartest, friendliest, and most enthusiastic young dealers for the program, and they all seem to emerge as the type of gallerist any other dealer would love to know and work with. Providing training to new dealers that is based on best practices and a shared sense of purpose strikes me as perhaps the ultimate consideration in how we create a more compelling gallerist value proposition, as discussed in Chapter 4.

9

Dealers Starting Art Fairs

WHY DEALERS ARE THINKING ABOUT THIS

In March 2015, there were eleven art fair-like events in New York, at least seven of which were founded by art dealers (The Armory Show, ADAA's The Art Show, Volta New York, Independent, Moving Image, Salon Zürcher, and Scope). The book *How to Launch and Run a Commercial Art Fair as a Dealer* does not exist, but it might have an audience. As discussed in Chapter 3, there are currently over 220 contemporary art fairs each year (see Appendix A for a list), partly because launching a successful art fair is straightforward enough, even for art dealers. It is a good deal of work, but not so complex that any dealer who identifies a solid opportunity or obvious omission in the art fair landscape should let a lack of fair-organizing experience stop them from trying. There may be other considerations, like the increased competition and potential art world backlash from the extraordinary number of fairs that exist already, the fact that many fairs take at least three editions to turn a profit, and the hours of sleep they will be sacrificing to pull it off, but very successful fairs have indeed been launched by art dealers or others with no prior experience.

The reasons dealers (or anyone) would launch or buy an existing art fair in this climate include (1) to develop or serve a particular market or audience; (2) to supplement their income; (3) to increase awareness of a geographically, conceptually, or media-connected group of galleries or artists; or (4) as an alternative to

selling art in a location where financial or logistical challenges make presenting art to the public via the gallery model more difficult. Another reason used to be the hope that a larger company would really like and then offer you an attractive sum of money for the art fair you launched. The licenses of the Armory Show and Volta art fairs were purchased by Merchandise Mart Properties, Inc. (MMPI) back in 2007, for example, when the art market was still red-hot and it seemed that many art fairs were being viewed as investment opportunities like technology start-ups. Things have cooled off in that department. Art fairs are no longer being gobbled up by larger corporations, and MMPI put the Armory Show back on the market in 2012, but had no buyers.

A Few Cautions

Just because I insist it is straightforward to launch one, I do not want to mislead anyone into thinking that producing a quality art fair is easy. In Chapter 3, there is a good deal of advice for dealers wanting to do art fairs from Heather Hubbs, director of the New Art Dealers Alliance (NADA), which produces arguably the world's top emerging contemporary art fairs (in New York, Miami, and in collaboration with Art Cologne), and Annette Schönholzer, former director of New Initiatives at Art Basel, which produces the world's best top-level contemporary art fairs (in Basel, Miami, and Hong Kong). Both of them also shared tips on a few logistical challenges in running an art fair that any dealer thinking about launching one should seriously consider. To start off, you will need to interact with a much wider group of vendors than you likely do in your gallery, some of whom you may have little choice about; you will be exposed to opinions about the most nakedly commercial aspects of the entire industry and not have much to hide behind in terms of curatorial concerns or other niceties, no matter how you envision your new fair to be different; and you will need to please perhaps the most *discerning* (I use the term euphemistically) members of the contemporary art world: other dealers.

Depending on where you produce your fair, you may need to hire union workers, whom many dealers have little personal experience with. As Annette noted, this often requires a different way of approaching how you get things done, especially as the profit margins you hope for are subject to a wide range of issues you cannot control:

> It's also that the logistics costs have really increased a lot. Especially in the United States, you're totally at the mercy of unions. I mean, they can make it twice as expensive for you if they choose to. And you have no leverage whatsoever. It amazes me the way they can just increase their hourly rate

from year to year without a blink of the eye, and we don't have even time to adjust our prices, even just to cover those costs. We can only pressure them for more efficiency, which doesn't create a great relationship either.

Even if you make choices that you feel should free you from "being at the mercy of unions," you may find it is not quite that easy. When Frieze art fair launched their New York edition in 2012, one of the deciding factors in locating it on hard-to-reach Randall's Island, a so-called "open shop site," was reportedly the conscious choice not to hire more expensive union workers, in order to help them more quickly recover their considerable costs in producing the fair how they envisioned it. Nonetheless, the unions protested outside the fair, complete with giant inflatable rat, for two years running. Frieze received a considerable amount of bad press for this decision, and some artists who had artwork in the fair joined in the protest in 2013. By April 2014, Frieze announced that they had reached an agreement with the unions after lengthy negotiations and would be using only union laborers by 2015.[1] Besides requiring you to negotiate terms you can afford with unions, some locations may also require you to hire their caterer or their audio-visual company or other vendors who, because you have no choice, can and will charge you their top price and may not care too much about how happy you are with the quality of their service. Obviously, you will want to ask about all such requirements for any location you are considering well in advance. Most rental agreements spell all this out, but by the time you are reading an agreement, you have usually mentally settled on that location.

Many dealers launching fairs have attempted to frame their effort as an alternative to the traditional fair model, crafting their brand and press releases to tout their more-curatorial approach, but it is extremely difficult to get the art world to buy into this. First of all, three or more dealers setting up shop for four to seven days somewhere outside their gallery spaces, especially when it coincides with other fairs, will be invariably see their efforts dubbed as just "another commercial art fair" unless they go to extreme lengths to discourage anyone from thinking the work on display is for actually for sale. Experimenting with installation design is one way dealers have tried to distinguish their vision from that of other fairs, but there is a particular risk there too. As Heather noted in our interview, she has noticed fairs that began with very unconventional installation designs gradually begin to follow a more standard format. She said this was a response not only to gallery feedback:

I feel it's collectors too. I remember overhearing collectors chatting about [two fairs, one with a standard installation format but arguably less interesting art and one with an unconventional format but what many

insiders would insist was higher quality better art], and they were all going on and on and on about how much they preferred [the standard looking fair] because they found [the unconventional one] too confusing . . . too messy. I feel like they couldn't see the art, they couldn't see that it was higher quality, because [the layout] was just too challenging for them.

She observed how other unconventional fairs also seem to gradually become "more defined":

Which is not a criticism. It's fine. It's the right thing to do, to respond to what people are saying. And I think it does help the galleries. It helps them do business in certain way.

Speaking from experience, I will agree that you can go too far in playing down the fact that the work presented at more curatorially conceived fairs is still for sale. In two of the fairs I have co-organized or co-founded, including SEVEN (a dealer-run fair that we did for three years in Miami and New York) and Moving Image (the experimental film and video artwork fair I co-founded with Murat Orozobekov and launched with Wendy Olsoff and Penny Pilkington of New York's P·P·O·W gallery), we struggled with visitors thinking they had stumbled into a "festival" or an "exhibition" and not understanding that they could buy the artwork they were clearly enjoying. We have taken several steps to correct that perception in Moving Image, but continue to experiment with others. Many contemporary art world insiders, including top collectors and curators, have told us how much they loved the less traditional approaches of SEVEN and Moving Image, but, initially at least, sales were not as consistent as they would have been had the signifiers clearly communicated that "Yes, indeed, you can buy this and take it home."

Finally, if there is one thing to keep in mind with every single decision you make as an art fair organizer, it is that fairs exist first and foremost to provide participating dealers with an opportunity to meet new collectors/curators and reinforce their relationships with known collectors/curators, all in the interest of networking opportunities and facilitating sales. Other side benefits—such as learning about new artists, enjoying an interesting panel discussion, or having streams of students or the non-collecting general public tell you how much they like the work in your booth—are nice, but dealers are paying to meet collectors and curators, full stop. By launching an art fair, you are saying you have an idea on how to help them do that. Switching hats, from the one you wear when competing with other dealers to the one that requires you to do everything you can to ensure they have a successful fair experience, is crucial. It helps if you keep in mind the metrics you use to judge how

successful any fair is and whether you would do it again. In short, the participating dealers in your fair, as demanding or unreasonable or exasperating as they may be, are your clients. Don't forget that, or you may not need to concern yourself with it for long.

Summary of Pros and Cons

We will delve into the mechanics of launching a commercial art fair below, but first let me list the potential pros and cons as I see them and share how other dealers who are organizing fairs see them as well,

Pros

- It is a good complementary business for an art gallery. If it is headquartered in the same space (and why not?), it can help a gallery's cash flow as well.

- It reinforces your position in the art world as an authority (see discussion in Chapter 4 on how this contributes to a strategic advantage).

- Much more than participating in fairs, organizing one greatly increases your network, particularly within the field the fair is focused on.

- The two preceding advantages can help you increase sales in your gallery as well.

- It enables you to work to change how fairs operate from the inside.

As dealer Andrew Edlin, who is also owner of the Outsider Art Fair, which takes place in New York and Paris (www.outsiderartfair.com), told me, "[T]he fair's success has increased my profile and credibility with collectors and press." Murat Orozobekov, co-owner of our gallery and co-founder of Moving Image, added, "One of the pros of running an art fair is the endless opportunity to promote your gallery artists while traveling for the fair, without exhausting the gallery's travel budget." Finally, dealer Elizabeth Dee, who co-founded Independent (with Darren Flook, formerly of London's Hotel gallery), a fair that launched in New York in 2010, added the completely format-bursting Independent Projects in 2014, and will open an Independent fair in Brussels in 2016, shared that having more than one business frees her mind creatively. Moreover, she said, "I'm interested in the tradition of gallery culture and believe in gallerists' work and want to champion it. [Running Independent] inspires me to know my colleagues and collaborators in a closer way. More now than ever, I sense that we are all making great sacrifices and facing similar challenges, and doing great work which will be remembered."

Cons

- It takes time . . . a lot of time.

- You will be held personally responsible for contributing to "fair fatigue."

- It requires start-up capital and as such represents a significant financial risk.

- If not managed well, it can take away from your focus on your gallery or your artists' careers (even as, noted in the "Pros," it can help with this as well).

Andrew told me the most noticeable downside for him was how "the sheer amount of time involved in running the fair adds a lot of weight onto my gallery operations, as the personnel involved are virtually the same." Murat echoed that time was what springs to mind the most, given how "it requires a lot of travel for meetings with dealers, collectors, museums to promote the fair in its upcoming city." Whereas Elizabeth noted the complicated social challenges sometimes involved: "It's hard when I cannot act to help a gallery by inviting them, especially friends. There is a lot of pressure to support all galleries who want to do the fair and invite them, which is impossible."

Why Dealers Make Great Fair Organizers

Despite the challenges, and before any of that discourages you from launching your own fair, let me also share why I feel dealers make particularly good art fair organizers. Most fairs launched by dealers have a gallery-centric model or point of view. Dealer-organizers "get it," in other words. They know what dealers think about certain unpleasant aspects of doing a fair and what they hope to gain by doing one, and often they work harder to address them in their model. They also understand that quality and context matter a great deal to their participants (because they also matter to them, when they do a fair). One of the criticisms that MMPI received when they first bought the Armory Show was they simply did not understand the gallery world or dealers' needs in the fair context, and they tried to maximize profit in ways that cost them credibility and the loyalty of longtime participants. (They have since made great strides to address some of those earlier mistakes, and nearly everyone agrees the Armory Show is back on the right track.) Dealers also often have relationships—with collectors, press, and museum groups—that non-art world entrepreneurs launching a fair may struggle for years to develop. Knowing, again, that they are expected to put those relationships to work to help participants meet new collectors and curators makes dealers particularly effective fair organizers in my experience. Finally, dealers usually understand artists better and understand how

to talk with them, which can be important for facilitating smoother installations or other projects artists need to be on site for, which makes the participating dealers' experience more pleasant as well.

THE MECHANICS OF DOING THIS

There are many more details to organizing a fair than I have space to share below. I am serious that someone could write a book on this topic. In the context of this chapter, it makes most sense to call attention to the mechanics involved as they relate to navigating the evolving contemporary art market or as they might intrigue you or make you decide this is definitely not for you. Toward that end, let's discuss the first major decisions you make when launching an art fair, framed by the basic questions your composition teacher taught you to answer in every essay you write: how, what, why, when, where, who, and then "how" again in more detail.

How

Out of the gate, you need start-up capital to produce a fair. As noted above, many fairs take at least three editions to turn a profit because start-up investments can be so high. Some of the resources you invest in can be reused in subsequent editions, plus you will learn a lot about how to save money each time you produce a fair, all making each time you produce one potentially that much less expensive. But the first time around, before any dealer has agreed to participate or sent you a check, you will still need to put deposits on a range of things or pay in full for others, including rent, materials, some staff perhaps, branding, a website, lawyer fees, and so on.

How much you need will depend to a large degree on your answers to the questions below. As benchmarks, though, we invested about $100,000 launching Moving Image (which is an extremely inexpensive fair to produce because we do not build any walls and, due to the time-based medium we present, the fair is limited to no more than thirty-five artworks). Andrew Edlin told me his estimate for the start-up costs for a new dealer-run fair (with perhaps thirty to fifty participants in a major city like New York, London, or Paris) was $200,000 to $350,000, depending on the size of the fair and their willingness to spend on advertising and PR.

Your total production budget will be considerably more than your start-up costs, but many of the checks you will need to write can wait until after participants have paid you. You will also need to create a legal entity and open a bank account for your fair. Many fairs in the US form as a limited liability corporation (LLC). How involved your attorney and accountant need to be may vary depending on your model, but I highly recommend at least talking with them about it, in particular about steps you need to take to separate the fair from your gallery business.

What

In the same way you decided where in the contemporary art market to position your gallery, you should position your art fair by answering a similar series of questions. Will your fair serve the primary market exclusively, or will secondary-market work be acceptable as well? Will you cater to emerging, mid-level, or top-level galleries, or a mix? Does it make sense to focus on works on paper, or photography, or some other medium? If so, how will you respond if participants ask to bring other types of artwork? What if they make a passionate argument that the lines you drew are outdated? How strict will you be about your decisions? (Some of this relates to your vision for the fair, which we will discuss below.) Does it make sense to limit who can participate to dealers or artists from a geographical region? It could; not only to promote dealers or artists who may benefit from such a context, but because such niche fairs can grab a certain degree of attention in the cacophony of messages more general fairs put out. However, they can also "ghettoize" the participants or limit the audience who thinks the fair will be interesting.

Other questions to answer include: will you be a satellite of another fair (and benefit from the promotions they do) or strike out into a new time period on your own? Will you position yourself not as a satellite, but as a direct challenger to what is viewed as the current "major" fair in that location and time period? Your answers to all these questions should inform how you answer the next question and the choices you make in defining your vision and in branding your fair.

Why

Once you have identified what kind of fair you are launching, you would be wise to form an advisory committee. This may be entirely different from your selection committee (if your model includes one) but should comprise international market and contemporary art experts. Ask this committee to advise on or review the series of thinking/writing assignments you will do next in deciding how to brand your fair.

Your first assignment is to write your vision statement. In addition to stating the purpose of your fair ("to educate the public and develop a wider market for contemporary artists working in chocolate and yarn," for an absurdly specific example), a vision statement also describes your organization's values. Are you challenging a particular position on contemporary art or the market itself? How should an art fair operate, in your opinion? What are its obligations to artists, dealers, and visitors?

Then write your fair's value proposition (see Chapter 4 for an outline of how to write a value proposition, a very useful tool in communicating what differentiates your fair from every other fair out there). Next, research and write an analysis of the competition's strengths and weaknesses; include a reality check on your own strengths and weaknesses as well. After that, write down the details of your market

strategy: how will you attract "customers," which in this context means galleries. Are you going after galleries already doing another fair at the same time, focusing on an underserved sector, or sliding somewhere in between? How competitive you intend to be will also inform your branding. With all these factors spelled out, you can move on to bigger decisions, like what to name your fair.

There was a trend for a while of naming art fairs things that might be confused for a brand of toothpaste. They are all vivid and punchy, and in that way easy to remember, but with so many fairs now, most of the best choices in that vein are arguably spoken for. Also, whereas many fairs branch out internationally pretty quickly nowadays, I would avoid names that have unintended meanings or connotations in the languages of countries you might later expand into, particularly within the subculture of gallerists and collectors. Your international advisory committee should be helpful with this. Along with ensuring that your chosen name is legally available to you, do a quick search on the domain names you would want for your fair's website. So many domain names that include "art" in them are taken. Being stuck with some unfortunately long, awkward, or hard-to-remember domain name can cripple your early promotional efforts, maybe even to the point of making it worthwhile to choose another name for your fair.

All the other branding decisions you would make for a new gallery or any business apply here as well. Do not forget your business cards and website. You will need them very early on in all this. Hiring a branding agency may blow your start-up budget, but there are few realms in the contemporary art market where the right brand makes as big a difference as it does for art fairs.

People will accept an unusual name for a gallery if it is the owner's surname or a clever twist on a concept, but your fair needs a name that 40 to 300 other dealers will not mind their gallery being associated with, and that extends to every branding decision the fair makes.

When and Where

Some of the decisions you made in the "What" section may dictate your "When" decision. If you are planning to be a satellite of another fair, your main decision is how best to strategize around their VIP opening reception. Most of the other "when" decisions have essentially been made for you by the major fair's dates. Scheduling of your reception, if you even have one, should consider what is realistic for your participants (given they may have business that requires them to be at the main fair for certain events) in conjunction with when collectors and curators are most likely to attend your fair. During the first week in December in Miami, for example, satellite fairs have taken to opening earlier and earlier in the week to try to catch the VIPs who fly in the previous weekend or at the beginning of the week but frequently leave

town the day after Art Basel in Miami Beach's "Vernissage" on Wednesday. This has led some of the satellites to be open a full seven days, which costs their dealers much more in accommodations and time away from home, but does not always pay off as a strategy to entice the VIPs. Nearly every year, some fair in Miami moves their opening reception in relation to all the other fairs, in a seemingly endless jockeying for position that often only confuses collectors. Typically, few satellites will go up against their main fair's opening reception, but if the likelihood that the big VIPs will ever attend your fair is slim or dependent on your physical proximity to the main fair, you may gain more than you lose with such a strategy.

If you are not orbiting another fair, your chosen dates should account for major holidays or other times when collectors and curators are less likely to attend a fair in your location, such as during the opening week of the Venice Biennale. The international contemporary art fair calendar is so packed at this point that there are fairs nearly every week of the year and often multiple fairs in places so far from each other that even the most intrepid fair followers now have to make choices. Consider carefully which collectors and curators your participating dealers most want to meet (and what those VIPs' priorities are) and schedule your fair when it seems most feasible they would attend.

Where you locate your fair includes two components: which city or suburb it will be located in and then what kind of structure it will be housed in. I say "city or suburb" because very remote locations without any supporting transportation systems may sound cool or inexpensive, but you have a lot of things to move into and out of your fair, the least of which is humans. Which city or suburb you choose, whether as a satellite or not, should be informed by your vision as well as the customs and preferences of that place's collectors and general public. Locating your fair where local collectors and institutions are likely to be excited by its vision is particularly helpful. After New York and London, for example, and with a wide range of other cities we were researching, we chose Istanbul as the third location for Moving Image art fair, based mostly on the support for video art its institutions and collectors have demonstrated.

The structure you house your fair in should, where possible, reinforce your brand. The more upscale your fair is, the more likely visitors will expect a higher level of production and amenities. That may be something you have more control over in some cities than others, depending on rents in that region. Tents are popular for fairs at the moment, as they can permit location flexibility and more control over the fair's interior look and feel. Custom tents are expensive, though, and many fairs that opt for them must pay them off over several years, limiting their initial competitive pricing strategies. In choosing a building or event space, also consider local collectors' and institutions' perceptions of that space. What might strike you as a cool

location may be viewed as anything but by the local art scene, for any number of reasons. Inviting someone local to join your advisory board is always a good way to learn about such things.

Finally, make sure you discuss in depth with the owners of any building or event space you are considering what their schedule or installation restrictions are. Are there hours when loud noise is forbidden because of neighbors? Does the building permit drilling into walls or the floors or the ceiling? Does the building turn off its AC during certain hours? Must you use union labor in this location? Is a freight elevator only available until a certain time? Must you rely on their operator? All of these issues have caught us by surprise in locations we have rented. We know to ask now. We also know to make very nice with the building managers who control so much of the flexibility you can be shown. In essence, they usually only want to know that you understand the regulations and are not going to try to violate them. After that, most of them become quite friendly and helpful, in our experience.

Who

Your next decisions, based on your brand and market position, will be who you invite to participate. Your fair participants set an important tone, as well as an expectation of quality, in the mind of potential visitors, but there are other questions to answer beyond how hip or stately you want to be viewed. Will you invite nonprofits, for example? If so, can you afford to make any accommodations for them? Will you invite post-brick-and-mortar galleries? Some fairs require participants to run a physical space and have strict requirements on how many exhibitions they must produce each year. The general impression among fairs is that such dealers deserve the opportunity more, because of the cultural role they play in presenting exhibitions, and the overhead they pay to do so. Such requirements seem to be loosening up for the smaller fairs to some degree.

Whom you invite should include price point considerations too. As discussed in Chapter 3, collectors generally expect certain price points for artwork in different fair contexts. Your vision may be to mix top-level galleries in with the emerging galleries, but that may not always work out so well for participants. As Murat noted, "As much as I want big name galleries in the fair, I don't want galleries who bring work whose price points creates ridiculous gaps in the overall prices of works in the fair." That consideration includes artwork priced too low as well as priced too high for the context you are building.

Once you have decided who you want in your fair, your next decision is how to invite them. It goes without saying that you advertise the opportunity by announcing your fair, its vision, place and time, etc. Then fairs generally follow one of two main models for extending invitations: open applications or exclusive personal

invitations. Moving Image and Independent use the exclusive invitation model. Art Basel, Frieze, the Armory Show, and many others use the open applications model. There are pros and cons to both models for any dealer who wants to do your fair. The main upside to open applications is anyone can apply. A downside is open applications generally require a processing fee, usually between $200 and $600. Some fairs also require a significant deposit with an application (as much as $3,000), which they will return (minus a processing fee) to any galleries who are not accepted, generally months later. I personally object to this model (none of the major fairs use it), particularly for fairs that encourage applications from emerging galleries, many of whom are struggling already to make ends meet. To me, it amounts to a mandatory interest-free loan to the fair organization. None of the dealer-launched fairs I know use this method. I assume that is because they understand how many other dealers view it.

The upside to invitation-only fairs is dealers do not have to submit extensive applications or wait to learn whether they were accepted. Waiting becomes particularly complex when there is a reasonable expectation an application may be rejected, but the fair does not announce their decisions until opportunities to apply to other fairs have closed. Does the dealer here apply to two fairs, with two fees, and hope that only one accepts them? (Many applications become binding contracts upon acceptance.) The downside to invitation-only fairs for dealers who want to do them is a lack of clarity on what leads to an invitation, or how galleries interested in the fair might secure one. Given this is the model we use for Moving Image, I feel compelled to explain that the main deciding factor for us was keeping the entire experience as inexpensive as possible for dealers. We did not want to add even an application fee, which would have been needed if we had to implement the time-consuming, resource-consuming application review process. Moreover, with a maximum of thirty-five artworks in a fair, the invitation method helps the edition's curatorial advisory committee ensure a balanced mix essential to the fair's vision.

Regardless of which method a fair uses for inviting galleries to participate, most of them have a selection committee or advisory committee, which is tasked with either choosing from among the applications or recommending whom to invite for invitation-only fairs, respectively. Although no fairs will put this on their application instructions, it is widely understood that committees also help shield the fair organizers from disappointed or even angry applicants who were not selected. The "black box" nature of the selection process (very few fairs offer any feedback at all with rejections) lets the organizers themselves remain on good terms with applicants, who may become future participants. Most selection committees consist of other dealers already committed to doing the fair. Advisory committees are generally more mixed and may include dealers, curators, collectors, art advisors, or others. Committee

members of both kinds also serve as ambassadors for the fair, helping to increase awareness of its programming and doing outreach to desired dealers and collectors alike. Inviting and meeting committee members is also an added networking opportunity for the fair's organizers, as well as the committee members themselves.

Once you have invited all the galleries who wish to participate in the fair you envisioned, you're ready to return to "how." How does one actually produce a fair? What are the steps involved? The overview below leaves out a fair number of details, but highlights the main things you need to consider.

Contracts

You need a written, signed contract from every participating gallery before confirming their participation or announcing it. The contract should include details of the hours and services the fair is offering participants, what their fee includes, and each party's rights and responsibilities by entering into the contract. Chapter 14 includes a template for an art fair contract, with explanations of the sections you would need to customize for a new fair.

Schedules

As early as possible, you'll want to send detailed schedules for participating galleries outlining deadlines for information or materials, as well as times for moving into the fair space, installing, maintaining a presence at the fair, de-installing, and moving out of the fair space. Schedules for any special events should be communicated as early as possible. Timing here is important so participants can schedule their shipments and make travel and accommodation plans for their team, hopefully securing less expensive early rates.

You will also want to work up a very detailed production/promotions schedule for yourself and your team, including reminders to participants about deadlines or other logistical issues, and of course every single communication you need to have with the landlord or your vendors to make sure nothing falls between the cracks. Don't worry. Things *will* fall between the cracks, no matter how on top of the schedule you stay. There are just that many moving parts. With each edition of the fair, you will get better at timing it all. The first time out, though, expect the final weeks before the fair opens to be entirely insane. Consider not over-engineering your programming in the first edition. Many fairs have panel discussions, performances, parties, and so on, and these have somehow become expected of every fair, but remember that what will matter most to your participants is how well the fair enables them to meet new clients and reinforce their relationships with existing ones. Put your energies into delivering that during the first edition, and you will have plenty of interest in a second edition.

Information Gathering System

Many fairs develop an "Exhibitor's Manual" that includes the schedule discussed above plus forms for the various information the fair needs to gather, such as names for badges, details for catalogs, shipping company information, insurance company information, booth build-out design, any booth extras like closets or extra lighting they want to purchase, any special requirements, and so on. Increasingly, much of many fairs' "Exhibitor's Manual" is contained in a gallery-specific online dashboard that tracks their individual progress in meeting deadlines, sends automated reminders, and avoids the need for mailing or faxing completed forms. We developed a bespoke one for Moving Image, and it is a life-saver.

Programming

Even though I advise against over-engineering your fair's programming in its first edition, there are some events, like opening receptions or certain VIP events, so common in fairs now that you may want to consider them. Keeping in mind your primary obligation to participants (that is, helping them to meet new collectors or to reinforce existing relationships), events with private collector groups or museum groups in particular are worth a little extra effort. Events that distract from that goal (and many fairs are packed with them) often seem like a good idea to new fair organizers or advisory committees more than they do to paying participants. Also, keep in mind that VIP events need to actually offer something exclusive. It need not be luxurious (although that is often the expectation), but it should be something VIPs who show up will feel was vetted and special.

Events that underscore your vision statement may be important to meeting the fair's long-term goals as well. If education if one of your stated values, then panel discussions or tours with student groups may be a good way to deliver on that. If community outreach is part of your vision, then off-site events may be what you want to focus on. Keeping it simple is always good advice.

Local Support and Diplomacy

Major fairs bring a lot of money into their locations, and so local officials are often involved with promoting them. Depending on the scale of the fair you want to produce, it may make sense to reach out to city officials. It definitely makes sense to reach out to local collectors, museums, and nonprofit art institutions. The latter two may view your commercial art fair as a potential new sponsor of their efforts, so be prepared for what initially seems like a hearty welcome to reveal itself as a pitch for financial support. Then again, you are pitching something to them as well, so don't let that stop you from reaching out. Have a polished presentation or document, with

full details about your fair, ready to leave with them. Definitely have your fair business cards ready by this point, as well.

In addition to seeking local support, if you are launching your fair where other fairs already take place—especially if you will be doing yours at the same time—make a courtesy call to the existing fairs' directors and let them know about your plans. Invite them out to lunch or request an appointment in their office. There is no guarantee they will receive your news warmly, but diplomacy goes a long way in the art fair community. Chances are you can collaborate on things like shuttle buses between your locations or coordinate your special events to everyone's advantage. At the very least, you will have paid them respect, and that will hopefully lessen the odds that they respond as defensively as they probably have the ability to do. One fair I know of, that was not at all pleased about the new guy setting up in their town, waited until the last minute to file suit against the interloper for "violating their copyright." It was a questionable case at best, but the new guy had no time or bandwidth to fight it and so had no choice but to rebrand and quickly remake and redistribute thousands of dollars' worth of printed materials, all at an extraordinarily hectic phase of launching their fair. (The new guy did an impressive job of recovering from the ambush, I must say.) I am not entirely sure what more diplomacy might have done in that case, but in hindsight I am sure it probably seemed worth more of an effort to the new guy.

Location Requirements

As discussed above, ask potential landlords plenty of questions. A quick list of things you need to know about includes contracts with union workers, existing building security, private security you may be responsible for hiring (and what kind of licenses they must have), build-out restrictions, timing for entry, electricity (whether you must pay extra for it and how, as well as their current capacity; you may need to supplement it), Wi-Fi capacity, elevator access or regulations, public access issues, available facilities (do they have suitable, accessible restrooms or must you hire your own; and where can they go), level of event insurance required, food and catering regulations, alcohol license and insurance requirements, and so on. Again, most of this will be spelled out in a rental agreement, but asking up front lets you move on if you cannot work within certain restrictions.

Architect

We have only worked with an architect tangentially for Moving Image. Fairs with high-end designs often use well-known ones, and the result is clearly noticeable, but there are also production companies with plenty of art fair experience who offer such services. How innovative your floorplan and design needs to be is usually a

vision and branding question, but it may also be required by an awkward event space. Architects are great for maximizing the square footage you have in a way that's resolved with your vision. Like branding agencies, PR agencies, and other expensive services, whether you hire an architect your first time out may depend mostly on the start-up capital you have. Working with students who may be more affordable is an option to explore here as well.

Build-Out Design, Planning, and Materials

If you are going to put up booths, you are going to need walls, flooring, trusses or something that carries a lighting system, and a way to deliver electricity to participants' booths. Regardless of whether you build booths (and several fairs currently do not, including Moving Image, so it is an option), you are still going to need an entrance design, information desk(s), possibly lounge areas, a food or beverage service area, a fair office, storage/loading/drayage holding areas, restrooms, and possibly large signage installed (indoors and outdoors) that indicates how visitors are to find their way around and, importantly, find specific participants and facilities. You do not need to know how to do all that or even manage it all yourself, though. You can, and depending on the size of your fair probably should, hire a specialized art fair production and management company, at least for some parts of the build-out planning. Unless you have a good rate on storage, you probably want to rent, rather than buy, the materials for your walls, flooring, and lighting as well.

Eric Romano and Sarah Haselwood have more experience producing art fairs in all kinds of locations and conditions than anyone I know. They run the company SPACE I design + production (space-productions.com) and were kind enough to send me the following insights into what first-time fair organizers should know and think about in planning their build-out:

> The markup [that fairs charge participants for walls, lighting, etc.] is usually around 100%. The reason this markup is so high is it is used to offset high overall production costs. For example a completed 12' x 24' booth might cost a fair $2,500 just to build, not including the rental of the space, which in a tent or a city like New York, can easily be another $2,500. The hard costs for a 288 square foot booth can easily be $5,000. After these costs, an organizer has to add overhead, marketing, PR, advertising, fees etc . . .

> The most important things that determine the costs are the size of the show and the location, less so the date, but that can also impact prices. (The second most important factor is if you are using union labor or not.)

> For producing and management fees, we determine a price based on the overall production budget of the event.

Wall prices are determined by the height and number rented. A 4' x 12' wall panel runs from $115–135. This is installed, taped and painted.

Light prices are determined by the type of light, from halogen to LED, and the amount of truss needed to hang the lights. The average price per light ranges from $40–50.

Electrical prices, to feed the lights and booth computers etc, are based on the size of the show and how much equipment is needed. A fair price range is anywhere from $8–30K.

The time you will need to build out your fair (before any art comes in) will again vary depending on the size of your fair, the level of its production, and the readiness of your space. For tents or other structures that may require flooring to be installed, the time can be considerably longer. Even if you are working in an event space with usable flooring, the typical build-out is at least two to four days, or longer for larger fairs. This is time during which you are paying rent, likely paying security and utilities, and definitely paying workers. Generally the working conditions during build-out days at fairs are dirty and uncomfortable. We have been freezing, roasting, or unable to sort out how any building could contain so much dust during build-outs at various fairs we have produced. Do not wear you best outfit to build-out days. Also, invest in walkie-talkies and develop a system with your staff for tracking problems that arise; more will pop up than any of you will likely remember. With everything you have been organizing for months coming together, or not coming together as will happen, build-out days are generally the most intense period of any fair. Pace yourself as best you can.

Design and Printing Needs
In addition to your logo and business cards, you will need to design stationery, badges, maps, possibly tote bags, wall text, a catalog, flyers, and a range of other materials. Paying for a good branding exercise will of course leave you with templates for most of these, but no matter how well you prepare, things will crop up that need to be designed and printed at the last minute. Examples might be an additional sign to solve a navigation issue (where people keep getting lost) or clear up confusion about a special project or other things you may not think about until visitors bring them up. It is a good idea to have a designer with all your images and specs and a printer who has delivered materials that have met your approval already standing by, just in case.

Promotions and PR
As Andrew Edlin noted above, marketing strikes many first-time fair organizers as perhaps a discretionary item in their budget, and so it is often the one that gets cut

to pay for other needs that crop up. Promotions and PR are perhaps easier to skimp on in locations where people already know you, but I would not recommend skimping somewhere you do not have strong connections to the press and art institutions already. Again, dealers are paying you to facilitate face-time with clients, which means that those clients need to know that your fair exists. Even knowing you exist is no guarantee they will show up, especially if there are other fairs happening at the same time or they are not clear what makes you worth the effort. We have paid as little as $5,000 to retain a public relations specialist for a fair we produced. Rates go up considerably from there. Negotiating with a younger PR specialist can save money, but in addition to their promotional advice, you are paying for their connections, so be sure they have some.

Sponsors and Media Partnerships
It used to be easier to get sponsors for art fairs before there were so many art fairs, especially before the recession. Bigger fairs get banks or watchmakers to sponsor them, while mid-level fairs tend to get beverage companies and publications. Some sponsors can afford to give you cash, whereas others will only be able to offer their product or discounts for your participants or in-kind sponsorships. It all helps. Bigger companies willing to sponsor an art fair need to be contacted about it many months in advance to get all their required approvals done in time. A year in advance is not too long, so do not get too discouraged if your proposals are less successful the first year. In your sponsor pitch, be sure to outline the demographics of your audience, estimated attendance, the fair's vision statement, your media plan, specifically what you provide to your sponsors in terms of exposure (for example, on your website, on all printed materials, on banners at the fair, etc.), as well as what they are asked to provide to you in return. If a sponsor wants a physical presence at your fair, definitely ask for something significant in return; consider how much you are charging galleries for the same space as a guideline and negotiate from there.

Catalog
If you are just starting a fair now, you are in luck when it comes to catalogs. Seemingly every online art selling channel out there wants to produce the online catalogs for any and every fair they can. I say this not only because they partner with us for the catalog for Moving Image, but because they quite literally set the standard for quality graphic design in the art world; Artsy.net produces the online catalogs to beat in my opinion. (There is growing competition in this field, but Artsy established early dominance in it, and we are truly grateful for their partnership.) The advantages to online catalogs—aside from printing costs and the logistics of receiving, storing, distributing, and invariably disposing of leftovers from the thousands of copies fairs

are used to publishing—include how they are available to collectors who cannot attend the fair (but can still email a gallery or pick up the phone to inquire about work they see there) and how they launch before the fair opens and remain up after it closes, often with indications of works that remain for sale. Print catalogs simply cannot compete. Moreover, I cannot count how many fair catalogs I decided to leave in a hotel room, realizing my luggage would otherwise be over the weight limit, and I suspect I am not alone in that.

Staff for Your Fair

The good news for your gallery staff is that they get to work on your fair! The bad news for your gallery staff is that they get to work on your fair, while they keep working on the gallery. They will indicate to you the limits of this pretty early on. In addition to what your gallery staff can assist with, you will likely want to hire someone to help with operations long before the fair opens. Titles vary widely between fairs, as likely do responsibilities. Our setup for Moving Image is perhaps as small a staff as a fair can get away with having. Several months before the fair, we hire a "Director of Operations" (most recently the wonderfully calm and capable Caitlin Bright) who helps us develop the schedule, stays on top of communications, and reaches out to participants as an additional resource for anything they may need. Closer to the fair, about two months out, we bring in co-producers, a technical director, countless expert vendors, and at least one assistant. We also hire interns about a week before the fair. We negotiate rates with each according to their experience and, quite frankly, what we can afford.

Collaborating with Other Fairs

Moving Image is probably a bit spoiled in terms of friendliness from other fairs because our model complements, rather than directly competes with, the other fairs in our locations. Indeed, many of our participants also participate in another fair at the same time. Regardless of your fair's model, if your diplomacy efforts as described above went well, you may also be able to collaborate on certain things with other fairs happening at the same time. Shuttle buses, honoring each other's VIP passes, linking to each other on your websites, listing each other in your programming section for what else is happening—all of these can be very productive in helping you achieve your mutual goals. Reaching out to the other directors early on is the key here.

Dealer Relations

As your participating dealers begin to arrive, no matter how many crises you are struggling with, and you will be, remember that **they are your clients** in this context.

Make sure someone in your operation, preferably someone they have already been in contact with, has the bandwidth to make them feel very welcome. Make that some-one's job. When they arrive, go out of your way to make introductions. Build as warm and fuzzy a feeling for the fair with them as you can. Remember, many of them have traveled a long way to be here, are likely tired, but have a long and pos-sibly stressful installation ahead of them. Have a welcome package ready with their badges, a full fair schedule, kind and helpful gifts (like mints or pens), possibly fair tote bags, any reasonably sized promotional materials they can hand out, the mobile phone number of their best fair contact, and a list of local restaurants, bars, hardware stores, pharmacies, etc. Don't make the welcome package too heavy or too big.

During the installation (also see the problem resolution section below) make sure your staff communicates "safety first" at every opportunity. Set as calm and reassuring a tone as you collectively can, so participants sense everything is going to be fine, even if they are way behind schedule. During the fair, seek their feedback at regular intervals. Do not overdo it, or you may send the signal they should be concerned. Just let them know you are interested in how the fair is going for them. Arrange an event where dealers can meet your advisory committee if you have one, either with cocktails before the fair starts, or as a breakfast one day before the fair opens, both as a networking opportunity and as a thank you for participating.

Problem Resolution

Make sure your staff knows how to separate out problems the fair should own, from ones you can help participants with but they will need to pay for, from ones you really cannot help them with at all. A good tool in triaging this is a work order list. Anyone who needs something is told where to go or who to tell they need it done. That staff member adds their name and request to the list and communicates back consistently that all requests receive attention in a first-come, first-serve order. This sends the requester away for a while, which gives the fair organizers an opportunity to discuss the best approach to unclear situations, again concluding when, according to the contract, the fair should pay to address something or when it is clearly the par-ticipant's responsibility. When it is easy enough for the fair to do something, weigh how much the additional funds mean to you versus building a good relationship with the participant.

Avoid becoming responsible for how happy any participant's artists are about anything at the fair. You own the relationship with the dealer. Dealers own the rela-tionship with their artists. Not only can you upset both the artist and the dealer by inserting yourself in a way that neither ends up appreciating, but very busy dealers have been known to take advantage of a fair's willingness to care, essentially dump-ing the hurt or angry artist on the organizers.

Some participants will simply become unhappy with the fair. Whether it is because they do not sell what they had hoped to, because they were upset with the placement of their booth, or because of logistical issues that they may or may not be right to be upset about, try to limit the impact any obvious disappointment they voice has on your staff or the other dealers in the fair. If you can address their concern, let them know you will try. If you simply cannot fix it, tell them that, and let them know you will be happy to discuss how it might have been otherwise at some later date. While the fair is ongoing, you have all the other dealers to keep as happy as you can.

Press
If you truly have something newsworthy to share, host a press conference. Put out some food and beverages, and have a microphone for whoever is going to speak, as well as a digital copy of their transcript on flash drives if it's lengthy. Even if you don't hold a formal press conference, consider hosting a press preview. Have digital press kits ready to hand out to any journalist, blogger, or interested party who asks for one. Again, flash drives are cordially accepted by most. Include your final press release; high- and low-res images of artwork in the fair and installation shots, from this edition if you can, but of previous editions if not possible; full captions for each image with credit lines; a full list of participants and special events; any materials your sponsors can provide digitally; bios and headshots of the organizers; and contact information for your PR specialist or whoever the press can call or email if they have additional questions. Give them phone numbers—journalists are often on tight deadlines.

If this is your first edition, most journalists will be interested in why you are launching "yet another fair" and what makes yours different. They will ask which galleries of note are participating and what artwork is particularly impressive that they should see. If this is not your first edition, they will ask what is new at the fair this time. Have well-considered answers to all these questions ready. They will also always ask who has sold what to whom, so you need to encourage participants to report sales to you as quickly as they can (which, for many reasons, dealers do not like to do). If you cannot tell the press about any sales, they often report there were none to report. This does not encourage the dealers in the fair or others who read the final article.

Communications during the Fair
While the fair is happening, be sure your team emails two updates every morning before the fair opens. One goes to the public with news of noteworthy events coming up or accomplishments that took place at the fair the previous day. Always include images that would encourage anyone who opens the email to think they need to make time to come see the fair. A professional photo of lots of people crowded around

some visually striking artwork at the fair is always a good choice. The other update goes out to participating dealers, again with the same news or upcoming events, but also with reports of VIPs who had stopped by yesterday or may be coming in today, as well as responses to questions that came up multiple times or the steps the fair is taking to address any problems that arose.

Deinstallation

If you have participated in fairs, you know the deinstallation is often as hectic as the installation can be. Everyone is rushing to wrap up their booth and head home. Other organizers I have talked with confirm that this is the phase when more art can be damaged than at any other time. It may not be as possible to set a calm and reassuring tone during the deinstallation as you did during the installation (your team needs to wrap things up quickly as well), but you can discuss well in advance with dealers who are bringing any artwork that needs particular care or space during deinstallation a plan for ensuring it happens safely. This may require them to wait until other dealers are out of their way. You may need to insist. Do not surprise them with this decision on the day the fair closes.

FINAL THOUGHTS

The discussion above is clearly only an outline of the thousands of decisions involved in organizing an art fair. I tried to frame it within our broader discussion of topics important to consider as the market evolves, but to tie a bow around this topic, I asked Andrew, Elizabeth, and Murat, the dealers kind enough to share their fair organizing experiences with me, to comment on three additional questions about running a fair: what lessons did they learn the hard way? what was their most pleasant surprise about running a fair? and finally, what predictions they had about the future of art fairs.

Their answers to the first question were the shortest. Murat's hard-learned lessons included a gallery not paying their participation fee ("You have to learn it yourself in order not to repeat it") and local restrictions that required quickly redrawing long-set logistical plans or events (and then their corresponding printed materials or communications), such as opening hours, security needs, liquor licenses, etc. Andrew noted that he learned to "be smarter on where you look to keep expenses minimal, and where to spend more freely." Elizabeth said simply there were "Too many to tell."

Andrew continued with succinct answers, saying his most pleasant surprise about running an art fair was that "Our press has been off the charts." Elizabeth clarified that while she co-founded it, she doesn't "run" Independent, but that still she is "most happy when the fair is in session." She added, "It's the most wonderful

inspiration to host such amazing dialogue and energy." Murat elaborated on the pleasure of endlessly meeting new people: "As much as we say the art world is small, there are so many people are involved in the art world. Even with the Internet accessible to near everyone, I am still surprised how many new people, especially similar thinkers, you meet at the fairs."

Their thoughts on the future of art fairs varied even more. Murat insisted, "As long as there are buyers and sellers the rise of art fairs will continue into the future," adding that he predicts more niche fairs. Elizabeth, consistent with her fair's reputation, focused on how "One has to have a philosophy, a point of view and clear audience for making fairs and participating in them. There is no fair in the world that isn't feeling the shifts of the fair-buying art market and looking for ways to refine the scope and develop the energy. I feel that's been our main vision from the beginning: always evolve and stay nimble to respond." Finally, Andrew predicted that "if the economy tanks, many of the satellites will disappear at least temporarily" but added that "our fair will continue to thrive because it is completely unique."

Speaking of the future, I noted above that many fairs are quickly expanding to international locations. The better ones are doing so only after a thorough analysis of when and how to make such a move. I have been very impressed with the paces Elizabeth Dee puts her thinking through before expanding Independent's activities. It is not enough to build a brand in this increasingly competitive part of the art market; you have to work constantly to distinguish it as well. Perhaps turning back to Art Basel, arguably the most successful of all contemporary art fairs, is a good way to illustrate this further. In our interview I asked Annette Schönholzer about their decision to purchase ArtHK and rebrand it as Art Basel in Hong Kong, in the context of fairs expanding internationally. I asked specifically what she thought was behind this trend. Was it all about staying ahead of the competition, was it about building a brand just to sell it off, or was it about serving the galleries who demand more access to another market? Acknowledging it might be any one of those for different fairs, she shared the thinking behind Art Basel's clearly successful approach:

> I can't speak for other fairs. (I often ponder some of the moves or things that we observe; you know, why did this fair add this sector, why did they expand to this area? We question strategies, or at least try. Or we think "That was really smart. We never thought of that.") I can only speak for Art Basel, and from our standpoint, it has been a slow progress. I think we're quoted often as "one of the first fairs to bring a sub-brand of their own brand elsewhere." But going to Miami was actually something that took many years to achieve. It didn't happen overnight, it wasn't a knee-jerk

reaction. There were at least four to five years of planning before it actually happened, and then it got postponed [due to 9/11].

And there was a lot of controversy around it at the time. "Are you cannibalizing your own brand?" Twelve years ago, that's the way it was perceived. The world was really a different place then. After Miami was founded, I recall that [former Art Basel director] Sam Keller started receiving offers from China to put on an art fair. They came generally from government authorities, basically saying "We'll set you up . . . we'll back you up financially, etc., etc." Wisely, Sam did not collapse under those kinds of offers. The analysis at the time was that [the China] market was not ready yet for the Art Basel brand. And that's not meant to be arrogant. Art Basel's strategy is to always be a leading art fair with leading artwork, with leading galleries, with leading artists participating and serious collectors attending it. Asia, at the time, just wasn't there yet. So having money in a market is enough to launch a fair, but it is not enough to launch a fair at the Art Basel level. There were multiple fairs taking place all over the region, and we saw that has something really going for them, and we played close attention to their development.

Annette summarized the essence of their strategy as not making any moves until it was clear they could do so while holding true to the standard of quality they were known for. As noted above, a few fairs have managed to bounce back from a perceived drop in the quality of their brand, but the better—if not always easier—path is to never compromise on quality. It will always be your brand's strongest selling point to galleries and collectors alike, and once lost can derail your plans for many years.

PART III

Why Do Contracts Keep Coming Up?
With M. Franklin Boyd, Esq.

The final five chapters of this book are co-authored by the New York-based arts attorney and former art consultant, M. Franklin Boyd, Esq. Franklin is my most trusted source for any arts legal advice, and she is also a close friend. The chapters in Part III focus on a common business tool that many outsiders are quite surprised to learn the contemporary art industry is extensively averse to: contracts. We discuss that aversion briefly below, as well as why hopes are that several of the evolutions discussed in the previous chapters are softening it up. In Chapter 10, we will look at an example of a standard consignment agreement that seemed perfectly acceptable to many dealers in 2008 and compare it with one that most dealers, and artists, would more likely prefer in 2015. In Chapter 11, we will review an excellent example of an artist representation contract with an eye toward what issues and discussions emerging now might lead artists, dealers, and their attorneys to reconsider certain sections in the near future.

In Chapter 12, we will discuss new art forms and the questions that arise in figuring out how to sell them, resell them, and ensure that the intentions of the artists who make them are clearly communicated to any buyer. As promised in the chapter on dealers starting art fairs, Chapter 13 presents a template contract between participating galleries and the fair organization that is easy to customize for any fair you may launch. Finally, in Chapter 14 we look at client approval agreements and invoices, two agreements with collectors that (with any luck) dealers may need to reconsider

in the context of the evolving market. Those are a few of the reasons that contracts keep coming up. But perhaps the real question at this point should be: why are they not completely common already? (Here it should be noted that contracts are already being made all the time in the contemporary art market; it is just that the parties don't realize they've done so until there is a dispute. The important distinction between written contracts [i.e., intentional] and oral/informal contracts [i.e., unintentional via email] is that by writing out the agreement in advance, the parties have a chance to influence the future outcome.)

Two comments about contracts were raised by influential collectors during my presentation at the Talking Galleries symposium in Barcelona in 2014.[1] The discussion centered on the issue of larger galleries poaching artists from smaller galleries, its impact on those smaller galleries, and some proposed solutions for dealing with the issue. Between them, these collectors simply annihilated any argument that anyone in the art market continues to make for why contracts are not important or why anyone's aversion to them (artists' or dealers') should not be laughed out of the room.

The first comment came from Belgian collector Alain Servais, who is quoted throughout this book and who roundly dismissed the idea that the close relationship between an artist and a dealer is too fragile for contracts:

When you get married you sign contracts, so why can't you sign any contracts between a gallerist and an artist? Why do you think it is? It is completely nonsense. Can you accept that your main assets could be walking out the door like nothing happened? Can you imagine the same thing in a marriage or any business relationship? Why don't you think about [written contracts] as the most obvious solution?

The second comment came from Mark Coetzee, who is the director and chief curator of Zeitz Museum of Contemporary Art Africa in Cape Town, South Africa, and who is actively assembling a major contemporary art collection. Mark added his comment from "a collector's point of view":

One of the questions I always try to determine with a gallerist is how secure that relationship is before we make in-depth purchases. . . . It's very dangerous for us to work with dealers who have not secured these relationships *legally* because if they drop the artist or the artist leaves to a gallery that is not efficient at career development our investment is wiped off the map. [emphasis ours]

Let's face it, no other multi-billion dollar industry runs as casually as the contemporary art market has tried to (and in many spectacular ways failed). Artists, dealers, and collectors to a large degree have simply let slide important protections that

so many other industries have easily implemented through signed agreements. Of all the ways that the art market has embraced corporatization over the past decade, it is perhaps ironic that the one basic business tool that could have helped more arts professionals than any other is arguably the one they resist the most.

More specifically, several of the changes in the market discussed in this book are making dealers think more about contracts. These changes include the more intense threat of poaching by galleries set on rapid expansion, new copyright and permission questions raised by social networks and online sales channels, contexts where dealers are spending more time promoting artists' work but may not have legal rights to sell it there, a more complex inter-gallery dialogue about access to works brought about by a more global art market, dealers expanding their businesses to include new ventures like running an art fair, and many others. In addition to looking at contracts that address each of these, in the next five chapters we also try to share some ideas about replacing legal jargon traditionally used in contracts with less intimidating (but still binding) language to address the resistance many artists still have toward using them.

The information contained below and elsewhere in this book is for informational purposes only and does not constitute legal advice. Legal advice is dependent upon the specific circumstances of each situation. Also, the law may vary from state to state, so that some information provided may not be correct for your jurisdiction. Finally, the law may change and the information may not be up to date. Therefore, the information contained in this book and these forms cannot replace the advice of competent legal counsel licensed in your state or country.

M. Franklin Boyd, Esq.: Franklin Boyd works at the intersections of contemporary art, finance and law. A New York-based arts attorney with a general commercial practice, Franklin is also the founder of Xipsy (www.xipsy.com) and the creator of the Negotiated Resale Right for Artists. She teaches art finance, market, and law courses at the Sotheby's Institute of Art and has served on the boards of Art in General, Zer01, and SmartSpaces. Franklin began her legal career at Cravath, Swaine & Moore LLP, after having worked in the General Counsel's office of the Metropolitan Museum of Art and for the State Attorney General of New York.

10

Consignment Agreements

T here are two basic contracts that help define the legal and working relationships between artists and galleries: consignment contracts (which pertain to, and are limited to, the right to sell and exhibit the individual works of art listed on them for a set period of time) and representation contracts (see Chapter 11), which pertain to the terms by which the gallery has rights to represent more of the artist's works in the future. Although some emerging or mid-level galleries may still wish to avoid representation contracts—because neither has enough experience in the art world, let alone with each other, to feel sure about being contractually bound to a relationship that may not work out, something discussed in Chapter 5 as frequently happening too quickly in many cases—consignment agreements have always been a tool for clarifying the terms of each consignment as well as doubling as a record of who has possession of which artworks. As the years go by, and artworks on consignment travel to fairs, or collectors' homes for approval, or in and out of the gallery's storage—or perhaps the artist has multiple galleries, or participates in many group exhibitions, or moves their studio—things will get confusing, if not occasionally misplaced. A consignment agreement, signed by both the artist and the gallery, proves that at one point both parties knew which works were in the possession of this gallery and upon which terms the gallery had the right to offer them for sale.

Below are templates for two versions of an artist consignment agreement. (They are admittedly tools developed by attorneys for dealers. They are also admittedly

New York-centric, meaning you should discuss with your attorney any terms you are not clear about. In Chapter 11 we will look at a representation contract written for artists that includes consignment terms as well. For this chapter, we decided to focus solely on consignment terms as dealers might want to reconsider them.) The first one is essentially identical to the only agreement used in the Winkleman Gallery in 2008, both for represented artists and for unrepresented artists (who were in a group exhibition or being considered for future representation). This agreement had been shared by another young dealer, and several other New York dealers at that time were also using the same basic format and terms. It seemed to serve young dealers well at the time. It includes or leaves space for the following information:

- Date

- Artist name, address, phone, and Social Security number (for tax purposes)

- Context for agreement, including name of gallery, the understanding that the gallery would attempt to sell the work, and the date the agreement would end

- Title, date, medium, size, edition details, and production costs for each item being consigned

- Terms of the agreement

- Artist and gallery signatures

2008
Consignment Agreement

Date _____ Artist _____

Address _____

Telephone _____ SS #: _____
(hereinafter referred to as the "Artist"), consigns the
following work(s) of art to _____ (hereinaf-
ter referred to as the "Gallery") with the understanding
that the Gallery will attempt to sell said work(s) of art
at the sale prices listed below until _____ or
an agreed upon later date.

TITLE	Year	Medium	Dimension/ Edition	Sale Price (US$)	Cost of frame and mounting

**The Artist and Gallery agree to the following conditions
of this consignment:**

1. If a work of art is sold, the Artist will receive
 50% of the agreed upon price as specified above,
 plus full cost of frame and mounting.

2. The Gallery is understood to be able to lower the
 agreed price by 10% if necessary to make a sale,
 unless otherwise noted above. Any additional dis-
 counts need to be agreed to by the Artist prior to
 a sale.

3. If a work of art is sold, the Gallery will notify the Artist within 7 days by telephone or mail.

4. If a work of art is sold, the Gallery will pay the Artist his or her portion of the sales price (or agreed-to discount price) within sixty (60) days after full payment is received by the Gallery. Until the Gallery has received full payment for the work sold, it will remain in the custody of the Gallery.

5. The Artist understands that the Gallery has insurance coverage to protect the art against damage, loss, or theft.

Gallery Agent Artist

In addition to providing legal protection and a detailed record of the works consigned, any consignment agreement is very useful in raising the issues that the artist and dealer should discuss and agree upon. The 2008 agreement touches on several key points that this discussion should include, but a number of things that happened between then and 2015 in New York, including the impact of the financial crisis on galleries, Hurricane Sandy, the rise of social media, the rise of the art fair (and how quickly everything must happen there), and so on, make it a less effective tool.

The template below provides much more protection, as well as a better outline for prompting the terms a dealer and artist should take time to discuss and agree how to handle. It contains a few footnotes for later discussion that you would obviously not include if adopting this. It also assumes the work on consignment will be in an exhibition or group exhibition at some point in the future. Any of the terms that do not apply for a specific consignment can be edited out of the template. It is a very pro-dealer agreement.

2015
Consignment Agreement

TITLE	Medium	Description	Agreed Upon Retail Price	Additional Framing Costs or Pricing Notes

The Artist consigns to the Gallery and the Gallery accepts on consignment the Works listed above. Gallery and Artist will split the Net Proceeds from each sale evenly. Gallery may sell the work at a discount of up to 20% from the Retail Price. Net Proceeds shall be calculated after Gallery has been reimbursed in full for any expenses associated with the production of the work (e.g. framing, printing, manufacturing of displays).[1]

The Artist has read and understands the "Additional Terms" that are attached here and agrees that those rights and responsibilities are fully incorporated into this Consignment Agreement, which constitutes a binding agreement between Gallery and Artist.

ARTIST

Signature: _____

Printed Name: _____

SSN or TIN: _____

Date: _____

[GALLERY NAME]

Signature: _____

Printed Name: _____

Title: _____

Date: _____

Additional Terms

I. SALES
Consignment Terms

1. Gallery is appointed Artist's agent for exhibition and sale of any works listed on the Consignment Schedules or otherwise delivered to Gallery.

2. Artist agrees that only works created and currently owned in full by Artist will be consigned to Gallery.

3. Artist agrees that none of the works consigned to Gallery are currently on consignment to any third party, and further, Artist agrees not to consign any of the works to any third party for so long as this agreement is in effect.

4. Delivery of additional works to the Gallery will constitute a consignment and be subject to these same terms, unless otherwise agreed upon in writing by Gallery.

5. For each work consigned, Artist grants Gallery a nonexclusive fully paid worldwide license[2] to produce and use images of the work in connection with the sale and promotion of the works or the gallery in general.

Purchased Works

6. For editioned work, the Artist shall provide a certificate of authenticity for each edition.

7. As a courtesy to Gallery and the purchaser, Artist will make, within reason, him/herself available for installation of the purchased work.

8. Within reason, Artist will cooperate with Gallery and any purchaser of a work to repair or restore a work that has been damaged or materially deteriorates after the purchase of such work. Artist and Gallery will cooperate to compensate Artist for his or her time and cost of any materials as necessary.

9. Gallery agrees to remit proceeds from each sale of work within 30 days of receipt of payment by Gallery.[3]

10. Gallery agrees to provide Artist with the name and address of any client who purchases a work by Artist.

II. COMMUNICATION
Cooperation with Gallery

1. Artist agrees to use his/her best efforts to follow through on any body of work that was in progress when selected for a future exhibition.

2. Artist agrees to deliver the specific works selected and reserved in advance by Gallery for upcoming exhibitions.

3. Artist agrees to make him/herself available for regular consultation with Gallery and agrees to use best efforts to quickly respond to emails and messages from Gallery.

4. Prior to framing a work to be included in an exhibition, Artist agrees to discuss the frame selection or other display options with Gallery.

5. Artist agrees to send images of works saved in accordance with Gallery JPEG naming convention as follows: Artist's full name-title of piece-date-medium-dimensions.

For example: *"Picasso, Pablo-Family of Saltim-banques-1905-oil on canvas-83x94inches.jpg"*

6. Artist agrees to refer press and sales inquiries related to the exhibition to the Gallery.

III. EXHIBITION
Exhibition Timeline

1. Approximately sixteen weeks prior to opening of an exhibition, Gallery will confirm dates with Artist.

2. Twelve weeks prior to opening, Artist must deliver to Gallery:

 o one hi-res image of a work to be included in the show;

 o a title for the Exhibition;

 o a current Artist's Statement;

 o updated biography including all prior and upcoming exhibitions, awards, or grants;

 o updated bibliography

3. Eight weeks prior to opening, Artist must deliver to Gallery:

 o one hi-res image (at least 4.5 x 6.5 inches and 300 DPI or greater) for postcard mailing

4. Six weeks prior to opening, Artist must deliver to Gallery:

 o completed Excel spreadsheet with Artist's email contacts for Exhibition announcement

5. Four weeks prior to opening, Artist must deliver to Gallery:

 o hi-res images (at least 4.5 x 6.5 inches and 300 DPI or greater) of all the Works in the exhibition

6. One week prior to opening, Artist must deliver to Gallery:

 o all works and any displays or equipment ready for installation (e.g. "finished" with the exception of reasonable assembly) and in pristine condition

Installation/Deinstallation

7. In the case where Artist requires an out-of-the-ordinary installation for an exhibition, Artist and Gallery may agree prior to exhibition that Artist shall bear or share in the cost of returning the Gallery to its condition prior to the installation.

IV. TRANSPORT
Delivery of Works

1. Artist shall be responsible for arranging delivery of artworks, display, and any other materials to Gallery. Works are to be delivered no later than one week prior to the opening of the Exhibition, unless a different installation schedule is agreed to.

2. All costs of shipping works to the Gallery, including but not limited to packing materials and insurance, shall be paid by Artist.

3. Upon delivery of the works to Gallery, Gallery will inspect each work and acknowledge receipt of the works, noting any damage, major or minor, to any work(s).

4. Each work will be delivered with care and handling instructions clearly indicated on the packing materials as well as separately written maintenance and installation instructions.

Return of Works

5. Unless otherwise agreed, Gallery will return Artist's unsold work to Artist on or before the date that is six months after the conclusion of an Exhibition.

6. Gallery shall be responsible for all costs of shipping, including but not limited to packing materials and insurance, but only for those pieces that were mutually agreed upon by Gallery and Artist for inclusion in the Exhibition or were otherwise requested for viewing by Gallery.[4] Artist agrees to assist Gallery in minimizing transportation charges and, when possible, agrees to personally drop off or pick up works from Gallery.

7. Any works not selected by Gallery that are nevertheless delivered by Artist to Gallery shall be returned to Artist at Artist's expense.

8. If at such time Artist is unavailable or unable to take delivery of Works that have been at Gallery or in Gallery's storage, Gallery shall arrange for storage at Artist's expense.

9. This Agreement shall be terminated upon the earlier of the delivery of the works to Artist or to a common carrier for the purposes of delivering the works to Artist. This Agreement may be terminated at any time prior to six months after the conclusion of the Exhibition by mutual written agreement of Artist and Gallery.

V. ET CETERA
Insurance

1. For so long as consigned works are at the Gallery or under the control of the Gallery, Gallery will insure all consigned works for no less than 50% of the Retail Price as listed on the Consignment

Schedule or, in the absence of a completed Consign-
ment Schedule, a Gallery price list.

2. In the case of total loss of a work, Artist will
 receive an amount equal to what the Artist would
 have received had the Gallery sold the work pursu-
 ant to this agreement (after the recoupment by Gal-
 lery of any investment costs made by the Gallery in
 the work, but prior to any discounts).

3. Artist understands and agrees that Works may be
 temporarily removed from Gallery without Artist's
 permission for the purposes of exhibition at art
 fairs or viewing by clients outside the Gallery.[5] In
 such case, Gallery (or Gallery's client as applica-
 ble) will continue to insure the work on the terms
 described above.

Miscellaneous

4. The consignment agreement between Artist and Gal-
 lery is governed by New York State Law, without
 regard to its conflict of laws provisions.

1. Consider whether credit card fees will be shared by Artist and Gallery.

2. This is a term added in response to how the proliferation of JPGs has changed the copyright considerations.

3. New York state law requires galleries to treat proceeds from a sale as "trust funds." Speak to your lawyer or accountant about best practices for complying with NY Cultural Affairs Law §12.01. Amendments to the law in 2012 allow artists (and their estates) to recover attorneys' fees for violations and may subject galleries to criminal penalties.

4. Galleries may be willing to pay for the return of work that they were unable to sell, but this protects the Gallery from artists sending along "extra" work that Gallery did not request.

5. Consider here also whether Gallery would also like to be able to consign works to online sales channels.

There is little room left for misunderstandings in the 2015 template (but there is often room for negotiations with artists the gallery is eager to work with). The basic position of this agreement, as opposed to the 2008 agreement, is that it spells out the

gallery preferences on every issue and puts the onus on the artist to negotiate those they do not like. As noted in Chapter 5, the reason that contracts have headed in this direction is partly a collective response by dealers to how many top artists smaller galleries have had poached by larger galleries since 2008. Even though this is not a representation contract, the effects of having lost an artist have hardened many dealers' positions on these terms.

11

Representation Contracts

A s Tad Crawford notes in the fourth edition of his book *Business and Legal Forms for Fine Artists*, "Many artists who sell their work through galleries rely on trust instead of contracts." He also notes, "Trust is fine when everything is going smoothly, but it is of little value after disputes arise and neither party is truly certain what contractual terms originally bound the artist and gallery together."[1] Today, many dealers might add that trust is also of little reliability when things are evolving so quickly in the art market.

The template for the representation contract we discuss in this chapter comes from "Form 7: Artist-Gallery Contract with Record of Consignment and Statement of Account" in Crawford's book and is used here with his kind permission. He also very kindly includes access to a digital template of this contract with purchase of his book. Here we should note that Crawford's book is a truly great resource, but it is written for artists, and focuses primarily on their concerns. We are glad that it does. His book needs to exist. But with the rising threat of poaching and corresponding potential loss of paid production costs or framing costs, a lack of clarity on online promotion permissions, and increasingly complicated global market issues, representation contracts should be reconsidered with a focus on the dealer's evolving concerns. Then again, we found very little to disagree with in the template below. The comments we do offer are mostly in anticipation of potential changes we see coming in the contemporary art market (as well as a few issues dealers might disagree on).

However, all of this "written for artists" or "written for dealers" talk paints a more contentious picture than actually exists in most galleries. Dealers still work with artists predominantly because they love doing so. Certainly in the emerging or mid-level sectors, and possibly even at the mega-gallery level, it is far from the most stress-free way to make money. Most dealers we know are close to their artists and truly want what is best for them, but because of changes in the contemporary art market, perceptions are turning toward thinking that "what's best" for both artists and dealers is a better method for outlining, discussing, and agreeing on the terms by which they will partner toward their mutual goals. Written contracts simply make more sense in this climate. There is also an idea afloat that part of the aversion that many artists still have toward contracts (and representation contracts in particular) might be alleviated if the language used in outlining the terms was less legalese and more, well, plain English. Some of the comments below are also in response to such ideas. As we did in the previous chapter, and so that here the template reads more easily, we will footnote our comments.

Artist-Gallery Contract with Record of Consignment and Statement of Account

AGREEMENT made as of this _____ day of _____, 20 _____, between _____ (hereinafter referred to as the "Artist"), located at _____ _____, and _____ (hereinafter referred to as the "Gallery"), located at _____ _____.

WHEREAS, the Artist is a professional artist of good standing; and
WHEREAS, the Artist wishes to have certain artworks represented by the Gallery, and
WHEREAS, the Gallery wishes to represent the Artist under the terms and conditions of this Agreement,

NOW, THEREFORE, in consideration of the foregoing premises and the mutual covenants hereinafter set forth and

other valuable consideration, the parties hereto agree as follows:[A]

1. **Scope of Agency.** The Artist appoints the Gallery to act as the Artist's [] exclusive [] nonexclusive agent in the following geographic area: _____ _____ [B] for the exhibition and sales of artworks in the following media: _____ _____. This agency shall cover only artwork completed by the Artist while this Agreement is in force. The Gallery shall document receipt of all works consigned hereunder by signing and returning to the Artist a Record of Consignment in the form annexed to this contract as Appendix A.

2. **Term and Termination.** This Agreement shall have a term of _____ years and may be terminated by either party giving sixty days' written notice to the other party. The Agreement shall auto-matically terminate with the death of the Art-ist, the death or termination of employment of _____ with the Gallery, if the Gallery moves outside of the area of _____, or if the Gallery becomes bankrupt or insolvent. On termination, all works consigned hereunder shall immediately be returned to the Artist at the expense of the Gallery.[C]

3. **Exhibitions.** The Gallery shall provide a solo exhibition for the Artist of _____ days between _____ and _____ in the exhibition space located at _____, which shall be exclusively devoted to the Artist's exhibition for the specified time period. The Artist shall have artistic control over the exhibition of his or her work and the quality of reproduction of such work for promotional or advertising purposes. The expenses of the exhibition shall be paid for in the respective percentages shown below:

Exhibition Expenses	Artist	Gallery

Transporting Work to Gallery
(including insurance and packing)...............
Advertising.......................................
Catalogs...
Announcements....................................
Frames...
Special installations............................
Photographing Work...............................
Party for opening................................
Shipping to purchasers...........................
Transporting Work back to the Artist
(including insurance and packing)...............
All other expenses arising from
the exhibition...................................

No expense which is to be shared shall be incurred by either party without the prior written consent of the other party as to the amount of the expense. After the exhibition, the frames, photographs, negatives, and any other tangible property created in the course of the exhibition shall be the property of _____ .

4. **Commissions.** The Gallery shall receive a commission of ____ percent of the retail price of each work sold. In the case of discount sales, the discount shall be deducted from the Gallery's commission. If the Gallery's agency is exclusive, then the Gallery shall receive a commission of _____ percent of the retail price for each studio sale by the Artist that falls within the scope of the Gallery's exclusivity.[D] Works done on a commissioned basis by the Artist [] shall [] shall not be considered studio sales on which the Gallery may be entitled to a commission.[E]

5. **Prices.** The Gallery shall sell the works at the retail prices shown on the Record of Consignment,

subject to the Gallery's right to make customary trade discounts to such purchasers as museums and designers.[F]

6. **Payments.** The Gallery shall pay the Artist all proceeds due to the Artist within thirty days of sale. No sales on approval or credit shall be made without the written consent of the Artist and, in such cases, the first proceeds received by the Gallery shall be paid to the Artist until the Artist has been paid all proceeds due.

7. **Accounting.** The Gallery shall furnish the Artist with an accounting every _____ months in the form attached hereto as Appendix B, the first such accounting to be given on the first day of _____, 20_____. Each accounting shall state for each work sold during the accounting period the following information: the title of the work, the date of sale, the sale price, the name and address of the purchaser, the amounts due the Gallery and the Artist, and the location of all works consigned to the Gallery that have not been sold. An accounting shall be provided in the event of termination of this Agreement.

8. **Inspection of Books.** The Gallery shall maintain accurate books and documentation with respect to all transactions entered into for the Artist. On the Artist's written request, the Gallery will permit the Artist or the Artist's authorized representative to examine these books and documentation during normal business hours of the Gallery.

9. **Loss or Damage.** The Gallery shall be responsible for the safekeeping of all consigned artworks. The Gallery shall be strictly liable for loss or damage to any consigned artwork from the date of delivery to the Gallery until the work is returned to the Artist or delivered to a purchaser. In the event of loss or damage that cannot be restored, the Artist

shall receive the same amount as if the work had been sold at the retail price listed in the Record of Consignment. If restoration is undertaken, the Artist shall have a veto power over the choice of the restorer.[G]

10. **Insurance.** The Gallery shall insure the work for _____ percent of the retail price shown in the Record of Consignment.[H]

11. **Copyright.** The Gallery shall take all steps necessary to ensure that the Artist's copyright in the consigned works is protected, including but not limited to requiring copyright notices on all reproductions of the works used for any purpose whatsoever.[I, J]

12. **Security Interest.** Title to and a security interest in any works consigned or proceeds of sale under this Agreement are reserved to the Artist. In the event of any default by the Gallery, the Artist shall have all the rights of a secured party under the Uniform Commercial Code and the works shall not be subject to claims by the Gallery's creditors. The Gallery agrees to execute and deliver to the Artist, in the form requested by the Artist, a financing statement and such other documents that the Artist may require to perfect the Artist's security interest in the works. In the event of the purchase of any work by a party other than the Gallery, title shall pass directly from the Artist to the other party. In the event of the purchase of any work by the Gallery, title shall pass only upon full payment to the Artist of all sums due hereunder. The Gallery agrees not to pledge or encumber any works in its possession, nor to incur any charge or obligation in connection therewith for which the Artist may be liable.

13. **Assignment.** This Agreement shall not be assignable by either party hereto, provided, however, that the

Artist shall have the right to assign money due him or her hereunder.

14. **Arbitration.** All disputes arising under this Agreement shall be submitted to binding arbitration before _____ in the following location: _____ _____ and the arbitration award may be entered for judgment in any court having jurisdiction thereof. Notwithstanding the foregoing, either party may refuse to arbitrate when the dispute is for a sum of less than $_____.

15. **Modifications.** All modifications of this Agreement must be in writing and signed by both parties. This Agreement constitutes the entire understanding between the parties hereto.

16. **Governing Law.** This Agreement shall be governed by the laws of the State of _____.

IN WITNESS WHEREOF, the parties hereto have signed this Agreement as of the date first set forth above.

Artist _____

Gallery _____

Company Name _____

By _____
Authorized Signatory, Title

APPENDIX A: Record of Consignment
This is to acknowledge receipt of the following works of art on consignment:

Title	Medium	Description	Retail Price
1. _____	_____	_____	_____
2. _____	_____	_____	_____
3. _____	_____	_____	_____

4. _____ _____ _____ _____

5. _____ _____ _____ _____

6. _____ _____ _____ _____

7. _____ _____ _____ _____

8. _____ _____ _____ _____

9. _____ _____ _____ _____

Gallery _____

Company Name _____

By _____

Authorized Signatory, Title

APPENDIX B: Statement of Account

Date _____, 20____

Accounting for Period from _____, 20____,

through _____, 20____

Title	Date Sold	Purchaser's Name and Address	Sale Price	Gallery's Commission	Due Artist
1.					
2.					
3.					
4.					
5.					
6.					
7.					
8.					
9.					

Gallery _____

Company Name _____

By _____

Authorized Signatory, Title

The total due ($ _____) is enclosed with this Statement of Account.

The following works remain on consignment with the gallery.

Title	Location
1.	
2.	
3.	
4.	

5. _____ _____

6. _____ _____

7. _____ _____

8. _____ _____

9. _____ _____

Gallery _____

Company Name _____

 By _____

 Authorized Signatory, Title

A. This is a good example of where plain English might help the parties involved feel less intimidated by the contract. While that may sound condescending to some people (and possibly risky to contract litigators), the truth is that few emerging or mid-level dealers or their artists have so much invested in their partnerships that taking things to court makes much sense for either party. In most cases, the advantages to discussing and signing a representation contract, when it is detailed enough, are that referring back to it can help keep things from getting to the point that anyone wants to sue anyone. Of course, that becomes much easier if both sides understand the agreement. One dealer we know, concerned that the language in her contracts would deter artists from working with her, asked her attorney to rewrite them so that the terms were contextualized as the "Gallery Rules." No artists have objected yet that we know of.

B. We would consider adding a clarification here about international art fairs or fairs outside the gallery's region. If an artist has multiple galleries and one takes work to a fair in the city the other is located in, does that violate the geographical exclusivity agreement? What if the gallery wants to take the work to a fair where the artist does not have other representation, but the fair is still located outside the agreed-upon geographical parameters? Certainly artists could be limiting how easily galleries promote their work at fairs, which as we saw in Chapter 3 means that the artist is at a big disadvantage in terms of sales potential through most galleries.

C. There are several reasons dealers might want to revise the wording in this item. In general it is clear enough, but the rising interest many dealers have in representation contract stems from not wanting, as the collector Alain Servais was quoted as saying in the introduction to Part III of this book, to see their main assets walk casually out the door. Many dealers who have had artists poached were left being legally required to return artwork that they had paid production costs for (and no collateral to help collect that money), as well as a loss in terms of what they had invested to promote that artist versus what they had been able to make in revenue before they left. There are many ideas on how to address such situations in contracts (see Chapter 5 for more), including

an agreement that through the remaining years of a representation contract the poaching gallery must still consign the work through the gallery being left (meaning the artist can go, and they will still receive their full portion of any sales in the new gallery, as well as the other benefits offered that enticed them to make the move, but the dealer holding the originally contract is paid, for example, 20% on any sales the new gallery makes through the end of that contract). Another idea is to include "liquidated damages" terms, which are damages of an agreed-upon amount paid by the party breaching an existing contract (which can protect an artist as well). Again, a gallery wanting to poach an artist can offer to pay the liquidated damages for the artist, but the gallery being left is not left in the lurch. None of this can happen if the original dealer never signs a representation contract with the artist.

D. This section could also clarify what the terms are for barters (where the artist trades a work with another artist). If the work was exclusively consigned to the gallery, does that constitute a sale that the gallery would be compensated for? This may not be worth arguing over at certain price points, but clearly would be for more expensive artwork. It is better perhaps to add this common situation to the possibilities here.

E. This could also perhaps elaborate on the circumstances under which the gallery is not entitled to a commission. Certainly if the dealer worked to secure the commission they are entitled to something, even if it may not be the same percentage they receive on sales of work the artist chose to create themselves.

F. We both feel strongly that percentages would be helpful here. There are no standards for museum discounts in general. Both parties would be better off discussing the maximum percentage the gallery has discretion to offer to the range of potential buyers who expect different discounts, and the procedure for handling offers that exceed those percentages (that is, is the response an immediate "no," or should it be "I will discuss with the artist"?). We would also update the list of people entitled to standard discounts—"collectors" or "advisors" are more in keeping with today's contemporary art world than "designers" (indeed, a "designer" may not qualify for a particularly good discount).

G. These may not be the best terms artists can get on this issue. Although dealers in New York would occasionally hear of or discuss disputes about how best to address artwork lost or damaged beyond repair while in the gallery's possession, one result of Hurricane Sandy was a much wider and more open discussion of what seemed appropriate in this situation. For example, although this template indicates what would seem the "fair" terms for both parties, some artists have insisted, in response to Hurricane Sandy, that they should receive more than "the same amount as if the work had been sold at the retail price listed in the Record of Consignment," because, unlike a normal sale where they could ask to borrow that work back for museum exhibitions, for example, the complete loss of the work represented more hardship to them than it did to the dealer who only lost the potential of income from selling it. We realize this discussion is supposed to be gallery-centric, but understanding the logic artists may bring to a discussion on this issue is helpful in being prepared to discuss it.

H. See the discussion above for this item as well.

I. In the strictest sense, taking all steps possible to ensure there are "copyright notices on all reproductions of the works used for any purpose whatsoever" becomes all but impossible in the age of Facebook and Instagram. Other than clarifying that this applies to professional images the gallery uses in promotions or sends to the press, we believe this item will likely need to disappear entirely moving forward.

J. We would add terms about copyright similar to those used in the 2015 Consignment agreement in Chapter 10, to the effect that "only works created and currently owned in full by Artist will be consigned to Gallery." Imagine the artist who finds an old hard drive in the back of a closet in his new studio, finds images on them, and prints them out and presents them as his work. Perhaps in some circumstances "fair use" arguments could be made for his position on authorship, but if the artist who originally created and put the images on the hard drive (but accidentally left it when she moved out) then sees the new studio tenant's "work" on the cover of *Artforum,* the gallery may wish it had added such terms.

In addition to the items covered in the template above, questions that artists or dealers have raised about Representation Contracts include issues involved in founding a foundation for the artist (to protect their legacy after they die), establishing collateral terms for production costs the gallery advances the artist, and a growing number of concerns about how to take full advantage of online promotional opportunities without jeopardizing the artist's copyrights or standing in the art world. One example that has come up more recently is dealers re-consigning primary market artwork to an online auction. Some online auctions require proof of clear title or authorization to sub-consign, others do not, and yet others actively encourage dealers to sub-consign primary market work. Some artists have strongly objected to this practice, but we suspect it may prove so successful a sales opportunity that artists may eventually change their minds about the context.

12

Contract Considerations for New Forms of Art

The contracts discussed in this chapter could as easily be included in Chapter 14 because they are essentially contracts for collectors' use in understanding their rights and responsibilities when purchasing certain types of art forms, as well as giving them what they would need if they wanted to resell them or donate them to a museum. We separated them into their own chapter because of the highly technical issues involved in some new forms of art (that is, as a courtesy to dealers who do not work in any "new" forms of art and who might appreciate the contracts in Chapter 14 being discussed in their own context). In 2008, selling a video prompted perhaps the most complex questions from a collector the average contemporary art dealers had ever had to answer about terms, conditions, and technology. Much of that complexity revolved around how the technology or platform in which an artist had created their work would invariably become obsolete, or how the means to copy and redistribute or present artwork in ways that may have violated the artist's copyrights or been counter to their intentions were being used by collectors who simply were unaware of the issues involved.

Jump forward to 2015, and with technologies like augmented reality, 3D printers as sculptures, video games, or even computer code itself being used, created, and sold as artworks, the number of technological concerns that might be involved are countless, making the rather complex certificates of authenticity and even more

complex art purchase agreements for video art look rather quaint in comparison with what contracts for newer forms of art might require. Indeed, the various concerns one would have to account for in trying to present a template for many new forms of art suggested to us that this discussion might be more useful if instead we examined a standard 2008 video art certificate of authenticity and art purchase agreement as a point of departure for discussing newer considerations that contracts may need to cover.

Not every artwork will require both documents we discuss below. A certificate of authenticity is often sufficient. Artwork purchase agreements are generally requested either by an artist concerned about inappropriate presentations of their work or particular copyright issues or by a collector who wants clarity on their rights and duties with regard to the work, either because they intend to present it or loan it in a public context (such as their own private museum) or because they intend to donate it to a museum that may not accept it without such terms spelled out in writing.

If that all sounds so complex that it makes you want to run from any artist creating new forms of art, let us make it all a bit simpler. There are five basic questions the documents should answer for collectors:

- How is the work maintained?

- Can I move it, and if so, how? (if the work is site-specific or site-determined)

- Can obsolete technology be addressed, and if so, how? (generally instructions for transferring work to a new platform or medium in the event of obsolescence)

- What are the artist's intentions for the ideal viewer experience? (independent of specific technology)

- What are the exact components of the "art work"? (important in transferring title, that is, selling or donating it)

Focusing your certificate and any purchase agreements on a plain-English description of the ideal viewer experience the artist intended is probably the most important of these; communicating that clearly often makes the other questions less vital. After that come guidelines from the artist on how collectors should address obsolescence, to ensure their intentions are maintained as best as possible. Each of these documents should also provide full details of the work, so any technician involved can assemble it or transfer it in a way that respects the artist's intentions.

As we did in Chapters 10 and 11, we will footnote our comments about the templates below to make reading them as they should be used more straightforward.

SAMPLE CERTIFICATE OF AUTHENTICITY

The main purposes of the certificate of authenticity for video or other digital or technology-based artworks are to confirm the artist authenticated this artwork as original and to provide the collector with a certified means of transferring title (donating or reselling the artwork as an authorized original) later if they choose. The official author of the document is the artist (although galleries often prepare them and artists then review and sign them). The most important components of the certificate are a verifiable description of the original artwork (that is, an explicit declaration of what comprises "the artwork") and the artist's signature.

Certificate of Authenticity

Artist: **Artist Name**
Title: *Artwork Title*
Year of origination: 20XX
Edition number: X of X, plus XAP[1]

The subject matter of this certificate of authenticity is the work specified above. It has the following features:

1. Type of work: single-channel digital video / video game / etc.[2]

2. Format: DVD / BluRay discs / USB Flash drive / etc.

3. Manner of installation: (see attached *Installation Instructions*)[3]

4. Duration: XX minutes / perpetual

5. Dimensions: Variable, but video has an aspect ratio of 4:3 / exact dimensions[4]

6. Color or BW: Color

7. Audio: Sound

8. Year of completion: 20XX

9. Signatures: On this certificate and box set cover[5]

10. The following items are provided with this work:[6]

 a. One exhibition copy of the disc in DVD / BluRay / etc. format

 b. One archive copy of the disc in DVD / BluRay /etc. format

 c. The digital file on an external hard drive / USB flash drive /

I hereby confirm that I created the work specified and described above, alone, and that it was completed in the year 20XX.

I also confirm that the work is completely described herein, and does not include nor require any other artifact or specific method of display or viewing, save as described in the *Installation Instructions* attached.[7]

Furthermore, I acknowledge that the *Installation Instructions* refer to current practice, and I agree that the references therein to specific technologies are likely, when circumstances change in future, to be difficult or impossible to follow precisely. In which case the owner of the work may use other technologies and equipment to display the work which best emulate the technologies described.[8]

It is the [1st/2nd/3rd/etc.] original from an edition of X (plus X AP) identical originals in total.

The artist's master is located at Address, City, Country. It is for backup purposes only and shall not as such be used for exhibition purposes or disseminated to third parties.[9]

The work is in its final version. I hereby undertake vis-à-vis the buyer and any future buyer of the work neither to alter the work (or its installation instructions)—or other originals of this edition of the work—nor to cause it to be altered in any manner whatsoever. Likewise, I also undertake vis-à-vis the buyer and any future

buyers not to prepare any further originals of this work or to cause such originals to be prepared.

I hereby confirm the authenticity of the work, which only subsists in conjunction with this document.

Location	Date	Artist's signature

Location	Date	Gallery representative signature

Installation Instructions
Artist Name, *Artwork Title*, 20XX

This description generally avoids prescribing equipment or player formats, but rather the artist's intent with regard to the experience. For example, how loud should the audio be, how large should the image be, should there be any considerations for seating or placement of items in relation to each other, etc.

1. This example assumes the work is editioned, but this template can be edited for unique works of art as well.

2. We have left specific examples in the template where what needs to be documented may not be entirely clear by the label being used. These too should be edited per each artwork.

3. Unless the manner of installation is very straightforward (that is, "hang it on the wall, plug it in, and enjoy"), it is often better to simply refer readers to the full Installation Instructions at the bottom, contextualized via the artist's intended viewer experience.

4. Here again it may be easier to direct the reader to the full Installation Instructions if the scale the work is presented in (when projected, for example) is critical to the piece.

5. Videos and other new forms of art for which the "artwork" is a digital file are increasingly presented in a "box set" of some form (rather than simply giving a collector a DVD in an envelope). In addition to being something many collectors appreciate, the box set offers an easier way to supply the artist's signature for certain types of artwork.

6. Approaches to how many copies (and what differentiates them) to supply vary widely. The essence of this section is to record what comprises "the artwork." Many museums consider the "artwork" to be a digital file that is as close to the artist's master as possible and able to be easily transferred to a new platform

should the current one become obsolete. That means a copy on a DVD, for example, is not considered the artwork and may not be accepted as a donation. Supplying a high-resolution digital copy of the artist's master on an external hard drive or USB flash drive is generally considered the current best practice for video and other digital artworks.

7. Again, the question is what comprises "the artwork" in total.

8. This section can become much more detailed and complex. If it needs to, it may be better to include such information in an artwork purchase agreement. Generally certificates of authenticity tend to be a maximum of one to two pages.

9. The certificate should also include where the artist's master copy is held, so that, should the collector's copy become unusable, they can pay the artist for another copy (terms for doing so are not yet standardized among artists, but we generally encourage artists to replace unusable copies of artwork at cost).

Sample Artist-Collector Agreement

In cases where technical information is required to explain the options for addressing obsolescence, the artist has complex requirements for presenting the artwork, or the collector simply wishes a detailed description of their rights and duties in owning or presenting the work, a purchase agreement is often a useful tool. The template below was developed over the course of six months with a UK-based collector who intends to donate his collection to a specific museum and had been in communication with it for many years about the types of uncertainties over presentation rights and such that might lead to the donation being rejected. Again, here we footnote our comments.

Artist-Collector Agreement
By and between

Collector Name
Address
City
Country

Hereinafter, the "collector," which expression shall include anybody to whom ownership of the work is in future transferred

and

Artist Name
Address
City
Country

Hereinafter, the "artist," which expression shall include the artist's estate.

Terminology
Artist's Master/Proof: The artist's master copy of the work, from which the DVD/BluRay/etc. and the digital file have been created referred to in Section 5 below.

DVD/BluRay/etc.: The exhibition device provided to the collector.[1]

Digital file: The digital file provided to the collector.[2]

The artist hereby sells to the collector—with the involvement of Gallery XXXXXX, City, Country (hereinafter, the "gallery")—their work bearing the title *Artwork Title*, and grant rights of use to the collector.

In detail, the parties hereby agree as follows:
1. Subject Matter
The subject matter of this Agreement is the work by the artist which bears the title *Artwork Title*, in accordance with the authenticity certificate of the artist which constitutes an integral part of the work and of this Agreement.

2. Sale
The artist acknowledges receipt of the purchase consideration and hereby sells the work specified in Clause 1 above, including the authenticity certificate, to the collector. Ownership and the risk shall pass to the collector upon delivery of the DVD/BluRay/etc., digital file, and the authenticity certificate.

3. Grant of Rights

The collector is to be permitted to use the work at his/
her discretion for archival purposes, exhibition pur-
poses, presentation purposes, public relations work,
scientific purposes, without any further payment or any
limitations in time, geography, media, in time or other-
wise.[3] The artist hereby unreservedly grants the rights
of use in these respects to the collector. The following
rights in particular are granted:

a. The right to exhibit and/or present the work in muse-
ums, galleries, training or teaching rooms, or other
premises, and to allow third parties to do so.

b. The right to use still photographs and to use such
photographs to advertise the work or the exhibition
or presentation thereof, and for training and educa-
tional purposes, or for scientific purposes, especially
in catalogs, specialist publications, newspaper arti-
cles and reports, museum catalogs, catalogs of works,
posters for exhibitions (presentations), on entrance
tickets for exhibitions (presentations), in adver-
tisement, on the homepage of the collector's website,
and in school and educational literature. The artist
authorizes and provides a selection of still photo-
graphs (as digital files, not to be presented as "the
artwork"). Only these authorized stills can be used by
the collector.

c. The right to transfer ownership of the work and any
and all rights of use—including the right to re-transfer
the rights of use—to third parties without restrictions.

d. The right to create copies of the DVD/BluRay/etc.
and digital file for conservation purposes or to facili-
tate the exhibition of the work, and to migrate the data

contained in the DVD/BluRay/etc. and digital file to a new medium or format should the original medium or format become obsolete.

These rights are granted the collector for the purposes of conservation only and specifically exclude the right to distribute any copy of the work, in whole or in part, by any means, to any third party save as explicitly allowed under this agreement.

In the case of migration, the collector shall make all efforts to contact the artist and shall follow their precise instructions as to how the migration is effected, and shall if requested by the artist allow the artist to undertake the migration his- or herself, in which case the collector shall pay their reasonable costs.[4]

In the event that it is not possible to contact the artist prior to a migration, the transfer must be done in a manner which most closely preserves (i) the aesthetic feel of the original work and (ii) the data contained in the DVD and digital file, using as a guide the following technical description of the original files.[5]

The work must be undertaken by a professional laboratory having experience in the conservation of artworks, and should as far as possible not only seek to preserve the original data but also seek to avoid the introduction of any new data or artifacts, even when the possibility to introduce such data exists.

4. Warranty of Rights

The artist hereby warrants that he created the work alone, and that he is entitled to dispose of the work, without restrictions.

5. Rights and Duties of the Artist

a. The artist shall keep the Artist's Master in their archive as a backup copy. The Artist's Master is currently located at Address, City, Country.

Should there be any change in the name and/or address of the archives in which the Artist's Master is kept, the artist shall ensure that the gallery is promptly notified thereof. In the event of damage or loss of the DVD/BluRay/etc or digital file, the artist hereby undertakes to provide the collector with a direct replacement or, in the case that the artist's practice has changed or such technology is obsolete, a replacement in another medium or format which may be used using then readily available technology. Only the reasonable cost incurred through the making of such a copy may be charged.[6]

b. The artist undertakes to refrain from making any changes to the work and to leave the Artist's Master in an unaltered condition. They also undertake not to change the manner of installation and presentation attached to the authenticity certificate, without prejudice to the necessary adjustments to a specific location.

c. The artist undertakes not to create or put into circulation a new work bearing the exact same title or same work number.

d. In case of an edition, the artist shall not be entitled to make more originals of an edition than the quantity specified in the authenticity certificate.

e. The artist agrees not to use or permit third parties to use their Artist's Master for exhibition or presentation purposes.

f. The artist is entitled to present the work at festivals, in touring programs, and at any other occasion they consider appropriate. The artist keeps all theater rights of this work. The artist also has the right to put the

work into video distribution for theatrical screenings or to have it broadcast.

6. Duties of the Collector

a. The collector shall store the DVD/BluRay/etc and digital file and their successors in safekeeping in the archive conditions at his/her disposal.

b. The collector shall pay attention to the quality of the DVD/BluRay/etc and digital file and their successors and shall renew such copies if need be.

c. The work is to be shown in its entirety and in its original version within the context of exhibitions and presentations.[7]

d. The following identification of the author is to be used within the context of exhibitions or presentations of the work: *Artwork title* by Artist Name. The following identification of the author is to be used within the context of all other uses of the work: *Artwork Title* by Artist Name.

e. Regarding the manner of installation of the work, where appropriate the installation instructions attached to the authenticity certificate by the artist shall be observed.

7. Legal copyright and succession

The artist commits to retain ownership of the copyright or only to transfer it (or create circumstances under which such a transfer could arise) on terms such that the grant of rights set forth above remains effective. Any and all rights and obligations shall also apply to the legal successors of both parties.

8. Final Provisions:

a. There are no oral covenants that modify this agreement. Amendment or supplements to this Agreement have to be in writing.

b. The Nullity or invalidity of individual provisions of this Agreement shall not affect the validity of the remaining provisions hereof. The parties shall then replace the voided or invalid provision by a provision the financial and legal objective of which comes closest to that of the void or invalid provision.

c. Jurisdiction and governing laws to be determined by the parties.

Location Date Location Date

Collector Signature Artist Signature

1. The assumption that collectors experienced in technology-based artwork and certainly museum curators will make here is that no matter what the artist delivers, it will be obsolete in less than a decade. Artists may insist that "this format is the artwork" and if they do, so be it, but we have seen artists change their minds about that after a work is no longer able to be exhibited by even the most dedicated collector or museum, so we encourage dealers to ask artists how certain they are that that would not matter to them.

2. Increasingly, the industry views this as "the artwork."

3. This section is where many artists might become concerned, especially if the main paragraph is all they read. The very detailed sublist below the main paragraph should convince them that their rights are all still protected, so walk them through it. Also discuss how these terms are spelled out, not because any private collector is likely to ever present the work outside their home, but because any museum they may donate it to will only accept it if these terms are explicit. Like any contract, many components of this one are negotiable. Having said that, there is a growing demand among some artists that they receive a screening fee any time a work is shown in public, even for museums or other institutions that purchased the work. Museums are generally in full disagreement with this (their position boiling down to how they don't pay a painter to exhibit a painting they own). This issue is likely to remain controversial for the foreseeable future.

4. This is likely the main reason an artist would be interested in a purchase agreement: to ensure that their intentions inform any migration of the artwork due to obsolescence. Technology-based artwork has been around long enough now that many collectors and museums will simply not purchase work if this is not possible to do with the artist's full participation and approval.

5. That probably sounds more reassuring to collectors and museums than it may to certain artists (we know artists who sweat the details of how exactly their work appears within the format they exhibit so much it would likely surprise a rocket scientist). Still, it contractually obligates the owner to make a good faith effort here.

6. This is where an artist insisting that, for example, "the DVD is the artwork" will discourage many collectors and museums from purchasing the artwork. Through countless discussions with collectors and curators, we have heard of artists demanding the full current price of a digital artwork to provide an owner with a duplicate copy. This is a position we strongly discourage. Even the most compelling conceptual reason for insisting on this rarely convinces a collector or curator.

7. Issues similar to this include requirements for site-specific or site-determined artworks. If "the artwork" presentation only meets the artist's intention when it is shown outdoors, for example, such requirements should be added to the Installation Instructions in the certificate of authenticity and this section of the purchase agreement. An example to consider here might be an augmented reality artwork created for a specific location that functions via GPS technology. Not only will this piece not work in another location, it cannot actually exist in any other location. Spelling out what constitutes the work, particularly when it may be presented without the artist's involvement, will become a much bigger issue for new art forms moving forward.

How complicated such considerations are, in comparison with considerations for how to own, present, or resell a painting, for example, undoubtedly contribute to how poorly sales of video art or other technology-based artwork compare with those of more traditional mediums. What will help increase those sales, by lowering collectors' concerns that issues like obsolescence and respecting the artist's intentions are too difficult to deal with, are contracts that clearly spell out straightforward solutions. Eventually, when agreement on what constitutes "the artwork" and other best practices is well-established, much of this will seem commonplace and the markets for artworks created in these kinds technologies, which artists are increasingly attracted to, will become stronger, serving everyone involved much better in the process.

13

Sample Contract for a Dealer-Run Art Fair

In Chapter 9, we promised to share a template for a contract between an art fair and a participant that any dealer wanting to launch their own art fair could customize. As with any of the contracts in Part III in this book, but particularly with this one, you will want to have your attorney review all terms before using it. The template below is very similar to the one Moving Image art fair has used without any problems for five years now, but Moving Image is a specialized fair. This template is provided here primarily to highlight the various considerations any dealer launching a fair should think about, as well as include in a participation agreement.

ART FAIR PARTICIPATION AGREEMENT

This Agreement (the "Agreement"), made as of [date] _____, 20___ , is entered into by and between [FAIR LEGAL ENTITY NAME, d/b/a Fair Operating Name] a [State of incorporation] [legal entity type] company located at Address, City, State ["Fair Name"], and the [GALLERY/PARTICIPANT LEGAL NAME] a [State of incorporation] [legal entity type] company located at Address, City, State ("Participant"). ([Fair Name] and the Participant

are each a "Party" and, collectively, the "Parties".) [Fair Name] has been conceived to [basic vision of your fair, including a declaration that it is a commercial art fair whose purpose is to present and sell artwork to the public]

[Fair Name] will be located at [Fair Address]

Exhibition Timeline [specify exact times for each day fair is open, and include installation and de-installation dates and times]
 Collector's Preview: Thursday, September XX, 20XX, 14:00 - 17:00
 Friday, September XX, 20XX, 17:00 - 21:00
 Saturday, September XX, 20XX, 12:00 - 20:00
 Sunday, September XX, 20XX, 12:00 - 18:00

Parties' Responsibilities
[Fair Name] will provide [list what comes with participation fee, such as walls, lighting, signage, placement in catalog, etc.], as well as staff the Welcome Desk [and any other public services the participants are not expected to staff]. The Participant is required to staff their booth during all fair hours [or whatever terms are required by the fair in this regard].

There is a participant fee of US$XX,000.00 for a booth [of whichever size the participant has been selected to receive].

[The following details will vary per fair model, but the goal is to outline the participant's responsibilities; this is only a sample]

Each participant is responsible for completing the Online Project Information Form in order to provide (1) images of each work being exhibited, (2) a brief profile of the gallery for the catalog and promotional materials, and (3) complete "Caption" information for each image of the work(s) being presented.

[Fair Name] is not bound to provide exhibition space unless [Fair Name] accepts this Agreement in writing and receives Participant's payment in full per the terms below.

Agreement Procedure
This Agreement forms a binding contract between the Participant and [Fair Name] upon written acceptance from [Fair Name]. The Participant guarantees that all the information in his/her own Participation Form is accurate and authentic. Payment for the exhibition is due upon receipt of invoice and must be paid by check, credit card, or wire transfer (including all transfer fees). Upon the execution of this Agreement, Participant shall pay the nonrefundable participation fee of US$XX,000.00. Participation in [Fair Name] is not guaranteed until signed Participation Agreement and Participation Fee are received in full.

Other Terms and Conditions
The submission of the Participation Form constitutes an irrevocable commitment on the part of the Participant and the Participant's full acceptance of and agreement to all conditions outlined in this document as well as any other rules relating to the operation of the Fair. No space will be reserved without a signed Participation Agreement.

Services and Amenities provided at no charge [these will clearly vary per fair]
[Fair Name] will provide the following services and amenities to Participants free of charge:

- Use of [Fair Name] VIP / Gallerist Lounge during regular fair hours
- General ambient lighting
- Wireless internet connection (provided that [Fair Name] shall have no liability for internet service disruptions, and lack of internet connection shall not constitute a breach of this Agreement)

- General cleaning service exclusively for the public
 areas of the building during the hours that [Fair
 Name] is open to the public

- Free entry in the catalog

- [Others]

Payments and Financial Considerations

[Fair Name] does not provide financial support of any kind
toward costs related to the participation of Participant
in the Project, including but not limited to: travel,
shipping, installation, maintenance, and staffing costs.

Participants are responsible for all aspects of the
installation and dismantling of their booth presentation.

Damage to [Fair Name] Space

Participant shall be liable for any damages, destruction,
or repairs, beyond ordinary wear and tear, caused by the
use of the [Fair Name] space by Participant, its agents,
guests, servants, invitees, employees, or service provid-
ers. Participant shall also be liable for any lost [Fair
Name] fees arising from the loss of the use of the Prem-
ises pending repairs necessitated by Participant's use of
the Premises (collectively the "Damages").

Advertising and Documentation [here too details will vary
per fair]

[Fair Name] will advertise the fair and participation of
the Participants in press and promotional materials as
well as print and online media, as [Fair Name] sees fit
in its sole and absolute discretion. Participant agrees
to permit [Fair Name] to document their participation
in the Project in all capacities for archival, promo-
tional, educational, and such other purposes as [Fair
Name] shall determine. Participant agrees that all infor-
mation contained in the Participation Agreement and any
other participating documents can be used for administra-
tive, statistical, and promotional purposes. [Fair Name]

will retain sole ownership and reproduction rights of all photographs and video documentation taken by [Fair Name] for the duration of the Exhibition.

Postponement, Cancellation, or *Force Majeure*

[Fair Name] has the right to change dates, opening hours, and procedures, as well as to determine any other variation in the fair including the change of the venue. In the event of a case of *Force Majeure*, [Fair Name] is entitled to postpone, reduce, or even cancel the fair without being required to pay any kind of compensation or damages; [Fair Name] shall provide written notification. Should the fair be cancelled or suspended before its planned termination, for reasons not attributable to [Fair Name], Participant shall not be entitled to claim any reimbursement or damages. Participant understands that the Project can be postponed or cancelled by [Fair Name] at any time and at the sole discretion of [Fair Name].

Non-Transferability of Agreement

The Agreement is solely intended for the Participant and shall not be transferred or assigned in any manner whatsoever without the prior written consent of [Fair Name].

Governing Law and Dispute Resolution

This agreement is made in and governed by the internal substantive laws of the State of [jurisdiction], without regard to conflicts or choice of law principles. Any disputes arising hereunder shall be adjudicated exclusively before the state or federal courts located within [jurisdiction]. Nothing herein shall be construed however to prevent a court of competent jurisdiction from granting provisional equitable relief.

This is a legally binding contract. By signing it, you assume certain legal obligations and give up certain legal rights. Your signature will acknowledge that you have understood all of the terms above, and that you

either consulted with a lawyer in this regard, or decided not to do so.

IN WITNESS WHEREOF, the parties hereto have executed this Agreement as of the day and year first written above.

[FAIR COMPANY NAME] **PARTICIPANT**

_____ _____

SIGNATURE SIGNATURE

_____ _____

NAME, TITLE, & DATE NAME, TITLE, & DATE

14

Contracts with Collectors

O ne group of contracts that dealers are generally very happy to use are those designed to protect all parties when a collector is considering a purchase and wants to temporarily install it in their residence or office, or when a collector purchases the work and the title is transferred. The "Client Approval Agreement" and "Invoice Terms and Conditions" examples provided below were revised to address any of the issues raised by the evolving art market deemed pertinent to them as of early 2015. (Some of the most interesting and challenging issues relate to new forms of art, which are discussed in Chapter 12.)

Client Approval Agreement
Although gallery foot traffic may be decreasing and the comfort of seeing artwork in JPEGs may be increasing, many collectors still like to see artwork in person before making a final purchase decision. As discussed in Chapter 4, even mega-dealers are finding it necessary at times to bring the artwork to the collector. When a collector requests a "test drive" so they can make sure how an artwork actually looks where they think they would install it, issues of insurance, suitable environments, possible damage to the artwork, and so on arise and should be discussed and agreed upon before the artwork leaves the gallery. The client approval agreement template below is a good tool for initiating that discussion and formalizing those terms.

Client Approval Agreement

ARTIST, TITLE	Medium	Description	Retail Price	Notes

_____, referred to herein as "Gallery," and

_____, referred to as "Client," agree:

1. Gallery has temporarily lent the artwork(s) described above to Client from _____ (date) until _____ (time) on _____ (date) for the purpose of viewing in the Client's _____ RESIDENCE _____ OFFICE located at: _____

2. _____ Client _____ Gallery is responsible for all packing and delivery charges from Gallery to the Client's location, and if necessary, from the Client's location to Gallery.

3. At or prior to the end of the viewing period, Client agrees that he/she shall either (i) purchase the artwork(s) at the retail price listed above, or such other price mutually agreed upon with the Gallery in writing or (ii) return the artwork(s) to the Gallery in accordance with the Gallery's instructions.

4. Each artwork is on loan to Client at Client's own risk; at all times Client agrees to maintain an environment suitable for a work of art and agrees to be responsible for any damage to any artwork while under the control of Client. Client will provide Gallery with a valid credit card number and authorization to charge such card. Should any damages occur, Gallery will charge Client's credit card for the full cost of repairs and loss of value, or the full retail price if repairs are not feasible (which shall be determined at the sole discretion of the Gallery).[1]

5. Client is responsible for insuring the artwork for the full Retail Price while at Client's location and during transportation from Gallery to the Client's location and, if necessary, from the Client's location to Gallery.

6. Title to each artwork shall remain with the current title holder, and shall not pass until Gallery receives payment in full. If Client chooses to purchase an artwork, title to such artwork will pass upon to Client upon payment in full. Until such time as Gallery receives payment in full for an artwork, it may, in its discretion, file a UCC-1 statement and perfect its security interest in the artwork while it is at the Client's premises.

7. Client will not allow any artwork to be photographed or any images to be created of any artwork while in Client's possession.

8. Gallery may terminate this agreement and seek return of the artwork immediately for any reason.

Gallery **Client**

By: _____ _____

See Following Page for Credit Card Authorization[1]

Condition Acknowledgement

Received by Client in good condition:	Returned in good condition: [GALLERY]
_____	_____
Client Name: Date:	By: Date:

1. If you are able to accept credit cards, you may wish to get pre-authorization to charge the client's credit card in case of non-returned or damaged work, ensuring of course that you maintain all information in a PCI-compliant manner.

Invoice Terms and Conditions

Likely every dealer's favorite contract is the one used to officially transfer title of an artwork to a purchasing collector. Changes in the art market have lengthened the terms and conditions of sale many dealers now have in their invoices, including how few sales transactions are concluded in person (see Chapters 3, 4, and 6); collectors taking an extremely long time to pay, resulting in dealer cash flow problems (see Chapter 5); and collectors increasingly living in places with different monetary units than the one a gallery can easily accept checks in (see Chapter 1)—that is, if the collector even writes checks for artwork anymore. The template for invoice terms and conditions below is designed to help dealers manage such issues and to facilitate a more problem-free transfer of title. Our comments are footnoted.

Sale is subject to acceptance of Additional Terms and Conditions of Sale

[Details of sale][1]

Please make all checks payable to [GALLERY] or contact the gallery for wire instructions.[2]

Additional Terms & Conditions of Sale

All sales are final, and payment is due upon receipt of this invoice. Accounts not paid within 30 days will be subject to a 2% monthly finance charge on the total outstanding balance. A 4% surcharge will be assessed for all payments made by credit card.[3]

Artwork will be released after payment is received in full, and title will pass to Purchaser at that time. If sales tax is not included, Purchaser shall be responsible for payment of all use taxes, import/export, and other taxes or customs fees. Unless otherwise arranged, deliv-

ery of the work will be made, after receipt of payment in full, to purchaser via common carrier. Standard packaging is provided by the gallery. Purchaser is responsible for all other shipping and delivery charges, including insurance and custom crating or packaging; risk of loss shall pass to purchaser upon the sooner of pickup of the work from gallery or 30 days after payment is received. Work stored with gallery for more than 30 days after date of invoice, whether paid or unpaid, will incur storage fees.[4] It is purchaser's responsibility to inspect the work immediately upon delivery and to report any damage to the common carrier. The work is sold "as is"; gallery hereby disclaims all other warranties whatsoever.

Copyright to the work does not transfer with the work. Purchaser agrees not to reproduce or publish images of the work without the prior written consent of Gallery or the appropriate copyright holder.

Gallery kindly requests that the purchaser first offer the gallery the opportunity to offer the work if the purchaser intends to sell the work.[5]

1. We assume your standard invoice includes full details on the artwork being sold, the price, and any discounts. It should also include any applicable state and city sales taxes, or a declaration that the work is being shipped out of state, as well as the gallery tax ID number.
2. Increasingly, galleries are simply adding their wire transfer information to invoice templates.
3. Some collectors may object to such terms. Others may simply ignore them entirely. Adding them may require some case-by-case consideration. Certainly top collectors who object to them might warrant editing them out for any invoice they receive going forward.
4. While changes in how far away your best collectors may live or simply responsiveness of collectors buying art all over the world on a constant basis may make this condition of sale prudent, again, many dealers will be happy to reconsider how strongly they insist on this for certain top collectors.
5. This provision is not intended to be a requirement, Different versions are intended to be binding upon the client. A gallery needs to be judicious here too and make sure that the terms of any "right of first refusal (ROFR) or "right of first offer" (ROFO) are reasonable in terms of duration (30 days), price (equal to the offer from a third party) and purpose (part of a larger deal). Courts will not enforce a preemptive right if the intention is actually to prevent the other party from transferring the property or is harmful to the owner of the property.

Conclusions

W hen I began writing this book in early 2014, I was convinced that the Leo
Castelli model might no longer be a viable choice for running a contemporary
art gallery. I thought it might be broken. With the growing corporatization of the art
market, an epic bloodbath among mega-galleries that was exciting cupidity down
through the system, and new intermediaries oozing out of the Internet to chip away
steadily at the gallery's preeminence, the genteel world of handshake agreements and
thoughtful contemplations that Castelli's model had helped inspire seemed quaint,
if not downright suicidal for any dealer who had survived the financial collapse of
2008. Or so I thought.

While I was researching and writing and rewriting, though, I was challenged by
a friend to consider how the concept of "success" in the art world had somehow been
hijacked. Much as it had come to be in nearly every other profession, "success" in
the art world was increasingly measured by numbers, and in particular by numbers
preceded by dollar signs. If such metrics were absurd in any context, it would cer-
tainly be the art world, no?

And yet, no.

So I began rethinking about (and rewriting) the book from dual perspectives:
was the Castelli model still viable, and was the mega-gallery track truly the only path
to success? In the opening of Part II, I outlined the central argument for the second
perspective: that "success" is measured by whether you meet *your* goals, not whether
you meet someone else's goals. And yet, again and again, the goals of a handful of
ambitious dealers were seemingly dictating many other dealers' goals or at least
their actions. So in addition to trying to answer whether the Castelli model still made
sense, I also approached each topic wondering what role it played in reinforcing the
misperception that there was only one definition of "success."

Here I should also note that when I began writing this book in early 2014, I was
also convinced that how the art market looked from our storefront on West 27th
Street in Chelsea was basically consistent with how it looked from virtually any-
where. People I interviewed from outside New York kept telling me my questions
were irrelevant in other cities, but it took attending the Talking Galleries symposium
in Barcelona in October 2014 for that to really sink in. Contemporary art galleries
in many other markets have no choice but to focus on a spectrum of goals, including

building a sustainable arts community, educating their artists and dealers on global market norms and practices, championing contemporary art in a climate of hostile or reactionary museums and art institutions, and often being on the frontline of social issues that can quite literally cost them their business or even their lives. In short, dealers in many other places around the world had much more serious things to worry about than which level VIP card they secured for which clients at an art fair or what strategic countermove they could make to block a competitor's designs on their artists. So a third perspective began to inform the conclusions I was drawing as well. With it came another round of rewrites.

Eventually I had to stop. Not only were new reports coming out constantly that made previous data points I had used now out of date (which would require even more rewriting), but it finally sank in for me that what this book was attempting to discuss required that it focus on a snapshot of the market. So I locked it down to the period from late 2008 to early 2015, fully aware that the data will have moved on by the time anyone reads this.

Still, with what I was able to discover about that time period, I did come to a few conclusions. As noted in Chapter 1, I basically agree with Olav Velthuis that while the very top of the art market is more global than ever before, for the rest of us it remains mostly regional, which, for the time being, while economies slowly pick back up, is probably a good thing. Trying to compete globally is extremely expensive, requiring long-term planning and investments, and even the best dealers keep making very expensive mistakes in trying to sort it all out. Which is not to discourage smaller galleries from exploring new markets (you may very likely need to, depending on your location), but rather to encourage them to match their strategies to their resources and focus on picking their battles, rather than trying to compete everywhere all at once.

On the topic of mega-galleries, I concluded that the market is certainly big enough to support a wide range of business models and every contemporary art dealer should appreciate the work the mega-galleries are doing to expand the market. Still, I would like to see changes in how artists are poached, perhaps introducing "liquidated damages" provisions in representation contracts, or, looking toward the future, just encouraging younger galleries to treat any gallery they poach from the way they would like bigger galleries to treat them (meaning, mostly, leaving them some way to recoup their investment on an artist being poached and to not take such a big hit in the prestige department in the process). Establishing professional guidelines that reflect the industry's understanding of the important role smaller galleries play and how poaching affects smaller galleries much more than it does larger galleries certainly seems feasible (other industries manage it). Failing that, (because, let's face it, it's business) I think the smaller galleries should inflict as much damage on

the dominance the mega-galleries have with museums and the market in general via the "giant-killing" strategies outlined in Chapter 2.

Perhaps the most detrimental impact art fairs are having on the industry is perpetuating the impression that art is to be viewed and purchased primarily at events. Not only has the rise of the art fair we discussed in Chapter 3 contributed to collectors spending less time in galleries, it has also contributed to dealers having less time to spend in studios. Even worse is how it is contributing to the increased production of "art fair art" and to a vicious cycle in which collectors only see art at fairs, dealers only take artwork that will sell to fairs, so artists begin focusing on making work that will sell at fairs, and so collectors think that's the best work out there, because, again, collectors only see work at fairs. And around it goes. Biennials are an alternative, of course. Or at least they used to be. Top collectors, turned off by fairs, are increasingly shopping at biennials, which could shortly lead to a similarly vicious cycle in that context as well.

Whether the art fairs are affecting the shifts in how collectors interact with other people in the art market probably needs a bit more investigation, but I suspect they are. Moreover, new expectations from their relationships with museum directors and curators, ambivalence toward art criticism, and progressively hostile resentment toward new collectors entering the market have all changed the culture of collecting contemporary art, as discussed in Chapter 4. Dealers inserting themselves into any of these conflicts are courting a lose-lose situation. The dealer-collector relationship is already being pulled apart by collectors' loyalties shifting to art fairs, a weakened position of dealer "authority" as the information dealers once had exclusive control over is more readily available online, and arguably new generations of collectors simply not seeing the value proposition of the gallery the way more experienced collectors do. As we discussed, dealers may need to learn new strategies for "influencing without authority" and should collaborate on developing a more compelling value proposition for the gallery model. The single hat that dealers have had the luxury of wearing in the West may need to give way to multiple sources of funding for their gallery, much the way independent contractors in most industries have had to evolve since 2008.

At the heart of the lengthy discussion in Chapter 5 about the mid-level gallery is a question I have gone back and forth on repeatedly. Beyond simply the Leo Castelli model, the consignment model, by which most dealers do not buy the work they try to sell, may be the source of many of the particular problems mid-level dealers are having a hard time solving. It is this model specifically that enabled so many dealers with limited resources and even less experience to open up so many galleries. It was also this model that led many of them to owe so many artists so much money when the crisis hit that it likely contributed to a deepening of distrust between dealers

and artists. If dealers had to buy the work from artists before they tried to sell it, much of that would disappear. Of course, so would many galleries, which needs to be weighed against the number of artists still waiting to be discovered by a dealer and get the opportunities a gallery still represents. If only 20 percent of the galleries that exist could afford to buy the work they exhibit up front, how many more artists would be struggling with that model? I have not reached any final conclusions on that, but suspect the consignment model is not going anywhere.

A surprising number of observers still seem confident in dismissing the potential of online art selling channels, which in 2015 were still experimenting with business models and had still not revolutionized the art market to where the brick-and-mortar gallery had become obsolete, as we discussed in Chapter 6. Of course, many such observers in 2015 worked for companies who had their own online channels, but . . . (a topic for another book perhaps). Two things make me believe the online channels may keep experimenting a bit, but they have finally gotten a foothold and it is foolish to ignore them. First is how traffic in galleries is dwindling. When most critics of online channels mock their low sales results, often they pepper it with a quote from some insider who insists collectors still want to see art in person. That does not compute. Online sales are low not because collectors still need to see art in person to buy it (they buy from JPEGs all the time), but because the online channels are only now figuring out that art is like heroin. You need to hook online customers first on lower-end luxury goods like wine or designer furniture. Eventually they grow comfortable spending that much online and they will work their way up. 1stdibs figured this out first (and their art sales are impressive), mixing fine art in with a range of luxury products. Paddle8 seems to have caught on too, and I suspect the others will soon follow. Second is the amount of venture capital these top companies continue to secure. I know it's a golden age for online tech companies and there is plenty of money to be sloshed about, but the VC crowd are pretty savvy about what is poised to win or lose at this point, and so as much as their pace is more tortoise-like than hare-like, I would not bet against the online channels looking much better by the finish line.

That covers the section of the book devoted to things dealers have little to no control over. I don't see much point in offering any conclusions about things they do have control over. How well any of the options discussed in Part II work out for any dealer will depend on the strength of their vision, their commitment to quality, and their ability to adapt. It will also likely depend on being in the right place at the right time. One thing I will recommend here is whatever new ventures you take on to secure your business, do so because it brings you closer to your own personal goals. Define what success looks like for your business and focus on that. There's a lot of noise out there, and very little of it is helpful.

Two final conclusions I would like to share center on the models. First is that after nearly two years of research and careful observation (this past year, with a self-enforced distance that I struggled with but actually now believe was the right decision), I am convinced that the Leo Castelli model is not broken. It remains viable. The main difference between Leo's time and ours is how much more competitive and complex the contemporary art market has become, but the basic principles of discovering the best artists out there, encouraging them, promoting them, carefully guiding them and their careers, and profiting together—if not happily ever after, at least for as long as it's mutually beneficial—all still make sound business sense. It may require a few tweaks to adjust to new pressures and opportunities, but it makes sense. And while I do not expect some dealers to care about this, it also makes sound cultural sense. It remains good for art, in my humble opinion.

Finally, as I have noted a few times in this book, the white cube gallery model most contemporary art dealers adopted (mainly because it was "the way it's done") is less than 100 years old, which is a fraction of the history of art dealing. New models are bound to emerge, and with kids and their fancy technology these days, the chances are some of them will represent an improvement or at least be better aligned with the values and needs of the artists they exist to serve. Mark my word . . . and now get off my lawn.

Appendixes

APPENDIX A: INTERNATIONAL ART FAIRS WITH CONTEMPORARY ART GALLERIES

MONTH	Fair name	City	Country	Website
January				
	LA Art Show	Los Angeles	US	laartshow.com
	MIA Miami International Art Fair	Miami	US	mia-artfair.com
	Photo LA	Los Angeles	US	photola.com
	BRAFA	Brussells	Belgium	brafa.be
	London Art Fair	London	UK	londonartfair.co.uk
	Art Palm Beach	West Palm Beach	US	artpalmbeach.com
	Metro Curates	New York	US	metro-curates.ticketleap.com
	Art Stage Singapore	Singapore	Singapore	artstagesingapore.com
	Arte Fiera	Bologna	Italy	artefiera.bolognafiere.it/en
	Artgeneve Salon international d´art	Geneva	Switzerland	artgeneve.ch/en
	India Art Fair	New Dehli	India	indiaartfair.in
	Paramount Ranch	Los Angeles	US	paramountranch.la
	Art Los Angeles Contemporary	Los Angeles	US	artlosangelesfair.com
	LA Art Book Fair	Los Angeles	US	laartbookfair.net
February				
	Zona MACO	Mexico City	Mexico	zonamaco.com/

MONTH	Fair name	City	Country	Website
	Material Art Fair	Mexico City	Mexico	material-fair.com/en
	Art Fair Phillipines	Manila	Philippines	artfairphilippines.com
	Art Wynwood	Miami	US	artwynwood.com
	Affordable Art Fair	Brussels	Belgium	affordableartfair.com/brussels
	Palm Springs Fine Art Fair	Palm Springs	US	palmspringsfineartfair.com
	Art 14 / 15	London	UK	artfairslondon.com
	Art Rotterdam	Rotterdam	Netherlands	artrotterdam.com
	RAW Art Fair	Rotterdam	Netherlands	rcartfair.com
	Art Up! Contemporary Art Fair	Lille	France	art-up.com/en
	Art Innsbruck	Innsbruck	Austria	art-innsbruck.at/index.php/en
	ARCO	Madrid	Spain	ifema.es/arcomadrid_06
	Art Mardrid	Madrid	Spain	art-madrid.com
	Cape Town Art Fair	Cape Town	Africa	capetownartfair.co.za
	Asia Hotel Art Fair	Hong Kong	Hong Kong	hotelartfair.kr
March				
	Affordable Art Fair	Milan	Italy	affordableartfair.com/milano/?lang=en
	Affordable Art Fair	Hong Kong	Hong Kong	affordableartfair.com/hongkong
	Art Karlsruhe	Karlsruhe	Germany	art-karlsruhe.de/de/home
	The Art Show (ADAA)	New York	US	artdealers.org/the-art-show
	The Armory Show	New York	US	thearmoryshow.com
	Fountain Art Fair	New York	US	fountainartfair.com

MONTH	Fair name	City	Country	Website
	Scope New York	New York	US	scope-art.com
	Moving Image	New York	US	moving-image.info
	Independent	New York	US	independentnewyork.com
	Volta NY	New York	US	voltashow.com
	Pulse New York	New York	US	pulse-art.com
	Art on Paper	New York	US	thepaperfair.com
	Art Basel in Hong Kong	Hong Kong	Hong Kong	artbasel.com/en/hong-kong
	Art Central	Hong Kong	Hong Kong	artcentralhongkong.com
	New City	New York	US	newcityartfair.com
	Art Paris Art Fair	Paris	France	artparis.fr/en
	Art Fair Toyko	Tokyo	Japan	artfairtokyo.com/en
	Art Dubai	Dubai	UAE	artdubai.ae
	Sikka Art Fair	Dubai	UAE	sikka.ae
	PAGES Leeds Artist book fair	Leeds	UK	leedsartbookfair.com
	TEFAF	Maastricht	Netherlands	tefaf.com
	MiArt	Milan	Italy	miart.it/en
	Art Prague	Prague	Czech Republic	artprague.cz
April				
	SP-Arte Brasilia	Brasilia	Brazil	sp-arte.com/en
	Art Expo New York	New York	US	artexponewyork.com
	Affordable Art Fair	Maastricht	Netherlands	affordableartfair.com/maastricht/?leng-en
	Paris Photo Los Angeles	Los Angeles	US	parisphoto.com/losangeles

MONTH	Fair name	City	Country	Website
	AIPAD Photography Show	New York	US	aipad.com
	Art Cologne	Cologne	Germany	artcologne.de/de/artcologne/home
	Dallas Art Fair	Dallas	US	dallasartfair.com
	Art Monaco	Monaco	Canada	artemonaco.com
	Art Brussells	Brussels	Belgium	artbrussels.com
	SP-Arte	São Paolo	Brazil	sp-arte.com/en
	Young Art Taipei	Taipei	Taiwan	youngarttaipei.com/
	Art Revolution Taipei	Taipei	Taiwan	arts.org.tw/2015/eng/
May				
	Art Beijing· Contemporary Art Fair	Beijing	China	artbeijing.net/dangdai/index.php?lung=en
	Verge Art Fair New York	New York	US	vergeartfair.com
	Love Art Toronto	Toronto	Ontario	loveartfair.com/toronto
	Downtown Art Fair	New York	US	artmiaminewyork.com
	Select Art Fair	New York	US	select-fair.com
	Seoul Open Art Fair	Seoul	Korea	soaf.co.kr
	NADA Art Fair	New York	US	newartdealers.org
	Frieze New York	New York	US	friezenewyork.com
	Cutlog	New York	US	cutlog.org
	Outsider Art Fair	New York	US	outsiderartfair.com
	Art Market San Francisco	San Francisco	US	artmarketsf.com
	Kunts Rai	Amsterdam	Netherlands	kunstrai.nl/pagina.php?lan=uk

MONTH	Fair name	City	Country	Website
	Art Athina	Athens	Greece	art-athina.gr
	20/21 international Art Fair	London	UK	20-21intartfair.com
	Kunst & Antiquitätenmesse	Munich	Germany	kunst-antiquitaeten.de
	Art15 London's Global Art Fair	London	UK	artfairslondon.com/
	MIA – Milan Image Art Fair	Milan	Italy	miafair.it/milano/en
	Affordable Art Fair Singapore	Singapore	Singapore	affordableartfair.com/ singapore
	Affordable Art Fair Hong Kong	Hong Kong	Hong Kong	affordableartfair.com/ hongkong/
	ArteBA	Buenos Aires	Argentina	arteba.org/?lang=en
	Asia Intern. Arts and Antiques Fair 24.	Kowloon	Hong Kong	aiaa.com.hk
	Photissima Art Fair	Milan	Italy	photissima.it/home_en/ expo-milano-2015-en/
	Untitled Artists' Fair	London	UK	untitledartistsfair.co.uk
June				
	Loop The Video Fine Art Fair	Barcelona	Spain	loop-barcelona.com
	Contemporary Art Ruhr Media Art Fair	Essen	Germany	contemporaryartruhr.de/en/ media-art-fair
	NEWD Art Show	New York	US	newdartshow.com
	BAAF Brussels Ancient Art Fair	Brussels	Belgium	antiken-kabinett.de/ kunstmessen/baaf.htm
	Brussels Non European Art Fair	Brussels	Belgium	bruneaf.com/en
	Art I Jog I 11	Yogyakarta	Indonesia	artjog.com/en

MONTH	Fair name	City	Country	Website
	Pinta - The Latin American Art Fair	London	UK	pintalondon.com
	Art Antwerp	Antwerp	Belgium	artantwerp.com
	Affordable Art Fair London, Hampstead	London	UK	affordableartfair.com/ hampstead
	Rhy Art Fair 2015	Basel	Switzerland	art-show-zurich.com/en
	Design Miami/Basel	Basel	Switzerland	designmiami.com
	LISTE	Basel	Switzerland	liste.ch
	SCOPE Basel	Basel	Switzerland	scope-art.com
	Art Vilnius	Vilnius	Lithuania	artvilnius.com
	The Solo Project	Basel	Belgium	the-solo-project.com
	Art Basel	Basel	Belgium	artbasel.com
	Pool Art Fair	Guadeloupe	Guadeloupe	poolartfair.com
	Print Basel	Basel	Belgium	oneartnation.com
	Volta Basel	Basel	Belgium	voltashow.com/index.php
	Masterpiece Art Fair	London	UK	masterpiecefair.com
July				
	Aspen Antique and Fine Art Fair	Aspen	US	aspenartfairs.com
	Les Rencontres d'Arles	Arles	France	rencontres-arles.com
	Art MRKT Hamptons	Bridgehampton	US	artmarkethamptons.com
	Art Hamptons	Bridgehampton	US	arthamptons.com
	Art Santa Fe	Santa Fe	US	artsantafe.com
	ART Bodensee	Dornbirn	Austria	artbodensee.messedornbirn. at

MONTH	Fair name	City	Country	Website
	Art Osaka	Osaka	Japan	artosaka.jp/en
	Turbine Art Fair	Johannesburg	South Africa	turbineartfair.co.za
	Art Apart Singapre	Singapore	Singapore	artapartfair.com
	Art Southampton	Southampton	US	art-southampton.com
	Art Marbella	Marbella	Spain	marbellafair.com/
August				
	Auckland Art Fair	Auckland	New Zealand	artfair.co.nz
	Art Nocturne Knocke	Knokke-Heist	Belgium	artnocturneknocke.be/home.php?lang=en
	Melbourne Art Fair	Melbourne	Australia	melbourneartfair.com.au
	SP-Arte/Foto	São Paulo	Brazil	sp-arte.com/en/foto
	Asia Hotel Art Fair	Seoul	Korea	hotelartfair.kr/hongkong2015
	FNB Joburg Art Fair	Johannesburg	South Africa	fnbjoburgartfair.co.za
	Art Copenhagen	Copenhagen	Denmark	artcopenhagen.dk
September				
	Texas Contemporary	Houston	US	txcontemporary.com
	START	London	UK	startartfair.com
	Affordable Art Fair Seoul	Seoul	Korea	affordableartfair.com/seoul
	BolognaFiere SH Contemporary	Shanghai	China	bolognafiere.it/en
	Unseen Photo Fair	Amsterdam	Netherlands	unseenamsterdam.com
	Sydney Contemporary	Sydney	Australia	sydneycontemporary.com.au
	abc art berlin contemporary	Berlin	Germany	artberlincontemporary.com
	SUMMA	Madrid	Spain	summafair.com

MONTH	Fair name	City	Country	Website
	Beirut Art Fair	Beirut	Lebanon	beirut-art-fair.com
	Houston Fine Art Fair	Houston	US	houstonfineartfair.com
	Expo Chicago	Chicago	US	expochicago.com
	Affordable Art Fair	Bristol	US	affordableartfair.com/bristol
	Art International Istanbul	Istanbul	Turkey	istanbulartinternational.com
	Moving Image Istanbul	Istanbul	Turkey	moving-image.info/istanbul-home
	Affordable Art Fair	New York	US	affordableartfair.com/newyork
	20/21 British Art Fair	London	UK	britishartfair.co.uk
	ArtRio International Contemporary Art Fair	Rio de Janeiro	Brazil	artrio.art.br/en
	Roma Contemporary	Rome	Italy	crownfineart.com/en-us/event/roma-contemporary
	Buy Art Fair	Manchester	UK	buyartfair.co.uk
	Toyko Photo	Tokyo	Japan	tokyophoto.org/2014
October				
	(e)merge art fair	Washington DC	US	emergeartfair.com
	Affordable Art Fair	Stockholm	Sweden	affordableartfair.com/stockholm/?lang=en
	SWAB Barcelona	Barcelona	Spain	swab.es/?lang=en
	Asia Contemporary Art Fair	Hong Kong	Hong Kong	asiacontemporaryart.com/home/main/en
	KIAF Korea International Art Fair	Seoul	Korea	kiaf.org
	Fine Art Asia 2015	Hong Kong	Hong Kong	fineartasia.com

MONTH	Fair name	City	Country	Website
	Art Silicon Valley/ San Francisco	San Mateo	US	artsvfair.com
	Asia Now Paris	Paris	France	asianowparis.com/gb
	Antiques and Art at the Armory	New York	US	nyfallshow.com
	VIENNAFAIR	Vienna	Austria	viennacontemporary.at/en
	BAAF Brussels Accessible Art Fair	Brussels	Belgium	accessibleartfair.com/ brussels
	Contemporary Art International Zurich	Zurich	Switzerland	art-zurich.com
	Art Show Zurich	Zurich	Switzerland	art-show-zurich.com/en
	Frieze Art Fair	London	UK	friezelondon.com
	Frieze Masters	London	UK	friezemasters.com
	Affordable Art Fair	Mexico City	Mexico	10times.com/ affordable-artfair-mexico
	1:54 Contemporary African Art Fair	London	UK	1-54.com
	World Wide Art	Los Angeles	US	worldwideartla.com
	Accessible Art Fair	Brussels	Belgium	accessibleartfair.com/ brussels
	SUNDAY Art Fair	London	UK	sunday-fair.com
	Multiplied Art Fair	London	UK	christies.com/multiplied
	Art Apart London	London	UK	artapartfair.com/london
	Art Verona	Verona	Italy	artverona.it
	SHOW OFF	Paris	France	variationparis.com
	The International Fine Art & Antiques Show	New York	US	haughton.com

MONTH	Fair name	City	Country	Website
	Affordable Art, Battersea	London	UK	affordableartfair.com/battersea
	Cutlog Contemporary Art Fair	Paris	France	cutlog.org/cutlog-art/en
	FIAC	Paris	France	fiac.com
	Outsider Art Fair	Paris	France	outsiderartfair.com
	Slick Paris	Paris	France	slickartfair.com/paris/en
	Artbo International Art Fair Bogota	Bogota	Columbia	english.artbo.co/portal/default.aspx
	Art Fair 24	Cologne	Germany	art-fair.de
	KUNST Zurich	Zurich	Switzerland	kunstzuerich.ch/en
	MIA – Milan Image Art Fair	Singapore	Singapore	miafair.it/singapore
	YIA ART FAIR # 04	Paris	France	yia-artfair.com/en
	Art Toronto	Toronto	Canada	arttoronto.ca
	Feature Art Fair	Toronto	Canada	featureartfair.com
	Buenos Aires Photo	Buenos Aires	Argentina	buenosairesphoto.com
	Art Taipei	Taipei	Taiwan	art-taipei.com/2015/en
	Affordable Art Fair	Amsterdam	Netherlands	affordableartfair.com/amsterdam
November				
	Winter Olympia Art & Antiques Fair	London	UK	olympia-art-antiques.com
	ART SAN DIEGO	San Diego	US	art-sandiego.com
	Artissima	Turin	Italy	artissima.it
	Photissima	Turin	Italy	photissima.it/home_en/
	New City	Taipei	Taiwan	newcityartfair.com

MONTH	Fair name	City	Country	Website
	Abu Dhabi Art Fair	Abu Dhabi	UAE	abudhabiartfair.ae
	International Fine Print Dealer Association	New York	US	ifpda.org
	Parte	São Paolo	Brazil	feiraparte.com.br/2015/cn
	Contemporary Istanbul	Istanbul	Turkey	contemporaryistanbul.com
	Pinta New York	New York	US	pintamiami.com
	Affordable Art Fair	Hamburg	Germany	affordableartfair.com/ hamburg
	Paris Photo	Paris	France	parisphoto.com/paris
	FotoFever	Paris	France	fotofeverartfair.com
	Boston International Fine Art Show	Boston	US	fineartboston.com/
	Bank Art Fair	Singapore	Singapore	bankartfair.com
	Room Art Fair	Madrid	Spain	roomartfair.hagocosas.es
	Chester Arts Fair	Chester	UK	chesterartsfair.co.uk
	ST'ART - Strasbourg	Strasbourg	France	st-art.fr/en
	PAN Amsterdam	Amsterdam	Netherlands	pan.nl/DesktopDefault. aspx?tabid=1&lg=en
	Mac	Paris		mac2000-art.com/NEW/ index.html
	FotoFever	Brussels	Belgium	fotofeverartfair.com
December				
	SCOPE Miami	Miami	US	scope-art.com/shows
	UNTITLED art fair	Miami	US	art-untitled.com
	Art Miami	Miami	US	artmiamifair.com
	Context	Miami	US	contextartmiami.com

MONTH	Fair name	City	Country	Website
	Miami Project	Miami	US	miami-project.com
	Red Dot Miami Beach	Miami	US	reddotfair.com
	Aqua Art Miami	Miami	US	aquaartmiami.com
	INK Art Fair	Miami	US	inkartfair.com
	Art Basel in Miami Beach	Miami	US	artbasel.com/miami-beach
	PULSE	Miami	US	pulse-art.com
	Select Art Fair	Miami	US	select-fair.com/miami
	NADA	Miami	US	newartdealers.org/Fairs/2015/MiamiBeach
	Pinta Art Fair	Miami	US	pintamiami.com
	Spectrum Miami	Miami	US	spectrum-miami.com
	Miami River Art Fair	Miami	US	miamiriverartfair.com/the-fair

APPENDIX B: ONLINE ART SELLING CHANNELS

NAME	URL	Headquarters	Focus	Business Model
1stdibs	1stdibs.com	Paris	Antiques, 20th century design, fine jewelry, watches, fashion and fine art	Online gallery/ marketplace
550px	500px.com	Toronto	Photography	Online gallery and licensing service
Absolutearts.com	absolutearts.com	Turin	Contemporary fine art, all media	Online gallery/ marketplace
Amazon Art	amazon.com search on "fine art"	Seattle	Contemporary art, fine art	Online gallery/ marketplace
Artfinder	artfinder.com	London	Contemporary art	Online gallery/ marketplace
Artful	theartfulproject.com	Unknown	Contemporary art	Online gallery/ marketplace
ArtList	artlist.co	New York	Contemporary art	Hybrid online gallery/inquire to buy
Artnet Auctions	artnet.com	New York; Berlin	Modern and contemporary paintings, prints, photographs, and more	Online-only auction
Artplode	artplode.com	London	Contemporary art, fine art	Peer-to-peer
Artslant	artslant.com	Los Angeles	Contemporary art	Online gallery/ marketplace
Artspace	artspace.com	New York	Contemporary art and limited editions	Online gallery/ marketplace
Artsper	artsper.com	Paris	Contemporary art	Online gallery/ marketplace
ArtRank	artrank.com/ products/ buytoday	Los Angeles	Contemporary art	Online gallery
Artsy	artsy.net	New York	Contemporary art	Inquire to buy

NAME	URL	Headquarters	Focus	Business Model
Artusiast	artusiast.com	Berlin	Contemporary art	Online gallery/ marketplace
Artviatic	artviatic.com	Monaco	Fine art	Peer-to-peer
AstaGuru	artusiast.com	Kolkata	Indian art	Online auction
Auctionata	auctionata.com	Berlin	Cars, jewelry, fine art, luxury items	Hybrid online auction / online gallery
Auction Network Sweden	auctionet.com	Stockholm and Berlin	Furniture, art, design items, collectibles	Marketplace for auction houses
Barneby's	barnebys.co.uk	Sweden	Jewelry, fine art, luxury items, furniture	Inquire to buy
Beyaz Muzayede	beyazart.com	Istanbul	Turkish contemporary and Modern art	Bricks and clicks
Bidsquare	bidsquare.com/ auctions	Unknown	Fine art, interior, antiques, wine, books, rugs, etc.	Online auction aggregator
Blomqvist	blomqvist.no/eng	Oslo	Fine art, interior, antiques, glass and porcelain	Bricks and clicks
Bukowskis	bukowskis.com	Stockholm	Design, fashion, art	Bricks and clicks
Casa d'Aste Della Rocca	dellarocca.net	Turin	Antique furniture and decorative objects, nineteenth- and twentieth-century paintings and sculptures	Bricks and clicks
Christie's LIVE	christies.com/ livebidding	Worldwide	Fine and decorative arts, jewelry, photographs, collectibles, wine.	Bricks and clicks
CultureLabel	culturelabel.com	UK	Art and design	Online gallery/ marketplace
Drouot Live	drouotlive.com	Paris	Fine art, antiques, and antiquities	Online auction
Epailive	epailive.com	Beijing	Fine art	Live auction e-commerce platform

NAME	URL	Headquarters	Focus	Business Model
Expertissim	expertissim.com	Paris	Fine and decorative art and collectibles	Online declining price auction
Fine Art Auctions Miami	faamiami.com	Miami, FL	Russian, Impressionist, Modern and contemporary works of art and artists	Bricks and clicks
Fine Art Bourse	fineartbourse.com	London	Fine art	Online auction
Heffel	heffel.com	Canada	Fine art	Online auction
Hihey	hihey.com	Beijing	Fine art	Online auction and "click to buy"
Invaluable	invaluable.com	Boston	Fine and decorative arts, antiques and collectibles	Online auction aggregator / marketplace
Lavacow	lavacow.com	Bucharest	Contemporary art	Online auction
LiveAuctioneers	liveauctioneers.com	New York	Fine Art	Online auction aggregator
Lofty	lofty.com	New York	Fine art, antiques and collectibles	Online marketplace
MasterArt	masterart.com	Worldwide	Fine art, antiques and collectibles	Online gallery / inquire to buy
Ocula	ocula.com	Hong Kong, New York, Shanghai, Auckland,	Contemporary art	Inquire to buy
Paddle8	paddle8.com	Sydney, London, Tokyo and Berlin	Art, design, collectibles, watches and jewelry	Online auction
Phillips	phillips.com/	New York; London	Contemporary art, photographs, editions, design, and jewelry	Bricks and clicks
Rise Art	riseart.com	London	Contemporary art	Online gallery, click-to-buy e-commerce and art rental

NAME	URL	Headquarters	Focus	Business Model
Saatchi Art	saatchiart.com	London	Contemporary art	Online gallery/ marketplace
Saffron Art	saffronart.com	Mumbai	Fine art and collectibles	Online auction
The Saleroom	the-saleroom.com	London and Seattle	Fine art and antiques	Online auction aggregator and marketplace
Sotheby's/ eBay	live.ebay.com/lvx/ sothebys	Worldwide	Fine and decorative arts, jewelry, photographs, collectibles, wine	Online auction
Swann Auction Galleries	swanngalleries. com	New York	Works on paper	Bricks and clicks
The Auction Room	theauctionroom. com	London	Fine art, antiques and collectibles	Online auction
WFA Online	wengcontemporary. com	Zug, Switzerland	Contemporary art	Online gallery and e-commerce platform

NOTES

~

CHAPTER 1

1. Nicholas Forrest, "Global Art Market Avoids Crash," *Art Market Blog with Nic Forrest,* January 8, 2009. http://www.artmarketblog.com/2009/01/08/global-art-market-avoids-crash-artmarketblogcom/

2. Melanie Gerlis, "Is the global art market a myth?" *The Art Newspaper*, April 25, 2014. http://old.theartnewspaper.com/articles/Is-the-global-art-market-a-myth?/32400#

3. Paddy Johnson, "New Art Market Report Greeted with Skepticism," *ArtFCity*, March 14, 2014 http://artfcity.com/2014/03/14/new-art-market-report-findings-greeted-with-skepticism/

4. "Skate's Annual Art Investment Report, 2013" http://www.skatepress.com/wp-content/uploads/2014/07/Skates_Annual_Report_2013_Part_2.pdf

5. Charlotte Burns and Riah Pryor, "Grow, grow, Gagosian…: Temporary space in Rio de Janeiro means the gallery's total space is greater than Tate Modern," *The Art Newspaper,* September 12, 2012. http://old.theartnewspaper.com/articles/Grow-grow-Gagosian/27143

6. Olav Velthuis, "The impact of globalisation on the contemporary art market," in *Risk and Uncertainty in the Art World,* Edited by Anna M. Dempster, 2014, Bloomsbury, New York, pp 87-108.

7. Jocelyn Wolff, "Craving out a Space among the Big Brand Galleries," Talking Galleries Barcelona Symposium, November 11, 2013. http://www.talkinggalleries.com/?p=1981

CHAPTER 2

1. Melanie Gerlis, "Gallery Giants Tighten their Grip," *The Art Newspaper*, December 6, 2010.
 http://www.theartnewspaper.com/articles/Gallery+giants+tighten+their+grip/22112

2. Jerry Saltz, "Saltz on the Trouble with Mega-Galleries," *New York* Magazine online (Vulture), October 13, 2013: http://www.vulture.com/2013/10/trouble-with-mega-art-galleries.html

3. Julia Halperin, "Almost one third of solo shows in US museums go to artists represented by five galleries: Survey reveals prevalence of Pace, Gagosian, David Zwirner, Marian Goodman and Hauser & Wirth in exhibition programming," *The Art Newspaper*, April 2, 2015.
 http://www.theartnewspaper.com/news/museums/17199/

4. Charlotte Burns, "Emmanuel Perrotin enters the bear pit," *The Art Newspaper*, 01 October 2013: http://www.theartnewspaper.com/articles/Emmanuel-Perrotin-enters-the-bear-pit/30484

5. Ken Johnson, "The Pace Years: When One Gallery Is Not Enough," *The New York Times*, October 17, 2010.
 http://www.nytimes.com/2010/10/18/arts/design/18pace.html?_r=1

6. Jerry Saltz, "At This Point, George W. Bush Is Actually a Better Artist Than James Franco," *New York* Magazine (Vulture), April 24, 2014.
 http://www.vulture.com/2014/04/jerry-saltz-on-james-francos-new-film-stills.html

7. Stephen Denny, *Killing Giants: 10 Strategies to Topple the Goliath in Your Industry,* 2011, Penguin Group (New York).

8. Roberta Smith, "Gladiatorial Combat: The Battle of the Big," *The New York Times*, May 16, 2013.
 http://www.nytimes.com/2013/05/17/arts/design/jeff-koons-at-david-zwirner-and-gagosian-and-paul-mccarthy-at-hauser-wirth.html?_r=0

9. Henri Neuendorf, "Leonardo DiCaprio Buys Art on Instagram at PULSE Art Fair," *Artnet News*, March 9, 2015.
 https://news.artnet.com/in-brief/dicaprio-buys-art-on-instagram-275078

10. Jillian Steinhauer, "Elizabeth Dee on X," *ArtInfo*, March 05, 2009.
 http://www.blouinartinfo.com/contemporary-arts/article/30666-elizabeth-dee-on-x

11. Roberta Smith, "Unspooling Time Loops," *The New York Times*, August 6, 2009.
 http://www.nytimes.com/2009/08/07/arts/design/07initiative.html

12. David Segal, "Pulling Art Sales Out of Thinning Air," *The New York Times*, March 7, 2009.
 http://www.nytimes.com/2009/03/08/business/08larry.html

13. Charlotte Burns and Riah Pryor, "Grow, grow, Gagosian...," *The Art Newspaper*, September 13, 2012.
 http://old.theartnewspaper.com/articles/Grow-grow-Gagosian/27143

14. John Hall, "Is Your Company An Industry Leader?" *Forbes*, August 6, 2013.
 http://www.forbes.com/sites/johnhall/2013/08/06/10-factors-to-crown-you-an-industry-leader/

15. Alice Gregory, "Does Anyone Here Speak Art and Tech?" *The New York Times*, April 3, 2013.
 http://www.nytimes.com/2013/04/04/fashion/art-and-techology-a-clash-of-cultures.html

16. Felix Salmon, "Why techies don't buy contemporary art," *Reuters,* April 8, 2013.
 http://blogs.reuters.com/felix-salmon/2013/04/08/why-techies-dont-buy-contemporary-art/

17. Eric Konigsberg, "The Trials of Art Superdealer Larry Gagosian," *New York*, January 20, 2013.
http://www.vulture.com/2013/01/art-superdealer-larry-gagosian.html

18. Nick Paumgarten, "Why are so many people paying so much money for art? Ask David Zwirner," *The New Yorker*, December 2, 2013.
http://www.newyorker.com/magazine/2013/12/02/dealers-hand

19. Blake Gopnik, "Marian Goodman: The Accidental Art Mogul," *Newsweek*, November, 12, 2011.
http://www.newsweek.com/marian-goodman-accidental-art-mogul-66259

20. Kelly Crow, "Keeping Pace," *Wall Street Journal Magazine*, August 26, 2011.
http://www.wsj.com/articles/SB10001424053111903596904576517164002381464

21. Vanessa Thorpe, "Jay Jopling: portrait of the perfect gallerist," *The Guardian (The Observer)*, October 8, 2011.
http://www.theguardian.com/theobserver/2011/oct/09/porfile-jay-jopling

22. Dodie Kazanjian, "House of Wirth: The Gallery World's Power Couple," *Vogue*, January 10, 2013.
http://www.vogue.com/865264/house-of-wirth-the-gallery-worlds-art-couple/

CHAPTER 3

1. Georgina Adam, "Fair or foul: more art fairs and bigger brand galleries, but is the model sustainable?" *The Art Newspaper*, 20 June 2012.
http://www.theartnewspaper.com/articles/Fair-or-foul:-more-art-fairs-and-bigger-brand-galleries,-but-is-the-model-sustainable?/26672

2. Clare McAndrew, "TEFAF Art Market Report 2014: The Global Art Market, with a focus on the US and China," Arts Ecnomics, 2014.
http://artseconomics.com/project/tefaf-amr-2014/

3. Nick Paumgarten, "Why are so many people paying so much money for art? Ask David Zwirner," *The New Yorker*, December 2, 2013.
http://www.newyorker.com/magazine/2013/12/02/dealers-hand

4. Robert Smith, "Safer Looks at Art but Only Hears the Cash Register," ArtsBeat, *The New York Times*, April 32, 2012. http://artsbeat.blogs.nytimes.com/2012/04/02/morley-safer-launches-a-halfhearted-salvo-in-his-war-on-the-art-world/

5. Blake Gopnik, "Great art needs an audience," *The Art Newspaper*, February 13, 2014.
http://old.theartnewspaper.com/articles/gopnik/31726

6. Graham Bowley, "For Art Dealers, a New Life on the Fair Circuit," *The New York Times*, August 21, 2013.
http://www.nytimes.com/2013/08/22/arts/for-art-dealers-a-new-life-on-the-fair-circuit.html

7. Eileen Kinsella, "Are Art Fairs Good for Galleries—Or Killing Them?" *Artnet News*, May 31, 2014.
https://news.artnet.com/market/are-art-fairs-good-for-galleries-or-killing-them-28920

8. Afshin Dehkordi, "Frieze 2012 and the contemporary art fair: a good or bad thing for artists?" *The Guardian*, October 15, 2012.
http://www.theguardian.com/culture-professionals-network/culture-professionals-blog/2012/oct/15/frieze-art-fairs-impact-artists

9. Hrag Vartanian, "Is All the Stuff at Art Fairs the Same-ish?" *Hyperallergic*, September 20, 2013. https://hyperallergic.com/84620/is-all-the-stuff-at-art-fairs-the-same-ish/

10. Scott Reyburn, "Art Fair 'Fatigue' May Resolve Itself," *The New York Times*, January 23, 2015. http://www.nytimes.com/2015/01/26/arts/international/art-fair-fatigue-may-resolve-itself.html

11. Georgina Adam, "The Art Market: all dressed up," *Financial Times*, October 3, 2014 http://www.ft.com/intl/cms/s/0/34d6a520-4982-11e4-8d68-00144feab7de.html?siteedition=intl

12. Andrew M. Goldstein, "Collector Alain Servais on Why the Venice Biennale Is the World's Best Art Fair," *Artspace*, May 2, 2015.
http://www.artspace.com/magazine/interviews_features/alain-servais-interview

CHAPTER 4

1. Deborah Sontag and Robin Pogrebin, "Some Object as Museum Shows Its Trustee's Art," *The New York Times*, November 10, 2009. http://www.nytimes.com/2009/11/11/arts/design/11museum.html

2. Tyler Green, "If you care about today's art, you care about "Skin Fruit," *Modern Art Notes*, April 13, 2010. http://blogs.artinfo.com/modernartnotes/2010/04/if-you-care-about-todays-art-y

3. Tyler Green, "Q&A with New Museum Director Lisa Phillips," *Modern Art Notes*, October 1, 2009. http://blogs.artinfo.com/modernartnotes/2009/10/numulpone/

4. Roberta Smith, "Anti-Mainstream Museum's Mainstream Show," *The New York Times*, March 4, 2010. http://www.nytimes.com/2010/03/05/arts/design/05dakis.html

5. Jerry Saltz, "Less Than the Sum of Its Parts," *New York*, March 26, 2010. http://nymag.com/arts/art/reviews/65115/

6. Milton Esterow, ""Are Museum Trustees Out of Step?" *ArtNEWS*, October 1, 2008.
http://www.artnews.com/2008/10/01/are-museum-trustees-out-of-step/

7. Mostafa Heddaya, "Bushwick Stalwart Interstate Projects Goes Nonprofit," *In The Air*, Artinfo.com, January 16, 2015.
http://blogs.artinfo.com/artintheair/2015/01/16/bushwick-stalwart-interstate-projects-goes-nonprofit/

8. Philip Kenicott, "As the price of art rises, is its value plummeting?" *The Washington Post*, February 7, 2014.
http://www.washingtonpost.com/entertainment/museums/as-the-price-of-art-rises-is-its-value-plummeting/2014/02/06/54b585e8-7190-11e3-8b3f-b1666705ca3b_story.html

9. Mickey Cartin, "Good Art, Bad Art: The Problem with Chelsea," *Artnet*, June 14, 2011.
http://www.artnet.com/magazineus/features/cartin/the-problem-with-chelsea-6-14-11.asp

10. Charles Saatchi, "The Hideousness of the Art World," *The Guardian*, December 2, 2011.
http://www.theguardian.com/commentisfree/2011/dec/02/saatchi-hideousness-art-world

11. Adam Lindmann, "Why I'm Worried About the Art World: Adam Lindemann on the Sizzle vs. the Steak," *New York Observer*, January 21, 2015.
http://observer.com/2015/01/why-im-worried-about-the-art-world-adam-lindemann-on-the-sizzle-vs-the-steak/

12. Stuart, Jeffries, "What Charles did next," *The Guardian*, September 6, 2006.
http://www.theguardian.com/artanddesign/2006/sep/06/art.yourgallery

13. Adam Lindmann, "Occupy Art Basel Miami Beach, Now! : By not showing up. Collectors need to boycott this art fair," *New York Observer*, November 29, 2011.

http://observer.com/2011/11/occupy-art-basel-miami-beach-now/#ixzz3PZtM8qIH

14. Jerry Saltz, "The Prince of the One Percent Would Like You to Know That Buying Art Is Less Fun These Days," Vulture, December 6, 2011.

http://www.vulture.com/2011/12/jerry-saltz-adam-lindemann-feud-art-basel.html

15. Kelly Crow, "The Gagosian Effect," *The Wall Street Journal*, April 1, 2011.

http://www.wsj.com/articles/SB10001424052748703712504576232791179823226

16. Jonathan T.D. Neil and Stefan Simchowitz, "An Eye on the Future: New Business Models for the Art Market," discussion at Art Los Angeles Contemporary, January 31, 2015.

http://vimeo.com/118377619

17. Jo Miller, "Influencing Without Authority—Using Your Six Sources of Influence," *Be Leaderly*, August, 2014.

http://www.beleaderly.com/ask-jo-influence-without-authority/

18. Peep Laja, "Useful Value Proposition Examples (and How to Create a Good One)," ConversionXL.com, February 16, 2012.

http://conversionxl.com/value-proposition-examples-how-to-create/

19. Karl Stark and Bill Stewart, "3 Rules of a Compelling Value Proposition," *Inc.*, September 24, 2012

http://www.inc.com/karl-and-bill/3-rules-of-a-compelling-value-proposition.html

CHAPTER 5

1. How's My Dealing? R.I.P list: http://howsmydealing.blogspot.com/search/label/R.I.P.

2. Steven Zevitas, "Kristen Dodge: Exit Interview," *New American Paintings,* March 20, 2014

https://www.newamericanpaintings.com/blog/kristen-dodge-exit-interview

3. Charlotte Burns, "Nicole Klagsbrun to close gallery after 30 years in the business," *The Art Newspaper,* March 28, 2013

http://www.theartnewspaper.com/articles/Nicole+Klagsbrun+to+close+gallery+after+30+years+in+the+business/29137

4. Alexander Forbes, "Berlin's Galerie Kamm Will Close in September," *Artnet*, July 2, 2014.

http://news.artnet.com/in-brief/berlins-galerie-kamm-will-close-in-september-53644

5. Charlotte Burns, "While the rich get richer… : As the top galleries branch out, the middle level is being squeezed" *The Art Newspaper*, March 4, 2013.

http://www.theartnewspaper.com/articles/While-the-rich-get-richer/28991

6. Sarah Murkett, "The Mid-Size Squeeze: Five Galleries Weigh In," *MutualArt,* September 4, 2013.

http://www.mutualart.com/OpenArticle/The-Mid-Size-Squeeze–Five-Galleries-Wei/3C4AADE7D32768E5

7. Anuradha Vikram, "#Hashtags: The Squeezing of the Middle Class Gallery," *DailyServing*, March 10, 2014. http://dailyserving.com/2014/03/hashtags-the-squeezing-of-the-middle-class-gallery/

8. Clare McAndew, *The TEFAF 2014 Art Market Report*, The European Fine Art Foundation, Helvoirt, the Netherlands, 2014. http://www.tefaf.com/DesktopDefault.aspx?tabid=102

9. Rachel Corbett, "Growing new service to ease cash flow in the art market," *The Art Newspaper,* October 2014

10. Magnus Resch, "Will Market Aversion Snuff Out German Galleries?" Artnet News, October 30, 2014 http://news.artnet.com/market/will-market-aversion-snuff-out-german-galleries-139060

11. David Batty, "East End art galleries forced to go west as local scene 'dies,'" *The Guardian,* June 6, 2012. http://www.theguardian.com/uk/2012/jun/06/vyner-street-galleries-east-london

12. "Soaring rent and demanding art fairs close a Mayfair gallery—but the picture isn't all bleak," *Spear's,* March 4, 2014. http://www.spearswms.com/blog/soaring-rent-and-demanding-art-fairs-close-a-mayfair-gallery---but-the-picture-isnt-all-bleak#.VX7dAPlViaI

13. Kenneth Baker, "Art galleries swallowed up by S.F. real estate boom," *SFGate,* February 27, 2014. http://www.sfgate.com/bayarea/article/Art-galleries-swallowed-up-by-S-F-real-estate-5270305.php

14. Katya Kazakina, "Desperate Art Galleries Give Up as Chelsea Rents Double," *Bloomberg,* February 20, 2013. http://www.bloomberg.com/news/2013-02-20/desperate-art-galleries-give-up-as-chelsea-rents-double.html

15. Charlotte Burns and Julia Halperin, "Slicing up the Big Apple: New York's galleries scatter as rents rise and generations shift," *The Art Newspaper,* October 24, 2013. http://www.theartnewspaper.com/articles/Slicing-up-the-Big-Apple/30566

16. Nicolai Hartvig, "Art Basel Opens in Time of Turbulence for Dealers," *The New York Times,* June 11, 2013. http://www.nytimes.com/2013/06/12/arts/Art-Basel-Opens-in-Time-of-Turbulence-for-Dealers.html

17. Charlotte Burns, "Emmanuel Perrotin enters the bear pit," *The Art Newspaper,* October 1, 2013. http://www.theartnewspaper.com/articles/Emmanuel-Perrotin-enters-the-bear-pit/30484

18. Jocelyn Wolff, "Carving out a space among the big brand galleries," Talking Galleries Barcelona Symposium, November 11, 2013. http://www.talkinggalleries.com/?p=1981

19. Katya Kazakina, "Lund Painting Sold for 1,500% Gain as Art Flippers Return," *Bloomberg,* May 24, 2014. http://www.bloomberg.com/news/2014-05-23/lund-painting-sold-for-1-500-gain-as-art-flippers-return.html

20. Lorne Manly and Robin Pogrebin, "Barbarians at the Art Auction Gates? Not to Worry," *The New York Times,* August 17, 2014. http://www.nytimes.com/2014/08/18/arts/design/barbarians-at-the-art-auction-gates-not-to-worry.html

21. Robert Smith, "Safer Looks at Art but Only Hears the Cash Register, *ArtsBeat, The New York Times,* April 32, 2012. http://artsbeat.blogs.nytimes.com/2012/04/02/morley-safer-launches-a-halfhearted-salvo-in-his-war-on-the-art-world/?_r=0

22. Jerry Saltz, "Wade Guyton May Be Trying to Torpedo His Own Sales," *New York* Magazine, May 12, 2014. http://www.vulture.com/2014/05/wade-guyton-may-be-torpedoing-his-own-sales.html

23. Olivia Fleming, "Why the World's Most Talked-About New Art Dealer Is Instagram," *Vogue,* May 13, 2014. http://www.vogue.com/872448/buying-and-selling-art-on-instagram/

CHAPTER 6

1. Cornell DeWitt, "Clare McAndrew Explains How She Prepares the TEFAF Art Market Report," Artnet News, March 9, 2015

http://news.artnet.com/market/clare-mcandrew-on-the-tefaf-report-274279

2. "Online art market now worth an estimated $1.57bn," Hiscox Group website, April 28, 2014.

http://www.hiscoxgroup.com/news/press-releases/2014/28-04-2014.aspx

See also *The Hiscox Online Art Trade Report 2014*

http://www.hiscox.es/shared-documents/estudio_arte_online_2014.pdf

3. *The Hiscox Online Art Trade Report 2015*

http://www.hiscoxgroup.com/~/media/Files/H/Hiscox/reports/Hiscox%20Online%20Art%20Trade%20Report%202015.pdf

4. Clayton Christensen, Key Concepts, claytonchristensen.com.

http://www.claytonchristensen.com/key-concepts/

5. Jill Lepore, "The Disruption Machine: What the gospel of innovation gets wrong," *The New Yorker*, June 23, 2014

http://www.newyorker.com/magazine/2014/06/23/the-disruption-machine

6. "Eighth Wonder: Paddle8 Takes Art Online," *Interview,* June 22, 2011.

http://www.interviewmagazine.com/art/paddle8

7. Benjamin Genocchio, "Artspace Sale Augurs Inevitable Shake-Out in Online Art Sales," Artnet News, August 14, 2014

http://news.artnet.com/market/artspace-sale-augurs-inevitable-shake-out-in-online-art-sales-78371

8. Adam L. Penenberg, *Viral Loop: From Facebook to Twitter, How Today's Smartest Businesses Grow Themselves,* 2009, Hachette Books, New York.

9. James Harkin, "*The Facebook Effect* by David Kirkpatrick," *The Guardian*, July 17, 2010.

http://www.theguardian.com/technology/2010/jul/18/the-facebook-effect-david-kirkpatrick-book-review

10. Scott Reyburn, "When the Fine Art Market Goes Online," *The New York Times*, March 20, 2015.

http://www.nytimes.com/2015/03/23/arts/international/when-the-fine-art-market-goes-online.html

11. Katya Kazakina, "Art Sales Move Online to Attract Buyers," *Bloomberg Business*, October 02, 2014.

http://www.bloomberg.com/bw/articles/2014-10-02/online-art-startups-look-to-attract-buyers-with-affordable-pieces

12. Edward Helmore, "Buy! Sell! Liquidate! How ArtRank is shaking up the art market," *The Guardian*, June 23, 2014

http://www.theguardian.com/artanddesign/2014/jun/23/artrank-buy-sell-liquidate-art-market-website-artists-commodities

13. Dan Duray, "They Clicked With Investors—Now What? Who Will Win the Race to Sell Art Online?" *New York Observer*, January 28, 2014.

http://observer.com/2014/01/they-clicked-with-investors-now-what-who-will-win-the-race-to-sell-art-online/

14. Kenneth Schlenker, comment in "ArtList," *GothamGal,* January 30, 2015.

http://gothamgal.com/2015/01/art-list/

15. Marisa Meltzer, "With Pop-Up Salons, Art Is Demystified: Gertrude Stein's Legacy Lives On in Pop-Up Art Salons," *The New York Times*, June 13, 2014.

 http://www.nytimes.com/2014/06/15/fashion/gertrude-steins-legacy-lives-on-in-pop-up-art-salons.html

16. Olivia Fleming, "Why the World's Most Talked-About New Art Dealer Is Instagram," *Vogue*, May 13, 2014.

 http://www.vogue.com/872448/buying-and-selling-art-on-instagram/

17. Elena Soboleva, "How Collectors Use Instagram to Buy Art," Artsy.net, April 19, 2015.

 https://www.artsy.net/article/elena-soboleva-how-collectors-use-instagram-to-buy-art

18. Ralf VonSosen, "This Week's Auctionography: Three Keys to Online Selling Success," Hammertap, June 6, 2011

 http://www.hammertap.com/o_cat_3_110606/

CHAPTER 7

1. Blake Gopnik, "Great art needs an audience," *The Art Newspaper*, 13 February 2014.

 http://www.theartnewspaper.com/articles/Great-art-needs-an-audience/31726

2. Julia Halperin, "Dealers abandon bricks and mortar galleries for more flexible models," *The Art Newspaper*, April 1, 2015.

 http://www.theartnewspaper.com/news/art-market/17216/

3. Julia Werdigier, "Pop! An Empty Shop Fills With Art," *The New York Times*, August 31, 2009.

 http://www.nytimes.com/2009/09/01/arts/design/01stores.html

4. Stuart Husband, "Kenny Schachter: Confessions of an art hustler," *The Independent*, June 25, 2006.

 http://www.independent.co.uk/news/people/profiles/kenny-schachter-confessions-of-an-art-hustler-405194.html

5. Alex Williams, "You Never Know Where Her Gallery Will Pop Up Next," *The New York Times*, May 12, 2010.

 http://www.nytimes.com/2010/05/13/fashion/13Close.html

6. Edward Winkleman, "Tips for DIY Art Exhibitions," edwardwinkleman.com, September 1, 2009.

 http://www.edwardwinkleman.com/2009/09/tips-for-diy-art-exhibitions.html

7. Alyson Kruegermay, "Just Like Taco Trucks, Art Takes to the Road," *The New York Times*, May 30, 2014.

 http://www.nytimes.com/2014/05/31/arts/design/just-like-taco-trucks-art-takes-to-the-road.html

8. Nicole O'Rourke, "Interview with Protocinema founder Mari Spirito, *The Guide Istanbul*, December 22, 2014

 http://www.theguideistanbul.com/news/view/1888/interview-with-protocinema-founder-mari-spirito/#ixzz3Zg0tYLhB

9. Alex Greenberger, "'Let's Make It Happen': Deitch on Almost Joining MoMA, Bribing Michael Jackson's Doorman, and More," *ArtNews*, March 15, 2015.

 http://www.artnews.com/2015/03/26/lets-make-it-happen-deitch-on-almost-joining-moma-bribing-michael-jordans-doorman-and-more/

10. Carl Swanson, "Jeffrey Deitch Curates Jeffrey Deitch: The Return of the Art World's Most Essential Zelig," *New York* (Vulture.com), January 12, 2014.

 http://www.vulture.com/2014/01/jeffrey-deitch-returns-to-the-art-world.html

CHAPTER 8

1. "Joint Gallery Events vs. Going Solo," panel discussion, Talking Galleries symposium, Museum d'Art Contemporani of Barcelona, October 29, 2014.
 http://www.talkinggalleries.com/?p=3719

2. Dan Duray, "Untitled and Zach Feuer Galleries Will Merge on the Lower East Side," *ArtNews*, March 11, 2015.
 http://www.artnews.com/2015/03/11/untitled-and-zach-feuer-galleries-will-merge-on-the-lower-east-side/

3. Jocelyn Wolff, "Craving out a Space among the Big Brand Galleries," Talking Galleries Barcelona Symposium, November 11, 2013.
 http://www.talkinggalleries.com/?p=1981

4. Julia Halperin, "Almost one third of solo shows in US museums go to artists represented by five galleries," *The Art Newspaper,* April 2, 2015.
 http://theartnewspaper.com/news/museums/17199/

5. Traven Rice, "TLD Interview: LUSH LIFE Curators Franklin Evans & Omar Lopez-Chahoud," *The Lowdown NY,* July 8, 2010.
 http://www.thelodownny.com/leslog/2010/07/tld-interview-lush-life-curators-franklin-evans-omar-lopez-chahoud.html

6. Holland Cotter, "Lower East Side Tale, Refracted Nine Times," *The New York Times*, July 8, 2010.
 http://www.nytimes.com/2010/07/09/arts/design/09lush.html

CHAPTER 9

1. Zoë Lescaze, "Frieze New York, Unions Reach Agreement in Art Fair Labor Dispute," *New York Observer,* April 9, 2014.
 http://observer.com/2014/04/frieze-new-york-unions-reach-agreement-in-art-fair-labor-dispute/#ixzz3ZN7o10wG

PART III

1. Edward Winkleman, "The position of the mid-market gallery in today's environment" Talking Galleries, Barcelona, November 2, 2015.
 http://www.talkinggalleries.com/?p=3705

CHAPTER 11

1. Tad Crawford, *Business and Legal Forms for Fine Artists,* Fourth Edition, 2014, Allworth Press, New York, p. 40.

Index

Books from Allworth Press

Art Without Compromise
by Wendy Richmond (6 × 9, 256 pages, paperback, $24.95)

An Artist's Guide: Making It in New York City
by Daniel Grant (6 × 9, 256 pages, paperback, $24.95)

The Artist's Guide to Public Art: How to Find and Win Commissions
by Lynn Basa (6 × 9, 240 pages, paperback, $19.95)

The Artist's Quest for Inspiration
by Peggy Hadden (6 × 9, 272 pages, paperback, $19.95)

The Art World Demystified
by Brainard Carey (6 × 9, 256 pages, paperback, $19.99)

Business and Legal Forms for Fine Artists, Fourth Edition
by Tad Crawford (8½ × 11, 208 pages, paperback, $24.95)

Business of Being an Artist, Fifth Edition
by Daniel Grant (6 x 9, 344, paperback, $19.99)

Create Your Art Career
by Rhonda Schaller (6 × 9, 208 pages, paperback, $19.95)

The Fine Artist's Guide to Marketing and Self-Promotion
by Julius Vitali (6 × 9, 256 pages, paperback, $24.95)

How to Start and Run a Commercial Art Gallery
by Edward Winkleman (6 × 9, 256 pages, paperback, $24.95)

Legal Guide for the Visual Artist, Fifth Edition
by Tad Crawford (8½ × 11, 304 pages, paperback, $29.95)

Making It in the Art World
by Brainard Carey (6 × 9, 256 pages, paperback, $19.95)

New Markets for Artists
by Brainard Carey (6 × 9, 264 pages, paperback, $24.95)

Selling Art without Galleries
by Daniel Grant (6 × 9, 256 pages, paperback, $19.95)

Starting Your Career as an Artist, Second Edition
by Angie Wojak and Stacy Miller (6 × 9, 320 pages, paperback, $19.99)

Where Does Art Come From?
by William Kluba (5½ × 8¼ , 192 pages, paperback, $16.95)

To see our complete catalog or to order online, please visit *www.allworth.com*.